D1649915

THE
Ascetic
Imperative
IN
Culture
AND
Criticism

THE
Ascetic Imperative
IN
Culture
AND
Criticism

Geoffrey Galt Harpham

The University of Chicago Press
Chicago and London

The University of Chicago Press, Chicago 60637
The University of Chicago Press, Ltd., London
© 1987 by The University of Chicago
All rights reserved. Published 1987
Paperback edition 1993
Printed in the United States of America

96 95 94 93 5 4 3 2

Library of Congress Cataloging-in-Publication Data

Harpham, Geoffrey Galt, 1946–
 The ascetic imperative in culture and criticism.

 Bibliography: p.
 Includes index.
 1. Asceticism. 2. Criticism. 3. Arts—Philosophy.
I. Title.
BL625.H33 1987 700'.1 87-10775
ISBN 0-226-31691-2 (cloth)
ISBN 0-226-31692-0 (paperback)

∞ The paper used in this publication meets the minimum
requirements of the American National Standard for Information
Sciences—Permanence of Paper for Printed Library Materials,
ANSI Z39.48-1984.

Contents

Contents

Illustrations

Acknowledgments

In 1980–81, I began the program of curiosity that eventually became this book with the aid of a Study Fellowship from the American Council of Learned Societies. In addition to freeing me from other responsibilities, this grant gave me the invaluable opportunity to associate with Leo Steinberg. Also during this year, I spent six or seven months of dreamy Thursdays at the legendary Princeton Index of Christian Art, where I was stirred into an appearance of industry by Mrs. Elizabeth Beatson and her remarkable colleagues. During the early going, I was fortunate enough to have the generous counsel and friendship of Frank Bowman. The book was written during my three years (1983–86) as the Andrew F. Mellon Scholar in the Department of English and American Literature at Brandeis University. I would like to thank the members of this department as a whole, and to single out in particular Judith Ferster, Phil Fisher, Billy Flesch, Allen Grossman, Bob Lane, Helena Michie, and Jim Merod. I learned more than I could apply from the work and advice of Howard Eiland. Robert F. Storey's sustained and sustaining interest has marked this book everywhere in ways apparent most of all to the author. The most complicated form of acknowledgement goes to Adrian, for whom this book was one of the trials of adolescence; and to Clare, who knew nothing of it beyond its power to immobilize her father. The book is dedicated to Joan Barasovska, for whom it was written as an act of love, and confession.

Portions of this book have appeared in slightly different form in *Criticism* and in *Studies in Autobiography*, edited by James Olney (New

York: Oxford Univ. Press, 1987). I am grateful for permission to reprint. I am grateful, too, to the museums and libraries that have provided the photos in this book as well as the permission to reproduce them.

Introduction

*I*n this book the term asceticism refers not only to a particular set of beliefs and practices that erupted into high visibility during the early Christian era, but also to certain features of our own culture, features that have survived the loss of the ideological and theological structure within which they emerged. This survival is one of the most remarkable things about asceticism, and forms a *sub rosa* concern, a continuing problem and fascination, of the entire book.

I have begun with the premise that asceticism has, even today, a certain descriptive resonance. While the term can plausibly "cover" early Christianity, the concept of asceticism exceeds the ideological limitations of that culture; it may best be considered as sub-ideological, common to all culture. In this large sense, asceticism is the "cultural" element in culture; it makes cultures comparable, and is therefore one way of describing the common feature that permits communication or understanding between cultures. As a new computer-literate, I find myself thinking of asceticism as a kind of MS-DOS of cultures, a fundamental operating ground on which the particular culture, the word processing program itself, is overlaid. Where there is culture there is asceticism: cultures structure asceticism, each in its own way, but do not impose it.

I cannot argue this enormous claim in detail, but it may seem less arbitrary if we remind ourselves of a less controversial idea, that all cultures are ethical cultures; for the idea of ethics is inescapably ascetical. No matter how hedonistic, materialistic, self-indulgent, wick-

ed, or atomistic they may be, all cultures impose on their members the essential ascetic discipline of "self-denial," formulated by the Christian ascetics as the resistance to what Augustine calls "nature and nature's appetites."

The numerous forms this resistance can take all derive from what may be thought of as primary psychic gestures. In part 3 I explore another analog to asceticism in Julia Kristeva's hypothesis of a "semiotic" mapping of instinctual drives connected with primary repression, a mapping that logically precedes any higher level of articulation. Just as the mark of culture is the conviction of the value and necessity of self-denial, the mark of human consciousness is the capacity for self-observation or self-criticism. These are the bases of asceticism, whose manifest, explicit, and conscious forms appear now not as intrinsically unnatural and perverse but rather as an intensification, a repetition, of the earliest and most instinctive psychic and cultural developments.

The interest of the early Christian experience, then, is that within its fanatical particularity, a profound and virtually universal idea struggles for articulation. But perhaps it is a mistake to call asceticism an "idea." The durability of asceticism lies in its capacity to structure oppositions without collapsing them, to raise issues without settling them. Even within the ideological restraints of the early Christian practice, asceticism exhibited a high-intensity comprehensiveness, a hyperarticularted ambivalence. Take for example the early Christian approach to culture, which often took radically anticultural forms, such as the retreat by the early monastic heroes to isolated caves in the desert. The often morbid or flamboyant deprivations and tortures they inflicted on themselves displayed a violence and self-loathing entirely incompatible with communal life or the family structure. But this apparent anticulturalism should not eclipse the fact that the Desert Fathers brought the Book to the Desert, and served as apostles of a textual culture in the domain of the natural. Asceticism neither simply condemns culture not simply endorses it; it does both. Asceticism, we could say, *raises the issue* of culture by structuring an opposition between culture and its opposite. Despite the fanaticism of its early Christian practitioners, who constantly extolled the value of "single-mindedness," asceticism is always marked by ambivalence, by a compromised binarism. To contemplate the ascetical basis of culture, for example, is to recognize that an integral part of the cultural experience is a disquiet, an ambivalent yearning for the precultural, postcultural, anticultural, or extracultural.

Christianity did contribute something new to asceticism by formal-

izing, systematizing, and theologizing it—by naming it as a concept. Within the Christian experience asceticism becomes visible as a specific set of practices and beliefs. At the same time, the extreme specificity of this "pure" or "raw" articulation has perhaps concealed the continuity of interest between that culture and this one, a continuity I hope to bring out in this book.

In treating the "ascetic imperative" as a primary, transcultural structuring force, I am following in the tracks of many who have had similar intuitions. William James, for example, understood that asceticism was not an exclusively religious phenomenon. In *The Varieties of Religious Experience*, he acknowledged the tendency of Christian asceticism to extravagance and excess, but praised its spirit of heroism, revealed particularly in the attitude of the ascetic towards death. In his cultivation of death as an imminent spiritual state, the ascetic, according to James, incarnates the "metaphysical mystery," that "he who feeds on death that feeds on men possesses life supereminently and excellently" (364). James even recommended the "old monkish poverty-worship" as "something heroic that will speak to men as universally as war does, and yet will be as compatible with their spiritual selves as war has proved itself to be incompatible" (367). As universal as war, of which it may be said to be a privatized version; and yet larger than war, for it is compatible with war's opposite, the urge for transcendence.

Accepting James's presumption that the spirit of asceticism can be found even in wholly secular practices and institutions, I have used the term throughout in both a tight and a loose sense, with the former denoting a highly specific historical ideology and the latter enabling the conceptual transposition of that ideology to other cultures remote from the original in time, space, and everything else. In the tight sense asceticism is a product of early Christian ethics and spirituality; in the loose sense it refers to any act of self-denial undertaken as a strategy of empowerment or gratification. Throughout the book, but particularly in part 1, I move back and forth between cultures and discourses in an attempt to give the term asceticism a certain historical density and to suggest an often ignored historical depth to contemporary thought. It may be objected that in suspending the obvious differences between periods, cultures, or species of discourse, I have forsaken a proper procedural rigor, to invoke an ascetic imperative. But without a relaxation of certain kinds of academic rigors, I would not have been able to exercise certain speculative freedoms—freedoms which, as anyone who works in this way understands, carry with them other duties, other rigors.

To see how these tight and loose senses work together, consider a

typical ascetic trope, a description by the pseudo-Clement in "The First Epistle Concerning Virginity" of Saint Paul as a celibate who by "treading down and subjugating the body" made of himself "a beautiful example and pattern to believers" (ch. 9: 58). An entire ideology is condensed here, involving self-denial, belief in God, and the tireless effort to starve out or punish the animal elements of the human condition.

But there is another way of looking at this figure, as a meditation on the relation between human life and aesthetic form. From this point of view the subject of the passage is the way in which a human being can become imitable, how he can meet what are sometimes called the conditions of representation. The passage implies that the body and its desires and appetites are not, as we sometimes think, the proper subject of representation, but are in fact inimical to representation. From the ascetical point of view it is self-denial that is eminently imitable. Through discipline, the author suggests, the self becomes at once self-aware, structured, knowable, and valuable. Asceticism is not merely capable of assuming a multitude of forms; it is the form-producing agent itself. Intriguingly, the task facing "believers" who would follow the "pattern" consists of the imitation of an original model whose distinction lay in a programmatic self-abuse. Value inheres in the imitation of a man who insisted on his own worthlessness. And through this deference to a person whose life consisted of denigrating his life, one can not only conserve the past and give birth to the future, but can also anchor oneself in a community of imitation which both temporally and spatially exceeds the boundaries of the individual life.

The means of situating the self in systems that exceed the self is the production of symbolic forms. The pseudo-Clement's words remind us how intimately bound the body is to such practices of representation and imitation. Even the body—or especially the body—can participate in symbolization, can acquire and bear meaning and value. It can do so through an ascesis that appears to deny the body, or at least to oppose it. But, again, asceticism does not oppose the body in any simple way. For by characterizing an entire life as an "imitation of Christ," or as "a pattern for believers," asceticism both denigrates and dignifies the body, casting it at once as a transgressive force always on the side of "the world" and as the scene or stage for discipline, self-denial, ascesis. Only through certain physical acts acknowledged to constitute "mastery" over the body—as opposed to the body's mastery over the self—could virtue be acquired, attested to, or proven. The pseudo-Clement characterizes the entire struggle in aesthetic terms because it is symbolic. Ascetic discipline is a bodily act that points beyond itself,

expressing an intention that forms, and yet transcends and negates, the body; discipline makes the body intelligible by indicating the presence of a principle of stability and immobility within the constantly changing physical being.

We look to a work of art for evidence of a will seeking expression by imposing itself upon alien matter. The ascetic body is in this sense an exemplary artifact: what the ascetics displayed to their audience was precisely their *form*. Early Christian asceticism was supported by a highly articulated theology, but essentially it was driven by the same desire to which Greek thought, for example, was so responsive—to live coherently, to stabilize life so as to make it knowable. On the other hand, however—and asceticism is always ambidextrous—one could maintain with equal justice that the ascetic spirit is anti-Greek and anti-aesthetic, regarding all form as wordly and therefore death to the spirit, an obstacle to perfect intelligibility. Characteristically, asceticism engages an issue, in this case the relation between life and knowledge, and articulates an opposition within which dialogue and dialectic can occur; but it leaves the issue unsettled by privileging both sides.

In the comment of the pseudo-Clement, then, we can see not only the manifest ideology of early Christianity but also the traces of a less obviously ideological meditation touching on issues of knowledge, desire, power, time, ethics, the body, representation, imitation, precedence, the constitution of the self, and the relation between human practices and aesthetic form. The "contribution" of early Christian asceticism is that it provided a perspective in which all these issues and forces were considered together as part of a complex whole. And so although historical asceticism is in certain senses a marginal and superseded form, its conceptual parameters are spacious and comprehensive, more so than most of the currently available forms of critical discourse would have us believe is possible.

Some contemporary critical methods, for example, place a higher value on human "practices" than on the various forms of discourse; others reverse the privilege. And in most instances of critical practice today, oppositions such as this are presented as though they required a choice: one must decide, for example, whether there is or is not anything "outside the text" (Derrida); or, conversely, whether there is anything "in" the text at all (Fish). Indeed, despite deconstruction, the besetting problem of contemporary criticism is that it seems unable to imagine a way out of such oppositions and the questions they provoke. For many of these questions, asceticism provides us with an extraordinarily useful concept, that of *resistance*. Ethics is grounded in the notion of resistance to temptation, but the concept can and should be

generalized, in ways I try to suggest throughout the book. The distinctive feature of resistance is that it suspends two apparently antagonistic terms—one fixed, the analogs or transformations of "soul"; the other mobile, the analogs or transformations of "body"—in a relationship of interdependence so that both opposition and relation are maintained. Text and reader, we could say, exist neither in opposition to each other nor are they one and the same. They exist only in a condition of mutual resistance.

How badly such a concept is needed may be illustrated by a recent discussion in the pages of *Critical Inquiry* in which Walter Benn Michaels took Leo Bersani to task for the latter's suggestion that literature provided a salutary opposition to the unbridled power of capitalism. According to Bersani, literature is "an exercise of power which self-destructively points to the impossibility of its claim to power-generating knowledge" ("The Subject of Power" 11); it sustains a posture of systematic irony towards its own "emptily limitless" power ("Rejoinder" 162). In contrast to the limitless but "strictly verbal" economy of literature, Bersani says, real economies operate with physical entities whose finitude provides brakes to desire at the same time that it enables the exercise of worldly power. Michaels replies that, considering in particular the "immortality" of corporations and the "fictitious dealing" of the stock market, the differences between the infinite verbal and the finite physical are far from absolute and that art's "excessive representations" constitute not a critique of but rather a form of commitment to "a voracious consumer society." Art, he claims, is "not *in principle* hostile" to exercises of capitalistic power ("Fictitious Dealings" 170).

This dispute bears on the subject of this book in several ways. Max Weber identifies capitalism as a form of "worldly asceticism," and his analysis shows how a monastic ideology of restriction and deprivation can dilate into a worldly principle of consumption, power, and excess. But what I want to draw attention to here is how this interesting debate between Bersani and Michaels is energized by a mistaken notion on both sides. Both believe that art can provide a responsive "resistance" to exercises of power, but neither seems to understand the full meaning of the word or its applicability in this case. While they do not agree on the relation between art and capitalism, they do agree on the nature of desire. Bersani contends not only that literature is hostile to worldly power but also that art is capable of invoking a principle of limitless desire; Michaels responds that capitalism, too, operates by models of infinite desire. Implicit throughout the third and fourth sections of part I, my counterargument to both these positions draws on a common-

place in ascetic writings, which teach that "Man's life on earth is a temptation"; the ubiquity of resistance as a structuring principle intrinsic to desire rather than an alien element imposed from the outside.

In other words, desire is never limitless; it is always resisted, and resisted from within. It is the resistance within desire between tropes of finitude and infinitude that constitutes the ground of agreement between art and capitalism. The economies of art and capitalism are comparable in the ways in which they structure desire, not in their dubious forms of infinitude. And art and capitalism themselves provide resistances, rather than stark oppositions to, or collusions with, each other.

The first part of this book identifies and elaborates "the ascetic imperative" as it has structured Western thought on the subjects of language, the self, desire, and narrative. In the second, Augustine's *Confessions* provides an occasion for an analysis of ascetic modes of self-representation, conversion, textuality, and interpretation. Matthias Grünewald's stunning and majestic *Isenheim Altar* serves as the fixed point of part 3, which explores notions of "conceptual narrative," the ethics of pictorial representation, the "passion" of representation, and the relation between asceticism and the sublime. The fourth part explores efforts by Nietzsche and Foucault to escape the binding force of traditions or structures they call ascetic by positing counterconcepts of power or the body. The contention of the polemical fifth part is that interpretation theory, alternating between modes of formalism and modes of subjectivism, is structurally and permanently an ascetic undertaking. I argue that the frequently explicit antagonism of literary critics toward "ascetic" practices of reading do not constitute true oppositions but resistances, and are therefore implicated in their own critiques as ascetic gestures which testify to the capacity of asceticism to efface even itself.

The Ideology of Asceticism

I

Ascetic Linguistics I

. . .writing with ink and paper, and thereby many
have sinned from all eternity unto this day.

Enoch 69:9

*T*he master text of Western asceticism is the *The Life of Anthony*,
written in the mid-fourth century by Athanasius, bishop of
Alexandria. It tells the story of an early ascetic hero, including his
conversion, his solitary life in the Egyptian desert, his struggles against
temptation, the spread of his fame, his polemics against heresy, and his
advice to other ascetics on how to combat the demons that crowded in
the air about them. As very nearly the first and by far the most
important work of hagiography, this text holds a position of extraor-
dinary prominence in the histories of Western ethics and spirituality.
Standing at the origin of the literary tradition that contributed so
crucially to the novel, the text is equally important in the history of
narrative. Hagiography is the most action-packed mode in our literary
tradition, and *The Life of Anthony* is notable for its dramatic and extreme
events, but it is also a theological and, in certain senses, a theoretical
text; and it is with this dimension of the text that an exploration of
asceticism should begin.

Athanasius devoted his life to opposing the Arian heresy, according
to which Christ was not made of the same substance as God, was not
Truth itself, but was rather a "complete" or "perfect" man, designated
as the Son because of his virtues and acts. In this form, the issue is no
longer of compelling theoretical interest, but as it touches on issues of
authority, priority, originality, the status of derivation, and—since
Christ is the Word—the nature of language, it has analogical descen-
dants in the fields of philosophy, linguistics, and phenomenology that

3

structure the central critical debates of our time. The Arian heresy is not a primitive precursor of today's conflicts, but simply the Late Roman form of the one continuing discussion conducted within Western thought since the Greeks, on the relation between appearance and reality.

Too often today this discussion is condensed into a misleadingly simple choice: either one glories in derivation (in the forms of "radical heterogeneity," "infinite semiosis," "freeplay," "dissemination," relativism, perspectivism, or conventionalism of any kind) or one more soberly claims that certain forces or notions (culture, nature, truth, economics, foundationalism, or idealism of any kind) are ascertainable beyond dispute. Today's Arians argue that in this world everything is worldly, and subject to time, change, and mediation; today's anti-Arians insist that even in this world certain absolutes still obtain. The simplicity, or, to put it more bluntly, the vulgarity, of such a choice is made possible by the exceptionally "pure" theoretical occasion for the discussion. In comparison with the scene of today's arguments, *The Life of Anthony* presents a striking contrast in that it addresses a situation that is at once theoretical, political, ethical, spiritual, and urgent.

In the cultural milieu of *The Life of Anthony*, relations between reader and text were complex. In the embattled, scattered little Christian communities of the Late Roman empire, the few texts that circulated were read in many ways: as messages from others in similar circumstances, as reminders of a common commitment, as theological or hermeneutical instruction, as exhortation to hold fast in the face of persecution, and, in the case of hagiography, as imitable models of exemplary conduct. Early Christian writings are preoccupied with questions of authority and precedence concerning Scripture, the local bishop, the inner voice of conscience. Such writings exemplify the condition Philip Fisher has called "emergency art," art produced in an atmosphere of fourfold uncertainty concerning appropriate form, proper content, possible audience, and the validity of the literary tradition.[1]

But it is not only the cultural situation that perturbs the hagiographer. This situation is complicated and radically intensified by the doctrine of Christ as Logos, which transposes theology into the key of language. Kenneth Burke has created "logology" to account for this transposition, arguing that "what we say about *words*, in the empirical realm, will bear a notable likeness to what we say about *God*, in theology" (*Rhetoric of Religion* 13–14). The production of any text within a community as hyper-aware of the analogies between words and the Word as the early Christians is likely to be an emergency

situation, with the result that, as the great scholar Hippolyte Delehaye says, "Nothing is more common in the prefaces to lives of saints than excuses for imperfections of form and a preoccupation concerning style" (66).

Athanasius inaugurates the tradition of nervous prefaces by asserting that his account of Anthony's life, though the best possible under the circumstances, is still flawed. Addressing himself to "the monks abroad," who have entered "on a fine contest with the monks in Egypt," trying to surpass them in feats of virtuous deprivation, Athanasius apologizes for the imperfections in his text: "since the season for sailing was coming to a close, and the letter-bearer was eager," he had abandoned his researches and had committed his work to the world. But he implies too that no account would be perfect, for "after each tells what he knows, the account concerning him would still scarcely do him justice." And yet even an imperfect account "provides monks with a sufficient picture for ascetic practice," enabling them to imitate his example, to "emulate his purpose" (*Life of Anthony* 29–30).[2] In these few phrases we can glimpse the features of a textual ascetics that applies to what Roman Jakobson calls the referential function and the poetic function. Referentially, an account would be perfect if it were perfectly obedient to Anthony's life, if the rules of its configuration were drawn solely from that life, if the author intruded nothing of his own creation. Athanasius appears to recognize that perfection in this sense is impossible to attain, the differences between accounts and lives being substantial, but he still maintains that virtue resides in the effort. The poetic function operates at the expense of the referential function by accentuating the message, the language itself, rather than the extralinguistic reality that language is modeled on (355–60). The value of the text lies in its capacity to replace and extend the life of Anthony; the poetic function even enables the text to be superior as a "picture for ascetic practice" to Anthony himself. Now as nobody can be another person, the obstacles to a perfect imitation are absolute; but again, virtue resides in the effort. So both Athanasius and his readers strive for the impossible perfect imitation of Anthony. They fail, but succeed in the failure. Anthony was in fact so widely known through this book, and so widely imitated, that he has become a saint of the book; he is commonly represented in art holding or reading a book.

This aspect of his later iconography is odd in light of the first paragraph of the book itself, in which Anthony is introduced as a voluntary illiterate: "As he grew and became a boy, and was advancing in years, he could not bear to learn letters, wishing also to stand apart from friendship with other children. All his yearning, as it has been

written of Jacob, was for living, an unaffected person, in his home" (1: 30). Athanasius is trying to describe a "natural" asceticism, the precondition for the systematic privations undertaken later on. This precondition, the very basis of virtue and "redeemability," consists of a detachment so comprehensive that even reading is considered an "affectation," a distraction, a token of worldliness. Anthony's aversion to letters does not, however, extend to language as a whole, for he pays extremely close attention to "the readings"—passages read aloud from Scripture—and "carefully took to heart what was profitable in them" so that "memory took the place of books" (1: 30–31; 3: 32).

It appears that the value of the written word is at war with the writing, or as if "what was profitable" were polluted by the ink. The emergent system might be represented by a three-part division: (1) Mind, or the "heart" which takes in "profit." The heart is untouched by representation, repetition, or mediation. It does not require language but can motivate language and understand it. It is essentially an "inside." (2) Writing, which can harbor profit but which is at odds with it. Not only an "outside," writing is a deformation: it is secondary, belated, contaminatory, parodic, dead. The "dread of the text" Anthony experiences as a boy is akin to the involuntary shrinking we feel at the threat of defilement. The corporeal form of script anchors it to the world of death, and so while it represents the living intention of an author, it is itself unalive, and so grotesque, vampiric. (3) Speech, which is magically capable of "redeeming" the profit from dead graphemes, delivering the living meaning from the letters to the heart. The heart, the silent intuition, is thus the origin of signs through intention, and the terminus of signification in understanding. In between lies the entire drama of the creation, the fall, and redemption. This drama is even projected onto the relation between Scripture and Christ. Anthony's fame as an ascetic hero grew so great that the emperor Constantine Augustus wrote letters to him, concerning which Anthony told a dazzled group of fellow hermits, "Do not consider it marvelous if a ruler writes to us, for he is a man. Marvel, instead, that God wrote the law for mankind, and has spoken to us through his own Son" (81: 89). Even God's writing requires phonemic redemption; even Scripture requires the mediation of Christ.[3]

Athanasius did not invent this system, but adapted commonplaces inherited from Greek thought, against which Christian thinkers defined themselves and with which they were in competition. Hence the triumphant emphasis placed by Athanasius on an incident in which Anthony confounds Greek visitors to his cell who had sought to embarrass him for his ignorance. Anthony had demanded, "'What do

you say? Which is first—mind or letters? And which is the cause of which—the mind of the letters, or the letters of the mind?' After their reply that the mind is first, and an inventor of the letters, Anthony said: 'Now you see that in the person whose mind is sound there is no need for the letters'" (73: 84). The Greeks depart, astonished at finding "such understanding in an untrained man." Perhaps they are amazed in particular to hear such a spectacularly uncivilized man, living in a remote mountain in Egypt through decades of solitude, utter such a "Greek" response. For the issue of language was even then an ancient academic dispute, with the Stoics holding that words bore a natural connection to things, and the Peripatetics claiming that the connection was merely conventional. More specifically, Anthony's answer is in rough accord with the views of Aristotle in *De interpretatione* (1, 16a, 3), with Plato's "Seventh Letter" (342c–343a), and particularly with the discussion in the *Phaedrus* in which Socrates describes writing as "the language of the dead," an "external" and "inferior" sign alien to the living presence of consciousness. In Socrates' well-known argument, writing cannot explain itself when challenged for its meaning, but requires the "protection" of its parent, the "man with knowledge." Writing is the lesser of the two sons of understanding: compared with "living and animate speech" which is "written on the soul of the hearer together with understanding," writing is but a shadow (275–76).[4] Anthony's comments are in the Greek spirit in the contempt they show for writing, and in the nascent distrust of all language—but not, of course, in the use of that contempt or that distrust as an argument against literacy.

From Athanasius's point of view the Arians took the metaphor of brotherhood too literally in drawing no essential distinction between Christ and man. According to the Arians, Christ was a "creaturely" being of extraordinary virtue whom humans could imitate. Athanasius and others (including Augustine, who had early doubts on the problem)[5] sought to strengthen the distinction between the "legitimate" and "adopted" sons of God, and to erase the distinction between the Father and the legitimate Son. Anthony is presented as an ascetic hero who supports a Nicene Christology that identifies Christ as the Logos, "eternal Word and Wisdom from the essence of the Father" (69: 82). For Athanasius, and for Anthony, most of whose excursions into "the world" are undertaken to propagandize against the Arians, Christ is the word-with-understanding, a derivation with the status of the original. "It is sacrilegious," Anthony tells the people of Alexandria, "to say "there was when he was not" for the Word coexisted with the Father always" (69: 82). Logologically, then, speech goes with the

Father, with the mind, while writing is relegated to the desert of externality and illegitimacy. Similarly, "logocentrism" is aligned with "phonocentrism" and, particularly in the Christian version, both are worked into a contempt for the "body" of writing.[6]

According to Jacques Derrida, all linguistic theories that distinguish a "body" of writing from a "soul" of speech—or indeed any system that produces such hierarchized oppositions—is implicitly metaphysical, motivated by a nostalgia for a center, a longing for a source of authority that stands at the origin and continues to provide validation even in a fallen world. As linguistics is commonly the locus of such metaphysical nostalgia, Athanasius's theologization of the distinctions between speech, writing, and thought is not an aberration but a typical event in the history of linguistics. The "humbling of writing beneath a speech dreaming its plenitude," Derrida writes, is "required by an onto-theology determining the archeological and eschatological meaning of being as presence." We must not, this passage concludes, "speak of a 'theological prejudice,' functioning sporadically when it is a question of the plenitude of the logos; the logos . . . is *theological*. Infinitist theologies are always logocentrisms. . ." (*Grammatology* 71). Onto-theology asserts itself in Rousseau's conception of an original "cry of nature" suffering the "violence of the letter"; in Saussure's presumption that the "bond of sound" is the "natural bond, the only true bond" to meaning; and in Husserl's claim that the voice is the "most ideal" vehicle of signs because it is closer than writing to the heart of intuitive knowledge, the silent interior life.[7] So pervasive is the theologization of linguistics that Derrida can claim with some justice that "the problem of soul and body is no doubt derived from the problem of writing from which it seems—conversely—to borrow its metaphors" (*Grammatology* 35).

Such an argument is clearly a strategic "mistake," emphasizing a corresponding mistake that has placed speech before writing and the problem of body and soul before the problem of language. By reversing the ordinary genealogy in this way Derrida draws attention to a certain Oedipal disquiet implicit in language, which tends to displace its "fathers," understanding or intention. What attracts Derrida's notice is the consistency of such disquiet in theories of language. Saussure notes that the peculiarities of writing sometimes creep into speech, as when a "silent" letter whose silence is forgotten gradually becomes vocalized, altering the word; this alteration produces an "orthographic monstrosity" that has nothing to do with the "natural functioning" of language, a "tyranny of writing" that is "really pathological" (*Course in General Linguistics* 31, 32; *Grammatology* 41, 42). Saussure echoes Rousseau and

is in turn echoed by Husserl, whose thought is constantly troubled by a foreboding, a "crisis of the logos" in the form of an intuition of difference at the heart of the silent interior life, exteriority at the center of interiority. Fully half of the burden of Derrida's work is to reveal how logocentrism has always been haunted by the threat of usurpation, of monstrosity, of Oedipal displacement.[8]

The other half, Derrida's response to logocentrism, is so familiar that it can be abbreviated into buzzwords. His approach is to point to such concessions as Socrates' admission that speech is "written on the soul" as evidence that the metaphysical interiorities of "soul," mind, or "heart" are inconceivable without the difference or distance exemplified by writing. The basis of Derrida's critique is the instituted trace, the repeatable sign that indicates presence but which is constituted by nonpresence and otherness. The fact that the trace is the condition of meaning in general means that the origin is always already differential and nontranscendent; that "usurpation" or "violence" has always already occurred; that the natural is always already unnatural; and that "from the moment that there is meaning there are nothing but signs. We *think only in signs*" (*Grammatology* 50; see pp. 46–73 passim). The Derridean heresy combines Arianism in its insistence that the spoken word is nontranscendent, and anti-Arianism in its equally strong insistence that the word coexists with understanding.

Athanasius is squarely in the logocentric tradition, but he does betray a muted crisis of the logos, a suppressed awareness of a contradiction in his position, when he portrays Anthony warning his listeners against thinking "that I am merely talking" (Keenan 39). Mere speech is just plausible noise unconnected by any "natural bond" to truth or the heart. To a logocentrist, speech is ontologically different, an authentic species of language; but "mere speech" indicates that speech itself contains a principle of inauthenticity, a hint that receives surprising reinforcement from Athanasius's demonology. The besetting problem in *The Life of Anthony* is what to do about the demons; and what makes demons so demonic is that they exploit the fallen dimension of speech. "They are able to say right away and repeatedly, as if in echo, the same things we have read" in Scripture (25: 50). The phonocentric presumption is that speech redeems the living meaning from its imprisonment in the static code. Demonic repetition calls the bluff of phonocentrism, as it is both phonemic and external, both living and dead. Indeed, demonic speech is even deader than writing, as there is no "profit," no meaning in it whatsoever.[9] It is mere repetition, and reveals that speech operates not by a one-way process of redemption, but by a two-sided possibility of *double mediation* that both realizes the meaning

9

of the text and empties it of meaning. In all they do, demons represent a principle of perfect imitation that is at once the goal of the ascetic and his undoing. They mimic human behavior so perfectly that it is impossible to tell the voice of conscience from demonic whisperings, the original from the parody. And the purity of their mimicry perpetrates a crisis of the logos in the suspicion that the "original" is already structured by repetition; this suspicion is, indeed, virtually institutionalized in the doctrine of the Logos: "In the beginning was the Word."[10]

The subject on which Anthony had been "merely talking" was the discernment or true interpretation of spirits, an idea that betrays in rich condensation both the crisis of the logos and the ascetic effort at a solution. Counseling his audience not to boast about expelling demons, Anthony cautions that "the performance of signs does not belong to us—this is the Savior's work. So he said to the disciples: *Do not rejoice that the demons are subject to you; but rejoice that your names are written in heaven*" (38: 60; Matt. 4:10). The expulsion of demons as the "performance of signs"—a marvelous notion that illuminates both demons and signs. We can call "demonic" any obstruction of reference, any impediment to understanding. In their structural disorder, the "temptations of St. Anthony" represented by Schöngauer, Teniers, Patinir, Cranach, Bosch, Bruegel, Cézanne, Dali, and many other artists are unassimilable to language categories; they present Anthony with the temptation to view the world and the self as unmasterable, alien, illegible. A sign that truly signifies, on the other hand, is like a person who has been cleansed so that the apparent is identical to the real. This is a goal worthy of any discipline, and yet human beings are incapable of true signification; the successful "performance" of signs can only be God's work. The best we can hope for ourselves is not that we learn to use signs, but that we become signs—and not spoken signs, but durable signs "written in heaven" in a script which, defying the nature of script itself, is intimate with the divine essence. Signs may be vulnerable to demonic pollution, but the mark of virtue is that we aspire to the condition of signs, aspire to an utter materiality, a totally degraded and therefore perfect dependency on the animating spirit.

So far I have been talking about the linguistic theories of Athanasius in terms of their similarity to other logocentrisms, a similarity particularly marked in his troubled and confused attempt to keep the mind or heart free from the qualities of exteriority, parody, death, or abstraction associated with writing. Derrida's critique of logocentrism takes the form of an insistence that language has not fallen into writing, but that the fall has always already occurred. This critique is trenchant, detailed, and virtually unanswerable, but it speaks to only half the

problem of logocentrism, that writing is unalive, inert. The other half of the problem, encountered with special intensity in ascetic linguistics, is that language is meaning with a "body," and shares in the carnality of the material world. Thus there is a double fall of language, into abstraction and into the body. If by celebrating the death of language in the sign, Derrida provides the theory for the first fall, then Mikhail Bakhtin, celebrating the living body of the text, is the theoretician of the second.

Bakhtin's view of language is opposed to logocentrism at every point, particularly in his rejection of abstraction and ideality themselves. "Outside the material of signs there is no psyche," he declares bluntly (*Marxism and the Philosophy of Language* 26). For Bakhtin there is little distinction between "inner" and "outer" forms of language: from top to bottom language is both carnal and carnivalesque. Its essential condition is one of unmasterable ambivalence and polyvocality in which words speak in multiple voices and bear multiple meanings; accordingly, Bakhtin as an analyst of this condition is drawn to occasions such as those in Rabelais when, he says, words are "released from the shackles of sense, to enjoy a play period of complete freedom and establish unusual relationships among themselves" (*Rabelais and His World* 423). In its natural state—that is, when it has not been artificially neutralized—language is in a high-energy condition that bears the imprint of the social in its mingling of discordant voices. Language is not, therefore, a function of a single originating intention, not the property or tool of the individual ego, which in fact it always exceeds. "Language is not a neutral medium that passes freely and easily into the private property of the speaker's intentions; it is populated—overpopulated—with the intentions of others" (*Dialogic Imagination* 294). Each utterance achieves coherence or comprehensibility only through silencing some of its voices and foregrounding some others. The sign, then, condenses a number of social valuations and processes; it is "an arena of class struggle" (*Marxism and the Philosophy of Language* 23).

For logocentrism the fall of language occurs with the invention of writing. Bakhtin's thought, too, pivots on a calamity, variously figured as the rise of capitalism, the passing of medieval carnival, or the dominance of philosophical abstraction. In terms of the study of language, it could even be said that for Bakhtin the fall occurs with the invention of the science of linguistics, which tends to operate by idealization and essentialization. For Saussure, for example, language could only be studied systematically by removing it from any historical, cultural, or personal context. "In separating language from speaking we are at the same time separating: (1) what is social from what is

individual; and (2) what is essential from what is accessory and more or less accidental" (*Course in General Linguistics* 14). No position could be more at odds with Bakhtin's, for it treats language as a ready-made system passively assimilated by the speaker. For Saussure, and for his descendents in transformational grammer (Chomsky) and speech-act theory (J. L. Austin and John Searle), language is an ideal system only partially comprehended by its users, many of whose utterances reflect, in Bakhtin's words, "accidental transgressions" or mistakes (*Marxism and the Philosophy of Language* 78). Bakhtin sees in such a procedure the lingering residue of Leibniz's transcendental grammar and of Cartesian rationality, and looks instead to actual language use on the assumption that language consists of precisely such nonsystematic and random "transgressions." Abstraction in linguistics arose, Bakhtin argues, from the study of dead languages, not from attention to living speech. A study of actual speech would produce not a science of linguistics but rather an "anti-linguistics," or, to use his own term, a "meta-linguistics" that takes into account not only language but also the social and historical contexts and uses of language.[11] Meta-linguistics would study not a neutral and passive object, but an all-embracing, fluid, and contradictory medium of change and exchange whose principles are "dialogization," "heteroglossia," and "carnivalization."

Bakhtin's critique of essentialist linguistics would seem to apply with equal force to ascetic linguistics, for what Athanasius characteri-cally denies is the social character of language, its necessary implication in the material world, the cultural moment. For Athanasius, this implication is confined to the worldly text, but Bakhtin would not admit of rigid distinctions between text, voice, and mind. For Bakhtin, the value of language does not inhere in the transcendental "meaning," but in the phenomenon of textual polyvocality itself.

The striking originality of Bakhtin's work in linguistics is that it brings language into the spontaneous life of the social present. At times, his insistence on the vitality of language borders on a primitive phonocentrism, as when he implies that the structure of language is virtually reinvented with each speech act. This is Bakhtin's naiveté. The originality of Derrida's attack on logocentrism lies in his exceptionally rigorous, even dogged, insistence on the deadness of language. "Writing in the common sense is the dead letter," he writes; "it is the carrier of death. It exhausts life" (*Grammatology* 17). Such claims, found throughout his work, constitute Derrida's subtler naiveté. Between them, Bakhtin and Derrida seem to have done away with the nostalgias of logocentrism, but they may have destroyed each other in the process for they stand in near-perfect contradiction. Together, they testify to a

crisis of the anti-logos which forces us to wonder whether there is any response to logocentrism that speaks the whole truth and nothing but the truth.

At this point, ascetic linguistics must emerge into its own and stand apart from the logocentrism of which it has seemed merely to be a rather confused instance. For it is in ascetic linguistics, outlined in *The Life of Anthony* but indicated in other contemporary writings as well, that we find not only the main principles of logocentrism, but the major premises of the anti-logocentrists as well.

In *The Life of Anthony* the anti-logocentric position is already visible when Athanasius mentions the usefulness of his own text in effecting imitations by others of Anthony's example. To a great extent ascetic discipline is a science of imitation made possible by the mimetic imitations of texts such as *The Life of Anthony*. As the vehicle of memory, textuality placed ascetics—many of whom were either living alone in the desert or in monastic communities where speech was severely restricted—in touch with prominent examples the imitation of whom provided the community with its continuing identity. Thus even in the passage where he is describing Anthony's dread of the text, Athanasius can write "All his yearning, as it has been written of Jacob. . . ." Textuality even preserved the character of imitation itself. An imitation by one person of another would inevitably lapse into repetition and parody; it would introduce the element of imitation into actions that had appeared to be "natural," and would rob those actions of their motivation by reducing them to pointless gestures, to "mere speech": this is the business of demons. One can, however, imitate a text without parody, for the text is already an imitation and is not necessarily degraded by further imitation. Nor, for that matter, can it be imitated in the same sense as a human being can. The imitation of a text is imitation without devaluation.

With its lengthy discussions of the deceptions and disorder of demons, about which I shall have more to say in later chapters, this text gives extraordinary rein to the voices that theology would silence. Indeed, from a certain point of view, the threat of Bakhtinian language is the dominant subject of *The Life of Anthony*. This text is also Bakhtinian in that it explicitly espouses the view that textuality is a locus of social judgments and processes. Anthony tells his brothers to "note and record our actions and the stirrings of our souls as though we were going to give an account to each other. . . . Let this record replace the eyes of our fellow ascetics, so that, blushing as much to write as to be seen, we might never be absorbed by evil things" (55: 73).[12] In *Le Souci de Soi*, Michel Foucault compares this description of the text as "an arm

in spiritual combat" with the earlier use of *hypomnemata* in Greek culture. *Hypomnemata* were notebooks in which one entered quotations, fragments of works one had read, records of events witnessed, reflections that had come to mind. They served the educated Greek as guides to right conduct, an accumulated treasure for rereading and contemplation. But as Foucault points out, Athanasius prescribes a somewhat different use of textuality as a means of pursuing the hidden, bringing to light the fugitive impulses of the mind, dissipating the inner shadow of desire. Where Xenophon recorded his diet in his *hypomnemata*, Anthony urged monks to record their dreams, moving textuality into the undisclosed regions of the self. Thus the ascetic text erases the distinction between inner and outer by serving simultaneously as an external record of inner thoughts and as an internalized eye of social judgment. In a study of the early ascetic communities, Philip Rousseau comments that in the Greek text of Athanasius the recommendation to "note and record" clearly refers to an imaginary exercise, and the writing remains metaphorical; while in the Latin translation of Evagrius, composed a generation later, the "record" is taken literally, and the text has entered the ascetic program of self-discipline. Moreover, Rousseau says, the dependency on texts grew steadily with the passage of time: "The move from an oral to a written culture was made easier by the sense among ascetics that their true masters were now dead" (71).[13]

Hagiographical texts, then, granted their heroes a continuing life after they had died. Paradoxically, they had served the opposite function during their heroes' lifetimes. For the effect of mimesis is to displace and so stabilize the wandering subject, to humble human pretensions to autonomy by submitting life to the rules of grammar, rhetoric, and generic convention, including the constant interpolation of citations from Scripture. Textuality constitutes an ascesis, a deadening, a purging of materiality and mutability that anticipates the release of the soul from the body at death. Hence for the early Christians textuality was closely linked with martyrdom, which lent a purpose and even an ideality to the randomness of existence, as well as "repeating" the death of Christ.

The most eloquent and extreme testimony to this link is in a letter written by Ignatius of Antioch, who died in 107. In "The Epistle to the Romans," Ignatius, then in the hands of the authorities, insists to his readers that he is awaiting his martyrdom "with all the passion of a lover" (106), and sees himself as God's "wheat, ground fine by the lions' teeth to be made purest bread for Christ" (104). No torture would be too extreme; in fact, the greater the pain the better: "Fire, cross,

beast-fighting, hacking and quartering, splintering of bone and mangling of limb, even the pulverizing of my entire body—let every horrid and diabolical torment come upon me, provided only that I can win my way to Jesus Christ!" (105). This ecstatic death drive accompanies another desire that at first seems incongruous and unrelated, that his letter itself be granted greater status and authority than his person. He is writing to beseech his friends not to interfere with his execution, and says, "Even if I were to come and implore you in person, do not yield to my pleading; keep your compliance for this written entreaty instead" (106). Ignatius's zeal for martyrdom is doubled in his wish that the text supplant him. Both longings are motivated by the desire to die to the world, to be transfigured into another, purer mode of being. Speaking, he is all too human; writing, he communicates through the dead letter, as though he were already dead. His readers can hasten and even anticipate his death by treating his letter as though it were he. In a gesture of radical anti-logocentrism, he writes, "I am not writing now as a mere man, but I am voicing the mind of God" (106). It is writing, not speech, that is intimate with the mind of God; and writing, not speech, that is intelligible: "For by staying silent and letting me alone, you can turn me into an intelligible utterance of God; but if your affections are only concerned with my poor human life, then I become a mere meaningless cry once more" (104). Life is the "cry of nature," while textuality is the lions' teeth, grinding the meaningless into the meaningful, the useless into the productive. Textuality multiplies the ascesis of language: not only is it based on an arbitrary code, but in its inert material form it stands outside the world. Textual self-representation can even prefigure death and redemption.[14]

(Derrida has come under fierce attack recently for his scandalous statement that "*il n'y a pas de hors-texte.*" Reducing culture, history, and desire to what many—but not Derrida—see as the sterile field of textuality, Derrida seems to erect an anti-ideal of writing that opposes the ethics and spiritualism of traditional humanism. What such an attack overlooks is the fact that the ethic of self-denial on which Western culture prides itself achieved its most condensed expression in the early ascetics; and that the unrelenting ambition of these people was precisely to eliminate the "*hors-texte*" from their existence, to become their own texts. Derrida is thus not anti-humanistic; he simply articulates the "inhumanity" that constitutes humanism in the first place.)[15]

And what of speech, the Christ-like, redemptive mode? Voice may animate the textual code, but in so doing it reactives the body, destabilizing the meaning by tangling it up in time and the flesh. Julia Kristeva has written of the dangerous position of speech in "The Ethics

of Linguistics," pointing out that speech is "a risky business, allowing the speaking animal to sense the rhythm of the body as well as the upheavals of history" (34). Speech may be alive, but it represents a principle of kinetic disorder which it has always been the goal of philosophy (and writing, and ethics) to order and contain. "Speech is moving," Ernst Cassirer writes, "and in this movement all our words and terms undergo incessant change. But it is for philosophy, for dialectic, to bring this change to a standstill, to transmute the mobile and uncertain shapes of words into steadfast and constant concepts" (311). The redemptive function of speech is entangled in transgression.

To recapitulate for a moment: ascetic linguistics embraces all the main principles of logocentrism, and for this reason it is vulnerable to the charges of both Bakhtin and Derrida. But logocentrism is not the whole story of ascetic linguistics, which actually anticipates and contains the basic principles of Bakhtin and Derrida. We find in Athanasius, for example, that the text is a locus of social processes and valuations, that speech can be parodic rather than redemptive, and that the text collapses the distinction between inner and outer modes of consciousness—all points central to Bakhtin's meta-linguistics. And in the congruence between martyrdom and self-textualization, ascetic linguistics accepts Derrida's contentions that textuality embodies a death force and that speech in no way transcends writing. In short, ascetic linguistics includes both logocentrism and its opposites without any sense of a disabling contradiction.

Nor is the contradiction disabling. The problem ascetic linguistics addresses—and solves by sometimes valuing speech over writing and at other times valuing writing over speech—is how to be alive to the spirit and dead to the world at the same time. In other words, how to be both living and coherent, a dilemma familiar enough in everyday life. It may, indeed it must, be objected that any theory that so thrives on contradiction has only a feeble claim to being a theory at all, and should perhaps be considered a myth, which mediates, as Lévi-Strauss says, cultural contradictions. But if this inquiry demonstrates anything, it is that certain areas of linguistics, including general comprehensive theories of the origin of language, and theories of the relation between writing, speech, and mind, have only a shaky basis in theoretical consistency themselves. These areas of linguistic theory are dominated by a Kierkegaardian dread. If dread is the emergence of a silenced voice within, the anticipation of a move that has already been implicitly made, then we can say that just as Anthony is in dread of letters, so is logocentrism in dread of the text, in dread of grammatology. Similarly, Derrida, who represents the irreducibility of writing, is in dread of

Bakhtin, who represents the irreducibility of the body; and vice versa. Those who speak of meaning in terms of presence are in dread of Derrida; those who speak of language as a system are in dread of Bakhtin.

A subversive speculation emerges, that any attempt at theory in these areas of linguistics contains and suppresses all the others, just as writing, speech, and intuition each may be said to contain and suppress the other two. The responsibility for this condition lies with both theory and language. Theory is committed to internal consistency, to the establishment of a hierarchy between dominant and subordinate elements, and to system. It operates by exclusion, restriction, and suppression. But language cannot be so ordered. No matter what is said about the areas of language we have been looking at, the opposite is also justified. Theory itself is in dread of the infinitude of language, in a mirror image of the dread which the "natural" cacophony of language has for fallen theory.

Only ascetic linguistics manifests this dread. Alone among the theories that have been considered, it stands in dread of both writing and speech, betraying a condition of general dread that points to the totality of language and the impossibility of reducing it to theoretical consistency. Logology would be impossible in a pagan culture, for it is only the Christian God that is modeled on language, that is, containing all attributes. Ascetic linguistics reflects an unsophisticated attempt to describe language in its global, or cosmic, dimensions. Because of Athanasius's willingness to sacrifice theoretical integrity and consistency to the totality of language, *The Life of Anthony* does not weigh heavily in the history of philosophy, in the context of which it appears crude and primitive. In the context of contemporary theory, this discussion, too, may appear primitive, an attempt to set theory back 1600 years; and in a certain sense that is right. For while theory has advanced in many respects, it has not become more adequate to language with the passage of centuries. Indeed, we may say that the better a theory is *as theory*, the worse it describes language.

Consider, finally, the negative. As has often been noted, the negative does not exist in nature, only in language. It stands, therefore, as a token of the purely linguistic, and, of course, as the essence of asceticism in all its forms. Heidegger, a radically untheoretical theoretician, sensed the profound continuities between asceticism and language, concluding from Hölderlin's lines,

> So I renounced and sadly see:
> Where word breaks off no thing may be. ("Words")

that "Renunciation is in itself a Saying: self-denial. . . namely denying to oneself the claim to something." Heidegger adds that Saying, the commitment to the rule of the word, is also a "worlding," for "the word makes a thing into a thing": it configures that which was prefigured in the thing. Saying makes the thing intelligible as a thing.[16] Beyond language there is no figure, no thing, and thus the renunciation or negative on which language is based turns out to be the essence of all positivity. The denial of a claim to something turns out to be a "nondenial of self" that "owes itself wholly to the mystery of the word." And so "Renunciation speaks affirmatively" (*On the Way to Language* 150–52).

This analysis of the plenitude of renunciation might help us understand how ascetic linguistics, a nonphilosophy based explicitly on the negative, can "contain" so many conflicting positions. It serves equally well as an introduction to a study of asceticism in practice and ideology. For renunciation, as Heidegger says, always cancels itself by turning out to be an affirmation. This self-cancellation is the essence of asceticism: a dynamic, mobile ideology whose mark is ceaseless struggle towards a goal that is always unreachable, a goal whose realization is blocked by the very methods of achieving it.

Technique and the Self 2

Ascesis (the impulse to ascesis) is directed toward
the other: turn back, look at me, see what you have
made of me.

Roland Barthes, *A Lover's Discourse*

*I*n the *Tractatus Logico-Philosophicus* of 1921 Wittgenstein tried to
define the principles of an essential language in which logical
error would be impossible. He situated this language "outside the
world":

> The sense of the world must lie outside the world. In the world
> everything is as it is, and everything happens as it does happen: *in* it no
> value exists—and if it did, it would have no value.
>
> If there is any value that does have value, it must lie outside the whole
> sphere of what happens and is the case. For all that happens and is the case
> is accidental.
>
> What makes it non-accidental cannot lie *within* the world, since if it
> did it would itself be accidental. (6.41: 145)

This attempt to specify a region of value in which knowledge is more
authentic than that which can be had in "the world" is an exemplary
"philosophical" gesture. The allegory of Plato's cave is one incident in
the history of such gestures, and the caves of the Christian ascetics
constitute another. For the ascetics, though not for Plato, the cave
represented that "other world," the locus of transcendent power and
value to which Wittgenstein sought access through the logical ideali-
zation of language.

The revolution of the "late Wittgenstein" turned on his abandon-
ment of this quest, and of the notion that language can be perfected so
as to be free from error, accident, and ambiguity. In the *Philosophical*

19

Investigations he argues that the essence of language lies precisely in its worldly functioning, in its imperfections. The task of philosophy, therefore, is not to construct an alternative language but rather to understand language's workings, attending particularly to those "trouble spots" in which language "bewitches the mind." Philosophy can achieve "complete clarity" by making minor repairs in the actual use of language, the "language games" by which we describe and mediate the world. We are not, he says in the later work, "*striving after* an ideal," but rather treating the problems of language "like a sickness." These problems must be remedied, for when language gets sick it "idles," it "takes a holiday," it does not work; and in this state of vague shiftlessness it occludes clear vision and stands in the way of philosophical clarity. Language, he implies, must work without cease.

The difference between the early and late Wittgenstein is significant enough to imply some conversion experience intervening between the two works; it is great enough that the deep compatibility between the two positions often escapes notice. But early and late, Wittgenstein is attempting to determine the true nature of language, and early and late, he is trying to determine the conditions of perfect linguistic clarity. The early work, with its implications of a language different from the ordinary language, is manifestly metaphysical; but the later work is covertly so, with the domain of "everyday use" acquiring a special privilege as the "original home" of language. In both cases, then, the goal is the grounding of language in a state of perfect intelligibility, a condition to be found "outside the world" in the *Tractatus* and "within" a corrected version of the world in the *Philosophical Investigations*.

The unity of early and late Wittgenstein emerges more clearly when the two positions are compared to asceticism, which I have described as an attempt by human beings to stand "outside the world" by assuming the character of language. Christian monasticism assumed two forms, eremitic and cenobitic, both of which were based on the example derived from Athanasius's text. Eremitic monasticism is the heroic fanaticism of the early desert solitaries such as Anthony, who lived essentially alone in remote settings in Egypt or Syria, torturing themselves and confronting demons in an improvisational, unregulated, and ecstatic warfare. First recognized as a distinct way of life around 305, eremitic monasticism spread so rapidly that within a few generations a *History of the Monks in Egypt* by Rufinus could assert that the Wadi Natrun area in Egypt was swarming with monks: "To this spot they withdraw themselves; for the desert is vast, and the cells are sundered from one another by so wide a space that none is in sight of

his neighbour, nor can any voice be heard. One by one they abide in their cells, a mighty silence and a great quiet among them" (quoted in Waddell, *The Desert Fathers* 53–54). Cenobitic monasticism was founded by Pachomius around 320, and consolidated by Basil around 360; it represented a more corporate and stable form of asceticism, an institutionalization of the primary charisma of the eremite. In cenobitic *laura* a number of monks and even nuns submitted themselves to extraordinary regulation, discipline, and obedience, living under a Superior in strict adherence to a Rule which prescribed their conduct, their attitudes, their food, and even their thoughts. The cenobitic community of Pachomius was called "The Village," and under Basil such groups were even located in cities. Cenobitism is first indicated in those passages in *The Life of Anthony* in which Anthony is shown emerging from prolonged periods of solitude to instruct the crowds that have gathered around him in the principles of the "life in Christ." The groundwork for both forms had been laid even prior to Anthony, in those Pauline texts such as Galatians 6:14 ("Now I live. Now not I, but Christ liveth in me"); and in the example of the early martyrs; and in the work of Clement of Alexandria, and of Origen, who described a kind of "Gnostic martyrdom" suffered by those who were "dead to the world." In a spirit equally congenial to both forms of monasticism, Athanasius describes Anthony as "a martyr to his conscience."[1]

Like the early Wittgenstein, eremitism seeks an unworldly mode of being, a radical dissociation from social customs, norms, habits. And like the late Wittgenstein, cenobitism accepts certain worldlinesses such as hierarchy, written laws, conformity and routine, and tries to perfect them. For both Wittgenstein and asceticism, the world as it existed was "a desert, without gods," without value or transcendence.[2] For asceticism, the desert was both an antiworld, a nonplace from which the world could be condemned, and a metaphor for the world itself. In its two forms asceticism embraces both transcendence and praxis. Wittgenstein could avoid such ambivalence as this by arguing first one side of the issue and then another, and monks could be either one kind or another. But asceticism as a whole is distinguished not by its conceptual clarity but rather by its conceptual richness, for it contains both. In the following discussion I will speak first of eremitism and then of cenobitism, but we must keep in mind that the two modes actually form a unity, with each side serving as the corrective shadow of the other.

It is the eremites Gibbon attacks in chapter 37 of *The Decline and Fall of the Roman Empire* as "hideous, distorted, and emaciated maniacs, without knowledge, without patriotism, without affection, spending their lives in a long routine of useless and atrocious tortures and

quailing before the ghastly phantoms of their delirious brains." There is much in this tirade that an eremite could agree with. The atmosphere of early Christianity was full of violence, and the early ascetic "stars" were famous for their exotic ferocity. Mindful that "the violent bear it away," monks lived in tombs, slept one or two hours a night, ate only a few figs or a little bread each day, loaded themselves with chains, lived on top of pillars, beat themselves with rocks, scraped their skin raw, exposed themselves to the stings of scorpions and hornets. Gregory of Nazianzus tells of a man who stood upright for ten years, absorbed in contemplation until his feet gave out, and then spent the next (and last) fourteen years on his side. (And yet, a pious modern commentator can write that "the sweet savour of their example is still fragrant in our midst," and a study with psychoanalytic pretensions can suggest that the early monks were motivated by "a subconscious wish to return to the security of the womb.")[3]

In ascetic linguistics, writing and speech approach the transcendental power of unmediated thought from different directions—speech, through its mobile, unconstrained livingness, and writing through the mortification of its utter materiality. Cenobitism is the "writing" of asceticism, while eremitism is its "speech," for what the eremite tries to display is the manifest operation of the spirit, which wars against the flesh. The goal of all asceticism is perfect union with God; but while cenobitism takes a defensive position, essentially avoiding mistakes, eremitism goes on the offensive, seeking to embody and exercise supernatural power, a power, as Peter Brown says, ideally removed totally from "the ambiguity, the criticism, the envy, and the resentment that were observed to attend the impingement on fellow human beings of mere human skill, human force, and human powers of persuasion" (*Making of Late Antiquity* 12). In all his writings on the subject, Brown emphasizes the social role of the eremite as he canceled debts, settled disputes, and so forth; but the real power of the eremite was held in reserve.[4] As Brown observes, "heavenly" power was defined "quite simply as power that was not to be used" (*Making of Late Antiquity* 93).[5] Through this strategy of *reculer pour mieux sauter*, the power of transcendence was kept pure and unworn by use.

The incorporation of transcendence was not accomplished without a certain flamboyant ambivalence. According to Brown, the rise of the "Holy Man," or "friend of God" in the fourth century compensated for the increasing silence of the pagan oracles. But the Holy Men and the power they bore imposed rigors that were utterly alien to paganism, which had fostered a sense of easy access to the divine, of a comfortable interlocking of the natural and the supernatural. According to Baudril-

lard, the "modern" always makes itself felt as the "cold," in contrast to a "warm" traditional or primitive; in the Late Roman empire the sense of a sudden drop in temperature must have been inescapable. The "new mood" of Christian asceticism presumed a total disjunction between the social and the divine. According to the doctrine of the soul, each human being contained an essence, the "grace of God within," or the "Christ in me." This essence imposed certain responsibilities. One text all ascetics knew by heart was Luke 14:26: "If any man comes to me and does not hate his own father and mother and wife and children and brothers and sisters, yes, and even his own life, he cannot be my disciple." A recent study of saintly starvation, Rudolph Bell's *Holy Anorexia*, argues that medieval ascetics such as Catherine of Siena undertook their astonishing rigors in the spirit of this text, as an antipatriarchal and antifamilial statement.

This statement would have been understood even by the patriarchs of the fourth century. A Holy Man such as Anthony spent his life in a studied rejection of the familial and indeed all of the social, engaging, as Brown says, in "a long drawn out, solemn ritual of dissociation—of becoming the total stranger." Going to live in the desert "in close identification with an animal kingdom that stood, in the imagination of contemporaries, for the opposite pole of all human society," the eremite rejected human culture not merely by leaving it but by existing at the extremities of human capacity ("Rise of the Holy Man" 91, 92). The life of the eremite was at once squalid and pretentious, beneath civilization and far beyond it, subhuman and semidivine. According to Jacques Lacarrière, the Byzantine painters who depicted eremites in frescoes of monasteries in Cappadocia or Greece sought to portray beings belonging to "a sort of humanity different from that of ordinary mortals and half-way to the other world." Portraits of ascetic heroes "represented them as beings half savage and half angel: they were given emaciated faces, tattered clothing, hair hanging down to their feet, but also the look of people lost in contemplation of another reality and flesh which was hardly substantial" (57). The most eminent of the "pillar saints," Simon Stylites, was once asked by a layman who ascended his pillar if he were human, a question he was doubtless tempted to answer in the negative.[6]

The essayist E. M. Cioran has said that the early Christians withdrew to the desert in order to achieve a "negation of history," that privileged category of pagan thought and life (216). More specifically, Nietzsche described as one of the "antidotes to history" the "superhistorical," by which he meant "the powers which guide the eye away from becoming and toward that which gives existence an eternal and

stable character, toward *art* and *religion*" (*Advantage and Disadvantage of History* 62). Impervious to history, the desert was an ideal site for ascesis, and the man who went there placed himself under a virtual obligation to reinvent himself, creating a mode of being that owed nothing to family, community, genealogy, or even subjectivity. The eremite was a self-made man—"objectivity personified," as Brown says. He was a man who, in his very solitude, was constantly on display, and could be "closely observed to be in the act of forging total dissociation in himself, by hammering it out like cold metalwork, from a lifetime of asceticism" ("Rise of the Holy Man" 93).

Nietzsche's comment directs our attention to the powerful aesthetic element in asceticism, a combination perhaps more familiar in the form of the ascetic element of aestheticism. Weary of the world's stupidity, Des Esseintes, the hero of Huysmans's novel *À Rebours*, dreams of "a refined Thebaid, a desert hermitage" in which he can pursue a life of "studious decrepitude." In the same spirit, Thomas Mann called "professional devotees of high art" the "Early Christians." The real Early Christians were often explicit about their art, which was preeminently an art of portraiture, with the self conceived as painter, paint, and image. In the fourth century Gregory of Nyssa wrote of asceticism as a repetition of Christ's original "taking-form," the act by which he fashioned "a beauty in accord with the character of the Archetype" and made of himself an "image of the invisible God." "Every person," Gregory observed, "is the painter of his own life, and choice is the craftsman of the work, and the virtues are the paints for executing the image." Remarkably, the ascetic "image" reflected a strict attention to certain canons of beauty. "There is no small danger that the imitation may change the Prototype into a hateful and ugly person instead of reproducing the master form," Gregory says, and so we must "prepare the pure colors of the virtues, mixing them with each other according to some artistic formula for the imitation of beauty, so that we become an image of the Prototype through activity as a kind of imitation, as did Paul, who became an 'imitation of Christ,' through his life of virtue" ("On Perfection" 110–11). Even the disfigurations that ascetic practice wrought on the body found their rationale not only in a model of virtue but also in an "artistic formula for the imitation of beauty." The body wasted away, grew pallid and insubstantial as the soul gained in ascendance, and so the horrifying emaciation of the ascetic body could testify to such traditional artistic virtues as "a mastery of one's materials," or "technical control of the medium." William James argues that the impulse to keep oneself both secure and clean amid the shocks and impurities of the world is identical to the

law which impels the artist to achieve harmony in his composition by simply dropping out whatever jars, or suggests a discord To omit, says Stevenson, is the one art in literature: 'If I knew how to omit, I should ask no other knowledge.' And life, when full of disorder and slackness and vague superfluity, can no more have what we call character than literature can have it under similar conditions. So monasteries and communities of sympathetic devotees open their doors, and in their changeless order, characterized by omissions quite as much as constituted of actions, the holy-minded person finds that inner smoothness and cleanness which it is torture to him to feel violated at every turn by the discordancy and brutality of secular existence. (296)

To assess oneself as a "character" was not only to omit the superfluous, the slack, the vague. It was also to experience the sensation of necessity. To leave the world was to confront oneself as an unfinished work constantly threatened by "mistakes" in the completion. Ascetic "artists" felt to an extraordinary degree the pressure of what must be said, the sense of inevitability and autonomy in the work; and they felt it as a necessity that was deeper than any merely personal exigency. In the ascetic self the personal is the trivial; it is that which must be sacrificed in the interests of form. It is the corrupt, the wavering, the kinetic, the *historical*. In the desert, no thought or gesture arises in response to a previous gesture in "the world," and so every thought or emotion was instantly revealed as a trace of selfhood, betraying a movement of desire that had to be specifically attended to. According to Origen, monks should "pray without ceasing," literal and specific advice repeated by Athanasius, the point of which was to leave no crevice in the day (or night) in which the merely personal could emerge.[7] Hence the desert became an empire of feeling constantly beaten into submission, crushed into form through prayer and ritual.[8] It is interesting to speculate whether certain theories of the work of art were modeled on notions of ascetic discipline or vice versa. One extremely influential such theory, that of Alois Riegl, holds that "the work of art is the result of a definite and purposeful artistic volition, which manifests itself in a struggle with practical purpose, raw material, and technique." For Riegl, art is produced by an act of will triumphant over recalcitrant matter or worldly concern. The comparable conception of ascetic discipline erects the ideal of a self fully present to itself, wholly externalized, utterly conscious, all surface with no reservoirs of the unknown, the unconquered, or the unpredictable.[9] In heaven, according to Augustine, we will be able to see our thoughts.

One effect of such elaborate self-consciousness was to provoke episodes of demonic "temptation," about which there will be more to

say in the next section. But another, equally revealing response lay in the phenomenon of *acedia*, memorably described by Cassian, a fourth-century French monk who toured the Wadi Natrun:

> When *accedie* besieges the unhappy mind, it begets aversion from the place, boredom, and scorn and contempt for one's brethren. Also, towards any work that may be done within the enclosure of one's lair, we become listless and inert. We lament that in all this while, living in the same spot, we have made no progress, we sigh and complain that bereft of sympathetic fellowship we have no spiritual fruit. . . . Finally we conclude that there is no health for us so long as we stay in this place short of betaking ourselves elsewhere as quickly as possible. . . . One gazes anxiously here and there and sighs that no brother of any description is to be seen approaching: one is for ever in and out of one's cell, gazing at the sun as though it were tarrying to its setting: one's mind is in an irrational confusion, and no remedy, it seems, can be found. . . . (18).[10]

Acedia is the nontranscendent voice of the personal as well as the voice of common sense, worldly wisdom, and "natural" feeling; it betrays the temptation to an impulsive but undirected formlessness, and so must be overcome.

All asceticism provokes versions of *acedia*, but the eremite met the challenge in a characteristic way, becoming known as the hero of self-denial, the "athlete of Christ." Origen had compared martyrdom to a public spectacle in which "thousands upon thousands gather to watch a contest in which contestants of outstanding reputation are engaged" (*Exhortation to Martyrdom* 158), but the figure of the athlete applied just as fully to the eremite. In fact, the trope of the athlete of virtue was a traditional conceit, borrowed from Greek culture and applied to a more ambitious *telos*.[11] Athanasius addresses his manuscript to Syrian monks seeking to outdo Egyptian monks in feats of self-denial, and the text remarks that Anthony, from his position of sublime isolation, was enough of an athlete to respond to competition in virtue: "toward those of his own age he was not contentious, with the sole exception of his desire that he appear to be second to none of them in moral improvements" (4:33). Brown notes occasions of sorcery used against another monk, of "framing," and even attempted assassination ("Rise of the Holy Man" 94). Behind the notions of athleticism and competition lies the assumption that denial is arduous and quantifiable. What else could produce the far from idle boast of one monk to another: "I am deader than you?"[12] Indeed, the utterance all monks aspired to was, "I am dead." In return for his own self-deadening, Anthony was explicitly promised fame by God (10:39), a fame that Athanasius's text secured.

Fame is so integral to the very idea of a "saint's life" that we must recognize a profound congruence between the practices of asceticism and the texts that documented these practices. The assurance that Anthony will be "famous everywhere" is the only encouragement that God offers to Anthony—in fact, this incident is the only appearance of God in the text.

To be Godly was to be famous. Or, to borrow the definition proposed by Hannah Arendt in *The Human Condition*, godliness for the eremite was a mode of *action*—behavior that has as its primary orientation the transformation of the self into narrative so that it may be preserved and remembered. Hagiography is a literature of action, an extended inventory of the astonishing, memorable, and text-worthy deeds of ascetic heroes. In this way, too, asceticism is an application to the self of certain insights into language: to be ascetic is to make oneself representable. On this basis William James criticized asceticism for its excessive worldliness ("If the inner dispositions are right, we ask, what need of all this torment, this violation of the outer nature? It keeps the outer nature too important" [361]). But we owe to asceticism the notion that the exemplary self is observable, and especially that it is narratable—a notion that decisively distinguishes asceticism from mysticism, which is relatively poor in literature, as opposed to prose.

In the second volume of *The History of Sexuality*, *The Use of Pleasure*, Foucault describes asceticism as the self-forming activity, and applies it equally to pagan and Christian religions.[13] In pagan culture, according to Foucault, the notion of mastery over oneself became by the time of Seneca a *techne* of the self, an aesthetics of existence. The burden of *The Use of Pleasure* is to define the "beautiful life" required by Greek ethics, the duty imposed by the prevailing *techne* to create oneself as a work of art, a notion that flourished in the pre-Christian era and reappeared (according to Burckhardt's *The Civilization of the Renaissance*, pt. 1) in the Renaissance. What had intervened, of course, was not asceticism as such but the specifically Christian asceticism that set itself against the pagan *pratique de soi*. Particularly in the period we are discussing, pagan modes of bodily beauty (which we have largely inherited) were anathema, a source of temptation but not of delight, and certainly not of pride. For the Christian ascetic, pagan beauty was thematized as the demonic, while the disfigured was figured as the desirable, the admirable, the holy.

The differences are radical, for pagan asceticism is founded on the idea of self-mastery and self-possession, a form of control available only to a few, and gained only through extensive learning, discipline, and culture. Pagan asceticism is a public and even a civic practice. Christian

asceticism, by stark contrast, concentrates exclusively on the self, which is predicated to be corrupt in body and deceitful in thought.[14] Christian asceticism enforced a sharp intensification of ascetic practices, but behind this difference in degree lay a difference in kind, for the power situated in the eremite was not a product or function of culture but was both universal ("in" everyone) and nonhuman.[15] The eremite went to the desert to achieve a self constituted entirely by transcendence-of-self.

What marks eremitic asceticism most clearly in contrast to pagan asceticism is also what makes it far more profound—its compatibility with cenobitism. Christian self-formation differed from its pagan counterpart not only in being more extreme, to the point of self-deformation, but also in being complemented by an activity of self-unforming. Often considered apart from eremitism, cenobitism is actually its necessary and intrinsic double, exemplifying the limits of human capacity to achieve perfect self-transcendence. Each remembered what the other had forgotten—the eremite, that the grace of God dwelt within each person; and the cenobite, that the dead weight of sin stood between the human and the divine. If the eremite courted temptation in order to achieve the sharpest possible definition of himself, the cenobite sought not to be led into temptation so that the self would grow indistinct in its outlines, and would, ideally, simply cease to be. These two gestures must be read as a double gesture; we must be able to perceive the humility of the eremite and the arrogance of the cenobite if we are to understand either one, much less the totality.

Cenobitism is not action, but what Arendt would call *labor*, as it stresses the routine performance of tasks that are nonproductive, noncreative, and yet essential for the maintenance of life (*Human Condition* 87). It is based on mortification, silence, and particularly obedience, the total subordination of the will to that of the Master. It is in the cenobitic communities that the "athletes of Christ" could compete head to head, "striv[ing] eagerly," in the words of Basil, "to be the last of all" ("Ascetical Discourse" 21). Chrysostom points out that monks should imitate athletes, who "exercise themselves every day in the palestra under a master and by rule," and warns that ascesis "comes not naturally but by our will" (3.4, 271:45). The cenobite is faultless rather than excellent, a subtracted rather than an achieved self, a pure disciple of what Durkheim called "the negative cult."[16] There are no portraits of individual cenobites, only ranks of anonymous staring faces. Nor are there narratives of cenobites, who scrupulously avoided the excesses that marked narratable action. Cenobites, for example, all practised silence, but hagiography records the feat of Abba Agatho,

who held a stone in his mouth for three years. The force of monastic Rules was to moderate such individualism and to warn of the temptations lurking even in competitions between athletes of Christ. Hence one narrative records what must have been a common experience, the devil whispering to a monk, "You are more just than all the others. You have practised ascesis more than they. Jesus loves you and lives in you and speaks by your mouth. . . ."[17]

If eremitism is superhistorical, to recall Nietzsche's term, then cenobitism pursues the other "antidote to history," the "unhistorical": "By the word 'the unhistorical' I denote the art and the strength of being able to *forget* and enclose oneself in a limited *horizon*" (*Advantage and Disadvantage of History* 62). The cenobite strives to empty his memory, to "walk in newness." And in a larger sense he tries to live a life without content, without events—just as Flaubert, in an ascetic spirit, wished to write a novel about nothing. Anthony sounds like an eremite when he tells his followers that "faith in our Lord is for us a seal and a wall of protection" (9: 39), impervious to demons. But for the cenobite, the goal was not to protect one's vital selfhood, but to extinguish whatever spark of temptability lay within. Eremites renounced the world; cenobites renounced themselves. Accordingly, eremites gained themselves; and cenobites, through the monasteries that exerted their powerful influence until the Reformation, gained the world.

The last assertion is the basis for Max Weber's analysis of "worldly asceticism" in *The Protestant Ethic and the Spirit of Capitalism*, in which he describes the transformation through the Reformation of the original "*ausserweltlich*" asceticism into an "*innerweltlich*" asceticism whose characteristic mode was capitalism. According to Weber the spirit of asceticism left the monasteries at the end of the Middle Ages and entered everyday life, especially in the form of a "calling" to a given occupation. With this move worldly success was legitimized, but at the expense of "the spontaneous enjoyment of life," the old spirit of unselfconscious *gemütlichkeit* now fallen victim to the relentless demands of economic competition. Weber's analysis of the ascetic character of the capitalist is anticipated in Adam Smith's conception of *homo economicus*, that paragon of rationality whose every act reflects his essential freedom from any institutional context or family obligations in the pursuit of the maximum profit.

But Weber is wrong to assert that such creatures suddenly appeared after the Reformation, for the "spirit of capitalism" was hard at work destroying *gemütlichkeit* in the name of profit in the fourth century. And in the thirteenth century, when the might of the monasteries had

not yet been shaken, Bonaventura advised his readers "to be deaf, dumb and blind, quite indifferent in fact to everything in which spiritual profit is not found" ("Twenty-five Points to Remember," no. 9). Moreover, Weber's description of laboring in a calling resonates with Chrysostom's description of the rigors of asceticism: "Labour must . . . be performed as if it were an absolute end in itself, a calling. But such an attitude is by no means a product of nature. It . . . can only be the product of a long and arduous process of education" (62). Both early and late forms of asceticism prescribe methods of becoming self-made men, beings that owe nothing to genealogy or community. What really separates *ausserweltlich* from *innerweltlich* asceticism is money, whose libidinous sterility is a worldly version of profit, the always-deferred but still present and real gains accruing from a competition in self-denial. Early asceticism is capitalism without money.

Weber provides the best gloss on the "Thebaid" paintings popular around the time of the Reformation—paintings, we may speculate, that sought to harmonize the old and new forms of asceticism (figs. 1–5). Named for the region near Thebes where ascetics gathered, these paintings depict an intensely social world, crowded with roads, meeting places, encounters. And yet it is also an unworldly world, unlike a village, for example, in that there is no center, no variety, no hierarchy or diversification, no women or children. It is, to adapt a phrase from Yeats, a country for old men.

Despite the homogeneity of the life depicted in the "Thebaid" paintings, they are works in conflict. To be sure, everybody is engaged in the same activity, motivated by the same desire. They exhibit what Weber called "that powerful tendency toward uniformity of life, which today so immensely aids the capitalistic interest in the standardization of production," that uniformity which "had its ideal foundations in the repudiation of all idolatry of the flesh" (169). But they also display what Weber, in a famous phrase, called the capitalist's "unprecedented inner loneliness," that sense of being apart from all collectivity. In the "Thebaid" paintings, as in asceticism in general, everybody is alike and everybody is alone. These phrases also describe cenobitism and eremitism, forms that became separated in the fourth century when the more "advanced" communal organizations began to consolidate their power, leaving the "primitive" or "mythological" eremite outside the walls. Both types reemerge, transfigured, with the rise of capitalism, cast now in the roles of producer and consumer, capitalist and worker, in a sudden and dramatic expansion of the inventory of ascetic gestures.

These gestures have also contributed to the history of art. The relation between eremite and cenobite, producer and consumer, has

been reenacted in the dialectic between romantic and classical myths of artistic creation. A figure of supernatural personal charisma, the romantic artist descends from the Holy Man, a thaumaturge who stands in uncanny proximity to a highly charged realm of imaginative power and privilege:

> Weave a circle round him thrice,
> And close your eyes with holy dread,
> For he on honey-dew hath fed,
> And drunk the milk of Paradise.

Except for the eating and drinking, this passage from "Kubla Khan" strikes all the right emphases of separateness, potency, sacrality, and spectacle. The romantic artist creates as a mode of heightened being, as a condition of an augmented selfhood. He submits to no rule but those that determine his own being.

The other dominant myth of the artist in the Western tradition is that of the classical artist who creates by subjecting his personality to the requirements of the material and the theme, the artificial laws of form. The discipline of cenobitic art is most vividly documented in the letters and journals of such artists as Keats, Flaubert, Conrad, Gide, and especially Kafka, whose tortured letters to Félice Bauer record his conflicting desires "to live" and to "die to life" in the consuming service of art. In this version of creation the artist works not in a state of heightened subjectivity but in a condition of self-negation, "negative capability," "anonymity," or "impersonality." In the words of T. S. Eliot, "the more perfect the artist, the more completely separate in him will be the man who suffers and the mind which creates; the more perfectly will the mind digest and transmute the passions which are its material." "The progress of an artist," Eliot writes in "Tradition and the Individual Talent," "is a continual self-sacrifice, a continual extinction of personality." The eremitic artist fills an aesthetic form with symbolic representations of self, but the cenobitic artist disappears into the work, leaving no trace of self. In both modes, asceticism transforms the gruesome "public spectacle" of sacrifice into a bloodless display of form.

One would hesitate to attribute to the cenobites an originality they would be horrified to claim for themselves, but they and their eremitic counterparts were the first to articulate certain modes of creative being, modes of self-creation, which have produced a powerful oscillating rhythm in Western culture since their time. One factor that unites them is the imperative to resist temptation. The eremitic artist renounces the temptation to order and uniformity, to mundanity and to mediocrity;

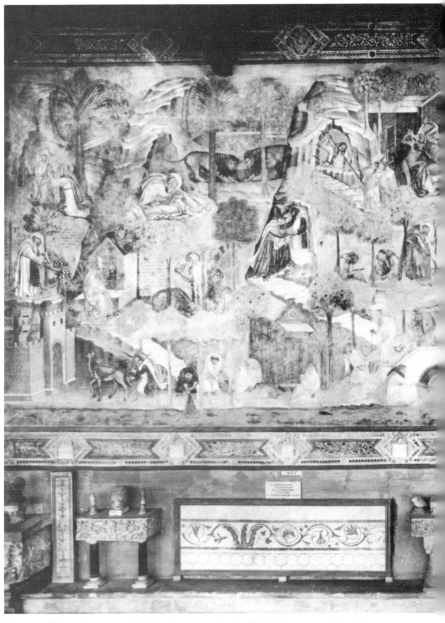

Figure 1. Pietro Lorenzetti. *The Anchorites in the Thebaid.* c. 1340, Pisa Camposanto. Photo, Alinari/Art Resource, N.Y.

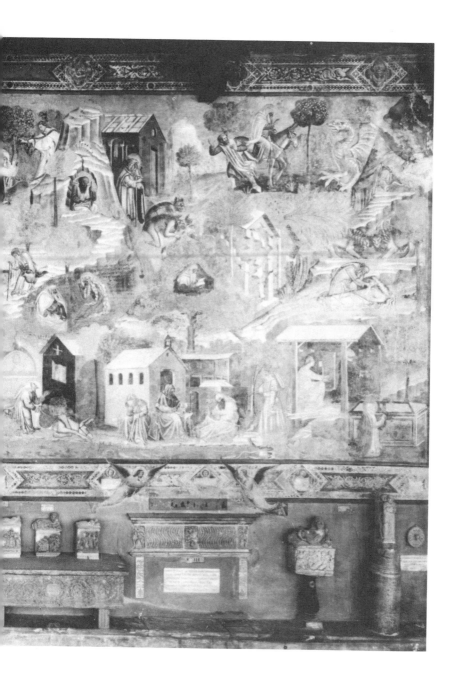

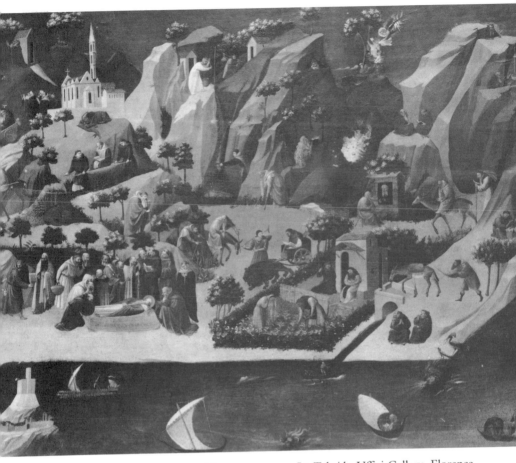

Figure 2. Anonymous, Florence, c. 1430, *La Tebaide*. Uffizi Gallery, Florence. Photo, Gabinetto Fotografico, Soprintendenza Beni Artistici e Storici di Firenze.

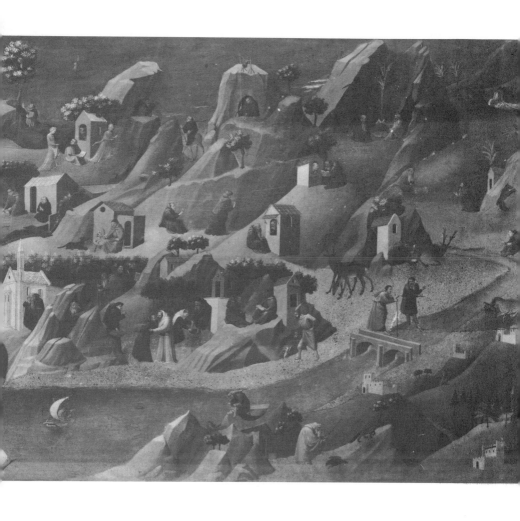

while the cenobitic artist resists distinctiveness, glamour, self-asser-
tion—what Borges calls "the most vulgar of art's temptations: that of
being a genius." Moreover, both propagate a sense of "divided
consciousness" or "split personality" that reflects the ascetic hierarchi-
zation of the levels of the self.

What distinguishes all forms of asceticism is the idea that the self is
a composite structure containing an essence that transcends, and yet is
intimately conjoined with, a substance or medium that is mutable,
degraded, and rebellious. From this basic structure of the self, which
was derived from Greece—"the most far-reaching, and perhaps the
most questionable, of all her gifts to human culture," as E. R. Dodds
says (21)—the early Christians extrapolated numerous systems and
charts of selfhood in an effort to explain why the essence is not always
manifest, why it does not always prevail, why it is so routinely
obscured, defeated, or betrayed. Origen speaks of a "will of the soul" as
"something intermediate between the flesh and the spirit, undoubtedly
obeying and serving that one of the two which it has elected to obey"
(De principiis 4.2: 338). Origen's system is elementary compared to that
of Maximus the Confessor in the seventh century. Maximus thought
the self contained a body, a mind, and a soul. The mind actually
contained a part of the soul, the "reasonable" faculty, while the rest of
the soul was contained in the soul proper, which had two parts, the
"concupiscible" and the "irascible," which together were called the
"passible"; and this, the passible, was the target of ascetic practice, the
part of the soul capable of being disciplined (see The Ascetic Life,
passim.) By the time of Aquinas the ascetic conception of the self was
complex enough to make Freud's appear rudimentary, but the goal of
such systematizing was paradoxically to isolate the source of transgres-
sion so that it could be neutralized, and the self made "simple,"
"perfect," and "single-hearted."

In certain respects, language, with its "body" of writing and "soul"
of speech, was an ideal model for this essentialist view of the self. But
language also invoked other, more intricate and elusive aspects of the
personality. In the ascetic view, language resembled the self in that
words had simple, plain, essential meanings which were often lost or
obscured in a confusion of multivocality and alternate possibilities. In
these reservoirs of connotative unmasterability, desire and indulgence
could lie concealed beneath a surface of orthodoxy. Thus Origen's
discussion of "human temptation" and the "commotions of the soul"
abruptly gives way to an angry polemic against certain "abuses of
language," particularly catachresis, which can be found even in the
Bible. In the critical phrase "the flesh lusteth against the spirit,"

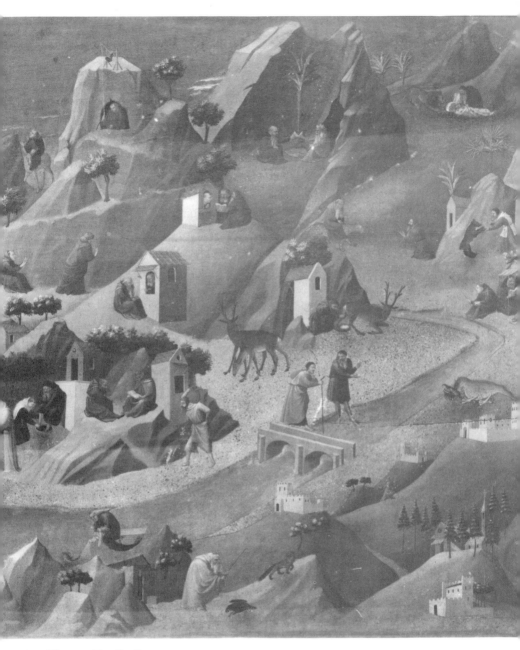

Figure 3. Detail of 2.

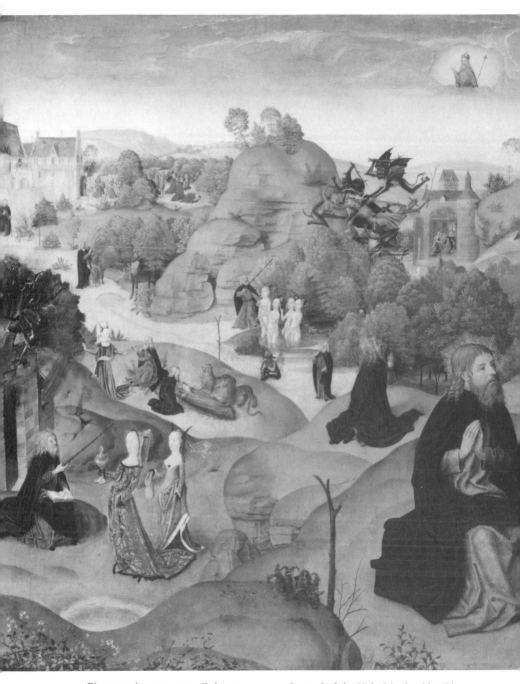

Figure 4. Anonymous, Cologne, c. 1500, *Legend of the Holy Monks*. Alte Pina-
kothek, Munich. Photo, Bayerische Staatsgemäldesammlungen.

Figure 5. Detail of 4.

for example, Origen glimpses a possibility for heresy in the interpretation that regards the flesh as an independent agent, a view which would imply that God had "formed a nature hostile to Himself, which cannot be subject to Him or to His law" (*De principiis* 4.4, 5: 340). In catachresis the "passible" dimension of language is engaged, so that even within the essential language of Scripture an entire system of antimeanings might emerge. This system does not merely resemble the fugitive recesses of the mind; it searches out, calls forth, and structures those impulses to self-love which are the basis of all transgression.

And yet, in a typical ascetic paradox, language also provides the only means of countering the instability of selfhood. Language alone can serve the self as what Foucault calls the *mode d'assujettissement*, the means of subjection, the enforcement mechanism which will remove the subject from "the world," and produce what Cioran calls the "tonality of death" in life (216).

One *mode d'assujettissement* has already been mentioned, that of continuous prayer, which empties the mind of context and point of view, filling it entirely with text. But another, more dramatic method is described in memorable detail by Athanasius:

> Six months had not passed since the death of his parents, when, going to the Lord's house as usual and gathering his thoughts, he considered while he walked how the apostles, forsaking everything, followed the Savior, and how in Acts some sold what they possessed and took the proceeds and placed them at the feet of the apostles for distribution among those in need, and what great hope is stored up for such people in heaven. He went into the church pondering these things, and just then it happened that the Gospel was being read, and he heard the Lord saying to the rich man, "*If you would be perfect, go, sell what you possess and give to the poor, and you will have treasure in heaven; and come, follow me*" [Matt. 19:21]. It was as if by God's design he held the saints in his recollection, and as if the passage were read on his account. (2: 31)

Augustine was impelled to his own conversion on hearing this story, which therefore stands behind the paradigmatic conversion in Christian history. Indeed, from Athanasius's account we might be able to infer the attractiveness of conversion—to infer, in other words, why Christianity, with its extraordinarily severe and antihumanistic ascetic ideology, spread. The answer cannot be merely that Christianity promised "treasure in heaven" to its converts, but rather that it offered a present-tense response to an increasingly nagging sense of sterility, endlessness, and *ennui* in the pagan ideology of self-formation.[18] While the pagan self was well formed, it manifestly lacked transcendence, and

belonged to the phenomenal and contingent world, a world that Platonism systematically devalued. In place of the self-sufficient self formed on the model of the work of art, Christianity proposed an identification of self with a text of transcendence, an experience that shattered all self-sufficiency and opened up the self both to other selves who had made this identification, and to idealization and closure. In the theology of conversion the self can be synchronized with a transcendent origin; it is invited to accede to the design that is already intrinsic to it. The Biblical narrative overheard by Anthony calls on the essential "perfect" self, setting it against "possessions," worldliness, inessentiality of all kinds. Through conversion one is called simultaneously to imitation and to an original condition. By contrast, pagan self-fashioning was predicated on individual uniqueness and cultural accomplishment, cold comforts in the long run.

The "theme" of conversion is the oscillating interplay between original and imitation, event and repetition. Although, according to Athanasius, "no monk knew at all the great desert" before Anthony (3:32), Anthony's flight from the world placed him in a chain of succession that originated with Christ—or perhaps, as later writers were to assert, with Elijah—and ran through Paul, John the Baptist, and, in other ways, the martyrs. Even the call to follow Christ was borrowed: Origen had referred to the same text from Matthew as the basis of a Christian life.[19] Among its other contributions to asceticism, textuality enables such imitation. In his illiteracy, Anthony exemplifies a way of reading that is enacted in life, a hermeneutics that tries to overcome the gap between (divine) intention and (human) understanding through the "reader's" recreation or rewriting of the text not on paper but in his own being—a way of reading that sees, as Gregory of Nyssa comments, "activity as a kind of imitation" ("On Perfection" III). The reception of the Biblical text becomes a form of ascesis, of self-overcoming in which the reader or hearer aspires to an identification with the text that is simultaneously original and derivative. This complicated project can be traced in practices as radically different from each other as that of Schleiermacher, whose goal in understanding was "to become the other"; and of Derrida, who does not so much read texts as inhabit them, speaking subversively from within them, completing on his own terms their "imperfect" or "incomplete" utterances.

In its meditation on language, as in much else, historical asceticism's consummate interest lies in the fact that while it is devoted to the notion of rigor it embraces practices and attitudes that appear mutually exclusive, opening onto a perspective more capacious and fundamental than those to which we might otherwise have access. In the dialectic

between eremite and cenobite we can see, for example, a conflation of the very oldest oppositions of the culture of writing. The eremite *looks* at his empty world and illegible temptations; the cenobite *reads* the narrative of this regard. The eremite *signifies* through his ascesis; the cenobite *imitates* that signification. Earlier I suggested that eremites and cenobites stand in relation to each other as speech and writing, perhaps the most elementary such opposition; but this formula requires some fine-tuning. Conceiving of himself as a direct or primary imitation of Christ, the eremite actually stands in the position of the transcription of the spoken Word. The highly mediated nature of even this posture undercuts any pretension to true originality on the part of the eremite, but this is not the real point. The eremite had predecessors but not intermediaries: he placed himself in direct relation, if it can be called that, to the Mediator. To be a cenobite, on the other hand, was to be a copy, one among many, of a manuscript—a second-order imitation, with both predecessors and intermediaries. So while both strove for the perfect imitation, both were also highly conscious of their own derivation and the impossibility of ever attaining the status of their model. Indeed, the illusion that one had reached an ideal or perfect identification with Christ the Word was the most notorious and insidious of temptations, slamming the door closed at the very moment when one had proven oneself worthy of entering. Hence asceticism, the discipline of the essential self, is always defined as a quest for a goal that cannot and must not be reached, a quest with a sharp caveat: "seek but do not find."[20]

This built-in limit to the perfectibility of the self gives asceticism a certain irreducibility, for it is both dynamic and static; the ascetic is constantly progressing, but never arrives. Although asceticism as I have been discussing it has a number of historical, cultural, and theological determinants, the basic form of ascetic thought on the self follows directly from the notion of essence. Hegel wrote of "The Doctrine of Essence" that it was "the most difficult branch of Logic" because its subject was always the ways in which things contradicted themselves. The essence, he said, does not simply lie behind "a rind or curtain" of appearances, but resides within those appearances in a way that defies logic itself. A thing with an essence is in a condition of "self-repulsion" or "negative self-relation," so that it is possible to draw a distinction between a thing and itself. And God alone has no essence—only the Absolute is altogether identical to itself. Like flesh and spirit, essence and appearance are in "reciprocal revulsion": the spirit is the revulsion of the flesh and vice versa.

Marxists and others have attached the legacy of Hegel by pointing

to the way in which the doctrine of essence hierarchizes the ideal, the abstract, the nonmaterial. But if the doctrine of essence is the most difficult branch of logic, it is because it conflicts with itself: not only does it privilege the ideal, but it also sets it in equal opposition to the nonideal, with all the contrary and contestatory energy an anti-Hegelian could desire. The doctrine of essence actually constitutes an uneasy moment in Hegel's philosophy because no synthesis emerges from this antithesis (see "The Doctrine of Essence" 130–39). Heidegger, for example, stresses the contestatory implication without betraying Hegel's thought, treating essence as "unconcealedness," a "curious opposition of presence in that it always witholds itself at the same time in a concealedness." Heidegger speaks of the "*strife* of truth" arising in the "rift" (*Riss*) between "earth" and "world," openness and closedness, opposing forces that belong to each other with "the intimacy with which opponents belong to each other" ("Origin of the Work of Art" 53, 63). In its double phase, the logic of essence leads us not out of struggle but into it, disclosing the ideal which it cannot deliver. Hegel speaks of self-revulsion and Heidegger of the rift, but these words come to human countenance and acquire a specific ethical urgency in the ascetic formulation to which we must now turn: Man's life on earth is a temptation.

The Signs of Temptation 3

The condition of Being in the world is that of
temptation.

 Heidegger, *Being and Time*

The organism seems made to avoid too much *jouis-
sance*. . . . All that is elaborated by the subjective
construction on the scale of the signifier in its rela-
tion to the Other and which has its root in
language is only there to permit the full spectrum of
desire to allow us the approach, to test, this sort of
forbidden *jouissance* which is the only valuable
meaning that is offered to our life.

 Lacan, "Of Structure as an Inmixing of Otherness
 Prerequisite to Any Subject Whatever"

*I*n the eyes of the world, asceticism often appears as a strategy of
perversion, a naive denial of desire plotted out according to a
pseudo-ideal of immobility and death. The ascetic stasis might be
contrasted with, for example, a "humanistic" model of human life as
narrative, a model that includes contingency, desire, and temporality.
Actually, there is less to such a contrast than meets the eye, for even in
the primitive and fanatical forms assumed by asceticism in the Late
Roman empire, desire and narrativity were intrinsic to the practice of
virtue and the conceptualization of the ethical life. Indeed, the broad
claim of this section and the next is that asceticism is essentially a
meditation on, even an enactment of, desire. It has always been
profoundly hospitable to verbal representation in general and to
narrative in particular—so hospitable in fact that narrative is virtually
the ascetical form of discourse.

 Desire is, of course, asceticism's abiding problem. But it is simply
wrong to say, as so many have, that Christian asceticism excludes desire,
for it manifestly exploits the desires to achieve spiritual perfection, to be
united with God, to reach a condition of stability and permanence.
While asceticism recognizes that desire stands between human life and
perfection, it also understands that desire is the only means of achieving
perfection, and that the movement towards ideality is necessarily a
movement of desire. Be like Daniel, Bonaventura counsels, "a man of
desires." "Ask grace not instruction," he insists, "desire not understand-
ing" (*The Soul's Journey into God* 55).

Desire for what? *"My soul chooses hanging and my bones death"* (115). As this choice indicates, asceticism does not exclude desire, it complicates it; it proposes gratifications which are represented as both "anti-desire" and yet (and for this reason) more desirable than desire because they do not insult the conscience.

Nowhere are the activities of complication and containment more intense and more visible than in ascetic discussions of sex. Consider, for example, Jerome's famous twenty-second letter, where he concedes that "it is hard for the human soul to avoid loving something, and our mind must of necessity give way to affection of one kind or another. The love of the flesh is overcome by the love of the spirit. Desire is quenched by desire" (17: 28). Asceticism fights fire with fire, supplanting erotic pleasure with an attenuated, "profound," and spiritual satisfaction. But Jerome does not simply suggest an alternative love object, as a later passage in the same letter makes clear. Here, Jerome counsels his reader ("a virgin") to "let the privacy of your chamber guard you; ever let the Bridegroom sport with you within. . . . When sleep overtakes you He will come behind and put His hand through the hole of the door, and your heart shall be moved for Him . . ." (25: 32). The difference between the pleasures of the figural Bridegroom and those of any literal one is not altogether clear; one cannot say with complete confidence that ascetic "sport" is altogether non-erotic.

Erotic figures mobilize sexuality against itself, seducing the desiring subject into seeking the abolition of desire, or charming him into thinking that certain gratifications constitute its abolition. The task of ascetic writers such as Jerome is to represent certain movements of desire as "innocent" in order to argue that transgressive desire can truly be overcome, that it has an opposite that can be freely chosen.

This task is the context for the emergence of temptation as the signature of all forms of asceticism. Between fallibility and fault, between innocence and guilt, lies temptation. Between human beings and the objects of their desire lies temptation. Between desire and the force that prohibits its fulfillment lies temptation. An experience of the margin, temptation mediates the oppositions that structure ethical thought, both bringing them together and yet insisting on the difference between them.

One conspicuous "use" of temptation for the ascetic is that it sharpens apprehension of the self's obscurities. As Origen says, temptations exist to "serve the purpose of showing us who we really are, and to make manifest *the things that are in our heart*" ("Prayer" 29.17: 125). Karl Jaspers is clearly thinking of something like temptation when he speaks in *Psychologie der Weltanschauungen* (psychology of worldviews)

of the "boundary situation," in which the individual is unable to determine his conduct by referring to science or any other mode of "anonymous" knowledge, but is thrown onto his own resources, reduced to what is his and his alone. According to Jaspers, existence is "illuminated" at such moments when what is concealed within a person is raised into the light of commitment. But from the point of view of temptation Jaspers is too sanguine. In temptation desire is illuminated, but always and only as a double desire balanced between obedience to the law and transgression, between the dictates of conscience and the impulses or drives of the mere self. In the experience of temptation we are situated at a moment of character-revealing choice, when the options presented by the world are reduced to two—to be or not to be, to do this or that. Thus the self-knowledge to which Origen and others refer is always a knowledge of oneself as doubled and contradicted, never a simple knowledge of one's "single-heartedness" or univocal "commitment." In fact, such a presumption of "singleness" or simplicity is precisely what temptation reveals to be an illusion by exposing a hitherto unsuspected complexity. The price of self-knowledge under these circumstances is great, for one only knows oneself as unknowable, dispersed; one comes to illumination and clarity only as a being in conflict with itself.

In fact, Jaspers has collapsed into the "boundary situation" two altogether different moments, marked by asceticism as "the hour of temptation" and its clarifying resolution, a decisive gesture of resistance or assent. Before assessing the emphatic closure of temptation, however, we should try to understand its beginning. This is more difficult, because temptation refers back to impulses already present, but latent and unrecognized. The tempted subject is situated before choice, but after innocence has been compromised by an awakened desire, in the moment Kierkegaard described in terms of "*Angst*," or dread.

A gathered fullness, dread mediates the paradox of innocence, which is that it "only comes into existence by the very fact that it is annulled, comes into existence as that which was before it was annulled and now is annulled." More than vegetative blankness yet less than the least particle of knowledge, dread is the margin of innocence, the jumping-off point for the "qualitative leap" into sin. Kierkegaard places dread at the moment when Adam receives the prohibition against eating the fruit of the tree of the knowledge of good and evil, a prohibition he cannot understand ("For how could he have understood the difference between good and evil, seeing that this distinction was in fact consequent upon the enjoyment of the fruit?"), but one which nevertheless arouses in him "the possibility of freedom," the "alarming

possibility of *being able*." Dread is the implicitness of sin within innocence, the expectation of an expectation; it is synonymous with innocence, begotten by innocence; and yet it is different, for it is a psychological condition, betraying the characteristic ambivalence of psychology: "Dread is a *sympathetic antipathy* and an *antipathetic sympathy*." The last extremity of innocence, no further—and yet it is already impossible to say that it is not too late. After the prohibition, innocence is "not guilty, and yet it is in dread, as though it were lost" (*The Concept of Dread* 33–41).

Dread may be the entrance of sin, but how does dread itself enter? What is dread's dread? With such questions Kierkegaard is impatient: "If I were allowed to make a wish, I would wish that no reader might be profound enough to ask the question. . . ." But for those inconvenient readers, Kierkegaard has provided a striking analysis of Eve as the point of weakness through which sin gains a foothold in the human world. Her weakness lies in her derived relation to Adam, the external position of a being created out of a precedent creature. This position creates "as it were, a presentiment of a predisposition, which indeed is not yet in existence, yet may seem like a hint of the sinfulness posited by reproduction. It is the fact of being derived which predisposes the individual without for all that making him guilty" (43, 44). And so, when the serpent speaks to Eve, he addresses a creature floating at a distance from the origin.

Some of the most interesting speculation, most of it Protestant, has gathered around this first, beguiling conversation, which begins with the serpent's question, "Yea, hath God said, Ye shall not eat of every tree of the garden?" This question is commonly taken to be the prologue to the temptation, which occurs when the serpent enjoins her to pluck the fruit of the one forbidden tree; but as the Lutheran theologian Dietrich Bonhoeffer points out, it is itself the most profound and dangerous of temptations—despite the fact that it is "the ultimate religious question," simply seeking to affirm the Word. In fact, the question's effect is the opposite, severing the Word from its source so that it floats Eve-like in derivation. The prospects opened by this polite and reverential query must, Bonhoeffer argues, throw Eve into the greatest confusion, in which she feels "the attraction of making judgments about the Word of God." The question "enables man to catch sight of a hitherto unknown profundity in which he would be in a position to establish or dispute whether a word is the Word of God or not." Unbound and scrutinized, the Word splinters, becomes suspect. Against this suspicion there is no possible defense, and yet this is the true temptation, to regard the Word as interpretable: of the

plucking of the fruit, which could have been avoided, Bonhoeffer nearly excuses Eve, since she could not have understood the consequences of her act except as "the possibility of being more devout" (*Creation and Fall* 66–71).

Some scholars, including Luther, have seen Eve as a "less excellent" version of Adam, offering as evidence her insufficently forceful response, which was simply to repeat the prohibition. Luther argues that "If Adam had been attacked he would have said Shut up! The Lord's command was different" (151). But Bonhoeffer's point is well taken: the damage is done before any reply is made. Any response—even Get thee behind me, Satan—merely confirms the conversation and so constitutes a yielding to temptation.

Innocence is the capacity to learn nothing; it is not the ability to conquer doubt, which belongs to faith, but the ability—really an inability—not to doubt at all. It is a static and present-tense condition incompatible with the dynamic exchange of information that comprises linguistic intercourse. Kierkegaard says that it is "language itself" that addresses Eve, and this may be seen as an abstract statement of Bonhoeffer's argument that in understanding the question, Eve is already lost.

It is, in other words, not merely a happy efficiency that the first conversation is also the first temptation as well as the first discussion of the problem of meaning. As the Fall is implicit in temptation, so is temptation implicit in language, especially the form Freud called the "temptation to imitate." All language issues the temptation to imitate, which is measured in the impulse to respond, to participate, to express oneself, to generate yet more language. This temptation is invoked subtly by the serpent when he invites Eve to participate with him in judging God's Word, and bluntly when he promises her that her "eyes will be opened" and she will "be as God."

Eve's fascination is that she has no past, no psychology, no characteristics. Temptation can discover what she is even though she is nothing. Eve emerges as an elaborately stratified, multifaceted and contradictory being as she understands the language of the question, filling an interrogatory gap with projections of a self that has desires and intentions of its own. Though Eve is nothing, the serpent can still speak to her pre-inclinations, her own thoughts. Nor is it entirely appropriate to consider Eve a mere cipher, for as Kierkegaard says, she has a "past" in her derived condition; and this condition posits a destiny in her desire to be as God (in whose image and likeness she has been made). Her temptation is exemplary in that it reveals a desire or tendency already in place, and already in a sense gratified. Ensnared in deriva-

tion, implicitly desirous and invisibly compromised, Eve in the garden is no different from those who are out of it, tempted both to what we already are and to what we cannot be.

It is, appropriately, Kierkegaard (or his mouthpiece, Johannes de Silentio) who teaches us the cost of resisting the temptation to imitate. This is the subject of *Fear and Trembling*, his meditation on the temptation of Abraham, whose perfection consists of his utter inimitability, his perfect unintelligibility: "No one is so great as Abraham. Who is capable of understanding him?" *Fear and Trembling* begins with four revisions of the story of Abraham, retellings in which the unyielding and stripped Biblical account is filled out with personalities, events, the stuff of narrative. Making sense of God's incomprehensible directive or of Abraham's incomprehensible submission, they represent attitudes contrary to faith by revealing possible points of correspondence between God's command and Abraham's desires. As such they represent temptation. The perfection of Abraham's faith lies in his refusal to interpret God's commands; he discovers in the order to slaughter Isaac no trace of self whatsoever. God's command is *his* because it so utterly negates him, Abraham. Between God and Abraham, God and Isaac, and Abraham and Isaac, there is void—and it remains a void through Abraham's noninterpretive act of perfect understanding. Hearing God's command, Abraham, the knight of faith, meets the temptation to interpret, to make a sense that accords with his inclinations, with an instant evacuation of desire, a total submission to God's self-evident though inscrutable Word. This Word, commanding the "teleological suspension of the ethical," rips Abraham from the society of men, so that he stands "in absolute relation to the absolute" (72).

Despite a monumental effort to wash Abraham's slate clean of intention, Kierkegaard did not provide for a telling objection brought by Martin Buber in *Eclipse of God*. Buber points out that the problematics of the decision of faith are preceded by the problematics of hearing itself: Whose voice is it one hears? Satan is a skilled mimic, and the relative is frequently confused with the absolute. "Where, therefore, the 'suspension' of the ethical is concerned," Buber writes, "the question of questions which takes precedence over every other is: Are you really addressed by the Absolute or by one of his apes?" (118–19). In support of Buber, it must be noticed that in the Biblical account God's words issue from no discernible source at all; here, it is truly language itself that speaks. And so Abraham finds himself in a dismal difficulty, of having succumbed to a temptation before the temptation, revealing by his very faith a corrupt readiness to be addressed in a horrifying way by

the Absolute. With this point, the distinction between Eve and Abraham collapses: Eve guessed wrong, Abraham guessed right; but they both yielded to temptation.

From the ethical point of view, the experience of temptation is perperpetually resolving into decisions—or guesses—that are thematized as either gratifications or denials of desire. But the discovery of dread suggests that temptation itself is already an "after"; only a potential "preface to transgression," it already betrays a commitment to assent. From within the experience of temptation, desire lies about on all sides, residing as comfortably in the murder of one's son as in apples. From within, adherence to the law is as fervently desired as disobedience. From within, it is impossible to distinguish desire from denial, for they are thoroughly implicated in each other: Abraham desires denial as a way of denying desire.[1] The enormous conceptual and ethical usefulness of temptation is that it quarantines this fact in a phase of crisis whose only purpose is to abolish itself, to give way to a clarity in which desire and denial are opposed.

What is desire that it should require such attention? Religious discourse on desire is often too "interested" to permit a direct examination of the kind undertaken, for example, by psychoanalysis. For Freud, desire is a mental activity whose function is to recover a lost condition of pleasure, ultimately a condition of primal gratification. In Freud's famous phrase, the finding of an object is always a re-finding of it. But the object re-found is always inadequate to the gratification sought, for the true goal of desire is the impossible reinstitution of the fetal condition; all desire is, in this sense, "displaced." Because it always exceeds the object, desire is intrinsically "fantasmatic," appropriating objects through a desiring fantasy that operates independently of them and even includes within itself a certain satisfaction: the ability to imagine gratification is itself gratifying. It is no paradox that the "same" desire can become detached from a particular object and settle on an other, for desire is resourceful, always capable of constituting new representations to move towards, new allegories of itself.[2] According to Julia Kristeva, Roland Barthes conceived of desire as "the space of a material contradiction where the 'other' is another *topos* of the subject, an other *practice* of the sexes" ("How Does One Speak to Literature?" 116). Desire reveals the world to be full of possible representations of self, possible magnets for erotic interest.

The volatility of desire seems to militate against the ascetic goal of coherent pictorial self-definition. The desiring self is a provisional self, attached to and defined by objects it could abandon at any time. The economy of excess that governs desire subverts the self's ability to bind

impulses into a controlled and controlling wholeness by placing the self within an unmasterable movement, a movement energized by loss and determined simultaneously by the past and the future. But while a "floating" desire menaces the projects of self-definition and self-transcendence that dictate ascetic rituals of objectification, such desire does not, as some have suggested, reveal an unlimited principle of fecundity within the self. It has become fashionable to accord to desire an infinite capacity for displacement. Leo Bersani asserts, for example, that "the desiring self *is* a temporally, spatially, ontologically disoriented being, a scattered, partial self existing nowhere but in the movements of fantasy" (*Baudelaire and Freud* 77–78). For Bersani, the self defines itself by choosing which of desire's fantasmatic, arbitrary, centerless repre-sentations it "prefers." But such a view implies that all integrity and coherence is achieved at the expense of and in opposition to a nearly autonomous agency of incoherence called desire. This seems to me not only logically dubious, but contrary to the most fundamental principle of the Freudian dynamic of the mind, repression.

As Freud treats it, repression occurs in the confrontation between what is variously called an impulse, drive, or instinct and a resistance whose goal is both to render the impulse inoperative and to keep it from consciousness. The most primary physic gesture of an acculturated or even conscious being, repression still seems from one point of view inexplicable—why would the mind thwart itself?—until we recognize that, as Freud says in the essay on "Repression," "the satisfaction of an instinct under repression is quite possible." When the pleasures of satisfaction conflict with certain consciously held values, so that the gratifications, as Freud says, "cause pleasure in one part of the mind and 'pain' in another," then repression even becomes strategically desirable as a way of concealing gratification (105). Repression is not, then, sustained only by cultural and ethical imperatives, but by covert forms of pleasure of which the consciousness is kept blissfully ignorant. This bliss helps account for the remarkable fact that repression does not strangle or depress the instinct, but actually seems to serve as a kind of instinctual greenhouse. Freud seems amazed at the way in which the "instinct-presentation" develops "in a more unchecked and luxuriant fashion if it is withdrawn by repression from conscious influence. It ramifies like a fungus, so to speak, in the dark and takes on extreme forms of expression, which when translated and revealed to the neurotic are bound not merely to seem alien to him, but to terrify him by the way in which they reflect an extraordinary and dangerous strength of instinct" ("Repression" 107).

Ascetic literature is rich in accounts of such terrifying forms of

instinctual expression. One of the most famous is in Jerome's twenty-second letter:

> How often, when I was living in the desert, in the vast solitude which gives to hermits a savage dwelling-place, parched by a burning sun, how often did I fancy myself among the pleasures of Rome! I used to sit alone because I was filled with bitterness. Sackcloth disfigured my unshapely limbs and my skin from long neglect had become as black as an Ethiopian's. Tears and groans were every day my portion; and if drowsiness chanced to overcome my struggles against it, my bare bones, which hardly held together, clashed against the ground. . . . Now, although in my fear of hell I had consigned myself to this prison, where I had no companions but scorpions and wild beasts, I often found myself amid bevies of girls. My face was pale and my frame chilled with fasting; yet my mind was burning with desire, and the fires of lust kept bubbling up before me when my flesh was as good as dead. (7: 24–25)

The internal prohibition, the "conscience," has not only driven Jerome into the desert, but has also nourished the "fungoid" proliferation of images. It might be, as Freud says, that the "final form" of the work of repression is "a sterile and never-ending struggle" ("Repression" 115), but at least in this case, repression is a fertile and expansive source of creative material.

When Freud described the never-ending struggle of repression he was referring to the forms it took in cases of obsessional neurosis. Jerome and the other desert ascetics certainly qualify at the very least as neurotics, for they exhibit in lavish abundance all the symptoms Freud listed, including feelings of "dread of the community, pangs of conscience, or self-reproaches" (114). They are also distinguished by what Freud called in *Beyond the Pleasure Principle* "an untiring impulsion towards further perfection," which results, according to psychoanalysis, from the insistence of the repressed instinct on "complete satisfaction, which would consist in the repetition of a primary experience of satisfaction" (42). But while Freud recognized the rarity of such obsessional forms, he did insist that the aberrations clarified the norm, and that the potential for these maladaptive or "ascetic" ways of managing repression was virtually universal.

The constant possibility of the mismanagement or miscarriage of repression had immediate consequences for Freud, who attributed to repression the "resistance" to analysis unfailingly offered by the analysand. Erecting a barrier between the unconscious origin of the drive and its conscious expression, repression resisted the tendency of analysis to translate the unconscious into conscious terms, thus prolonging the

analysis ("Resistance and Repression" 204). But if repression is not only the origin of many forms of neurosis, but also of all that is "highest" and most precious in civilization—and if it is a basic precondition of consciousness at all—then it would be just as misleading to attribute this resistance to the willed behavior of the analysand as it would be to pretend that resistance, or repression, could ever be overcome even in the most successful analysis. This, and not the irrational blockage of analysis by an analysand who fully comprehends the need for change, is the reason why analysis is inherently "interminable."

Interminable, that is, within the duration of man's life on earth. Repression creates not just resistance to analysis, but resistance in general, including the phenomenon of temptation, which is a structure of resistance between what might be called impulse and prohibition, desire and conscience, assent and denial. Temptation is the sign of repression. But if repression precedes all forms of consciousness, then the status of "desire" needs to be qualified. What ethics, literary criticism, and even psychoanalysis call desire is a speculative construct inferred from repression rather than an independent energy that exists prior to repression. Repression is not a fate befalling desire but a condition of desire itself, and of everything else in mental life. "Desire" cannot be opposed to "conscience" or to other regulatory agencies, for both the impulse and its opposition arise simultaneously at the origin of consciousness, and assume from the first the relational form thematized by asceticism as temptation.

A "perfect" repression would assume the non-form of a silent and sterile invisibility, the complete obliteration of impulse, the closure of the self. The only repressions we can know in any sense, and perhaps the only ones worthy of the name, are those partial "failures" which leave traces for analysis to pursue. Jerome's dancing girls constitute such traces, and enable us to define the relation between repression and asceticism very clearly. Ascesis is the strong form of the universal condition, the cultivation of repression's tempting failures. Through such cultivation, the self is simultaneously opened up (or "transcended") and closed off. Ascetic discipline does not seek an impossible perfect repression; indeed, it requires resistance. Without, for example, the resistance offered by the feminine (and its figural transformations, which can include "man"), ascetic discipline deflates into *acedia*. If asceticism is, finally, a more comprehensive phenomenon than repression it is because the discipline undertaken by Jerome and his obsessive brethren is both instinctual and chosen; it engages the conscious as well as the unconscious mind, worldly as well as mental "work," and so

comprehends the strategies we pursue knowingly as well as those that pursue us.

The ascetic flight into the desert away from objects of desire would seem not merely a neurotic avoidance of reality but also a radical misreading of desire itself. In the desert, the self was not simply circumvented or denied, for as Jerome's passage indicates, desire could symbolize, represent, and allegorize the self without the impediment of objects.[3] The very vacuity of the desert drew out repressed desires, which became expressed, or "pressed out" into images that shimmered like desert mirages. Thus the attempt to escape the desirable world actually pitched the ascetic into the world of desire, in which the blank monotony of the external scene provided no resistance to the generation of images which, however censored or placed under banishment, contained within themselves the very pleasure the ascetic was trying to renounce. The desert does not even provide a true refuge from the material world. Sartre speaks of the "enchanted" world of desire as "a destructured world in which things have lost their meaning and jut out like fragments of pure matter" (371).[4] Objects emerging under the "enchantment" of desire acquire not an ideality but a refined materiality.

Nevertheless, desire is a source of profit as well as of loss. The profit for the ascetic in this unpromising situation lay in precisely the same area as the danger. In the world, material reality provided a camouflage for the activities of desire. One could not be held accountable for having an image of dancing girls in the mind if girls were dancing before one. In the desert, however, every thought other than the thoughtless thoughts of perfect prayer appeared as a residue of the world. Such thoughts gave evidence of a still-unpurged and desiring will, and were subject to critical scrutiny and judgment. The temptations of the desert had, in short, a number of distinct advantages. They illuminated the secrecies of the self like a flare shooting over enemy territory, and thus promoted self-definition and self-externalization, even producing a sense of progress in a gradual self-revelation. Moreover, by suggesting the operation of some demonic faculty ("desire") that produced hallucinatory images of temptation, they helped make the case that drive or instinct should not—indeed, that it could not— be gratified. At the same time, these images activated, mobilized, and channeled the drive; as we have seen, they even provided a species of pleasure by operating, as it were, under the sign of negation.

"Negation," according to Freud, "is a way of taking cognizance of what is repressed; indeed, it is already a lifting of the repression, though not, of course, an acceptance of what is repressed" ("Negation" 235–36).

This exact sentence describes the position of impulse in temptation. Asceticism requires the "moving-towards" of the impulse, but cannot accept it on principle, as it is alien to the ideal. Temptation, on the other hand, may be "courted" as a way of burning off impurities, enabling the ascetic to "take cognizance" of desire without approving it. *"Ignis probat ferrum, et tentatio hominem justum"*: As fire proves iron, so temptation proves the just man (Wisdom 3:6; Proverbs 17:3).

The ascetic *fuite du monde*, therefore, has a double effect of preserving the impulse and of relegating it to a transgressing self that is almost a possession of an observing, judging self. This self-division is actually represented in *The Life of Anthony*: "Once when he was about to eat, rising to pray around the ninth hour, he felt himself being carried off in thought, and the wonder was that while standing there he saw himself, as if he were outside himself, and as if he were being led through the air by certain beings" (65: 78–79). Perhaps the conjunction of eating—of which Anthony was famously ashamed—and prayer effected the self-separation, the splitting of the self into essence and attribute, or desire and conscience. But whatever the cause, the incident, dramatizing the strain in the relationship between the desiring and judging functions, is treated by Athanasius, and represented by Schöngauer, Callot, Cranach, Bosch, and others as a "temptation of St. Anthony."

Nowhere is the usefulness of the concept of temptation more apparent than in its thematization of this event. The great danger of the ideology of the divine essence is that the connection between the essence and the material being will appear to be severed. Such a severance would create two autonomous selves. There would be an observed self which would have the opacity, lack of self-awareness, and materiality of an object; it would embody a principle of unchecked drive, what Bersani might call desire itself. And there would be an observing self which would represent ideality, coherence, restriction, judgment, choice, and will. If Anthony does not return to "stand with himself," as Athanasius puts it, then drive, instinct, motion, and temporality would be installed in a province of being essentially untouched by judgment or restraint. Conversely, the observing, correcting function, cut off from its subject, would become sterile, eviscerated, and static, prey to complacency and pride. Conceiving itself as untainted by the body, the observing self would be guilty of pretending to a Godlike impregnability to impulse or drives, which would be a betrayal of the human condition.

We are approaching the secret spring of ascetic dynamism, the heart of the ascetic problematic. The divine essence must always be

preserved as an internal structuring principle of the self. For what distinguishes ascetic from nonascetic temptation is the ascetic's belief that in assenting to desire he is transgressing not against an external rule or the force of coercion, but against his own truest self, his own deepest interiority, an internalized absolute. But at the same time the divine essence must be held in absolute disjunction from the mortal self, and from all formal coherence and structure. How can the relation between essence and expression be described without contradiction?

Here again temptation is the means of overcoming paradox without dissolving it. Temptation is the point of congruence between the ascetic and Christ, whose forty-day sojourn in the desert was marked by the three temptations of Satan. But it is also the point of disjunction. For although Christ was tempted, he had, as the anti-Arians (prominently including Athanasius) insisted, no "creaturely" taint and was therefore untemptable. How can Christ be tempted and not tempted? A tradition of commentary has sought to distinguish Christ's "external" and *pro forma* temptations from our own internal and unpredictable ones, but such distinctions do not match in subtlety or comprehensiveness Stuart Curran's recent characterization of Milton's representation: "there is essentially one temptation in *Paradise Regained*, that of narrowing one's spiritual and psychological range to accord with an already structured and external pattern" (218). As the Godhead, Christ has no true "psychology," no unconscious, and cannot be tempted in the same way as those who do. But Curran's statement stands as a description of the temptation appropriate to the divine essence. Christ must resist the tendency to form; he must remain infinite and inchoate, free from all objectification of his being, all commodification of desire—we might say he must remain in parable and resist all metonymy. In other words, the ethical project of self-externalization is Christ's degradation; and the impossible fantasy of an unconditioned desire is Christ's true essence, his divinity. Indeed, the divinity of Christ is most forcibly inscribed in the fact that he can be tempted to form. The ascetic is caught in the middle. Defining his self and honoring the Christ within, the ascetic is subject to both temptations, his life on earth "one long trial."

The interplay of form and formlessness in the ascetic's longing has been rendered with consummate complexity and richness in Bosch's Lisbon triptych of *The Temptations of St. Anthony*. The temptations of the saint are comprehensible as such only if we view these blasted, erupting, metamorphosing, exploding forms as invocations of a principle of limitlessness and freedom from restriction. Insofar as both virtue and coherence entail restriction, withholding, discipline, and

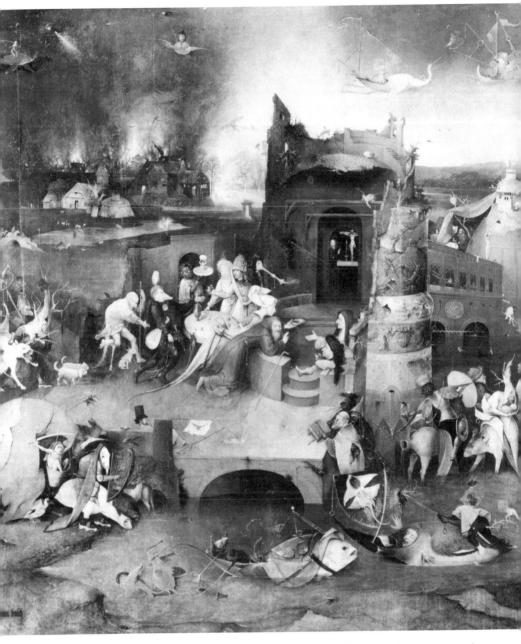

Figure 6. Hieronymous Bosch, c. 1500, *The Temptations of St. Anthony,* central panel. Museu Nacional de Arte Antiga, Lisbon.

exclusion, the formal catastrophes threatening to engulf Anthony might be attractive in their liberation of impulse. The decomposing composition is filled with containers that do not contain, bodies that do not cohere, forms that do not exclude. Resisting these, Anthony kneels in the central panel before a small altar with a crucifix, itself placed within a ruined structure that lies open, fortifying himself through the presence of the One God, the Truth. And yet it is Christ himself who is most radically incongruous, most irreducibly mixed, most utterly "open"; and in worshipping before the crucifix, Anthony may be expressing a kind of sideways assent to temptation. And yet he cannot do otherwise and remain faithful. His resistance is embedded in assent. Perhaps this is why Anthony does not focus on Christ at all, but twists to stare helplessly at the viewer. (See fig. 6.)

In imitating Christ the ascetic diverges decisively from him. Christ might disdain all self-definition, but the athlete of Christ could never ignore his condition "in the flesh, yet not of the flesh." For the ascetic, self-discipline was a way of "mortifying," or making-dead the flesh. He could not seek this death as an end, but only as a means, a middle that could never end. Self-definition is a resistance to temptation that is an assent to another kind of temptation—"white temptation," we could call it: a subtle betrayal of the Christ within. Nietzsche's warning is here appropriate: "He who reaches his goal thereby surpasses it"—and thereby transgresses (*Beyond Good and Evil* no. 73). The inescapability of assent *and* resistance in temptation serves as a reminder that the final resistance has not been made, that it can never be made unless a man would pretend to a divinity greater even than Christ's. Through such a pretension, Paradise was lost in the first place.[5]

It is through the concept of temptation that the ascetic is both united with his essence and forever divided from it. Such a paradox attends all aspects of temptation. A marginal concept in itself, temptation unites and disjoins the polarities of ascetic thought, expressing both the interdependence and the independence of impulse and prohibition, observed and observing selves, essence and expression.

As Foucault describes it, the concept of transgression bears a strong resemblance to temptation: "The limit and transgression depend on each other for whatever density of being they possess: a limit could not exist if it were absolutely uncrossable and, reciprocally, transgression would be pointless if it merely crossed a limit composed of illusions and shadows. But can the limit have a life of its own outside of the act that gloriously passes through it and negates it?" ("Preface to Transgression" 34). No, it cannot, and herein lies the difference between transgression and temptation. In the former, polarities are collapsed

into each other; they provide no resistance, insist on no independence from each other. The difference between the two ideas is reducible to this: transgression is temptation minus resistance; as such, it is temptation's temptation. Positing the identity of transgression and the limit, Foucault suggests, for example, that sin is committed at the moment it is conceivable. Temptation negates this suggestion—that is to say, it takes cognizance of it but does not accept it. Temptation *resists* transgression.

Temptation is paradoxical but transgression is inconceivable. In transgression there is virtually no space between the two terms, so that not even the tension of a paradox can be sustained. As Foucault says about transgression and the limit, "thought is ineffectual as soon as it attempts to seize them." We can now be very specific about the function of the idea of temptation. I said earlier that temptation quarantines the role of impulse in self-denial in a phase of ambivalence before the final gesture of "decision" is made. In Foucault's terms, it makes possible the struggle against transgression by restoring, however minimally, the effectuality of thought, and therefore the possibility of resistance. It does so by insinuating itself into a hitherto unglimpsed early phase of transgression, which, as Foucault says, consists of "a wave of extremely short duration" (34). Extremely short, but long enough to contain two parts, a phase of temptation and a phase of transgression proper. In temptation, notions of transgression and the limit are in force, but have not yet become identical or indivisible; sin has not yet occurred. In a purely temporal sense, temptation is prior to transgression and distinct from it: temptation is the true "preface to transgression." But in a logical sense the two cannot be strictly separated for they are related as implicit to explicit, which is more a matter of degree than of logical type. Temporally, assent or resistance appears suddenly, marking a decisive end to temptation. But logically, the decision is already "there." Transgression is strictly logical; it ignores the phase of temptation and makes one of those decisions, "assent," explicit. It therefore has the devastating and even "anti-ethical" effect of foreclosing resistance by implying that it is already too late.

It is not excessive to say that the entire notion of ethical conduct is built on the foundation of the opposition of resistance and assent. Foucault helps us understand the sense in which transgression and the limit are inseparable. What we must next understand is the relation between temptation and transgression, a distinction crucial both to asceticism and to the idea of ethics in general. As we have seen, temptation is desire's doubleness, marking the impossibility of a perfect act of self-denial. Temptation cannot, therefore, be considered apart

from the transgression of which it is but an early and indeed somewhat precariously distinct phase. On the other hand, temptation implies a notion antithetical to transgression, but one without which transgression is incoherent. The ethical essence of temptation is choice and therefore resistance to transgression. Temptation is paradoxical in that it is situated neither within innocence nor within guilt; but for this very reason it opens onto a larger category of thought than that afforded either by traditional humanism, which would piously overemphasize the capacity for resistance, or by Foucault's theory of transgression, which overemphasizes the impossibility of such resistance. Resistance to temptation is *both* imperative and impossible.

In the first section I said that ascetic linguistics embraced both logocentrism and its opposites. A similar case can be made regarding temptation, which paradoxically suspends within itself both transgression and choice, both the effectuality and the ineffectuality of decision and will. The broadest description of the project of asceticism is that it recognizes and manages drive or impulse, commonly called desire, by harnessing and directing resistance.

Ascetic writings concentrate on the problem of temptation almost to the exclusion of the general category of desire. But does this exclusion constitute a conceptual limitation or a more synthetic and complete understanding? To put it another way, is temptation an aberrant or a typical case of desire? Those who regard desire as essentially unrestricted in its mobility would feel that temptation is special and anomalous. But from the ascetic point of view—which I believe is both more satisfying and more profound—desire is inconceivable without resistance. The satisfaction of desire is the death of desire, and a desire instantly satisfied is desire instantly erased and therefore not desire at all. We can only call by the name of desire an impulse whose goal is frustrated, deferred, or displaced. In other words, any desire that is known to us must contain within itself a restriction on its own freedom that operates as a stabilizing force. There is no need to posit a "self" which "chooses" among desire's representations, for the self is only a configuration of desire. But this does not mean that the self is an incoherent and haphazard assemblage of random impulses. To say that the self is a configuration of desire is tantamount to saying that the self is a structure of resistances. To put it another way: the "pleasure principle," in Freud's late formulation, seeks death; while the "reality-principle," which also ultimately seeks pleasure, leads through detours and substitutes, charting a course that marks the life-line itself. Under the reality principle, life on earth is ascetic: a deferred, deflected, and complicated gratification. Indeed, as a perfectly effective pleasure

principle would produce instant death, this deferral-deflection is a criterion of reality, and even, paradoxically, of pleasure itself. What we call the pleasure in desire's gratification is actually the pleasure in desire's resistance.[6] Concentrating on the resistance to temptation, asceticism does not prescribe the imposition on desire of an alien and external system of restrictions, but rather simply describes a rigorous realization of elements intrinsic to the economy of desire itself.

In *Love in the Western World*, Denis de Rougemont spoke of "desiring the obstacle." In a similar spirit, René Girard speaks in *Deceit, Desire and the Novel* of "desiring the mediator." But both theories treat such desires as peculiarities, perversions, or special cases. In Girard's argument, for example, mediated or "triangulated" desire is compared to a norm of "simple" desire, from which it is a deviation. But simple desire, like the pleasure principle, is purely theoretical. Life on earth bears witness to no simple desire, but bears constant witness to a desire in which resistance is embedded as an internal structuring principle. An apt analogy might be the "resistance" that constitutes the electrical circuit. Resistance, we might say, is what prevents desire from moving at the speed of light and enables it to do work.

And with work comes profit. Asceticism foregrounds the disequilibrium of desire, its way of searching after a gratification it deflects, defers, or avoids; and it systematizes the "profit" found in the avoidance. Profit is not a mere by-product of resistance, but the goal and even the enabling metaphor of asceticism in all its forms. This metaphor informs the very earliest conceptualizations of asceticism, but is stressed particularly in ascetic economics. According to Weber, capitalism produces profit by a "limitation of consumption . . . combined with [a] release of acquisitive activity" (172). Profit results from the resistance to the temptation to attach oneself to objects, to read oneself allegorically into the world, to commodify desire. Especially in the suggestive mode of "liquidity," profit is a reward for a resistance to form.

One way to achieve this resistance is through money, which represents a conceptual and even spiritual advance on barter economies in that it keeps profit abstract and preserves desire in a state of frustrated potential. Money is a crucial ascetic invention, concentrating all the torsions of the entire program in a single complex form. Maintaining the fluid potentiality of desire, money is a species of nonconsumption, a resistance to the temptation of objectification and attachment to the world; money is the form of profit. And yet money is also a form of consumption, an assent to the world, even a kind of purified worldliness in the sense in which Sartre speaks of the pure materiality of the world

of desire. Money seems almost to resist and assent to itself, to enact an ascetic struggle even without the participation of a human subject. From this point of view, money is in a restless, dynamic, kinetic condition which never achieves stability although it represents a striving. Indeed, as Marx showed in the *Manifesto*, perpetual change is not some alien rhythm within capital, but constitutes the "permanent revolution" of capitalist production itself. Earlier, I argued that as both form and formlessness were temptations, resistances on one level were always assents on another. Money is a perfect and comprehensive figure for this paradox.

A good definition of money is "something everybody else has and I must get . . . power in itself" (Michaels, *"Sister Carrie's* Popular Economy" 388). This definition of money as the desire for money suggests that money is just a word for desire itself. But it would be more precise to say that money is desire-as-temptation. The essence of asceticism, it is worldly *différance*: in its incorporeal phase it is different from objects of desire; while in its libidinal phase it is a substitute for them and a deferral of their possession. Expressing *différance*, the law of desire, so utterly, money is far more desirable than any object could be. The aberrant psychology of the miser does not pervert the spirit of money, but, in its knotted self-cancellation, constitutes money's fullest appreciation.[7]

In the words of the narrator of Huysmans's *Là-bas*, money "defiled the clean, debauched the chaste, and, acting simultaneously on the body and the soul, it insinuated into its possessor a base selfishness, an ignoble pride; it suggested that he spend for himself alone; it made the humble man a boor, the generous man a skinflint." But it "reached its real height of monstrosity when, concealing its identity under an assumed name, it entitled itself capital. Then its action was not limited to individual incitation to theft and murder but extended to the entire human race" (18). According to Weber, the capitalist resists the allure of money by making it abstract, purging it of its corporeality through reinvestment, a strategy that fosters, in Weber's words, "an amazingly good, we may even say a pharasaically good, conscience in the acquisition of money" (176). Transforming money into capital, reinvestment accomplishes the task of limiting consumption; but in detaching money from the "brakes" provided by any correspondence to the world of objects, it also enables money to grow, as it were, at its own pace. And so it brings temptation even into the heart of abstraction.

It appears that no abstraction can be abstract enough. Weber, the anti-ascetic, regarded reinvestment as a perversion, and identified consumption with "the spontaneous enjoyment of life." His contem-

porary Thorstein Veblen also held that profit was the locus of tempta-
tion, a violation of the state of nature; but for him, nature was not to
be found in consumption, but in continuous work to maintain a
subsistence-level existence. For Veblen, surplus value harbored the
temptation to conspicuous consumption, the genesis of a nonproduc-
tive leisure class (35–67). Whether work is innocence and consumption
sin, as for Veblen, or vice versa, as for Weber, it is the middle term,
profit, that leads from one to the other and so serves as the focus of
temptation. For Veblen's leisure class, "excess" goods not immediately
necessary for existence had become incorporated as profit (money),
which had ultimately generated a self-sustaining and expanding econ-
omy that had no further need for labor: the money did all the work. For
Weber's capitalists, "excess" labor had also incorporated itself as profit,
generating a self-sustaining and expanding economy. But Weber's
economy had no need for consumption, for the money absorbed all
consumption into itself. Weber and Veblen are resolutely opposed in
their values, and appear to describe altogether different systems. But
their differences are as nothing compared to the fact that both articulate
a theological economics involving a violated state of nature, and
prescribe an ethical economics based on resistance to temptation.
Weber describes the temptation to abstraction, and Veblen the temp-
tation to commodification. Together, they testify not only to an
inescapable ascetics of economics, but also to the equally inescapable
economics of asceticism.

The dependence of ethics on the notion of temptation creates, as we
have seen, certain problems, especially in separating resistance from
assent. These difficulties might seem crippling to a system of prescrip-
tions and prohibitions that seeks clarity, and in one sense they are. But
in another sense they are essential to the system, for they reflect a
profound intuition concerning evil. Paul Ricoeur describes the shape of
this intuition in the thought of Augustine, in which it is crystallized.
Ricoeur positions Augustine between the Manicheans, who held that
sin was the involuntary movement of an already perverted will, and the
Pelagians, for whom sin was a mere imitation of Adam by the entire
human succession. Negotiating between these two positions, Au-
gustine developed a concept of sin that included the juridical category
of voluntary, punishable crime and the biological category of inherited
guilt. His compromise produced the idea of a "natural guilt, inherited
from the first man, effective as an act and, as a crime, punishable." The
very logical inconsistency of this idea keeps the mind from grasping it
all at once and enables the transmission of "dark analogical riches" that

include a sense of (1) the *"realism"* of sin in a "wandering course of being"; (2) a communal, transbiological and transhistorical solidarity of sin; and (3) the power of sin which binds man and holds him captive—sin not as a veering but as a fundamental impotence, sin as passivity, as "misery" ("Original Sin" 282–83). Sin is a submission to an evil which, as Ricoeur defines it, is "a kind of involuntariness at the very heart of the voluntary, no longer facing the voluntary but within the voluntary; and it is this which is the servile will" (286).[8]

The analogical riches of sin are concentrated in temptation, which is that part of sin that resists direct description. It resists it, and yet attracts it. We can comprehend something like an emergent institutional strategy of description by examining the implications of three commonplaces of asceticism.

1. Man's life on earth is a temptation (Job 7:1; Vulgate). This statement exactly preserves both the juridical and the biological. It implies that evil is constantly around us and is embedded in the very condition of human life, and also that evil has not yet been committed. Arresting the movement of evil from the biological to the juridical, the circumambient to the defined, this simple sentence at once separates the two forms and unites them. It reinforces both resignation and exertion. It suggests that resistance is a constant necessity, and that resistance is impotent to overcome the evil. And it implies that the idea of a final resistance within human life must itself be resisted. It affirms that there is no refuge from the danger, but that the danger has not yet become damage.

2. Lead us not into temptation (Matt. 6:13). This sentence seems to affirm that there is a refuge from the danger, for temptation is not constant but intermittent; one can be "out" of it. It suggests, moreover, that temptation is a form of punishment and that if God heeds our prayers we will not be tempted. This juridical or "Pelagian" element in temptation is reinforced by phrases such as "the hour of temptation," "the time of trial," and so forth. The wish not to be led into temptation implies a resistance not to the specific temptation, but to the experience of temptation itself, and a denial of the fact that man's life on earth is a temptation. Acknowledging an obscurity in the Lord's command that we pray not to enter into temptation, Origen said that "enter into" actually meant "capitulation" or "assent." "Accordingly, let us pray to be delivered from temptation, not that we should not be tempted—which is impossible, especially for those *on earth*—but that we may not yield when we are tempted. He who yields to temptation enters, I believe, into temptation because he is entangled in its nets" ("Prayer" 29.9: 117). The concept of temptation itself recovers the juridical from

an otherwise omnipresent state of sin by discovering an early phase of sin before sin has been committed. Origen recovers the biological from an otherwise strictly juridical conception of temptation by discovering an early phase of temptation in which we are in it without knowing it.

3. The greatest temptation is not to feel temptation (Gerard the Great, Maximus the Confessor, Thomas à Kempis, and others). Precisely at the moment one feels out of temptation, one is most securely entangled in it. If the first sentence says there is no refuge from the danger, and the second says there may be a refuge from the danger, the third insists that the refuges are the greatest dangers. The essence of evil is, as Kant said, imposture and bad faith. We must, therefore, distrust whatever we know simply because we know it. Beneath every temptation lies the temptation to consider it no temptation, no test of resistance. What made Job's trial so trying was that he didn't know it *was* a trial: for a time, Kierkegaard says, "every explanation was still possible" (*Repetition* 115). Origen considers the dangerous phase of temptation to follow on the failure of resistance, in transgression; according to this sentence, the greatest danger threatens before we know resistance is necessary, so that by the time we resist we have already transgressed.

The cumulative meaning of all three is not reducible to any single utterance that makes ethical or even logical sense. But taken all together they enforce a sense of the complexity of ethical issues arising in the interplay between what we can know and do something about and what we can't. Expressing the reciprocity between the biological and the juridical aspects of sin, the rhetoric of temptation describes the ethical world with the same compact and resonant efficiency that "inertia" describes the physical world. Inertia means both that objects at rest (such as prohibitions) tend to stay at rest, and that objects in motion (such as impulses, drives, instincts) tend to stay in motion. Combining this double principle into an indissolubly single concept, inertia is to matter what temptation is to ethics.

Resistance is neither static nor unencumbered; it is directed movement. In its juridical sense, temptation is *before*, and motivates a sequence, an *after*. But in its biological sense, temptation is *within*, and negates sequence, supplementing the movement of progress with a principle of nonmovement. Here again, asceticism provides a paradoxical formulation of a normative situation, for the fullest expression of this aspect of man's life on earth is, as the next chapter will argue, nothing less than narrative itself.

Narrative on Trial 4

End and goal.—Not every end is the goal. The end
of a melody is not its goal; and yet: as long as the
melody has not reached its end, it also hasn't
reached its goal. A parable.

Nietzsche, *The Wanderer and His Shadow*, no. 204

*M*ost accounts of the history of Western narrative forms grant a
seminal position to the genre of hagiography inaugurated
and epitomized by *The Life of Anthony*. As Herbert Schneidau says, our
dominant narrative paradigm "goes far back in history, linking saints'
legends, allegorized individual lives like *Pilgrim's Progress*, 'spiritual
autobiography' as in Defoe's work, and the novel *per se*" (183). What is
it about asceticism and narrative that makes them so congenial? Why
would asceticism, with its ideal of deathly stillness, issue so naturally in
narrative, which has since Lessing been considered the art of tempo-
rality? And why does narrative find such fertile soil in tales of tempted
hermits living in the desert? Do these tales stand—as temptation to
choice—both before and within the novel? If so, then does asceticism
constitute a dormant, and overwhelmingly patriarchal, ideology of the
novel? And what relationship does the marginal and fanatic ethical
program of early Christian asceticism bear to narrative, which Roland
Barthes describes as "simply there like life itself . . . international,
transhistorical, transcultural"; and which Fredric Jameson characterizes
as "the central function or *instance* of the human mind"? (Barthes,
"Structural Analysis of Narratives" 79; Jameson, *Political Unconscious*
13.)

Before these questions can be answered we have to determine what
are the specifically narrative features in a saint's life. I will begin with a
hypothesis: that the affinity between asceticism and narrative lies in
their common interest and investment in temptation. The case to be

made here will not concern asceticism but narrative, which is not commonly considered a discourse of temptation. It is, however, frequently characterized as a discourse of order, regulation, normalization, coherence, and totalization, and with these crucial functions we may begin. We find in Hegel's introduction to his *Philosophy of History* the view that historical narrative is the record of the state. While the subjects of annals, family chronicles, and other nonnarrative forms generally do not labor under a constant and overarching consciousness of the regulatory mechanisms of the state, the subjects of historical narrative are never free or far from the Law. "Only in a State cognizant of Laws," Hegel writes, "can distinct transactions take place, accompanied by such a clear consciousness of them as supplies the ability and suggests the necessity of an enduring record" (61). Narrative needs the Law, which drives the documentary impulse and determines not only what is narratable but the form of narrative "transactions" and events. Hegelian narrative arises in the confrontation or conflict between the Law and the impermanence, fluidity, and formal indifference of human life.

If narrative requires a principle of obligation, then it is not merely a coincidence but a structural necessity that many characters in narrative are faced with a choice, a conflict, a decision, or a trial of some sort. Theoreticians as diverse as Aristotle, Greimas, and Bakhtin regard such trials as crucial to the determination of character and to the structuring of plot. Greimas classifies the characters or "actants" of narrative according to their participation in three main semantic axes—communication, desire or quest, and ordeal. The preceding sections of this book may be taken to show how asceticism provides a context in which these three axes are unified into one, which it calls trial or temptation. For the ascetic, ordeal is the heart or core of desire, and centers on the issue of communication, either written or spoken, either "horizontal" with other people or "vertical" with God. Bakhtin argues that narrative is defined by precisely such a definition of trial. The testing of the hero, Bakhtin writes, consists of "testing his discourse," a process that "may very well be the most fundamental organizing idea in the novel, one that radically distinguishes it from the epic." While the epic hero stands "on the other side of trial," the novelistic hero is always a person about whom there are doubts. In general, the idea of trial

> permits a complex organization of diverse novelistic material around the hero. But the very content of the idea of trial may change fundamentally in different eras and among different social groups. In the Sophistic novel this idea . . . is expressed in a manner that is crudely formalistic and external (a

psychological or ethical dimension is utterly lacking). This idea underwent a change in early Christian legend, saints' lives, and confessional autobiographies, where it was usually united with the idea of crisis and rebirth (these are embryonic forms of the adventure-*cum*-confession novel of trial). The organizing idea of trial was given specific content in the enormous hagiographic literature of early Christians, and later in medieval lives, on the one hand by the Christian idea of martyrdom (trial by suffering and death) and on the other by the idea of temptation (trial by seduction).

As the history of narrative proceeds, the idea of trial preserves its "overwhelming organizational significance" (*Dialogic Imagination* 388–89).

As Bakhtin acknowledges, the idea of trial acquired a sudden depth with hagiography, whose subject was the vagrant secrets of the will, the hidden weaknesses of the character. For the ascetic, temptation revealed and exploited an irreducible division in the self. But a certain kind of psychology doubles for a certain tension in the narrative of a saint's life, a tension that has other sources than character and circumstance; and it is these I would like to consider first. For example, temptation virtually constitutes the scene of action itself in most hagiographical texts. The desert to which the ascetic is called is a complex geography, a binary grammar of temptation. Under one aspect the desert is a scene of primal rectitude in which man and beast exist without disharmony.[1] The Edenic desert awaits human defilement: it does not encourage or promote defilement, but it does not resist it either. It provides a passive stage for an act of transgression. But in an equally accepted trope the desert is the allotted domain of demons. As such the desert brings sin to man, so that the human act of transgression consists of a passivity, an accession to the prevailing environmental evil. The ambivalence of the desert reflects the ambivalence of the will in transgression, which Ricoeur described as an involuntariness occurring in the heart of the voluntary. It is precisely such an analogy between scene and psychology that has become enshrined in narrative as the interplay between "character" and "circumstance" as determining factors in plot.

Even subtler forms of temptation inhere in language itself. Many of these can be approached through the following passage, Anthony's description of the ascetic task to his assembled disciples:

> Having therefore made a beginning, and set out already on the way of virtue, let us press forward to what lies ahead. And let none turn back as Lot's wife did, especially since the Lord said, *No one who puts his hand to the plow and turns back is fit for the Kingdom of heaven.* Now "turning back" is

nothing except feeling regret and once more thinking about things of the world. . . . All virtue needs, then, is our willing, since it is in us, and arises from us. For virtue exists when the soul maintains its intellectual part according to nature. It holds fast according to nature when it remains as it was made—and it was made beautiful and perfectly straight. . . . So the task is not difficult, for if we remain as we were made, we are in virtue, but if we turn our thoughts toward contemptible things, we are condemned as evil. If the task depended on something external that must be procured, it would be truly difficult, but since the matter centers in us, let us protect ourselves from sordid ideas, and, since we have received it as a trust, let us preserve the soul for the Lord, so that he may recognize his work as being just the same as he made it. (20: 46–47)

Couched in metaphors of the path, of returning borrowed objects undamaged, and of sticking to the plow, the entire passage implies that the "way of virtue" merely systematizes common sense. It bespeaks its own reasonableness and epitomizes what many commentators have described as the "moderation" or "sweetness" of Anthony's asceticism.

Sweet it may be; clear, however, it is not. Remaining as we were, we must press forward to an unprecedented condition. Or, as Anthony says on other occasions, we must live "as one always establishing a beginning" (7: 37) by "dying daily" (19: 45). In ascetical time the present is the only time that counts, but it counts only insofar as it is not the present, only in that it connects those times out of time, the beginning, when we received our souls, and the end, when we give them back.

Later I will discuss the complex temporal structure of this passage; for the time being I wish to concentrate on its figurality. The entire passage is as independent of literal meaning as the ascetic himself is from the world of time. But for vague invocations of "sordid ideas" and "contemptible things," the passage performs a perfect ascesis of referentiality, so that the act referred to by this call to action is left obscure. Moreover, it sustains this resistance to literalism and to the world literalism betokens by doublecrossing itself: in Anthony's discourse, the goals of stasis and dispossession are accommodated to a rhetoric of "advance," "profit," and "discipline" without contradiction in a way that literalism could never achieve.

Anthony's speech does not provide a reliable guide to action but it does give us insight into the way in which ascetic discourse manages the world through a figurality that speaks to the "inner self." We may recall how Jerome's formula, "Desire is quenched by desire," offers a rhetorical and figural substitute for the gratifications of the senses that the ascetic denies himself. Such a strategy permits the entry of desire, even of lust and wantonness, into the arena of denial that constitutes the

official program of asceticism. By the same means, Athanasius, record-
ing Anthony's heroic flight from the world, reclaims the world very
nearly on its own terms when he notes Anthony's reminder that
"Everything in the world is sold for what it is worth, and someone
trades an item for its equivalent. But the promise of eternal life is
purchased for very little." Having renounced possessions, Anthony's
disciples can still recognize a bargain: although "we live . . . eighty
years, or even a hundred in the discipline, these hundred are not equal
to the years we shall reign, for instead of a hundred we shall reign
forever and ever" (16:43–44). Anthony even explains the afterlife as a
matter of owning versus renting: "Let none among us have even the
yearning to possess. For what benefit is there in possessing these things
that we do not take with us? Why not rather own those things that we
are able to take away with us—such things as prudence, justice,
temperance . . ." (17: 44).[2] In such rhetoric, the excluded world makes
a triumphantly innocent appearance through a figurality that condemns
it only to recover it, essentialize it, and wash it clean of its worldliness.
Ascetic figures immunize the speaker against any seeming affinity with
the world that governs his discourse. Through figural negation the
world is both displayed and disowned, held up to a fascinated and
nostalgic gaze that insists on denying its own interest.

In figurality ascetic writers discovered an element in language that
enabled them to recover and, in a sense, control the world they had
renounced. This element, which we may broadly call substitution, is
implicit in the idea of language itself, but is explicit in tropes, and
therefore operates at high intensity in literary language, which Monroe
Beardsley characterized as being "distinctly above the norm in ratio of
implicit (or, I would say rhetorical) to explicit meaning" (37). It is not
only meaning that lies implicit in tropes, or in literary language; it is
also, and perhaps most conspicuously, the referent, which ascetics call
"the world." Tropes operate in the mode of negation: they admit the
world of discourse, but deny it as their own. Literary language is ascetic
in that it tends to repress the world, inclining towards what Roland
Barthes calls a "Utopia of language," a self-sufficient universe of
discourse.[3] An ascetic artist such as Flaubert can even dream of a novel
so utopian that it would be "about nothing," drawing its being not
from any referent but entirely from the resources of language itself.
Figurality, in sum, is the money of language, enabling an abstract and
distanced appropriation of the world, a representation that can even
appear altogether unworldly.

And, like money, figurality distills the element of temptation—
double temptation, and double resistance—in the economy of lan-

guage. Pagan tropes were always considered by ascetic writers as temptations ("Egyptian gold") because their ornamentation and embellishment were semiotically superfluous, not part of the meaning but supplemental to it, representing a principle of worldly excess and sensory gratification in language. Anthony's spare, plain, and homely language resists the temptation to ornamentation but in so doing assents to another form of worldliness. Attempting to renounce literal meaning and reference, Anthony's figures do not dissolve into signless knowledge, but actually draw attention to themselves as objects of contemplation, and therefore belonging to the world of referents. Leaving the world and constituting it, playing both ends of a struggle that can never be concluded, language is an exemplary temptation.

With its codes, conventions, and precedents, literary language presents a trial, especially for the artist who attempts "free composition" or originality. According to Barthes,

> Every writer opens within himself the trial of literature, but if he condemns it, he always grants it a reprieve which literature turns to use in order to reconquer him. However hard he tries to create a free language, it comes back to him fabricated, for luxury is never innocent: and it is this stale language, closed by the immense pressure of all the men who do not speak it, which he must continue to use. (*Writing Degree Zero* 87)

In the "trial of literature," each element, freedom and fabrication, the invented and the inherited, offers a temptation the other denies; and a resistance to one is an assent to the other. In his "Introduction to the Structural Analysis of Narratives," Barthes even locates the specific site of temptation in narrative in the relation between the powerful code of language, whose "farthest point of combinatorial freedom" is achieved in the sentence, and the equally powerful code of narrative action, which forms a "strong and restricted code." Caught between these codes, the "freedom of narrative" is "literally *hemmed in*" (123).

Hagiography suffers the trial of literature with special intensity because of its intimate relation with the inherited text of Scripture, which it constantly cites, weaving it into the new composition. By this method of constant citation the hagiographical work is made to appear as a fulfillment, a completion, a confirmation, an instance of the eternal truth of the Biblical story, so that the sacred original serves as the "soul" or essence of the historical derivation. We may even speculate that the proper reading of the hagiographical text is as a figure for Scripture, so that all the events narrated by Athanasius, for example, have a literal, that is, historical unique referent as well as a metaphorical or Scriptural referent.

Asceticism is dominated by what might be called the ethics of legibility. The imperative to imitate Christ dictated either a paring-down of the self to the essential core, the Christ-within, or an elevation of the self to the majesty of the Lord. In this context, "cenobite" indicates a humbling of subjectivity to the Word, reading as a way of life; while "eremite" defines the ambition of becoming an imitation of oneself and a model for others, or representability as a way of life. It is the latter class that interests us here. What *The Life of Anthony* discovered and promoted was that the truest self of a man, his divine essence, was recuperable in his biography, which redeemed a contingent, sequential life on earth by representing it as an imitation, placing it in the line begun in the Gospels. Hagiography documents a class of people trying to achieve complete narratability, trying to become dead to the world, and recuperable only through textuality. At the same time that one sought to become textual, however, one had to live in order to *have* a biography: hence "temptation."

Scriptural precedent legislates which actions in a human life or a historical narrative may be considered advances and which may not. Advances are those acts that may be described in Scriptural language, preferably of course Gospel language. Regressions are those which require writerly "freedom," as Barthes puts it—those which require new language. A resistance in the form of frequent Scriptural citation drains contingency from life, leaving only the archetypal. But such a purification, however desirable, can never be completed because of the doubleness of all temptation, which here takes this form: (1) the temptation to wander into the unprecedented and unmotivated, to express the personal and historically unique self at the expense of the grace of God within; and (2) the temptation simply to collapse into mere citation of Scripture, easing the alienation of humanity by forgetting it, so that Scripture accomplishes no work in the human world, yielding no profit. The only proper reading is one in which the historical and archetypal, the literal and metaphorical, are suspended in mutual resistance.[4]

At every level the ascetical narrative text is in a situation of denial-and-assent, so that not only Anthony but the text itself is suspended on the point of temptation, the point explicitly thematized as the essence of "man's life on earth." Indeed, the words of Job may be modified to read: man's *narratable* life on earth is a temptation.

Theoreticians of narrative bear fitful but definite witness to this proposition by constructing models of narrative that reflect the dynamics of temptation. It appears to be almost impossible to think about narrative without positing a logical order or structural principle that is

at once "external" to the narrated events and profoundly "internal" to them, providing their motivation, form, intelligibility, or meaning. Such conceptions are not the exclusive property of traditionalists or formalists. Even Bakhtin, who polemicizes against formalism and all transcendental structures, speaks of meaning as a centering force that operates centripetally in all narratives, in opposition to the centrifugal and social forces of heteroglossia (*Dialogic Imagination* 270–75). Jonathan Culler describes narrative's double logic less dramatically but more efficiently. Narrative, he argues, is comprised of two forces, one which "assumes the primacy of events," while the other "treats the events as the products of meaning." For Culler, the discontinuity between "events" and "meaning" enables narratology even as it renders it—and narratives—incoherent, overdetermined by conflicting "logics" between which the reader is continually switching ("Story and Discourse in the Analysis of Narrative" 171). Unable to renounce either, the stressed reader must negotiate both logics, aware that a resistance to one is an assent to the other. Especially while reading, the reader must accede to the logic of events, but powerful forces operate on behalf of the emergent meaning produced by the logical or pseudo-spatial pattern of plot, which Aristotle describes as the "life and soul" of tragedy and E. M. Forster describes more generally as the "soul of narrative."

Though they try to be antitranscendental, both formalism and structuralism rely on some specification of this "soul" in their accounts of narrative. For them, however, the soul lies not in the plot but in the "story," an implied prenarrative chronological ordering of events. Structural narratology descends from Saussure's founding distinction between *langue* and *parole*, the system of relations that enables communication and the actual performance of communicative acts. Applied to narrative, such a distinction separates the system or underlying form of a narrative from its "surface" or actual appearance as it is read. The Russian Formalists distinguished between *fabula* and *syuzhet*, a distinction that reappears with modifications in the influential work of Emile Benveniste and Tzvetan Todorov as story (*histoire*, *deigesis*) and discourse.[5] This distinction, highly elaborated, also informs the narratology of Gérard Genette, and, with a few differences, of Seymour Chatman. Chatman's *Story and Discourse* yields the following pithy description of the founding opposition of narratology:

> Each narrative has two parts: a story (*histoire*), the content or chain of events (actions, happenings), plus what may be called the existents

(characters, items of setting), and a discourse (*discours*), that is, the expression, the means by which the content is communicated. In simple terms, the story is the *what* in the narrative that is depicted, discourse the *how*(21)

For Chatman and other narratologists, the story is a kind of wave that requires a medium to flow through, to be incarnated, and especially to be meaningful, but which has an essential life of its own, moving without fundamental distortion through any medium, any telling, any contingent arrangement.

But the most profound test of narrative discourse lies in the ways in which it integrates the logical relations that secure meaning with the temporal sequence that qualifies the narrative to be a representation of life and make the meaning worth having. Here again the theological meditation on temptation provides a rudimentary but suggestive model for narrative's strategies. One curiously consistent feature of theological discussions of temptation is the way in which questions of time and space are raised together. Recognizing that temptation raises the issue of the boundaries of the subject—*where* is evil?—Thomas Aquinas, for example, considers first whether temptation is inside or outside of the self. As a way of preserving the innocence of the untempted subject, he decides that it must be outside, as a property of some object or external agency. But then he is forced to consider the sequence by which temptation makes its way inside by degrees of assent, and concludes that temptation may be resisted if it is caught at the beginning. The analysis of structure is complemented by one of sequence, so that the tempted subject is implicated in time and space.[6]

In general, structuralist narratology, especially as practiced in France, is not content merely to distinguish between the temporal and the structural, between "event" and "meaning"; it systematically favors the latter, treating it as the essence, goal, and point of narrative itself. As Barthes puts it in "Introduction to the Structural Analysis of Narratives," narratives consist of a pyramid of logical relations that lead up from "functions" and "indices" to "actions" and finally to "narration": "To understand a narrative is not merely to follow the unfolding of the story, it is also to recognize its construction in 'storeys,' to project the horizontal concatenations of the narrative 'thread' on to an implicitly vertical axis" (87). Without such a projection there is no narrative, for the "thread" of the narrative line is, by itself, incapable of signification because unable to achieve closure or to cap the pyramid. The horizontal, which is doubled in the reading act, can be formed, but cannot form itself; this responsibility falls to the vertical axis, a principle of atempo-

rality, abstraction, and rationality that emerges most forcefully at the end when the reader gathers the narrative into "spatial form" in a kind of "memorial synthesis" or last judgment.[7] In a typical structuralist approbation of the atemporal, Barthes says that "from the point of view of narrative, times does not exist." Instead, "narrative and language know only a semiotic time" freed from the referential or realist illusions of "real" time (99).[8]

Genette, who prefers the slightly more kinetic term "pseudo-time" to describe narrative's temporality, rightly calls Barthes's structuralism an "ascesis" which "stops the vertigo of meaning," threatened by the horizontal, the merely differential drift of signs ("The Obverse of Signs" 38). Structuralism is a discipline designed to isolate and liberate the soul of narrative. But it does not do full justice to the narrative ascesis, for it systematically succumbs to the temptation of metaphysics, the temptation of "pride" in feeling the vertical immune from the meanderings of temporality, or the story from the contingencies of discourse. Even Genette's pseudo-time minimizes the ways in which narrative is based on meanings deferred, delayed, and extended; and it ignores the inevitable and necessary effects of a prolonged and interrupted reading experience, with intervals of worldly time alternating with sessions of narrative engagement. Based on the triumphant vertical, structuralism is willing to wrestle with resistance only if the match is rigged.

But what is the alternative? Is there any way to account for narrative that is not rigged in favor of the vertical? Recently, Barbara Herrnstein Smith has tried, arguing in response to Chatman and others who assume that a "deep structure" always lies behind a narrative's "surface manifestations." Smith sees in the idea of deep structure a "lingering strain of naive Platonism . . . which is both logically dubious and methodologically distracting" ("Narrative Versions" 209). She proposes instead a unitary model that has less in common with narratology than with speech act theory and ordinary language philosophy. In her view, stories can be genetically, rather than ontologically, defined as modes of behavior appropriate to given people in given circumstances, and should not be "marked off or segregated from other discourse . . . it is questionable if we can draw any logically rigorous distinction between them or, more generally, if any absolute distinction can be drawn between narrative discourse and any other form of verbal behavior" (228).

At a stroke, Smith has removed the rigor both from the internal distinction between surface and deep structure, and from the external distinction between narrative and other modes of discourse. For Smith, narrative falls in line with other kinds of social and symbolic behavior,

and can lay claim to no special or peculiar modes, no privileged "logics," no distinctive vertical-horizontal torque. But this kind of pragmatics cannot, and indeed does not even try to, account for narrative form. Moreover, while it is illuminating chiefly with respect to speech and social encounters, Smith's anti-narratology simply does not have much to say about written narratives, in which information about the social determinants of the author-audience relation is either minimal, indeterminate, or irrelevant. If narrative is just one more thing that people do, if it is defined simply by its situation ("someone telling someone else that something happened," as Smith suggests), then there is indeed no way to distinguish narrative from any other kind of verbal action; but that means that the term narrative no longer describes anything and should be gotten rid of, and this very nearly seems to be Smith's intention. Smith's attack, in other words, is not merely on narratology, but on the entire notion of narrative as academics have defined it.

Chatman's response to this article concludes with a defense of the "logical rigor" enabled by the analysis of deep structure. He defends, in other words, the structuralist ascesis of time in favor of logic. But while structuralist dualism does focus usefully and necessarily on the question of form, it is itself suspect on the question of rigor because the distinction it draws is absolute: the surface manifestation is "at the service of the deep structure" in a master-slave relation that implies domination but not true rigor. Structuralism, in other words, is not rigorous enough because it is so perfectly dualistic. What is needed is a conception of narrative form that locates it intrinsically in the temporality of events, some more intimate relation between forces, dimensions, or logics. We need, ideally, a model of form that could simultaneously account for narrative's thematic predisposition towards tales of trial and resistance.

Perhaps the story-discourse relation is the wrong place to look. Another approach would be to consider the relation between the force of closure and the resistance to that force that occupies the entire narrative until the conclusion. Such an approach would embrace both the logic and the temporality of narrative form by representing closure both as the end of a quest and the ultimate cap of the Barthesian pyramid. D. A. Miller has developed such a method in *Narrative and Its Discontents*, in which he identifies a tension, or "discontent" obtaining between what he calls "narratability" and closure, the means and end of narrative. According to Miller, the narratable consists of "the instances of disequilibrium, suspense, and general insufficiency from which a given narrative appears to arise. The term is meant to cover the various

incitements to narrative, as well as the dynamic ensuing from such incitements, and it is thus opposed to the 'nonnarratable' state of quiescence assumed by a novel before the beginning and supposedly recovered by it at the end" (ix). Miller's closure is an alien death-force, the law or limit of a constantly transgressing energy which, until the end, more or less successfully defies it by "continually wandering in a suggestible state of mediation," a state that opposes a full and settled meaning. "Whether in its erotic or semiotic dimension, the narratable inherently lacks finality" (xi).

Miller's thesis yields some striking results when applied to *The Life of Anthony*, which is chiefly concerned with demons. As the resistance through which the ascetic must work his way to perfection, demons are conspicuously exempt from the closural force of a saint's life. It is the business of demons to resist closure and containment in any form: they are not bound by the limits of mortal time and exist in a state of such constant metamorphosis that they can scarcely be called by the same name twice. "Everything they do," Anthony says, "—they talk, they cause mass confusion, they pretend to be others than themselves, and they create disturbances—all this is for the deception of the simple" (26: 51). The very word "demon" seems a futile gesture of containment, a hopeful attempt to circumscribe them in a single term. Demons appear, in short, to exemplify incompleteness and ambivalence, and thus to condense the energies of the narratable.[9]

But this is not the whole story of demons, about whom even scholars are ambivalent. Peter Brown says in one book that the Late Roman Empire witnessed "the definitive splitting-off of the demons as active forces of evil against whom men had to pit themselves" (*The World of Late Antiquity* 53). But in another he concedes that "The demonic stood not merely for all that was hostile *to* man; the demons summed up all that was anomalous and incomplete *in* man" (*The Making of Late Antiquity* 90). Brown's waffling reflects an ambivalence deeply felt by early Christians about the role and position of the demons, a doubleness that correlates with Miller's view of the two forces of narrative. Even in *The Life of Anthony* a fierce dispute rages concerning the relation between demons and humans, and the evidence seems equally balanced on both sides. The demons are an independent realm, swarming in the air between the earth and moon. But they are also uncannily intimate with the human condition. We are told that "their actions correspond to the condition in which they find us; they pattern their phantasms after our thoughts" (42: 63); and Satan confesses to Anthony that "I am not the one tormenting them, but they disturb themselves" (41: 62). Maximus the Confessor said that during

temptation "the soul begins to see the demons warring against it through its own thoughts" (*The Ascetic Life* 18: 113). More sophisticated, Augustine considered the demons not at all; for him, temptation consisted in an otherness within the self, and thoughts were the true temptations.

Assimilating the discourse of asceticism to the discourse of narrative theory, we can say that insofar as a demon is identifiable as a demon, and external to the self, it represents the force of the nonnarratable that is "present" in the narrative only before or after the action; and insofar as it is internal to the self, it figures the instability of what Miller calls the narratable. But the real point about demons is that they are in both places, and this fact has consequences for narrative. The temptation to which Miller succumbs is to regard the two dimensions of narrative as oppositional rather than relational. But the ontology of demons indicates that closure and narratability are grounded in each other. "Demon" is the name of this grounding; and the demons indicate that Miller's somewhat "carnivalesque" assertion that there is anything at all in narrative that lacks finality, that does not intimate closure, that has no "verticality," is misguided and partial.

In Miller's view, closure is a diminished partner in narrative rather than a necessarily constant presence. I do not mean to suggest that closure is more effective than he thinks, only that the two are more intimately related than he suggests. Actually, Miller comes closer to a more properly ascetical conception of narrative when in a recent article he describes as the "literature-effect" the failure of the decorums of closure to contain or limit the energies of the text. His example is the "failure of closure" in Balzac's novels, in which there is no "principle of arrest," only an "eminently narratable 'exercise of functions.'" What this exercise drills us in, Miller says, are the principles of the nineteenth-century social order, an order which aspires to "the condition of money: to its lack of particularity, to the mobility of its exchange, to its infinitely removed finality" ("Balzac's Illusions Lost and Found " 181).

To see narrative in terms of the dynamics of money is to glimpse an ascetics of narrative which is, I believe, finally the most—the only—adequate way of conceiving the matter. For money, as we saw in the previous section, is the exemplary ascetic invention, a double resistance to materiality and ideality. But Miller's understanding of money is limited—an understandable and forgivable shortcoming in academics—and this limitation is related to his ideas about the narratable. A narrative modeled on money would resist not only closure but unstructured wandering as well; and it would constantly embrace both those principles in a movement of advance figured by the concept of "profit."

Complete closure lies just beyond the reach of narrative, just *after* the last word, because the drive towards closure is itself dynamic and anti-closural; nevertheless, the end is immanent in those means, immanent in the narratable.

In an apparent effort to preserve desire from the imperialism of closure, Bersani has, with Ulysse Dutoit, recently suggested a model that opposes narrativity not to closure but to desire itself. In *The Forms of Violence: Narrative in Assyrian Art and Modern Culture*, they claim that the essence of narrative is the "detemporalized process" paradigmatically figured in a military march, and that narrative systematically suppresses the restless, infinitely mobile, structurally disruptive force of desire in the name of coherence and rationality. Assyrian art, they maintain, offers a model of expression that liberates the "natural tendency to swerve" and the Freudian "primary process" by thwarting the tendency of narrative to gather, cohere, and stabilize.

But is narrative the empire of paralysis Bersani and Dutoit depict, or is it the home of the restlessness and "swerving" portrayed by Miller? Both can't be right. Indeed, neither is, for both are operating with a one-dimensional model of narrative. Narratives do dilate, wander, and digress, as Miller says; but how can this be the essence of the narratable when narrative form is closural? And narratives do hierarchize, subordinate, and immobilize, as Bersani and Dutoit argue; but to claim that this is the essence of narrative is not just to underestimate the forces of horizontal dissemination but to suppress them altogether: it is to blame narrative for structuralism's account of it. Both Miller's and Bersani-Dutoit's versions invoke desire, and the inadequacy of each may reflect an inadequate view of desire, an uncritically quasi-Lacanian conception of an inherently unsatisfied and unsatisfiable impulse, desire as perpetual motion. If we reconceive desire on the model of temptation, as a force seeking permanence, stasis, or perfect repression just as powerfully as it seeks a perfect fantasmatic mobility of impulse, then we can see that both are right, but both taken together: narrative is an ascetical art of desire, an art of temptation—doubled, self-limiting, and self-resisting. The essence of narrative form is also the essence of narrative thematics.

A kind of support for this position comes from some contemporary feminists who see in narrative a weapon of patriarchy, a machine of the "Oedipal" drive for knowledge of the origin and end. Theresa de Lauretis, for example, writes in *Alice Doesn't: Feminism, Semiotics, Cinema* that narrative is indeed an art of desire, but claims that it is engendered by a "masculine, active gaze" which produces narrative point of view—a view, not coincidentally, of the feminine, which is

therefore confined to the specular and masochistic. In "making sense" of the world, narrative "endlessly reconstructs it as a two-character drama in which the human person creates and recreates *himself* out of an abstract or purely symbolic other—the womb, the earth, the grave, the woman; all of which . . . can be interpreted as mere spaces and thought of as 'mutually identical'" (121). The narrative program is, she argues, everywhere determined by masculine desire; the problem for feminism is that narrative has no true opposite, for it is bound to the "secondary process" and constitutes a fundamental condition of signification in which all images, and all languages, are implicated. Still, de Lauretis insists that feminism must find ways to "resist the drift to narrativization," to subvert the forces of cultural-ideological coherence by enacting "the contradiction of female desire," even by announcing "the question of desire as precisely enigma, contradiction, difference not reducible to sameness by the signification of the phallus" (156, 157).

This is a dangerous and self-defeating mistake. The value and suggestiveness of hagiography as model does not lie in an unquestioning promotion of the Oedipal subject (indeed, it *also* describes the anti-Oedipal desire to "kill" the mother and "marry" the Father, to become a "Bride of Christ"). For within its fascinated concentration on the masculine, hagiography focuses on the doubling and self-subversion of the subject, in which it ceaselessly discovers gaps or contradictions of desire. In other words, hagiography both establishes the masculine program and destabilizes it, "feminizing" the subject by exposing its enigmas of desire and even the "masochism" of its rigors. The tempted subject of ascetical literature finds itself in the "feminine" position of specular masochism just as surely as it does in the "masculine" position of active sadism. In a larger sense, narrative's gigantic cultural coherence-machine also serves as an engine for incoherence and carnivalization. The most powerful consequences of the "literature-effect" lie in this simultaneous making and unmaking of coherence and of the subject. Self-subversion cannot be imported to narrative by critics for it is exactly what narrative typically does.

In short, while feminism offers a compelling cultural and interpretive tool, it misconceives its task if it sets itself against narrative, as though narrative and not specific cultural practices were the object of political critique. There is no need for the melancholic tone de Lauretis adopts as she concedes that feminism has only narrative to work with, and that the most "exciting work in cinema and in feminism today is not anti-narrative or anti-Oedipal; quite the opposite. It is narrative and Oedipal with a vengeance" (157). There is room in narrative for everyone, and nobody and no gender is excluded from it. To believe

otherwise is to be needlessly self-consigned to a ghetto of representation. The fact that hagiography's heroes are masculine and its temptations are often female says far more about Christianity and Late Roman culture than it does about narrative, which happily accommodates the opposite. Like the sexes, narrative coherence and incoherence achieve themselves neither in contradiction to each other nor in perfect unanimity, but only in frictional interdependence, only in resistance.

Feminism's challenge to narrative is strongest at the point, or points, of closure. For feminism as for others, closure provides the crisis for narratology today. Not only at the end of narratives, but at certain points achieved by every reader where the narrative progress halts in a knowable configuration, the temporality of narrative seems provisionally neutralized in a coherent structure. Structural narratology was born from the attempt to understand this phenomenon, but its solution was often simply to substitute the structure for the narrative; and feminists and others are right to insist on a "processual" view of narrative, a view that should entail a reassessment both of narrative's effects and of narrative form. Speaking of the latter, Paul Ricoeur has argued forcefully against an "anti-narrative bias" among historiographers, epistemologists, and "structuralist literary critics" who propose a false dichotomy between the "plane of manifestation" and a higher, achronological model or code. In a Heideggerian analysis of "Narrative Time" Ricoeur asserts that nothing in narrative can be divorced either from temporality or from the logical or spatial "configuration" within which events achieve their meaning; and it seems that such a model may at last be capable of describing the ascetics of narrative.

According to Ricoeur, narrative time is repeated time; it is time recuperated by memory and so—whether the narrative is based on real events or not—is already accommodated to a structure that motivates its telling. The discourse, we might say, repeats the story, working it for meaning, making events accessible to evaluation. Driven by what many critics call desire, the telling reflects what Heidegger describes as "care," whose "primary direction" is toward the future. Ricoeur concludes that the present-tense activity of narration is determined by a regard for the past and oriented toward the future; or, as Heidegger puts it, "Saying 'now' is the discursive Articulation of a *making-present* which temporalizes itself in a unity with a retentive awaiting" (*Being and Time* 173).

The difficulty of Heidegger's prose replicates the difficulty of Anthony's discourse, in which he urges his disciples to make perpetual beginnings so as to remain as they were made and advance to what lies ahead. Both conceptual knots address the complexity of narrative time in which the recounted past is made present out of a concern for the

future. At no point in narrative are we ever free from past, present, or future. Our reading of the narrative itself, Ricoeur says, takes the form of a "grasping together" which elicits a configuration from a succession of "nows," a structure from a sequence. What Miller treats as independent kingdoms of instability and the law, Ricoeur treats as "two dimensions in various proportions, one chronological and the other nonchronological" (174). Everything in narrative is doubly determined. As Brooks says, narrative "not only uses but *is* a double logic" ("Reading for the Plot" 29). We cannot switch back and forth between logics, for the logics do not function separately; they are conditioned by each other, suspended in resistance.

This new model is deeply consonant with the oldest model of plot. According to Aristotle, plot moves, through the choices of characters, from a condition of ignorance to a condition of knowledge. This choice is not random but directed by causal necessity or probability, and produces an ending that is implicit in the beginning. Aristotle's model is not only rational and moral, but nearly biological as well: the ending converts a scene of suffering into a scene of pleasure through the purgation of the sources of pity, pain, and terror, a purgation which must be seen as fitting or acceptable because embryonically implicit from the outset. The idea of the implicitness of closure throughout the narrative nicely blends the temporal and the logical: in one sense closure is waiting to be "born," while in another it is always there, driving and determining progress.

The beginning of a narrative might be seen in terms of a configuration of elements whose stability or adequacy has fallen into doubt. Narrative progress consists of an exploration of the potential for movement or change within this initial configuration under the pressure of the question, "What final configuration does this inadequate or provisional configuration conceal?" Narrative explores a reservoir of implicitness within an inaugural condition and drains it dry until a new explicitness, a terminal configuration, stands forth at the end. If the finality or solidity of this terminal condition is itself dubious or uncertain, as it is in many modernist, postmodernist, or feminist works, this fact does not compromise closure or limit its conceptual force; it simply warns us in an exemplary way against the sin of narratological pride by insisting that all closure is fictive with respect to man's life on earth; that all explicitness, especially in literary language, casts a shadow of implicitness; and that human existence is necessarily temporal, contingent, multiple.

Narrative is etymologically linked to "knowledge," and serves as a distinctively human way of knowing, a way linked to temptation, which

"discovers what we are" and reveals "the things that are in our heart." More so than any other representational mode, narrative shows us how to think time and space, sequence and structure, horizontal and vertical together, and to think them in resistance to each other. Narrative itself is a form of knowing logically prior to the distinctions between story and discourse, sequence and structure, which theoreticians have retroactively attributed to narrative. As useful as these distinctions are, they are *properties* of narrative, not neutral instruments with which to analyze narrative. The narratable, we can say at last, is that property inherent in the representation of temporality that presses towards closure, contains closure, produces closure, and yet opposes closure: the narratable resists the closure that resists it.

Hagiography is most originary, in the double sense of being new and fertile, in its cultural function. This function is contained in what Benveniste calls discourse, the implied relation between narrator and audience. Recounting Anthony's imitation of Christ, *The Life of Anthony* reveals that a human life can "repeat" the life of Christ by acquiring form and configuration in narrative. In the Pauline tradition, Christ was himself a "repetition" of Adam; *The Life of Anthony* carries repetition into the human community, showing how the origin of the Incarnation, already a repetition, could be extended into the future.

Ricoeur's theory of narrative time is most darkly illuminating to this account of an ascetics of narrative when it touches the subject of repetition. Following Heidegger, Ricoeur says that repetition enables us to "read time backward, as the recapitulation of the initial conditions of a course of action in its terminal consequences" ("Narrative Time" 179). This is "narrative repetition," which establishes human action in memory. But this repetition is not only regressive; it is also progressive in that it elicits through its drive towards closure a sense of fate or destiny within the time of the narrative. In this way narrative organizes and transforms culture. "It is," Ricoeur writes, "this communal act of repetition, which is at the same time a new founding act and a recommencement of what has already been inaugurated, that 'makes history' and that finally makes it possible to write history. Historiography, in this sense, is nothing more than the passage into writing and then to critical rewriting of this primordial constituting of tradition" (185).

The antiformalist tendency of this insistence on repetition is brought into even sharper focus with Ricoeur's suggestion that the "configuration" of the narrative itself is only completed in the "refiguration" or "transfiguration" of reading. The work of narrative does not

conclude with the closure of emplotment but continues into the reception of the work by the reader. This reception is the always dynamic and ongoing "end" of narrative form—the transcendence and undoing of form in communal understanding and historical action. What does narrative envision in its future? The answer must be, it anticipates its own transformation into communal memory, its own participation in an ongoing world, its own "repetition" in the community of readers who recognize themselves in the narrative. Necessarily, the narrative anticipates the moment when it ceases to be read, when it surrenders and transforms itself in the reader's understanding, a moment in which the reader is himself transcended and transformed. Peter Brooks describes this well when he defines the "desire of the text" as "ultimately the desire for the end, for that recognition which is the moment of the death of the reader in the text" ("Freud's Masterplot" 108). In several senses, this death is the "ideal moment" in the total narrative function, and the point at which the analysis of narrative comes closest to the thematic preoccupations of the ideology of asceticism. Indeed, when Ricoeur reflects on his own discussion of how reader and form "die" together, into each other, he notes "an asceticism in my analysis" (*Time and Narrative* 2: 160).

Hagiography both remembers a man in the world and idealizes that man's life so that it may serve as a model for further imitation. So the cultural situation of hagiography describes on another level the theory of narrative itself. On both levels a communal act of repetition newly founds the community, revealing how a human life can be accommodated to a preexisting pattern, enabling the community to "advance to what lies ahead" through a continually reborn repetition. Asceticism seems to some an ideology of immobility and closure, and to others an ideology of pure desire and volatility; in accommodating both, it is actually an ideology of narrative, and the narratives it produces are action in Hannah Arendt's purest sense, action oriented towards its own recounting. Athanasius stresses the fact that Anthony achieved fame "on account of religion alone" (93: 98), his religion being most clearly evident in his ability to resist temptation, the quintessentially narratable act. In resolving all of human life into temptation, asceticism "narrativizes" it, insisting that every moment of existence has a vertical dimension, both containing closure and resisting it. If it is true, as I suggested at the beginning of the last chapter, that narrative is the ascetical form of discourse, it is equally true that asceticism is the ideological form of narrative. And if saint's lives are in some way the origin of Western narrative, perhaps we can also say that narrative is the origin of saint's lives.

What, finally, is the relationship of narrative to human life? According to one view, narrative organizes the disparate and heterogeneous phenemona of life by binding them into a coherent whole. Such a view is one of the few held in common by Freud and Marx, and clearly holds true at both the local level of the individual subject and at higher levels as well, including historical processes, cultural movements, and even some kinds of scientific description. Given a mass of information, narrative is highly efficient at attributing causality and ascribing value: whatever elements contribute to the closure or the pattern of an emergent narrative will appear more valuable and necessary than unassimilable elements. This is why narrative structure is indispensable, for example, in the formation of literary canons (see Kenner, "The Making of the Modernist Canon" 61).

The most powerful and comprehensive recent treatment of the relation between narrative and human life is Alasdair MacIntyre's *After Virtue*, which argues that Aristotelian notions of narrative unity can provide a way of retrieving crucial conceptions of virtue and the good life. MacIntyre contends that ethics only makes sense within a "narrative concept of selfhood" according to which a person is the subject of a history "that is my own and no one else's, that has its own peculiar meaning" (202). We are always in the middest of this narrative, and yet always more or less conscious of the direction in which we are heading: we anticipate "a future in which certain possibilities beckon us forward and others repel us"; so that "like characters in a fictional narrative we do not know what will happen next, but none the less our lives have a certain form which projects itself towards our future" (200–201). Only through such a conception of selfhood can people be held accountable for their actions, accountable for the rationale or sense of what they do, accountable for the relation between the present and a future or *telos*, however imperfectly conceived. On this point MacIntyre is unambiguous: "The unity of a human life is the unity of a narrative quest" (203).

By seeing human life as enacted narrative, MacIntyre is able to redefine virtues according a model of form: virtues are those dispositions and qualities which enable us "to overcome the harms, dangers, temptations and distractions which we encounter, and which will furnish us with increasing self-knowledge and increasing knowledge of the good" (204). Virtues are, in other words, everything that drives towards the closure of "spatial form," completed design, or perfected knowledge. In this way art and life are reunited; and the prevailing neo-Nietzschean view, as well as the predominantly bureaucratic and individualist tendency of modern life, are resisted in the name of a reconstituted virture.

MacIntyre elegantly accounts for the stories—or rather the story—that we live; but what relation does this story, with its own "peculiar meaning," bear to that great number of stories that we imagine and tell about ourselves? Why, within our single lives, do we represent ourselves as the subjects of a multitude of discontinuous stories? Are these smaller stories properly conceived as "chapters" of the larger story; or might they be irreducibly unassimilable to any single super-narrative? Do only fragmented, confused, and therefore in a sense unethical people imagine themselves to be participating in disconnected collections of events that simply do not add up to anything? When we try to apply MacIntyre's principle of narrative unity to the sum of the stories we imagine and tell, and not just to the one life that we lead, we run into trouble; for while it seems plausible to assert that human life has ethical significance insofar as it has narrative unity, it seems equally plausible to contend that at the local level narrative actually serves the function of articulating the discontinuities of lives by enabling us to formulate discrete stories about ourselves that have nothing to do with one another, or by inviting empathetic identification with others whose stories in no literal way intersect with our own.

Even if we met this objection by saying that we could always ask a person to work out the local incongruities by devising a super-narrative that accounts for how one comes to be all the characters one is taken to be, MacIntyre is far too sanguine about the individual's ability to get a life-story to hang together, and far too emphatic in his assertion that unity is equivalent to virtue and value. While MacIntyre considers the multiple ways in which our life-stories can work out and still be, as Ricoeur says, narratologically "acceptable," he does not consider the possibility—which is surely actuality for the vast majority of people on the planet—that life-stories could fail to achieve any kind of acceptable conclusion, that events could fail to cohere into form at the end, that lives could terminate in confusion, chaos, or disorganization *despite our own best efforts*. Nor does he consider the possibility of contradiction or discontinuity as a positive good. MacIntyre can account for failure—which he calls tragedy—but not for mess, and not for creative disunity.

But there arises another, more fundamental objection to MacIntyre's thesis, an objection that can be framed as a challenge to the idea of unity. In what does the supposed unity of narrative consist? As we have seen, all attempts to found views of narrative based on conceptions of achieved design, spatial form, memorial synthesis, and so forth, leave out half the story. Such attempts begin, it seems, at the end by stressing the understanding of the narrative available to the reader through his memory after he has finished reading, or, in MacIntyre's case, finished

living. But this "vertical" dimension of narrative only achieves itself within and through resistance to a "horizontal" dimension, with its temporality, randomness, and contingency. All the totalizing operations of narrative operate through resistance to de-totalizing operations; and so while narrative can organize a human life, it cannot do so simply or unequivocally, for all its coherence functions are implicated in their opposites.

Can narrative serve both as a means of organizing life and of disorganizing it? Does it serve an incongruous double function; and if so what possible value could it have?

As MacIntyre describes it, narrative is an ethical force, a means of resisting the temptations to unintelligibility, unaccountability, and randomness; it is a way of keeping oneself together by imagining that one is the subject of a coherent and therefore idealized representation, imagining that one is generating a story whose outlines are already established. But what he fails to account for is the doubleness, the inescapability, of temptation. One particularly insidious assent arises within resistance itself, the temptation to consider oneself untemptable, completed, perfect, formed. At the moment when one imagines that one's story is complete—and MacIntyre presumes throughout that we always project a future for ourselves that is in some ways determined by the present and in that sense completed in advance of its actual enactment—we have succumbed to temptation, and must, if we are to obey the imperative to resist, imagine discontinuity, heterogeneity, and contingency in order to keep ourselves temptable, maintain the uncertainty of the future, and preserve the possibility of virtue through resistance. We must imitate the model; we must not think that the model is or ought to be imitable.

Within these conditions a human life emerges that embraces and is embraced by principles of unity and coherence, and also multiplicity, discontinuity, and chance. Temptation is a name for this complex coupling; narrative, for its representation.

Discipline and Desire in Augustine's Confessions

2

The Language of Conversion I

O ne of the complex pleasures of Augustine's *Confessions* is that it documents an ascetic's success story, a progressive and apparently successful movement from involvement in the world, to reflection, to writing, as the text itself shifts from autobiography to philosophy to exegesis. It provides, therefore, an opportunity not only to examine the ascetic "point of view" on three scenes of action, but also to consider these scenes as stages in a kind of narrative structured by a self-transforming ascetical energy. In other words, the modes of Augustine's text can be seen as phases of an evolution towards the perfect ascesis, in which desire ultimately renounces its ambitions and submits to domination by the Scriptural Word.

The specifically ascetical features of this project emerge clearly when it is compared to a comparable progression, Karl Jaspers's description in *Psychologie der Weltanschauungen* (psychology of worldviews) of the three "levels of the soul": (1) world orientation, as supplied, described, and verified by science; (2) illumination, as it occurs to the individual in "boundary situations"; and (3) metaphysics, in which the "ciphers of transcendence" become "legible" for the individual in an existentially binding way. Jaspers's three stages move in the same direction as Augustine's; in fact, Augustine reveals himself in Book 13 to be a "metaphysician" when he suggests that we should understand the Trinity in terms of three dimensions of human life: "The three things are existence, knowledge, and will, for I can say that I am, I know, and I will" (13.11: 318). But the end of the *Confessions* itself

implies something more than metaphysics; it testifies to a specifically ascetic conclusion in which "legibility" is completed in exegesis, in the writing of a critical text. It is this final gesture, the composition of a particular kind of text—secondary, derivative, dependent—that completes the ascetic self-effacement.

Metaphysics culminates in a state of wordless knowledge like the condition of philosophical enchantment in which Socrates would stand for hours in silent solitude (*Symposium* 220C–220D).[1] Asceticism, by contrast, culminates not in the knowledge of essences but in self-transformation, accomplished through the agency of writing—either writing *about*, as in the case of Anthony, or writing *by*, as in the case of Augustine.

Most accounts of the *Confessions* reflect a metaphysical prejudice, or limitation, according the textual voice at once too much security and too little productive capacity. Even recent revisionist readings in which uncertainty or instability might be expected to figure prominently reflect this bias, describing the text in terms of an ever higher ascent, an ever greater transcendence. In a 1973 article on "Augustine's *Confessions* and the Grammar of Selfhood," Eugene Vance concludes that by the end of Book 9, which terminates the autobiographical section, "Augustine can now orient himself in good conscience toward that Text where the Word stands partially revealed to men in the flesh. Just as the spirit liberates the letter, so Augustine, inspired by Christ and imitating Christ, addresses himself to the divine message concealed in the letter of the Old Testament. Discourse is not only purified, but contemplates its own origins" (24). This qualifies as a metaphysical reading because the terms it holds up—good conscience, revelation, liberation, spirit, inspiration, purification, and origin—reside on Jaspers's third level of the soul; they are the properties of metaphysical closure. And in *The Forms of Autobiography*, William Spengemann, having argued a truly radical case that "the narrative mode and theological ideas of each succeeding part appear to invalidate, or at least to qualify, the assumptions behind the structure and doctrine of each preceding part" (2–3), comes finally to rest in what he describes as the achieved stability of the final book of the *Confessions*: "As he expresses his faith in words, singing the song of ecstasy, he experiences poetically something akin to a state of grace" (31–32). So Spengemann accomplishes the metaphysical closure as well, though in order to do so he has to suppress the writing in favor of speech, and even the more "innocent" song—far from an "innocent" difference, since speech is analogous to Christ—and even then he has to settle for "something akin" to grace rather than grace itself.

To be sure, there are persuasive reasons for reading the *Confessions* in light of the metaphysical prejudice. Most narratives seem to accede to it, closure itself carrying a certain metaphysical implication; and this narrative in particular has had a prominent role in forming it: ample evidence in this and other texts suggests that Augustine's values are entirely metaphysical-transcendental. And yet, according to Peter Brown, Pelagius, whose doctrine of perfectionism Augustine was to be instrumental in having condemned, was "deeply annoyed" by the *Confessions* because, Brown suggests, it did not present the story of a "successful conversion," an event "often thought of as being as dramatic and simple as the 'sobering-up' of an alcoholic" (*Augustine of Hippo* 177).[2] Pelagius's annoyance points to an inadequacy in the metaphysical reading of this text, an inadequacy that might be corrected not by a counter-reading, but rather by a shadow-reading that takes its place *within* the canonical reading, completing it without contradicting it. In the terms of such a shadow-reading, the *Confessions* must be read not through a model of irreversible progress and increasing spirituality alone, but also in terms of repetition, according to which the situation described in the autobiographical books (1–9) is reinscribed in Book 10 in the discussion of textuality, memory, and temptation, and then again in the exegetical books (11–13).[3] At the same time that Augustine frees himself of certain entanglements in the corporeal world and approaches God, he also, and by the same gestures, gains in power and even gratification. This double movement is the characteristic torsion of asceticism, and marks this text as an exemplary ascetical machine.

Formally and thematically, the text centers on the conversion in Book 8, the most famous event in the narrative. It is the conversion that secures Vance's "good conscience" and Spengemann's "grace" by unifying Augustine's conflicting wills and purging his soul of "nature's appetites" so that he stands in total univocity, single-minded before God, his will one with that of his maker. The canonical reading, which Vance and Spengemann do not challenge in this respect, depends therefore on a certain (perhaps "Pelagian") view of conversion as what Niebuhr calls the "intelligible event which makes all other events intelligible" (69). The principles of the "successful conversion" were vigorously set forth by William James:

> To be converted, to be regenerated, to receive grace, to experience religion, to gain an assurance, are so many phrases which denote the process, gradual or sudden, by which a self hitherto divided, and consciously wrong

inferior and unhappy, becomes unified and consciously right superior and happy, in consequence of its firmer hold upon religious realities. (189)

What strikes the eye here is the contrast between the radical effects of conversion and the rather limp cause, the "firmer hold upon religious realities." How can an augmented firmness produce such an absolute break with one's past? James's description actually implies two separate views of conversion, one closural and one processual, one according with what I have been calling the canonical reading of Augustine and the other according with the shadow-reading that remains to be established.

To articulate the difference we may refer to Thomas Merton, who points out that conversion has historically been understood in two ways. In the sixth-century Rule of St. Benedict, the term *conversatio morum* expresses "the conversion of life," while in the Rule of the Master, on which it is based, as well as in later manuscripts of the Rule of St. Benedict—as well, in general, as in all subsequent profession formulas for monastic orders—this term is replaced by an apparently equivalent term, *conversio morum*. The distinction corresponds roughly to the difference between the "primitive" and individualistic eremetic monasticism of Anthony and the communal, "advanced" cenobitism of Pachomius that succeeded it. As Merton puts it,

> We might summarize all this by saying that the vow of *conversio morum* is a vow of renunciation and penance, a vow to abandon the world and its ways in order to seek God. . . . It is the vow to obey the voice of God, to place oneself under a Rule and an Abbott in order to follow the will of God in all things. . . .
> There can be no doubt that one of the most important aspects of *conversatio morum* is the persevering determination to bear with patience and courage all the trials one may meet in the monastic life. . . . It is in a sense precisely to these trials that one has been called by grace, so that fidelity to grace demands this acceptance. (*The Monastic Journey* 149).⁺

According to Merton, the dramatic, relentless *conversatio* view of conversion as a consecration to ceaseless struggle was rapidly and effectively suppressed; some later writers even portray the "renunciation" of *conversio* as a surrender precisely of the solitary heroism of *conversatio* (154–55); or they represent the communal *conversio* as the end to which *conversatio* is only a means (159).

The fanaticism of *conversatio* harbors the continual possibility of fraud—Merton speaks darkly of heretical "sarabaites" and "gyrovagues"—in the exaltation of one's own will and resources over God's.

The official Church suppression of eremitic monasticism, repeated in the scribal substitution of *conversio* for *conversatio*, testifies to a certain hesitancy concerning the convertability of the soul and a corresponding reliance on imitation, on adherence to rule. So successful had this suppression been that Merton, whose own *The Seven Storey Mountain* has been the *converting* text in our time, found it necessary to try to redeem the monastic spirit from "the dead hand of conventionalism" by reviving *conversatio* in order that the contemporary monk's "openness to the living word of the Gospel and to the sanctifying word of the Church, may be completely authentic and alive in our time" (146). In something of the same spirit I would like to propose, or perhaps to restore, a view of the *Confessions* that recognizes the narrator's continuing "openness to the word," his continuing confrontation with temptation, even his voluptuous immersion in what he calls in Book 13 the "abundant sea" of language.

To understand how intimately conjoined are *conversio* and *conversatio* in practice we can examine the element in the conversion experience that seems most directly to support the cause of the former, the elaborately mimetic or, as John Freccero has called it, the "literary" character of Augustine's decision to commit himself to Christianity. Although this aspect of the conversion is often analyzed, it has not been understood in this context, and requires revaluation. Book 8 begins with Augustine's visit to Simplicianus, who tells him of the conversion of the pagan Victorinus, at which Augustine "began to glow with fervour to imitate him" (8.5: 164), to give up being "a vendor of words" in order to cleave, or "cling" to God's Word.⁵ Later, Ponticianus visits Augustine and the faithful Alypius, and notices a volume of Paul's epistles lying on a table. He tells them of Anthony, of whom they had not heard, and of his own first encounter with Athanasius's text. In Trier, two friends of Ponticianus's had discovered *The Life of Anthony* in a house, just as he had discovered Paul's epistles. One of them read it "and was so fascinated and thrilled by the story that even before he had finished reading he conceived the idea of taking upon himself the same kind of life" (8.6: 167). Suffering "the pain of the new life that was taking birth in him" (8.6: 168), he reads on until a cry bursts from him and he makes the decisive commitment. His companion does the same, and they go back and tell the women to whom they are engaged, producing the same result in them.

Hearing all this from Ponticianus, Augustine retires to a garden and, after laboring under great internal stress, hears a child's voice chanting, "Take it and read, take it and read" (8.12: 177). Recalling a similar incident in the life of Anthony, which he had just heard,

Augustine rushes back into the house, seizes Paul's epistles, and opens by chance to the words "spend no more thought on nature and nature's appetites"; and doubt vanishes. But the process is not complete. He shows the passage to Alypius, who, adapting his coloration to the prevailing foliage, reads on in the passage (Romans 14:1), applying the words to himself and converting on the spot. This stacking of models continues even beyond this episode, driving the entire project of the *Confessions*, which its author hopes will stir other hearts, providing a model "so that they no longer lie listless in despair, crying 'I cannot'" (10.3: 208). Reading, we may infer from this sequence of events, stabilizes the wandering subject by proposing a species of imitation with the power to convert, to bind the life of the reader into its own pattern.

How different this is from Jaspers's "boundary situation," in which the subject, having exhausted the resources of anonymous scientific knowledge, is abandoned to itself. The significance of the imitative element in conversion is that Augustine understands himself, awakens to himself, possesses himself, only as a repetition of other selves. Augustine converts when he joins the community—or rather when he recognizes that he has always been joined to the community—organized around a few texts that are finally grounded in the mediating figure of Christ, whose radiant "Follow me" stands at the origin of imitation. This origin is itself an imitation, translating divine power into knowledge through what might be called primary repetition, originary imitation. As Kenneth Burke says in *The Rhetoric of Religion*, "the second person of the Trinity would be, as it were, the 'first distinction,' or 'departure,' the very essence or principle of divisiveness, though in a 'happy' sense of the term" (152).[6] In converting, Augustine is situating himself in the chain of imitation that extends back to and even includes the origin.

Can such a recognition of one's own imitativeness constitute self-understanding? Gadamer suggests that it can when he asserts that a text "gives ever new answers to the person who questions it and poses ever new questions to him who answers it. To understand a text is to come to understand oneself in a kind of dialogue. . . . the text yields understanding only when what is said in the text begins to find expression in the interpreter's own language" ("Self-Understanding" 57). Gadamer explicitly identifies this dialogical property of texts with the power of the Scriptural text to "call us to conversion," implying that conversion emerges not from an act of free self-possession but rather from the interaction between the self and the text. "The words we find capture our intending, as it were, and dovetail into relations

that point out beyond the momentariness of our act of intend-ing" (56).[7]

Of course, Augustine had read Scripture all his life, and had committed much of it to memory without converting, so we must infer that some additional element was present in this scene that drove him to decision. This element is not just the story of Anthony, but the narrative of the discovery and reception of the story of Anthony. By providing a model of how texts are to be taken, this narrative educates Augustine in the ways of readership. In particular, Ponticianus's narrative introduces the concept of the "found text." I take this phrase from a recent article by Juliet Fleming that discusses "all those written fragments which blow about the world and present themselves to notice in mysterious ways." For Anthony the found text is Matthew 19:21, Christ's call to perfection, which he overhears as he passes the church door; for Ponticianus, the found text is *The Life of Anthony*; and for Augustine, the found text is Paul's epistles. The accidental, un-sought-for nature of the found text creates an intense dialogic bonding between text and reader. As Fleming puts it,

> On the one hand, it rivets its finder's attention on the physical world by suggesting to him that meaning is inscribed on nature's surface, and needs only to be read. On the other hand, a found text has no meaning until it is embraced by its finder. It is not so much a message from the real world as from the self, since it says nothing until it has been taken possession of and interpreted.[8]

Scriptural "found texts" have extraordinary force because they do not "blow about the world" in a random or undetermined way, but are God's text addressed to the world and to each convertible individual in it. At the same time, because the Scriptures are vast and constantly quoted, they constitute a kind of atmosphere of possibility in which any given fragment will suddenly stand forth as a message addressed to the self at this particular moment. Thus what Augustine understands for the first time in Book 8 is not the *meaning* of the Scriptural text but rather the *force* of that text and its relation to him. Situating himself within the community of imitators, Augustine understands the text when he understands that it is a model for himself; and he understands himself when he grasps his own "tropological" nature, that is, when he sees not only that he can imitate the text but that he has in fact been doing so all along. The "new life" of the convert is an old and borrowed life, authentic because aesthetic.[9]

According to James, conversion unifies the self. But it would be more accurate to say that it essentializes it, fostering a self-understand-

ing that comprehends two selves, one knowing and bound to God, and the other known and free, or wandering by its own desires. This distinction is similar to that between the body and the soul, but it has particular features in this context. Hearing Ponticianus, Augustine feels the hand of God "twisting" him around to look at himself (*retorquebas me ad me ipsum*): "For I had placed myself behind my own back, refusing to see myself. You were setting me before my own eyes so that I could see how sordid I was, how deformed and squalid, tainted with ulcers and sores" (8.7: 169). Before conversion Augustine had formed a grotesque beast with no back, with the knowing principle unconscious of itself, under the illusion that knowing and being were one. With the conversion, the knowing self splits off from the being self, and observes it from a position magically free from being known, free from representation. Thus imitation (*conversio*), far from uniting the self, inculcates a sense of the otherness of the self.

Conversio, or the imitation of models—which, if we follow Gadamer's suggestions, may simply be the strong form of reading—corrects the "eremitic" arrogance of thinking oneself and one's story unique. And it does so in a manner consistent with the covert asceticism of the early Heidegger, whose doctrine Gadamer paraphrases: "Dasein that has fallen into the world, that understands itself in terms of what is at its disposal, is called to conversion and experiences the turn to authenticity in the shattering of its self-sufficiency" ("Martin Heidegger and Marburg Theology" 206). According to Gadamer, Heidegger's work following *Being and Time* underwent a "turn" in which he abandoned the notion of authenticity and with it his unspoken asceticism, in favor of a concentration on language and a notion of truth as an event containing its own error within itself. According to the later Heidegger, the truth of the work of art occurs only in its closure or concealment, so that understanding always strives after precisely that which conceals itself. This kind of understanding, Gadamer suggests, lies "beyond the horizon of any self-understanding" (208); but perhaps self-understanding, in particular the kind achieved through dialogue with texts, is misconceived here by being idealized, as though error could not play a part in true self-understanding. Such a notion depends upon a strict distinction between the kind of understanding we have of texts and the kind that we have of the self. But everything said so far about Augustine's acquisition of self-knowledge indicates that no rigorous distinction can be drawn between these two processes. Perhaps we could say that within any form of knowledge, a dimension of selfhood resists a dimension of textuality.

The idea of the found text applies equally to the text that is found

and the self that finds it, for the event of finding both textualizes the self and "personalizes" the world. As Fleming puts it, "The found text is an assurance of the otherness of the world and the existence of the self as object and not imagining subject. It seems to exist both inside and outside the self, a message to the self that returns from the outer world to assure the individual of his phenomenal existence in that world." This points to the worldly circumstance of finding. All imitation, in fact, is worldly in that sense, and so confirms the material self, the deformed, spotted, ulcerous self at the expense of the knowing, unconditioned self.

What we are approaching is a limit in *conversio*, a limit indicated by Freud's phrase (concerning archaic thought), "the temptation to imitate" (*Totem and Taboo* 72). For Augustine, imitation might be subject to the prohibitions of taboo because while it secures the boundaries of the self, it also violates the "livingness" of the self, deadening the spirit, making it, as Merton says, deaf to the Word. Thus, like all other resistances, it is also an assent, in this case to the temptation to cease the struggle.

It is possible that a critique of imitation informs the second most famous incident in the *Confessions*, the theft of pears in Book 2, in which a sudden outbreak of imitative fever had the effect of "bewitching my mind in an inexplicable way" (2.9: 52). Augustine begins his probing into this fascinating event with the presumption that as human beings have no power to "break" the Law, he and his companions must have merely *imitated* one of the Lord's powers "in a perverse and wicked way" (*perverse imitatus*, 2.6: 50). Augustine does not decide which power was perverted, nor does he consider the possibility that imitation itself is at fault. Kenneth Burke has taken the hint, however, arguing that this imitative act was deviant and even "homosexual," a parody of the Brotherhood of the Church in the "absolute unfruitfulness" of the act (95). Imitation, Burke concludes, has a double valence for Augustine, as both exemplary humility and parody, a reworking of the origin in contradiction to itself.[10]

This is not a point on which Augustine is entirely articulate, but he does, in Book 13, suddenly open fire on imitation as false conversion:

> We must obey in full the message which you gave to us through your apostle when you said: *Do not fall in with the manners of this world. . . .* the next words you spoke were *There must be an inward change, a remaking of your minds.* When you said this, you did not add "according to your kind" as though you meant us to imitate others who had already led the way or to live by the example of someone better than ourselves. . . . when he has

remade his mind and can see and understand your truth, he has no need of other men to teach him to imitate his kind. (13.22: 331–32; Rom. 12:2)

In this passage Augustine condemns not just perverse imitation but imitation as perverse. Here, conversion is a solitary experience of reconstruction by which the self becomes other than what it was, becomes other than anybody, other than a self.

Although the two functions of conversion seem to contradict each other directly, Augustine is unwilling to surrender either one. Just one page before this passage he argues in praise of the work of the evangelists, who served "as a pattern to the faithful by living among them and rousing them to imitation," adding that the soul "keeps itself intact by imitating those who follow the example of Christ your Son." He concludes with a suggestion that imitation does not even require effort: "Be as I am, says Paul, for I am no different from yourselves" (13.21: 330–31: Gal. 4:12).

If imitation and remaking can be compared, respectively, to "defense" and "offense," it is apparent that conversion cannot quite work free from the defensive strategy of imitation; and that conversion therefore remains in a sense unconverted. Oddly enough, the act of conversion, requiring as it does an assent to imitation, contains a resistance to conversion, so that the term designates not only a principle of radical change in life, but also a principle of recalcitrance and unchangeability. As a turn to "authenticity," conversion remains earthbound, containing its own "error." (Thus, incidentally, we can see that Heidegger did not liberate himself from asceticism in his "turn," for asceticism anticipates this turn.) Structurally self-inhibited, conversion assents to its own temptation: hence the element of *conversatio* in every conversion.

In his highly original analysis of the *Confessions*, Burke devotes several pages to a curiosity, the "conversion of a word" (160–63). The word is *pondus*, which refers to weight, as in the following passage: " A body inclines by its own weight towards the place that is fitting for it. Weight does not always tend towards the lowest place, but the one which suits it best, for though a stone falls, flame rises" (13.9: 317). Noting that in earlier books *pondus* and its cognates had referred in general to the "various and diverse loves" that bind the soul to the world, Burke suggests that the word "undergoes a conversion all its own" (161). In the books following the conversion experience (during which Augustine is "in suspense" [*suspendio*]), *pondus* is frequently used in connection with a dependency (*penderent*) on God's will. Burke con-

cludes that "the word 'weight' must have conveyed to Augustine rather the sense of *lightness*, somewhat as though a stone were to levitate" (163).

Burke's comments are most useful in that they point to a principle of conversion working not just on Augustine himself but on the very terms of his discourse. This principle is most active in Book 8, which yields a number of instances of local or topical conversion. The book begins, for example, with the statement that "the bonds of woman's love" presented the sole remaining obstacle to new life, but it ends with the climactic appearance of the allegorical figures of *Continentia*, "not barren but a fruitful mother of children, of joys born of you, O Lord, her Spouse" (8.11: 176). Her appearance triggers the final assent of this book, and illuminates the dynamics of conversion. The sexuality of *Continentia* has been purged of its weight through figurality, leaving only an essential lightness. Within the allegory, sexuality has been liberated from its literalness, its roots in the world: the heaven signified by allegory is populated by eager bridegrooms, fertile mothers, and numerous children, begat without fornication.

The concept of chance provides another example. In Book 4, Augustine had exposed the occasional successes of pagan astrologers in predicting the future by attributing them to chance, "a force that must always be reckoned with the natural order." His example—and we must remember that he was writing twelve years after the date of his conversion—is the experience of opening a book at random "and although the poet had been thinking, as he wrote, of some quite different matter, it often happened that the reader placed his finger on a verse which had a remarkable bearing on his problem" (4.3: 74). He must have forgotten this dismissal of chance by the time he wrote Book 8, in which just such freaks of nature figure crucially. Ponticianus "happened to notice" the text of Paul's epistles; his friends had "wandered on" to a house that contained the *Vita Antonii*; Anthony himself, as Augustine notes, "had happened to go into a church while the Gospel was being read"; and Augustine opens to the text that most applies to himself. The "natural order" continues as a force to be reckoned with but its force derives from the fact that it conceals within itself the divine order. Chance is not just an intrinsic possibility of all things, but is, to use a Heideggerian term, the "unconcealedness" of their essential necessity.

Weight, sexuality, chance—all tokens of the natural order that undergo conversion in the same way as Augustine: by doubling themselves so that one part stands in relation to the other as provisional to final, expression to essence, implicit to explicit, even parody to type.

In conversion the essence, the true configuration, declares itself as such, bringing motion to a halt. This is the sense in which René Girard argues that conversion serves as the principle of closure in any complex plot: "All novelistic conclusions are conversions, it is impossible to doubt this" (294). The "unconverted" condition obtaining at the beginning of a plot bespeaks a *hamartia*, a flaw in the nature of things; and the conclusive conversion is brought about by a reversal, whether in the mind of the protagonist or in the structure of events, and a recognition that the new configuration was implicit in all prior configurations.

This implicitness throughout the events leading up to the formal conversion makes it difficult to establish exactly when the decisive moment occurred. Pierre Courcelles argues, in fact, that the formal conversion in Augustine's life occurred several years later than he represents it in his text, an adjustment that would not violate the truth if in certain respects the conversion had already occurred anyway.[11] Augustine simply placed the conversion experience at the point in his life-story where a plot-climax was required.

But if it has occurred before it occurs, if it is always self-inhibited and therefore never quite occurring, if it changes everything and nothing, if it unifies the subject and doubles it—*what is it?*

Vance has tried to answer this essential question by arguing that the conversion occurs at the moment in Book 8 when Augustine decides to permit the "transgression" of his autobiographical text by the Word of God. Renouncing eloquence and the profession of rhetoric, Augustine suffers, according to Vance, a "death in language" that is also a "death to himself," and this double death is the essence and basis of conversion. This elegant formula rightly focuses on the issue of language as the proper scene and mechanism of conversion. But Vance goes further, linking the violence at the moment of decision, when Augustine tears his hair, hammers his forehead, hugs his knees, and so forth, with the beatings the young Augustine had received at school, beatings that had demonstrated to Augustine (or so Vance argues) that language learning is "an institution of fallen society . . . acquired through institutionalized rites of violence" ("Grammar of Selfhood" 21, 19). The earlier incidents are allied with the later self-flogging as comparable occasions of "the transgression of his identity by the word of another. This," says Vance, "is the single violence of death in language, except that in the latter case Augustine's death to himself is the drama of salvation" (21). At this point the elegance of the formula suddenly appears as a simplification, unifying under the notion of a "single violence" both the fall and salvation—and also, we might add,

the "ordeals of martyrdom," to which Augustine compares his school beatings in 1.4. Language has multiple violences, and multiple benevolences; it transgresses, chastens, mortifies, expresses, acculturates, and redeems. In other words, Vance's attempt to define conversion in terms of language acquisition has not articulated the event as much as it has extended the idea of conversion to other events apparently remote from it in structure and valence. Arguing for a tight definition of conversion, Vance has in fact been forced to open up the concept and make it permeable to a vast conceptual range.

Vance's apparent loss of control over his terms might be damaging to his argument, but it actually illuminates the global character of conversion. In order to approach this character we must first clear away the unargued idea on which Vance's argument depends, that of a pristine personal or private language that passively, yet virtuously, awaits violation or transgression by the word of another. Where does Augustine—where does anyone—ever use his "own" language? Of what would such a paradisal language consist? How or what could it communicate?

We do not have to look far for a counterargument to this romantic notion of a private language, for in Book 1 Augustine notes how, first through gestures, then facial expressions, and finally through speech the infant learns by memory and imitation to repeat the signs made by others, to participate in the language and the community that always precedes its wishes or intentions. The very first instinct of the self—surely genetically imprinted through biological "imitation"—is to seek precisely the transgression of the self by the "word of another." This is original desire, transgression by the alien word. Only through such transgression can the child acquire wishes and intentions at all; only through such transgression can anyone achieve a self. This means that the conversion Augustine undergoes does not constitute a radical break with his previous behavior, but is rather a particular adaptation or sedimentation of the first "behavior" learned. In this sense, conversion draws on the most "natural" form of behavior possible; perhaps this is why it strikes the new convert with the force of inevitability.

The fact that we are never free from impingement by the "word of another" leads to another quarrel with Vance (and with almost every other reader of Augustine), this time in his claim that conversion can be assigned to a definite temporal moment. The self emerges from, and constantly defines itself through, the conversion of instinct or impulse into language, which means that the conversion cannot be localized in a single event. No moment of consciousness is "preconversion." Nor, we must remember, does the subject ever achieve a "postconversional"

condition, for as we saw, conversion contains its own inhibition, its own antidote. Conversion, broadly conceived, is a constant and ubiquitous process capable of absorbing any value, any thematization: it is the unchanging condition of our existence; its most comprehensive and familiar process is language in all aspects of acquisition and use, including self-representation. Insofar as the *Confessions* pivots on conversion, it simply projects into a plotted, linear depiction of human action the manifold operations of language, operations that gather into nodal prominence in language acquisition, spiritual conversion, and, for Augustine, the composition of an autobiographical text. Language does not provide a document of conversion, nor does it serve only as the scene of conversion. Language *is* conversion. Enabling the marking of time, the definition of events, the articulation of the self, and communication with others, language testifies to conversions achieved, conversion in the process, and conversions yet to come.

In certain essential features Augustine's discussion of language acquisition corroborates Freud's analysis in *The Ego and the Id* of the "conversion" of elements of the unconscious to the preconscious. "'How does a thing become preconscious?'" Freud asks; "the answer would be: 'Through becoming connected with word-presentations corresponding to it'" (20). Freud's analysis takes in the concept of confession, which attaches words to instincts, or "nature's appetites," thereby making them accessible to criticism. But what drives the *Confessions*, what keeps it from reaching a "successful conversion," is the fact, unrecognized by Freud but not by Augustine, that the attachment of words to instincts is not only a result of repression but *is itself an instinct*, and so requires ever more confession: if instincts are transgressive, then confession itself is an assent to temptation, although it occurs in the very heart of resistance.

Perhaps the instinct to which confession, as a specifically ascetic language, most closely corresponds is the "death instinct." If, as ascetic writers felt, language served the interests of mortification, then Freud's puzzling suggestion that the death instinct is not an aberration but the most comprehensive and typical instinct, becomes clearer. For what category of human experience is larger than language? The connection between confession and the death instinct becomes even more sharply focused with Freud's virtual identification of instinct with the "repetition compulsion," "*an urge inherent in organic life to restore an earlier state of things*" (*Beyond the Pleasure Principle* 36). Both Aristotle and Augustine recognized imitation, or repetition, as the basis of language. Imitating, repeating, and "restoring" an earlier condition, the autobiographical narrative would intensify the death instinct of language itself,

providing a signal instance of the repetition compulsion. The desire driving the autobiographical act is actually attracted not to the life of the human subject, or even to any idealization of that life, but rather to the margins or frames of that life, to a prenatal or instinctual past and to a projected death.

Normally concealed in its operation, the repetition compulsion may nevertheless produce effects that become conscious, producing the sense of the "uncanny." The *Confessions* are rich in experiences of the uncanny, especially the kind Freud calls "possession by some 'daemonic' power" (*Beyond the Pleasure Principle* 36). The incident in Book 8 where he gazes on himself must be placed in this class, and Freud discusses just such a phenomenon in the 1919 essay on "The 'Uncanny,'" where he attributes the idea of the "double" to the earliest phase of mental life, primary narcissism. The feeling of having a double can continue, Freud suggests, into later life, when

> A special agency is slowly formed [in the ego], which is able to stand over against the rest of the ego, which has the function of observing and criticizing the self and of exercising a censorship within the mind, and which we become aware of as our "conscience." . . . The fact that an agency of this kind exists, which is able to treat the rest of the ego like an object—the fact, that is, that man is capable of self-observation—renders it possible to invest the old idea of a "double" with a new meaning and to ascribe a number of things to it—above all, those things which seem to self-criticism to belong to the old surmounted narcissism of the earliest period of all. (235)

The impact of Augustine on Freud is to correct the notion that instincts exclude language; the impact of Freud on Augustine is to establish that even self-criticism proceeds from instinct, its origins synchronous with "the earliest period of all."[12]

Augustine records in Book 1 a quieter but more threatening instance of the uncanny when, rehearsing his learning of signs, he breaks off to marvel, "Where could such a living creature come from if not from you, O Lord? Can it be that any man has skill to fabricate himself?" (1.6: 26) The miracle of signs engenders the sudden suspicion that the self is capable not merely of making itself known but of making itself altogether, that the self, or rather the signs manipulated by the self, contain a creative capacity. The self makes signs and signs make the self in a self-motivated creative cycle that appears to exclude the intervention of God the Maker.

This line of thought is not completed, but simply repeated in the final book, in which Augustine compares the individual soul to the

cosmos. Forming the ur-material of the universe into heaven and earth, God converted it: "For, by undergoing a change which bettered it, it was turned towards that which cannot change, either for better or worse, that is, towards you" (13.3: 313). From the first instant of time the Word creates and converts, so that not only the writer but the universe is the issue of conversion. And yet, conversion has not only "always already" happened; as Augustine was literally the first to admit, it is also always imminent, always yet to occur. Insofar as the world exists, it is the product of conversion, and yet insofar as it is changing it is also unconverted, awaiting conversion. Augustine's thought is most tightly knotted precisely where it is most expansive: where there is a word there is creation; where creation there is conversion; where conversion there is death; where death there is instinct; where instinct there is transgression; where transgression there must be confession; and where confession there is the word. Each word initiates a new drama of the soul, a drama analogous to the history of the world.

Profit and Loss in the 2
 Ascesis of Discourse

*A*s a depersonalizing force that "mortifies" the subject, language bears ascetic credentials. But as an expressive instrument or a medium of socialization, language also subverts ascesis and works against the conversion it seems at times to promote. For the confessing subject the problem becomes strategic: how to discover the truly renunciatory element in language; how to deploy the ascetic functions of language against the nonascetic functions; how to pit language against itself?

Such considerations must motivate the jettison of narrative after Book 9. Between books 9 and 10 a caesura falls, and narrative as a dominant mode is through, succeeded by an atemporal discourse that concentrates not on the life of the man Augustine but on the subjects of textuality, memory, and temptation. Since the entire text of the *Confessions* was written after the conversion, we cannot simply say that Augustine discovers something about narrative that he had overlooked before; presumably, he begins in knowledge. But if this is the case, why was narrative employed in the first place? Why didn't a converted and enlightened Augustine simply begin with Book 10, or better yet with Book 11, the beginning of his Scriptural exegesis? Despite limitations that must have been apparent to Augustine before the writing, narrative must have served some necessary purpose as a first step in an ascesis of discourse.

One of its functions may have been the symbolic murder of Augustine's father Patricius. According to Vance, narrative was for

Augustine "in some deep sense patricidal" as "it destroys progenitors" ("Grammar of Selfhood" 15).[1] Setting aside the general case, it is clear that Augustine's narrative in particular constitutes a sustained assault on Patricius, who is repeatedly aligned with the two sins most odious and dangerous to Augustine, sexual desire and eloquence—the desire to excel in the profession of rhetoric and public speech. With great contempt Augustine notes how Patricius overextended the family's slender resources in order to procure an excellent education for his son, caring "only that I should have a fertile tongue"; and with great embarrassment he relates how his father, seeing "the signs of active virility coming to life in me" at the public baths, began "to relish the thought of having grandchildren" (2.3: 45). These two sins—or rather one sin, of mortal fabrication, a parody of true creation—are not merely promoted by Patricius but nearly attributed to him as the exemplary human parent. When Augustine at last renounces sex and eloquence, he reconceives himself as the child of God: "I am no more than a child, but my Father lives forever and I have a Protector great enough to save me. For he who begot me and he who watches over me are one and the same," rather than two, as when he was protected by God but begotten by Patricius (10.4: 210). The conversion does not change Augustine directly as much as it changes his genealogy.

But again, why had Augustine not simply begun after the patricide with the discursive mode of the later books? No historical data can answer this question, but we may acquire a speculative understanding through the redefined semiotics of Julia Kristeva (whose ideas will figure more prominently in part 3). According to Kristeva, language, and symbolicity in general, is rooted in a prior process with which it is always in dialectical conflict. This prior process effects a "semiotic" mapping of instinctual drives which Kristeva associates with the feminine, particularly with the maternal. Ascending to language through the paternal prohibition, the subject obeys a demarcating, acculturating, and socializing imperative, repressing a maternal authority associated with undifferentiation, "immediate identification," and what she calls "abjection." The sign owes its vertical and hierarchical structure to the repression and subordination of this maternal force, which continues to exert its influence into adulthood, though from a covert and diminished position.

What Kristeva describes is precisely the allegorization of language according to the terms of Augustine's narrative. For it was Patricius who had inducted Augustine into the use of language as commodity, language as display, language as skill; while Monica had cared only for the state of Augustine's soul. The narrative of Augustine's increasing

fame as rhetorician proceeds directly from the initial provocation given to his career by Patricius. The turn of narrative, in which a condition is reversed, and then recognized as having been "true" or present all along, is conveniently turned on Patricius and on the dimension of language he has sponsored. With the conversion Monica emerges, Monica who had from the first done "all that she could to see that you, My God, should be a Father to me rather than he" (1.1: 32). With the conversion, in short, the narrative achieves its Oedipal project, and language then ejects a dimension of itself, turning to other modes designed for other tasks.

Actually, narrative seems to receive a temporary stay of execution, for it is permitted one more book after the conversion in Book 8—the "Book of Monica," as Peter Brown calls it; narrative concludes only with her death, forcing us to consider a "matricidal" function of narrative as well. Why does Augustine continue to narrate up to the apparently arbitrary point of Monica's death; why not switch modes immediately upon conversion?

Perhaps there is a clue in the unforgettable moment in which mother and son, looking out of a window overlooking a garden in Ostia, speak together on the subject of eternal wisdom:

> And while we spoke of the eternal wisdom, longing for it and straining for it with all the strength of our hearts, for one fleeting instant we reached out and touched it. Then with a sigh, leaving our spiritual harvest bound to it, we returned to the sound of our own speech, in which each word has a beginning and an ending—far, far different from your Word, our Lord, who abides in himself for ever, yet never grows old and gives new life to all things. (9.10: 197–98)

Augustine concedes that in weeping for her at her burial he may have been "guilty of too much worldly affection" (9.12: 203)—never a danger with regard to Patricius—but he buries this affection with her. The narrative climaxes with the conversion of paternity, and concludes with the transformation of Monica into "our Catholic mother the Church" (9.13: 205). The almost casual sublimation of Monica into an institution testifies to her identification with what Kristeva describes as the already-renounced character of the maternal for the linguistic subject. For while it takes a narrative to get rid of Patricius, the very fact of language itself is from the beginning a paternal gesture, working against Monica. In the passage cited above, Monica is linked to two kinds of language, neither adequate: to a nonlinguistic, unmediated understanding of eternal truth, and to the random temporality of conversation. Monica does not resist transcendence as Patricius had, but after attaining it for

an instant, she relapses into the aimless and audible flow of speech. Hers is not an ascetic mode which constantly measures and tests itself against the silence of divine apprehension. This language Monica surrounds without touching. She is not personally invested in the ascetic struggle of self-definition and self-transcendence. Indeed, when Augustine converts she suddenly slackens. Telling her son that her only goal in life had been to see him a Catholic Christian, she concludes her lifelong conversation with him by saying, "So what am I doing here?" No model for the ascetic, especially for the linguistic ascetic who honors the Father, Monica passes from the scene, exemplifying a language which, in its ephemerality, abolishes itself in anticipation of the Word.

By the time narrative has ended it has produced, from a life devoted to rhetoric, a "life" modeled on the lives of Christ, Anthony, Paul, and others in the chain of imitation. Completing Augustine's imitation of Christ, it has also remade him through textualization, and so has achieved, it would seem, both ends of the process of conversion. Narrative has enabled Augustine to take both his own and God's view of things, to confess his sins as his and simultaneously to place them behind or outside himself.[2]

But narrative, a "converted" mode in this respect, also inhibits advance because of its attachment to the world, to the past, to time. Gérard Genette defines another transgressive aspect of narrative when he speaks of its tendency to "description," which he calls "the most attractive" of narrative's functions. Description "lingers on objects and beings considered in their simultaneity, and . . . considers the processes themselves as spectacles . . . ("Frontiers of Narrative" 136). In the lingering of narrative lies the temptation to a stop-time idolatry, or at least of "too much worldly affection." Narrative itself requires conversion, and so the next move taken by the striving text is to cross, between books 9 and 10, what Genette calls a "frontier of narrative" in order to focus, as its author says, on "what I am now, at this moment, as I set down my confessions" (10.3: 209).

Genette builds on distinctions in Plato and Aristotle to argue for a difference between narrative and what he calls discourse, which he defines in terms of a tolerance for the first person, a use of the present and future tenses, and a conspicuous "subjectivity," or attention to the circumstances of its production. This difference has spiritual force for Augustine. Turning in Book 10 to a meditation on the principles of memory and the anatomy of temptation, Augustine's text passes from narrative to discourse; or perhaps it would be more accurate to say that discourse purges itself of narrative, since discourse, in the form of authorial addresses, had been present from the beginning, embedded in

a stubbornly narrative matrix. But in Book 10, the text ascends into discourse and general principles as narrative, both converted and concluded, falls away.

One distinctive mark of this ascent is the gradual recession of the trope by which writing is conceived as speech. Surrendering both the profession of rhetoric and Monica, Augustine appears to relinquish the vital connection between language and the body, as well as the implication that speech is the ideal or normative condition of language. This was not an abrupt or unmeditated decision. R. A. Markus notes "a profound shift in perspective" occurring between *On Christian Doctrine*, most of which was completed by 397, and *On the Trinity*, which was written several years after the *Confessions*, which appeared about 400. In the earlier work, Markus comments, signs are directly linked to the material world as substitutes for things; while in *On the Trinity* an unspoken word can free itself from substitution and present, as Augustine says, an unmediated meaning to consciousness "even before the images of its uttered sounds are rehearsed in thought" (15.19.10). In its power to address the mind directly, the unspoken or written word bears "a certain likeness" to the Original and Originary Word. Meaning is transmitted from it instantaneously, and the word itself, disappearing as an object, is one with the intention motivating it (Markus 80). The elevation of writing that steals over the tenth book of the *Confessions* condenses an evolution in Augustine's thought that is not fully articulated until *On the Trinity*.

As always, Augustine is prompted by the profit motive. "I have declared how it profits me to confess to you," he begins confidently; "And I make my confession, not in words and sounds made by the tongue alone, but with the voice of my soul and in my thoughts which cry aloud to you" (10.2: 207). Although ennobled by its analogical connection to Christ, the audible voice is mysteriously insufficient here, requiring supplementation by the noiseless voice of the soul, essential vocalization that speaks without a material mouthpiece, as God must have "spoken" the creating Word (11.6: 258). The confessing word seeks to share in the divine directness, its unmediated clarity, "And so my confession is made both silently in your sight, my God, and aloud as well, because even though my tongue utters no sound, my heart cries to you" (10.2: 208).

Augustine wants to claim (1) visibility, which secures accountability; (2) silence, the quality of interior knowledge; and (3) audibility, but only audibility to God, who hears the cries of the heart. Writing detaches language from its anchorage in the self, but compensates for this loss by fulfilling all the other conditions. We know from the

Confessions that Ambrose may have been the first man to read silently (6.3: 114). Fascinated by this new possibility, Augustine may have written the first text that demands to be read silently. It cannot be read aloud by another for it is Augustine's; and it is not read aloud by him for it is his text.

Renouncing the simple market economy associated with being "a vendor of words," Augustine enters the more sophisticated "capitalistic" economy of textuality in which a small investment in the dead letter of writing can bring a large return in the remission of sins and the cleansing of the soul. In William James's trenchant phrase, he who confesses has "exteriorized his rottenness," transforming himself in a way not easily achievable through introspection alone (462). In the traditional view, held by writers as diverse in their orientations as James, Bonhoeffer, and Sissela Bok, confession enables a breakthrough from isolation to fellowship and community, and therefore to openness, plain speaking, simplicity of soul, sincerity, and opposition to "all that is secret and hidden" (Bonhoeffer, *Life Together* 112; see Bok 76).

But profit in such an economy is always accompanied by downside risks, a factor that James, Bok, and Bonhoeffer miscalculate, but which Augustine does not. The first risk is that textuality subjects his confessions to misappropriation.

> Why, then, does it matter to me whether men should hear what I have to confess, as though it were they who were to cure all the evil that is in me? They are an inquisitive race, always anxious to pry into other men's lives, but never ready to correct their own. (10.2: 208)

Interestingly, when Augustine worries about the possible misunderstanding or misuse of his confessions, he describes them as spoken. Insofar as they are useless, ineffective, or opaque, they partake of the ephemerality and indeterminacy of speech. In this respect, the mortal syllables of spoken confession present a temptation to curiosity and complacency, contributing to the multiplication of sin. And suddenly Augustine becomes uneasy about his investment, beseeching God to "make me see clearly how it profits me to do this" (10.3: 208).

The second risk wells up within the first, in the violation of the essential interiority of knowledge. The gap between knowledge and the material sign had seemed so insurmountable to Augustine eleven years before the *Confessions* when he wrote *The Teacher* that he could not imagine any passage from one to the other: "We do not learn anything by means of the signs called words . . . we learn the meaning of the word . . . only after the reality itself which is signified is recognized,

rather than perceive that reality by means of such significations" (10.34: 174). In the circuit of knowledge signs are the outsiders, for truth can only be taught "internally" by Christ the Teacher, and is learned and known, as Paul says in a passage Augustine cites, by "the man's own spirit that is within him" (10.3: 208).

When it comes to receiving messages from God, Augustine wants mediation without words; but when sending messages to God in confession, he wants words without mediation. This dilemma points to the hovering problem of Book 10, the inescapable unity-in-resistance of profit and loss. On the social level, this principle integrates the confessor into the community, but only through falsification and misunderstanding. And on the epistemological level, it externalizes rottenness, but only by betraying the inner self.[3] This principle applies not just to autobiography but to all textuality, which liberates the sign from animality but places communication under a death sentence.

At the widest reach, the oscillation, or unified doubleness, of profit and loss characterizes the countless systems that comprise language as a whole. Everything that constitutes the intelligibility of language derives from those features that are at once arbitrary and peculiar to language. Language functions as an instrument of knowledge because we understand its structural conventions and rules of reference, rules systematized at one level in grammar and at another in rhetoric.[4] These conventions and rules lie entirely within the domain of language, with no necessary connection to subjectivity or worldly objects, much less to "truth" or absolute being. They exemplify the nontranscendence of mortal words, which exemplify the temptation to nontranscendence in mortal life. Nevertheless, they enable language to provide the confessor a "peculiar freedom and buoyancy" by virtue of the very fact that language "obeys its own set of laws," so that the position of the confessing subject is analogous to that of the player in a game which is at once arbitrary and deadly serious. I am borrowing here from Gadamer's description of the dynamics of faith, in which a "loss of self" becomes simultaneously a self-enrichment as the burden of worldliness is converted into "a condition of weightless balance" floating in what Augustine calls the "abundant sea" of language ("Self-Understanding" 53). Attractive as Gadamer's phrases are, they lack the ascetic subtlety and profundity. Augustine would surely have been dismayed to think of his confessions in this light, for according to Gadamer the linguistic subject can be relieved of the weight of selfhood simply by speaking in faith. Indeed, according to Gadamer, faith is not a struggle or even a willed act, but an event that happens *to* one; and there is no room in his analysis for the ascetic premise that man's life on earth is interminable

temptation. To the ascetic, the buoyancy of language offers not a release from temptation, but simply one more temptation.

The great tenth book of the *Confessions* tackles the central question: "What is God?" The path to the answer leads through the memory, which is one stage "higher" than the "natural faculty," and which presents a scene of such immensity and variety, such power and scope, as almost to seem a token of the divine, "the great force of life in living man" (10.17: 224). The memory is immortal, or at least un-mortal, too, in that it abstracts representations from sense impressions and stores them along with universal truths and mathematical verities, effecting a virtual ascesis of the world. As it contains, to Augustine's astonishment, images of himself, it seems actually larger than the person who can barely claim to possess it, and nearly answers the question posed in the opening pages of the *Confessions*—is God in man, or is man in God?—with the suggestion that both are in both.

But the coherence and integrity of memory are suddenly thrown in doubt with the recognition that the memory retains even forgetfulness (*oblivio*), which logically should obliterate itself. At this point his powers of analysis break down in the presence of the uncanny: "Who is able to carry the research beyond this point? Who can understand the truth of the matter? . . . I have become a problem to myself" (10.16: 222–23). The memory of forgetfulness signals a generative and creative faculty within the memory, and at this point the question that had lain like a slumbering dragon since the first book—"Can it be that any man has skill to fabricate himself?"—begins to stir again. And a new question arises to displace "What is God?": "What, then, am I, my God? What is my nature?" (10.17: 224).

In one sense, then, memory is a turning-away from God as well as a turning-towards, a regression as well as an advance. Its account of the past may be self-created or fictive, and may contribute to the illusion of self-fabrication (including the self-fabrication of the autobiographical narrative of time past). The duplicity of memory doubles that of writing, and for an excellent reason, one that Augustine clearly understood, that memory and writing are essential to each other. In *On Christian Doctrine*, Augustine had revived the Platonic idea that writing was invented as an *aide-memoire* because of the ephemerality of speech (2.4.5).[5] Augustine must have known, too, of Aristotle's characterization of the operations of the memory in terms of rhetorical functions. While Augustine might have resisted this characterization he must have been troubled by the bare thought of a link between the trace of divinity in man and the tools of pagan eloquence.[6] The "anti-metaphysical" potential of Aristotle's case is suggested by Derrida's use of it as an

argument on behalf of the inscribed "trace" as the "*arche*-phenomenon of memory," disseminating the presence it manifests (*Grammatology* 70).

With an almost perceptible collapse Augustine realizes that not only does memory betray a presumptuous power and fecundity, but it also provides the very basis of animal life: "For beasts and birds also have memory: otherwise they could never find their lairs or nests or the many other things which are part of their habitual life" (10.17: 224). At one point Augustine even compares the memory to a humble stomach.

The dismal coherence of Book 10 is beginning to emerge. Looking for God he had turned to memory, the basis of the ascetic removal from the world, only to discover fabrication and habit, the constants of temptation. Augustine turns now to temptation in the hope that once known it will be conquerable.

He discovers three types, which he articulates in order of ascending rarity and gravity. The first is sensual temptation, which he describes in general as the "lust of the eyes." The temptation of food establishes the type:

> I look upon food as a medicine. But the snare of concupiscence awaits me in the very process of passing from the discomfort of hunger to the contentment which comes when it is satisfied. For the process itself is a pleasure and there is no other means of satisfying hunger except the one we are obliged to take. And although the purpose of eating and drinking is to preserve health, in its train there follows an ominous kind of enjoyment, which often tries to outstrip it, so that it is really for the sake of pleasure that I do what I claim to do and mean to do for the sake of my health. . . . My unhappy soul welcomes this uncertainty [by which] under the pretence of caring for health it may disguise the pursuit of pleasure. (10.31: 235)

Resisting the temptations of food, or of the senses in general, is not entirely a matter of moderation, for assent lurks in the stoutest resistances, even in "medicine." Moreover, the difficulty is not properly in the sensual realm at all. The final sentences indicate that sin lies in the area of unconscious motivation, which is beyond his direct control.

The second temptation is *curiositas*, an impulse that includes the desire to witness freaks, prodigies, and other aberrations; all forms of vain inquiry such as necromancy and sorcery; and finally the simpler desire to observe natural processes such as a lizard catching flies. Again, although the route to resistance is apparently plain, *curiositas* "even invades our religion" when, for example, we ask for signs from God (10.35: 242). *Curiositas* is most serpentine when we simply attend to something, anything at all, without consciously praising God for the

disposition of the world. Even if we eventually come to praise we are too late, for "It is one thing to rise quickly from a fall, another not to fall at all" (10.35: 243). Again, this temptation is irresistible, for a perfect resistance would demand a perfect unresponsiveness to the world, a great dishonor to God and his creation.

The final temptation is "the desire to be feared or loved by other men" (10.36: 244), which Peter Brown misleadingly characterizes as the temptation of "friendship." Against this temptation no resistance is even theoretically imaginable, for confession itself is implicated in the sin. "If we are to do without praise in order to test our powers, are we to live such outrageously wicked and abandoned lives that all who know us will detest us?" (10.37: 246). Augustine's self-analysis becomes most pitiless in this section, yet he cannot construct a defense against this sin. Even when he reproaches himself for his love of praise he detects in the reproach an assent to a related temptation, "for often, by priding himself on his contempt for vainglory, a man is guilty of even emptier pride"; but not to be contemptuous of vainglory is to fall prey to complacency, "the vanity of those who are pleased with themselves" (10.38: 247, 248). This third form makes explicit the implications of the first two, that every profit is also a loss, that every advance is hobbled by regression, that desire cannot fail to be gratified. Book 10 concludes with a discussion of the mediation of Christ, who, as Priest and Sacrifice, Victor and Victim, is caught up in the same going-nowhere economy.

Beginning with a confident assertion of the profit of confession, Book 10 arises from the ruins of narrative, its discourse invested with the expectation that it will be a more perfectly ascetical form of expression in which the temptation to "linger" and to regard oneself as a finished product had been resisted. But the discourse of Book 10 not only investigates, almost obsessively, the inescapability of assent, but actually constitutes an assent to all three temptations it anatomizes. Still, the real point is even larger; it is that discourse itself is not a rarer, sterner, more austere or disciplined mode. In all the ways in which it differs from narrative—its subjectivity, attention to the present, and hospitality to the first person—discourse falls in with "nature's habits." Genette says as much when he points out that not only is discourse absolutely anchored in the world through its attention to its own circumstances, but it is if anything a less rigorous or exclusive mode: "narrative inserted into discourse is transformed into an element of discourse, discourse inserted into narrative remains discourse and forms a sort of cyst that is very easy to recognize and to locate. The purity of narrative, one ·might say, is more manifest than that of discourse."

Indeed, he concludes that "discourse has no purity to preserve, for it is the broadest and most universal 'natural' mode of language" ("Frontiers of Narrative" 141). The move to discourse may reflect a subtle and inevitable assent brought about by the effort to resist. But the important thing to notice is that it is a *move*, that the going-nowhere economy is still dynamic, still an engine of change, and that even if it never gets anywhere it still effects conversions that produce a sense of motion; and this sense, organized around the figure of Christ, can give rise to dreams of eternal salvation.

We might be tempted to regard this movement as idiosyncratic and peculiar to Augustine's text if it were not so exactly replicated elsewhere. Earlier I suggested that the "turn" in Heidegger's thought following *Being and Time* was comparable to the idea of conversion in the *Confessions*; but perhaps there is a broader resemblance between Heidegger's turn and Augustine's. Heidegger's early work constituted a critique of the metaphysical tradition in its insistence that the essence of human Being lay not in its ahistorical transcendence but in its historicity, its finitude. But as Derrida and others have pointed out, Heidegger remained bound to the tradition he sought to overturn, a bond perhaps most apparent in his use of notions of "conscience" and "temptation," and in his opposition of "authentic" to "inauthentic" being. Indeed, Heidegger's inauthenticity closely resembles Augustine's temptations, as it is dominated by concepts of "they," "idle chatter," and "curiosity."

In the 1936 lecture "On the Origin of the Work of Art," Heidegger seems to have recognized his earlier covert metaphysical allegiances, and tries to correct the situation by opposing himself on a key issue. In the earlier work the idea of "world" served as a kind of horizon for human self-understanding. But in the essay a counterconcept appears alongside "world": "earth." The world is a principle of openness, a "consecrating-praising erection" opposed by the earth as a principle of self-seclusion and self-concealment.

> World and earth are essentially different from one another and yet are never separated. . . . The world, in resting upon the earth, strives to surmount it. As self-opening, it cannot endure anything closed. The earth, however, as sheltering and concealing, tends always to draw the world into itself and keep it there.
>
> The opposition of world and earth is a striving. But we would surely all too easily falsify its nature if we were to confound striving with discord and dispute, and thus see it only as disorder and destruction. In essential striving, rather, the opponents raise each other into the self-assertion of their nature. (45)

Thus the "clearing" of Being is pervaded by a constant concealment that emerges with and within the openness. Even through Heidegger's rhetoric we can feel the pressure of Augustine's economy declaring itself once again. This declaration is all the more remarkable as "The Origin of the Work of Art" supposedly marks an even more decisively anti-metaphysical position than that of *Being and Time*. Heidegger's "striving" to free himself from the temptation of metaphysics is itself afflicted with the spirit of ascetical renunciation and is therefore partly concealed from itself, just as Augustine's assents were concealed within his resistances. The ascetical impulse operates, even flourishes, within an explicit refusal to be ascetic. The renunciation of asceticism is still ascetic.

The play of reciprocity in "The Origin of the Work of Art" works to destabilize not only the ontology of the aesthetic object, but also the conventional idea of the subject. The creation of the work of art by the artist includes an act of "co-creation" by the beholder. This "preservation," essential to the work of art, calls into question the idea of the artist as expressive subject by implicating the beholder in the work from the outset. The difficulties this co-creation presents for the interpreter who humbly, even desperately, seeks only to understand and explicate provide Augustine with subject, problem, and task in the last three books of the *Confessions*.

The Fertile Word

*I*f, as Roland Barthes says, a writer "is someone for whom language is a problem, who experiences its profundity, not its instrumentality nor its beauty," then Augustine was surely a writer (*Critique et vérité* 46). Author of a thousand books—many short, many lost—Augustine was so prolific that, according to a fifth-century witticism, only God had read him through. Driving this phenomenal productivity were not only genius, energy, and endurance, but also an absolute conviction that writing was indispensable to his life and ideology, the only worthy conclusion to the story of conversion he documented in the first part of his confessions.

The elaborately mimetic, even literary character of the conversion in Book 8, in which models are stacked upon models and cumulatively opposed to "nature and nature's appetites," clarifies the "choice" of conversion. Either Augustine can continue to insist on his own uniqueness, denying that he is in any way an imitation of his textual and real-life predecessors; or he can accede to the proposition that his story has, in its essential outlines, already been written. In converting, Augustine acknowledges that he has been "preconverted," as it were, all along—converted to God, converted to textual representation. Conversion accompanies a type of readership in which literary interpretation is a form of self-knowledge; and in which self-knowledge, by a further extension, carries with it the conviction that one is and always has been permeable to other and textual selves. To be converted is to understand that one's essential self is contained in and expressed by those models.

The force of the "critical moment" of conversion in the garden in Ostia, then, is to discredit not only the very idea of a free, convertible ego, but also the notion of a critical moment; for what the conversion means (and one comes to this realization all of a sudden) is that one has been conducting one's life under a mistaken belief in one's autonomy: it means that one's essential life exists out of time, or in the erased time of textual narrative.

What this moment does for Augustine that may be considered critical is radicalize the question, "What next?" What becomes a legend most? Clearly, the answer is, a written account of one's own career, an account that enables the author to link up with the chain begun by Christ's "Follow me." The convert imitates Christ by converting himself into a textual representation which both imitates the textual imitation of Christ in the Gospels and serves as an imitable model for others. In a deeper sense, writing in general offers itself as an activity fit for one whose highest ambition has become the purging of the "*hors-texte*" from his life, the abolition of everything not textualized or textualizable. The ascesis of writing enables the articulate convert to "die to the world" so that he may "live in the spirit." Mortifying and deadening an unstable and temptable subjectivity by submitting it to a code, textual self-representation performs a function analogous to ascetic discipline, analogous to martyrdom.

Approaching God through his Word, striving to be the referent for that Word, the ascetic bears witness to an ethics of language. While the written word is unalive, inert, material, it is also capable of pointing beyond itself, to transcending itself in its meaning. Paul Valéry has this "conversional" aspect of language in mind when he writes that "the essence of prose is to perish—that is, to be 'understood'—that is, to be dissolved, destroyed without return, entirely replaced by the image or impulse that it conveys according to the conventional language" (46). Less eloquently, Husserl defined the "successful reference," like the successful conversion, in the disappearance of the signifier into the signified. Gadamer extends the point to include not just prose but all language, which, in its "essential self-forgetfulness" "vanishes" behind what is said in it ("Man and Language" 64–65). But while language condenses the dynamics of conversion, it can also "tempt" the reader to overvalue either the material signifier or the (transcendental) signified. Its double ontology structures a scene of temptation and so exemplifies man's life on earth.

The *Confessions* are a sustained and incremental resistance to such temptations, a restless, discontented striving after the perfect ascetical mode of being, the perfect ascetical practice of writing. As writing, the

text betrays a search for the mode that most fully exploits the conversional aspect of language. This striving helps explain the differences and the continuities between the three parts of the text. Books 1–9 document an unselfconscious and transgressive self, recording the worldly career of the man Augustine. The ascesis of these books is imperfect because they explore and preserve only the outer man, that part of the human being analogous to the grapheme itself. Book 10 turns to the inner self in a discourse on memory and temptation; but in this book Augustine, it seems unexpectedly, discovers in the mind principles of autonomy and unmasterability inconsistent with his goal to be "cast and set firm in the mold of your truth" (11.30: 279). In the last three books Augustine abandons the self as object of study altogether and dedicates himself to Scriptural exegesis as the most perfectly "converted" mode of writing, even of being.[1] Cleaving to the Word, humbly producing the intentionality behind the sign, exegesis is at once a secondary, imitative, and self-denying mode, a way of writing with no reference in the self, and therefore a mode of pure writing. It is also, as Borges has noted, "the mother of heresy," for the exegete is in the position Kierkegaard assigned to Eve, making judgments about the Word, presuming an expressive power superior to God's.

This intriguing possibility, whose consequences have been so flamboyantly enacted by recent literary criticism, has gone virtually unnoticed by Augustine's readers, who almost unanimously have found virtually nothing of serious interest in the last three books. Scholarly discussions of the *Confessions* typically avoid these books altogether, and even in critical studies that deal specifically with the entire text a veil generally falls over the exegetical portion, as if it could simply be nodded to, as if no analysis were necessary or even possible. Spengemann discusses these books in an extremely cursory way, characterizing the thirteenth book in terms no more specific than "faith"; Vance, in an article on the "grammar of selfhood" that takes these books as its ostensible focus, in fact refers to them only briefly, concentrating on what precedes them.[2] Peter Brown reveals his reluctance to venture out of the realm of cultural history in his virtual dismissal of this part of the text simply as "a fitting end to the self-revelation of such a man: like soft light creeping back over a rain-soaked landscape, the hard refrain of 'Command'—'Command what You wish'—gives way to 'Give'—'Give what I love: for I do love it' " (*Augustine of Hippo* 180). Brown has caught the note of desire but has mistaken it for passivity, a point I will take up later on. Perhaps the most mysterious disappearance—and the one revealing the most exaggerated will to power—is that of Kenneth Burke, who after analyzing the first ten books at enormous length

simply turns away from Augustine at that point and conducts his own exegetical study of Genesis.

Behind the academic resistance to Augustine's text precisely at the point where its author believes he has discovered his subject lies not only a preference for narrative over commentary, but also a sense that Augustine's methods belong to a tradition that, however, historically valuable, is now safely locked away in the museum, or mausoleum, of yesterday's *idées reçus*. Critical theory defines itself—and indeed, for the past century or so has always defined itself—against the hermeneutical practices employed by the Doctors of the Church, whose methods were meant as ways of replacing uncertainty by certainty. Traditional "allegorical" exegesis supplements an enigmatic and figural sign with a clear one in the confident expectation that such a clarification is both effective and virtuous, a normal operation implicit in and even in effect desired by the language of Scripture itself.[3]

To be advanced, to be contemporary, has, on the other hand, been for quite some time identical with certain forms of skepticism. Advanced critics do not hold the text in reverence, they do not presume a perfectly expressive authorial intention, they do not regard the text as infallibly true, they do not search for the signified. Respecting the multiplicity, "polyvocality," or "dissemination" of textual meaning, critics today often speak of *reading* instead of *hermeneutics*, and advocate not a replacement of the text with understanding, but rather the supplementation of one text by another equally linguistic, equally unstable, even equally "literary." This is the spirit in which Geoffrey Hartman argues in *Criticism in the Wilderness* for an "unpredictable" criticism that refuses to "be subordinated, a priori, to its referential or commentating function," a criticism that does not seek to stabilize the text, but rather participates in the text's instability (201). The most influential theoreticians today are likely to be suspicious of Husserl's "successful reference" and more receptive to arguments by Ferdinand de Saussure and C. S. Peirce that signs refer not directly to things, meanings or intentions, but only to the ungrounded system of other signs. For Paul de Man, a rigorous reading produces not the quiet calm of certain understanding but a profoundly unquiet "state of suspended ignorance" ("Semiology and Rhetoric" 19).

Such a state represents one way out of what many consider the "rightist" practises of the past. *The Anti-Oedipus* by Gilles Deleuze and Félix Guattari is idiosyncratic in many respects but highly representative in the general import of its polemic against the Freudian strategy of reducing the rich and random multiplicity of experience to a few strategically contained terms such as the family romance, "nar-

cissism," or the "oedipus complex." Proposing an anti-interpretive method ("schizo-analysis"), they seek to restore multiplicity by denying the transcendental privilege of certain ur-narratives.⁴ Derridean decon-struction, Marxist textual analysis, and feminist critical theory share with schizo-analysis a rejection of various strategies of containment, and a critique of models of transcendence and privilege. The most appealing statements of this position come from Roland Barthes, who argues for the "triumphant plural" against the "ascetic" interpretive practices of the past (*Pleasure of the Text* 3). Fortunately, Barthes asserts, criticism has, "over the last few years," moved away from the paradigm of the Work (author-bound, self-enclosed, determinate) to that of the Text (the opposite). In the ideology of the Work, Barthes says, "plural is Evil. Against the work, therefore, the text could well take as its motto the words of the man possessed by demons (Mark 5:9): 'My name is Legion: for we are many' " ("From Work to Text" 160). "We now know," he says in "The Death of the Author," "that a text is not a line of words releasing a single 'theological' meaning (the 'message' of the Author-God) but a multi-dimensional space in which a variety of writings, none of them original, blend and clash" (146). None of them original—none with Authority, none with the power or right to constrain interpretation. Indeed, the entire goal of interpretation runs against the grain of the Text, with which our relation should not be one of understanding, but of pleasure, of *jouissance*. The most fundamental principle of Scriptural hermeneutics, transcendent authority is consid-ered a principle of regression, false consciousness, and nostalgia.

Foucault provided the canonical formulation of contemporary criticism's resistance to authority in his mockery of author-oriented hermeneutics in the famous essay "What Is an Author?":

> The question then becomes: How can one reduce the great peril, the great danger with which fiction threatens our world? The answer is: One can reduce it with the author. The author allows a limitation of the cancerous and dangerous proliferation of significations within a world where one is thrifty not only with one's resources and riches, but also with one's discourses and their significances. (158–59)

In this essay Foucault was trying to establish the basis for a prodigal semiotics that recognizes only an "author-function," not an individual intending author, and certainly not a perfectly expressive, transcendent Author. His strategy was to appeal to the proliferative system of language, an appeal that situated his argument immediately in an historical polemic against the interpretive practices that dominate—

indeed, that constitute—the "cultural" element in Western culture from the Early Christian era until the Renaissance.

The exclusion or suppression of the author is not always conducted as an appeal to the mere play of signification. The elimination of the author enables a demystified criticism less indebted to the bourgeois glorification of the ego, a criticism that can be attentive to the silenced or suppressed "voices" in the text, to the historicity of a text, to the ways in which the text organizes and reflects social practices and cultural values. This attentiveness, too, is set against an earlier concentration on an ahistorical and transcendent meaning epitomized in the commentaries on Scripture authored by the Church Fathers. For many critics today the unequivocal enemy is the idea of the definitive reading, the One Meaning sanctioned by neo-theological orthodoxy, critical piety, or cultural patriarchalism. Edward Said speaks for many others when he argues that criticism should take on a more frankly inventive and even subversive function, exposing meanings that "otherwise lie hidden beneath piety, heedlessness, or routine." Most of all, criticism should become "worldly" by opposing "monocentrism" in all its forms. "Monocentrism," he writes, "is practised when we mistake one idea as the only idea, instead of recognizing that an idea in history is always one among many" ("The Text, the World, the Critic" 188). In Said's view criticism is properly historicist, and properly contemporary, when it is celebratory, restorative, and emancipatory—when it is "poly" instead of "mono." In this mood, today's advanced readers mark their contemporaneity by positioning themselves against the monocentric, Author-bound, joyless, subservient, and ultimately pointless labor of the sort (presumably) exemplified by Augustine's practice in books 11–13 of the *Confessions*.

What needs to be stressed in this minimal inventory is the way in which critical theory typically defines itself in opposition to various aspects of a discredited hermeneutics exemplified by Scriptural exegesis. When Althusser calls for a critical method in keeping with the spirit of Marx's *Darstellung* ("the concept whose object is precisely to designate the mode of *presence* of the structure in its *effects*" [189]), he is arguing against transcendent structures in general. When Fredric Jameson calls for an "ideological analysis," he is repudiating an "immanent analysis" that seeks to recover the truth of the individual author's intentions. When Gadamer claims that language necessarily exceeds the intentions of the author and that we understand *differently* when we understand at all, the force of his comments derives from their tacit opposition to the view that a full understanding of intention is the goal of reading. When semiologists draw attention to rays and layers of intertextuality, they are

implicitly rejecting the unique bond between intention and sign. When Derrida encourages the liberation of the play of signs from the governing idea of authorial presence and thematic construction, he is running against the ancient habit of conceiving the author on the model of God animating the Word, or the world.

While this distancing of the practice of criticism from its origins is understandable, it is also self-serving and more than a little defensive. One of its more dangerous effects might be to marginalize Augustine as a thinker of contemporary interest, impoverishing not Augustine, of course, but ourselves. To prevent this, we need to open up the specific content of Augustine's exegesis so that we may see what he actually discovers about the Word.

At this point Augustine may be permitted to enter the discussion in order to speak for himself, or rather to write for himself, for as he says, "my pen is my spokesman," (11.2: 253) and exegesis is manifestly a mode of writing. It is a mode, too, that accords greatest privilege to the author, a privilege Augustine may be presumed to take for granted. As even one deconstructionist critic of the *Confessions* (whose goal, he writes, was to measure "how much 'free-play' was inscribed" in the text) has written, "What he must strenuously insist upon . . . is the prestige of authorship, of the Author-authored links, of the voices of created beings . . . saying that they do point, if only that, toward their Maker" (Flores 294). The "prestige of authorship" denotes not just the interpretive assumption for Scriptural exegesis, but an entire cultural situation in which all texts are seen in a specifically patriarchal line descending from the Bible, a situation in which reading is intimidated from the outset. One characteristically modern response to this situation is to insist on the replacement of the transcendental author by the "scriptor," who "no longer bears within him passions, humours, feelings, impressions, but rather this immense dictionary from which he draws a writing that can know no halt" (Barthes, "Death of the Author" 147). But the scriptor is not the invention of the "last few years"; it is the most ancient of authorial principles, defining not only the provisional "author" of oral-formulaic narratives but also the author of the Biblical text itself: God "filled" Moses with himself, remaining impeccably absent from the text, serving Moses in the same way that the dictionary serves the scriptor as the reservoir from which the writing is drawn.

For Barthes, the death of the author has cleared the way for the birth of the reader, whom "the new writing" has unearthed from the debris of "Classical criticism" (148). For readers of the *Confessions*, however, this renaissance is unnecessary. For the absolute prestige of authorship and the presumption of divine inspiration in every particle

of the text have the reverse effect of what we might expect: the reader is not only encouraged to speculate about the meaning of obscure passages (see 6.5: 117), but is morally obligated to do so. Barthes says in *The Pleasure of the Text* that all criticism rests on the assumption that the text contains insignificant elements, that is, "nature" (51). This element is particularly strong in the system of reading most appropriate to the modern text, which compels us "not to devour, to gobble, but to graze, to browse scrupulously, to rediscover . . . the leisure of bygone readings" (13). Strikingly, the reading of the ancient text of saturated meaning, the text that transcends and discredits all culture, is similarly "natural." Augustine describes the situation at the beginning of Book 11:

> . . . nor is this forest without its deer, which repair to it and there refresh themselves, roaming at will and browsing upon its pastures, and lying there to chew the cud. (11.2: 254; ref. to Ps. 28:9)

We cannot overlook Augustine's intense concern over "wandering" or "useless" interpretations (see *On Christian Doctrine*, 3.9.13), but neither can we fail to appreciate the perhaps unexpectedly latitudenarian attitude he has towards pluralism, an attitude that brings the Bible perilously close to Barthes's text of pleasure, "a sanctioned Babel" (4).[5] It is precisely the prestige of God, the infinite privilege accorded him, that places him at one remove from the scene of textuality, which is abandoned to humans, or to human "deer." Some readers of Barthes have complained that he would empower neither author nor responsible critic but only the irresponsible and self-indulgent reader, but what such a critique may overlook is the sanctioning of the reader who roams, browses, and even chews the cud in the most "classical," most austere readership in our tradition. To judge from this image of Augustine's, Scriptural understanding is an innocent and unconscious walk in the woods. The Bible's plenitude does not harbor pockets of nature; it is *all nature*, all given.

The great Augustinian scholar Pierre Courcelles speculated that Augustine intended to write a commentary on the entire Bible, a complete exposition of the faith, to which his own autobiography would serve as a preface. But if such a project had occurred to Augustine, the eleventh book would surely have persuaded him of its impossibility, for it is entirely devoted to the sentence, "In the beginning God created heaven and earth."

Concerning this plain sentence, countless questions throng in: How do we know Moses is telling the truth? How could we understand his Hebrew even if he were here to tell us that he was—and why should

we believe him? How could God utter the creating Word without a previously created material mouthpiece? How did God decide to create; how did a new thought arise in him? And what is time that we can know "the beginning"?

The most vexed question in this book is that of time. If the phrase "the beginning" is to have any meaning it must be understood not only from the "point of view" of God, who never suffers alteration, but also from that of humans, who do so constantly. Time has no meaning at all in terms of God, but no concept is more dense with meaning for humans; and thus the concept of time addresses the incomprehension that attends any human attempt to understand God. But time is also incomprehensible from the strictly human perspective, for, dense though it is, time dissolves instantly upon examination into traces and species of nonexistence. Of the three divisions of time, two of them, past and future, cannot be said to *be* at all, while the third *is* only in the sense that "it is *not to be*" (11.14: 264); its existence consists of an imminent, and virtually immanent, nonexistence. The present is but an articulated absence, "coming out of what does not yet exist, passing through what has no duration, and moving into what no longer exists" (11.21: 269). Pressing ahead—and nowhere in Augustine is the sense of the process of discovery more compelling—he declares that the fundamental nature of time is "an extension, though of what it is an extension I do not know. I begin to wonder whether it is an extension of the mind itself" (11.26: 274). And how do we measure this extension? The best model turns out to be the measurement of syllables of speech as they are anticipated or recalled. What this means is that the measure of time is human, rather than divine creation, mortal rather than immortal words. And what this means is that time does not exist; it is a temptation: "I must not allow my mind to insist that time is something objective" (11.27: 276).

Beginning at the beginning, with the origin of the cosmos—for Augustine the most manifest and verifiable event imaginable—he arrives swiftly but through wildly swerving detours at his own mind. As in Book 10, when the question "What is God?" became, within a few lines, "What am I?" so here the issue of divine creation leads him directly to the self he is seeking, through exegesis, to efface. Even exegesis seems to harbor a secret principle of autobiography.

The subject of Book 12 is the phrase "heaven and earth" and the following sentence, "The earth was without form and void, and the spirit of God moved over the face of the waters." But in terms of hermeneutics the subject is the multiplicity of truth and the inability of the mind to embrace the totality of the text, even a text constrained by

transcendent authorship. What Augustine discovers as he reflects on the text is the illimitibility of interpretation—not just of possible interpretations, but of *right* interpretations.

Augustine's thought is worth following here in detail as he ponders the question of what God made and what he made it of. The evolving answer is that he made heaven and earth out of nothing at all; he did not, in other words, make them out of himself, for they are mutable. "Heaven" and "earth" signify, respectively, a principle of mutability without actual mutation, and a principle of mutability with mutation; both were fashioned from a formless void that was itself more than nothing, although literally inconceivable as anything definite. Like time, the ur-material of the cosmos is a version of nothing, such minimal stuff as to be utterly without attributes. Why creation? How creation? It is a mystery of such irreducible wonderment that we must be content "to know without knowing, or should I say, to be ignorant and yet to know" (12.5: 283). This state of "de Manian," or perhaps demonic, suspension exemplifies the issue of exegesis for Augustine. Pondering the Word, hard things become soft, to use Kant's terms; objects become absorbed into the subject or evaporate into fine conceptual mist, a transformation (or conversion) that seems implicit in understanding itself but which is here dramatically thematized in the dissipation of time, heaven, and earth, the disintegration of all the nouns.

The real fascination of Book 12 is what Ricoeur calls the "conflict of interpretations," a battle whose turning points are easily marked. Gazing down into the stupendous "depth" of the Scriptures Augustine sees not the bottom of the well but rather a pool of aggressively conflicting interpretations propounded not by enemies of God's word, whose views can simply be thrown out, but by faithful "acclaimers" of it. To these believers Augustine makes an initially vigorous response. "This is the case I put to them," he says: "Within me I hear the loud voice of Truth telling me . . ." (12.15: 290). "What do my opponents reply to this?" he demands; and he provides their reply. By the middle of the twelfth book the form of discourse is not argumentation but dialogue, with Augustine casting himself in one role in a discussion that includes more and more voices until Augustine's own voice is nearly overcome. "Others may maintain that . . ."; "Others again may say that . . ."; "Still another theory might be that . . ." (12.17: 294–95). Beginning with the loud voice of truth and dispersing into a cacophony of truths, the argument itself replicates the history of the world in its inevitable and yet transgressive fall from immutable unity into particulate dissemination. "How can it harm me," Augustine implores God,

or his reader, "if I understand the writer's meaning in a different sense from that in which another understands it?" (12.18: 296).

How can it harm me? This preface to transgression announces an erosion of control for the interpreter aware of the infinitude of truth. In chapters 20 and 21 Augustine abandons his own voice altogether in favor of a series of sentences beginning, "Another says. . . ." In chapter 22 he does not merely report conflicting views, but rather impersonates the voice of such a view, not his own. He is "quite sure that [Moses] saw the truth and expressed it accordingly" (12.24: 301), but this certainty, like the absolute prestige of the author, has the effect of placing the issue of truth out of play, inaccessible to criticism. The fact that we know that the text is true only means that we cannot limit interpretation by referring to some external circumstance, for truth is not "out there" but "in here," in the text itself, where it remains despite Augustine's efforts to extract and express it. By chapter 25 Augustine has given up on interpretation, given up on reporting alternative interpretations, given up on impersonations of interpreters, and states only what he would say if he were to speak: "If anyone were to ask me what Moses meant . . ." (12.25: 301). Not even Moses could settle disputes or put the brakes on interpretation, for "Even if Moses were to appear to us and say, 'This is what I meant,' we should not see his thoughts but would simply believe his word" (12.25: 302).

In such a situation interpretation is reduced to what Carlo Ginzburg has called the "conjectural method," which treats everything, including details that appear absurd and trivial, as though it bears a potentially great significance. The conjectural method works through random and unsystematic means to infer the whole from the parts, the cause from the effects, no matter how various or aberrant those effects may be. Ginzburg claims that this method "stemmed from the distinction . . . between the certainty of divine knowledge, and the provisional, conjectural nature of human knowledge," but there is no distinction, for there is no divine knowledge accessible to humans, not even when the loud voice of truth speaks within us.[6]

In conventional terms truth is "the possibility of referential verification," or "the correspondance between the mind and some set of objects." But for Augustine in Book 12 truth is a principle of excess in language, a measure of meaning exceeding any possible interpretation, any coherent authorial intention. Truth in Book 12 has fallen under the spell of what D. A. Miller has called the "literature-effect," the subversion of the closural decorums set up by a text by the disseminal operations of language, narrative, or desire. A property of every right interpretation, truth is multiple (indeed, infinite), public, dispersed

among readers who together must try to assemble the totality God intended. Interpretation becomes by necessity a collective process, for the human mind, bound to time and grammar, can only comprehend a fragment of the divine intentionality. It is also an act of self-denial, the submission of the personal both to the absolute and to the communal. All true interpretations are shared, but "he who utters falsehood utters what is his alone" (12.25: 302). Faith grants not the meaning of the text but only the assurance that the text means, and that the meaning is true.

Supposedly, the Higher Criticism of the nineteenth century effected a radical break with traditional exegetical methods by disclosing, instead of a single animating inspiration, a multiplicity of sources and redactions held together by an anonymous and unsystematic process of compilation. But Higher Criticism did not contribute a new principle to the study of the Bible; it simply transferred the principles of multiplicity and unmasterability back from the community of interpreters to a community of scriptors. Long before the advent of Higher Criticism, ascetic self-extinction had produced a "carnivalized" text, a text speaking in many voices. If conversion had brought about an "aesthetic" conquest of chance in Augustine's life, had enacted a certain "death drive," exegesis—transcendent, ironic, and comic—now restores indeterminacy both to the Word and the interpreter.[7] In so doing, it actually seems to work for desire and against knowledge, against coherence. As Deleuze and Guattari have said, "Desire makes its entry with the general collapse of the question 'What does it mean?' " (109).

By the thirteenth book we can no longer ignore the collusion between desire and exegesis, for this is the subject of Augustine's discussion. One of Kenneth Burke's discoveries was that Augustine's conversion was specifically Trinitarian, progressing from the Father (Power) to the Son (Wisdom) and finally to the Holy Spirit (Love) (85–86; 106–07; 111). Accepting Burke's discovery, I would suggest that the final book is the domain of Love. But as the exegetical activity of Book 13 progresses, we become aware precisely of the difficulties that attend the equation of Love with the Holy Spirit. For when the Scriptural text has replaced all other objects of desire, the interpreter assumes a posture of voluptuous submission, laid open to the Word. Moreover, in the thirteenth book the Word has acquired a density, a worldliness, that it did not have in Book 12, in which it is an engine for the explosion of univocal truth. Perhaps a "successful conversion" would be completed when the self was reduced to one function, writing; and to one motive, love. Augustine seems to desire such a reduction when he writes, "I write this book for love of your love" (11.1:

253). But to see love as a mere substitute word for the Holy Spirit is to miss the point both of the Holy Spirit and, of course, of love.

In Book 13 language itself is under scrutiny in a discussion that will acquire force if we take a moment to recall some of the principles of interpretation announced in *On Christian Doctrine*. The interpretation of the Bible, Augustine says, must produce a twofold love of God and our neighbor (1.35.39); all meanings must be consonant with all others (1.37; 3.27–28); all meanings must contribute to charity and censure lust (3.10.15–16); the literal meaning is primary but if no literal interpretation meets the above conditions then the figurative must be considered (3.10.14). Curiously, these constraints on free interpretive desire harbor their own temptations. Literalism, for example, is primary because of its plainness and directness; but it is also linked to carnality, and the literal reader is in constant danger of confusing signs with things (3.5.9). Figurality is also a cloven concept, for although it is a secondary mode it is also "higher" than literalism.[8] Its obscurity, moreover, has the worldly effect of "subduing pride by toil" (2.6.7), and, incidentally, of enlisting desire: "It is pleasanter in some cases to have knowledge communicated through figures . . . [for] what is attended with difficulty in the seeking gives greater pleasure in the finding" (2.6.8). Thus the figures of Scripture stimulate "nature's appetites"; they glow with a "darkening radiance," as Gerald Bruns says of allegory, masking the blinding light of transcendence with their own alluring luminosity.

One way to think about figurality is as a preview of eternal bliss, a confounding of the normal operations of language that "prefigures" a time when the "canopy of skins" separating heaven from earth will be rolled back and we can enjoy "face-to-face" intimacy with God (see 13.15: 321–23). Figures, in other words, imply the end of time, when all earthly language vanishes, as Gadamer suggests, into unmediated meaning. The concept of figuration as prefiguration stands behind Augustine's justification of the Bible's obscurity: "Man with his natural gifts alone is like a mere infant in Christ's nursery. He must be fed on milk until he is strong enough to eat solid food, and until his sight is fortified to face the sun, if he is not to be left in a night of utter darkness, he must be content with the light of the moon and the stars" (13.18: 326). The charming domestic image contains a nuance we must not overlook, that the present stands to the future as liquid to solid, reflected to direct. The end of time will not bring a greater ideality but an infinitely greater substantiality: in the future we will be eating real food, seeing real sights.

This moment in chapter 18 suddenly crystallizes a gathering force in the text, a force indicated by the increasingly frequent reference to images of bounty, fertility, even satiety. As Augustine moves through

the words of Genesis, this new energy erupts on contact with God's command to "Be fruitful and multiply," a dispensation given to all living things, including the living Word, now situated among the works God has wrought. "Can it be," Augustine wonders, "that I am confusing the corporeal works which [you have] accomplished . . . with the clear understanding of these mysteries . . . ?" (13.20: 328). As a principle of creation the Word belongs to the historical, material world; it does not "perish," as Valéry says, but lives and breathes—indeed, breeds. Thus the "metaphysical" Logos both grounds language in transcendence and anchors transcendence in the world. The objects of reverence and awe in Book 13 are the "wonders of a palpable, material kind" (13.20: 329) that testify to the operation of the Spirit on earth. The Word is compared to fruit, to fishes, to soaring birds. Augustine even says that the "earth produces the living soul" rather than the other way round (13.21: 329). The One Meaning of the Bible may be, as he says in *On Christian Doctrine*, the "pulling down of the dominion of lust" (3.11.17), but Paul "begot children in the Gospel" (13.22: 332), and the Word is always and everywhere spectacularly fertile.

If we read this book back into the conversion we can see that conversion does not stabilize the subject by purging it of desire, but rather shifts desire from the world to the word, to (in Barthes's phrase) "the sumptuous rank of the signifier" (*Pleasure of the Text* 65). We may speak, then, not of a converted subject but of a rerouted desire that discovers its object in language, the true medium of sexuality. In a remarkable passage explicating God's command to be fruitful and multiply, Augustine describes language in terms of the reproductive processes in the sea and on dry land:

> But it is only in the case of signs outwardly given that we find increase and multiplication in the sense that a single truth can be expressed by several different means; and it is only in the case of concepts apprehended by the mind that we find increase and multiplication in the sense that a single expression can be interpreted in several different ways.
>
> I therefore understand the reproduction and multiplication of marine creatures to refer to physical signs and manifestations, of which we have need because the flesh which envelops us is like a deep sea; and I take the reproduction of human kind to refer to the thoughts which our minds conceive, because reason is fertile and productive. . . . This explains how the fish and the whales *fill the waters of the sea* [Gen. 1:22], because mankind, which is represented by the sea, is impressed only by signs of various kinds; and it explains how the offspring of men *fill the earth* [Gen. 1:28], because the dry land appears when men are eager to learn and reason prevails. (13.25: 336–37)ꞏ

The production of signs is figured by submarine fornication; interpretation, by fornication on dry land. When we make signs we love like fish; when we understand them, we love like humans. But in the sea and on the land the almighty principle of increase prevails. So complete is the rehabilitation of the pullulating material world that, whereas in Book 10 he condemned the "lust of the eyes," he now proclaims, "Thanks be to you, O Lord, for all that we see!" (13.32: 343)

From life as temptation, life to be *hated*, we have arrived gradually, and yet with an impression of suddenness, at life as feast, as celebration, as banquet of desire. The refrain running through the final chapters is God's affirmation: It is all very good. Nowhere in Book 13 is the self problematic; the desiring subject has taken its place among the works of God, the works of the world, the functions of the Word. Perhaps the *Confessions* end at this point not because Augustine got tired but because the project of converting the self to the Word was concluded. But inasmuch as the Word has been "converted" to desire, the conversion seems to have gone backwards, and the *Confessions* are in their own terms a failure. Augustine is unable to arrive at a truly renunciatory mode because every denial, every submission, simply results in more power, more pleasure.

Barthes analyzed critical desire as a product of the critic's speaking to an "other," of a recognition of heterogeneity in the symbolic order, and of the implication of history and the body in the realm of the symbolic (see *Critique et vérité* 33). His analysis marches under the banner of modernity against traditional criticism and ascetic morality, but all of Barthes's insights are anticipated and vividly *experienced* by Augustine. Following Barthes, "advanced" contemporary criticism is in the position of heralding a conversion that has already occurred.

But "conservative" contemporary criticism is in an even more anomalous position, shared by "canonical" interpreters of Augustine's text, of triumphing in a conversion that has not yet occurred and could never occur. For the successful conversion, like the successful reference, is an impossibility from the outset. Not even the angels dwell in unobstructed clarity of meaning; Augustine can describe their understanding of God only in terms of a perfect reading. "They read your will: they choose it to be theirs: they cherish it. They read it without cease and what they read never passes away. . . . The book they read shall not be closed" (13.15: 322–23). As a dead code, writing, unlike speech, *lingers*; and exegesis is a purer writing in that, intensively and deliberately, it lingers on the lingering of other writing, paying, in this case, rapturous, devoted, passionate homage to its otherness, its materiality, its power. We now know why life must necessarily be "*one*

long trial," and why, as Augustine says elsewhere, "When you hear a man confessing, you know that he is not yet free."[9]

What Augustine's capacious and exceptionally fertile example suggests is that the opposition drawn by Barthes and implicitly honored by many others between the "ascetic" practices of "Classical criticism" and those of contemporary criticism is far from absolute. In fact, it is possible to track a movement in books 11–13 from "Classical criticism," with a self-effacing reader confronting a text of transcendence, through various forms of modernity which include invocations of indeterminacy, polyvocality, pluralism, and desire—presumably anti-ascetic values that are still contained in an ascetic practice of reading. Perhaps the classic and the contemporary are best considered as internal variants on such a practice rather than as truly opposed and discontinuous. Rigorous distinctions between ascetic and nonascetic may reflect an ignorance of the richness and plasticity of the classic, and a correspondingly feeble and one-dimensional view of the possibilities of contemporary criticism.

For Augustine, the essence of asceticism was the submission of the merely personal to a text of transcendence. This text addressed the inner being, the divine essence, the soul, and so was anchored both in transcendence and interiority. And yet as everybody has a soul, ascetic hermeneutics is necessarily social, for all true readings will be consonant. So the ascetic practice of reading was at once, and profoundly, personal, transcendent, and social. It is grounded and groundless, relative and absolute, restrictive and carnivalesque, univocal and pluralistic. In short, it covers the field.

What, we may ask, would a nonascetic theory of reading be like? It would be no theory at all, for it would eschew the hierarchies that define theory. To name only the most important, it would not distinguish between meanings perceivable only to one reader and those apparent to many. Augustine's principle that error is one's own while truth is common to all is simply the principle that enables interpretation in the first place. No theory can do without the distinction between the idiosyncratic and communal; and no theory, having made the distinction, can fail to favor the latter. Nor can any theory fail to insist that even when the reader's "desire" is being gratified in a reading, the gratification be expressed in terms provided by the work itself; that, in other words, subjectivity must appear to submit itself to the extrasubjective.[10] That submission is the very condition of intelligibility in interpretation. In this respect, all readers are ascetics.

A Passion of Representation: Grünewald's Isenheim Altar

3

Anonymity, Modernity, and the Medieval

... the sense of tragedy [in the Isenheim Altar]
makes the very word "civilisation" falter on our lips.
Kenneth Clark

One of the many representational irregularities that confront the viewer of the Isenheim Altar (1512–15) suggests the fate of its creator, whom tradition has misnamed Matthias Grünewald. Regarding his gigantic, flayed, expiring Savior with an almost unseemly equanimity, a fanatic neutrality, John the Baptist points at him with an improbably angled finger, his arm forming a niche or cradle for his message: "ILLVM OPORTET CRESCERE ME AVTEM MINVI" (He must increase, but I must decrease; John 3:30; see fig. 7). Stipulating both the relation between Christ and the Precursor (dead at the time of the Crucifixion; resurrected by Grünewald for emblematic purposes) and the ascetic reciprocity between the divine and the human, these words also define the relation between Grünewald and this work, his creation, into the radical and gorgeous spectacle of which he has virtually disappeared, leaving almost no traces of himself elsewhere.

One of the most visually stunning artworks of any time or place, the Isenheim Altar is the most imposing monument of German painting, the culmination of German Gothic, the largest such commission ever given to any Northern artist, and the most impressive series of religious paintings of the entire Middle Ages. It is enormous, measuring about 11′ × 19′6″. But so modest was the artist that he not only failed to sign this work, but neglected to leave any proof of his passage through life other than a few initials, rarely the same, on sketches, frames, or panels, and one short, mutilated signature on a sketch now at Oxford. The works still in existence include, in addition to the

Isenheim Altar, some thirty-eight drawings and eleven other certain works, of which five are variations on the Isenheim Altar. The subject to which he returned time and again in these other paintings was Christ mocked, beaten, martyred, and lamented. He is the only distinguished painter of his time who portrayed exclusively religious subjects, and the only distinguished German artist who made no engravings or wood-cuts. He was a painter of the Savior in distress, and to a rare degree, a one-work artist.

Like all other knowledge about Grünewald, this much is the product of recent research. Unlike Dürer he left no diaries, no signed letters or manuscripts of any kind, and only one self-portrait, of questionable authenticity, sketched in middle age. And unlike Holbein he inspired no documentary impulse in his contemporaries; he cast no shadow of remembrance among those who met or knew him. Although his works were in demand for a time after his death, the man himself was quickly forgotten or confused with others, and some of his works misattributed. In 1531 Melancthon accorded the artist known to his contemporaries as Mathis von Seligenstadt, Mathis von Würzburg, or simply Mathes, equal rank with Dürer and Cranach; but when, a few decades later, the Emperor Rudolf II wished to acquire the Isenheim Altar, the name of its creator could no longer be determined. Joachim von Sandrart (1606–88), the "German Vasari," found that "not a single man could be found who might be able to give account of Grünewald's activities even in a scanty memorandum or by word of mouth." He had to speculate about the place and date of his birth, which remain uncertain (but probably in Würzburg, between 1460 and 1475; d. 1528); and with no evidence whatever invented the name Grünewald. In his confused and perfunctory remarks (he calls Grünewald the "German Correggio"), Sandrart barely mentions the Isenheim Altar, which remained in a small church in the Alsace until 1777; and so the most informative of premodern accounts leaves out any estimation of the central work of his life.[1] In fact, until the nineteenth century, the Isenheim Altar was persistently attributed to Dürer, a mistake recog-nized in 1844 by Jacob Burckhardt and decisively corrected only some fifty years later. Archival research in the 1920s turned up an inventory of his estate made after his death which referred to "Meister Mathis Nithart oder Gothart" (Meier 21), a discovery that brought into the Grünewald canon a few works signed with an interlocking of M, G, and N.

We now know with some assurance that he was, in addition to being the supreme mystical painter of his age, a small-time architect, occasional hydraulic engineer ("*Wasserkunstmacher*"), artistic consult-

ant, and entrepreneur. (It is comforting, one scholar confesses, to know that his chimneys and fountains didn't actually work.) He served the archbishop of Mainz for a time, but never stayed with any master for an extended period. The most revealing source of information about his life and activities comes from the records of a lawsuit over payment in which he was involved in 1514–15. This suit names him as "Master Mathis, the painter . . . at the time servant of myself (the defendant) archbishop of Mainz." So despite the spectacular idiosyncrasy of his art, he was, at least for a time, a court painter with a fixed salary. On the basis of other documents, it appears that he never strayed from his home province until he was summoned to Isenheim in the northern Alsace by Guido Guersi, the Sicilian perceptor of the church of the Antonines, an order of hospitalers devoted to the monastic life founded by Anthony of Egypt, to execute the altar.

While Dürer saw himself as an innovator and revolutionary who had to justify, teach, and even preach, Grünewald apparently had no such presumptions. According to E. H. Gombrich, "His works afford no indication that he strove like Dürer to become something different from a mere craftsman or that he was hampered by the fixed traditions of religious art as it had developed in the late Gothic period" (*The Story of Art* 257). Nor does Grünewald seem to have been as profoundly affected by Luther's ideas as Dürer. Although he may have supported the Peasants' Uprising of 1525, his sympathies with Lutheranism are doubtful, with some writers asserting that his spirit always remained Gothic and medieval, opposed alike to Humanism, the classical tradition, and the Reformation; and others insisting that his possession of some works written or inspired by Luther, as well as his attempt to "wrest essential meaning from the model of the gospels" through a "language that is directly expressive" provide evidence of his receptivity to the new currents that culminated in the Reformation.[2]

Everything about Grünewald, but particularly his art, seems to provoke contradictory assessments, even on the most basic issues. While Gombrich, for example, says in a summary description that Grünewald was happily bound by the artistic traditions of the medieval guilds, H. W. Jansen, in an equally neutral and descriptive passage, characterizes him as Lutheran and Renaissance, boldly breaking with the guild and Church traditions. Gombrich contends that on the subject of the role of art, Grünewald "does not seem to have felt any doubts. Art for him did not consist in the search for the hidden laws of beauty—for him it could have only one aim, the aim of all religious art in the Middle Ages—that of providing a sermon in pictures, of proclaiming the sacred truths as taught by the Church" (257). Opposed

to this decidedly "middle-aged" assertion we have Jansen's admirable sensitivity to the qualities of spectacle and freedom: "In a word, Grünewald seems to have shared the free, individualistic spirit of Italian Renaissance artists; the daring of his pictorial vision likewise suggests a reliance on his own resources" (390).

So "Grünewald" has been an uncertain reconstruction, a scholarly rescue by workers toiling patiently in the archives of Würzburg, Halle, Frankfurt, Mainz, Aschaffenburg, and Isenheim; and a speculative recreation by art critics and historians who read in his works the lineaments of the man capable of producing them. That this rescue and recreation has been conducted in the period of cultural Modernism is coincidentally appropriate in light of the ascetic tendencies of Modernism itself. It is in Modernism, after all, that we find enshrined the concepts of the "anonymity" or "disappearance" of the artist, concepts already fully developed in the following letter, written in 1852, in which Flaubert describes to Louise Colet his work on *Madame Bovary*:

> You speak of your discouragements: if you could see mine! Sometimes I don't understand why my arms don't drop from my body with fatigue, why my brain doesn't melt away. I am leading an austere life, stripped of all external pleasure, and am sustained only by a kind of permanent frenzy, which sometimes makes me weep tears of impotence but never abates. I love my work with a love that is frenzied and perverted, as an ascetic loves the hair shirt that scratches his belly. Sometimes, when I am empty, when words don't come, when I find I haven't written a single sentence after scribbling whole pages, I collapse on my couch and lie there dazed, bogged in a swamp of despair, hating myself and blaming myself for this demented pride that makes me pant after a chimera. A quarter of an hour later everything has changed; my heart is pounding with joy. . . . There exist even higher emotions of this same kind: those which are devoid of the sensory element. These are superior, in moral beauty, to virtue—so independent are they of any personal factor, of any human implication. Occasionally (at great moments of illumination) I have had glimpses, in the glow of an enthusiasm that made me thrill from head to foot, of such a state of mind, superior to life itself, a state in which fame counts for nothing and even happiness is superfluous. . . . we must (regardless of material things and of mankind, which disavows us) live for our vocation, climb up our ivory tower, and . . . dwell alone with our dreams. At times I have feelings of great despair and emptiness—doubts that taunt me in the midst of my simplest satisfactions. And yet I would not exchange all this for anything, because my conscience tells me that I am fulfilling my duty, obeying a decree of fate—that I am doing what is Good, that I am in the Right. . . . (*Letters* 158–59; 24 April 1852)

Literary Modernism can almost be said to begin with this letter, which announces the "religion of art," and defines its peculiar torsions: the "impersonality" of the artist, the retreat from "the world" to the "ivory tower," the moral superiority of the aesthetic to the mundane, the relative indifference to a "naive" or "merely personal" thematics, the tortured wrestling with technique, the ethical compulsion to deny one's "own" feelings as a sacrifice to the creative work, and the *acedia*, doubts, and torments that constitute the "temptations" of the artist who creates in such an atmosphere.³ Flaubert spent most of his career trying to achieve a *Tentation de St. Antoine* that would express his life as an artist in these terms, a work that would depict the dynamics of creative self-denial.

The antiquity of Modernism is nowhere more apparent than in this letter, which is situated securely in the aesthetic tradition begun by Anthony and Athanasius and continued by Grünewald. Flaubert was not the only artist attracted by the theme of the temptations of St. Anthony, which is the most conspicuous survival in the nineteenth century and after of the theological themes of the Middle Ages, with representations by Odilon Redon (as illustrations for Flaubert's book), Cézanne, Felicien Rops, Max Ernst, Louis Corinth, James Ensor, Salvador Dali, Stanley Spencer, and others. St. Anthony may be the subject of more representations than any other historical person not from Scripture in the Western tradition, and the reason for his evergreen currency may lie in the synchrony between the trials of the ascetic hero and those of the creative artist.

The fact that this currency extends before and after the period of Modernism suggests that Flaubert and others did not invent the asceticism of art, but simply focused it. Rather than insisting as some have that Modernism is a uniquely ascetical art, we should say that asceticism constitutes the perennial modernism of art. Something like this view has recently been advanced by Jean-François Lyotard, who argues in *The Postmodern Condition* that "modernity takes place in the withdrawal of the real" (79). "Modernisms," Lyotard argues, follow periods in which a satisfaction with the reigning conventions of representation suppresses or eases a kind of friction between the "presentable" and the "conceivable"; modernism always insists "that the unpresentable exists" (78). Thus the modernist tendency to abstraction in painting pays homage to the Exodus ban on graven images, an homage that can take two forms: an emphasis on the nostalgia for presence and the importance of representation; or—the "eremitic" complement—on the power and "inhumanity" of the creative faculty, or as Lyotard puts it, on the "increase of being and the jubilation which

result from the invention of new rules of the game." If modernism is the asceticism of art, then the postmodern, in Lyotard's view, is the asceticism of modernism; it is "that which, in the modern, puts forward the unpresentable in presentation itself; that which denies itself the solace of good forms" (80, 81). One of the most attractive elements of Lyotard's thought is its nonnostalgic surrender of the consolations of that great aid to historical thought, the "period." For him, modernism and postmodernism emerge whenever art becomes sensitive to issues of representability. The task of the following pages will be to assess this sensitivity in Grünewald's work, to align it with a specifically ascetic dimension of thought and feeling, and to argue, through the magnificent and comprehensive example of the Isenheim Altar, that asceticism is a name for that in a work of art which explores art's capacity for representation in a way that necessarily exceeds the limitations of aesthetic history because it is fundamental to art, and not simply characteristic of a period.

Description is the most effective, because most covert, form of analysis. Never neutral, description tends nevertheless to conceal its interest by adhering to certain ascetic imperatives, countering the worldliness of color, form, and representation through discursive abstraction. In a Renaissance commonplace, language, particularly the exemplary homiletic language of emblem-books, is the "soul" of the image.[4] Description seeks to subordinate the pictorial by claiming for itself the capacity to isolate an essential, nonvisual image. If all representation effects an ascesis of the world, description effects an ascesis of pictorial representation. But despite the disingenuousness of all description, fairness to those readers unacquainted with the Isenheim Altar demands at least that they be given a chance to become familiarized with it before submitting to persuasion about it; and one of the functions of description is to mark time.[5]

The Isenheim Altar is the most highly developed example of a distinctively German form, the folding shrine altarpiece, a polyptich with hinged panels painted on both sides and enriched with sculpture. Before the Reformation made such extravagant works unfashionable, the form produced astonishing works, including Michael Pacher's St. Wolfgang Altarpiece and Dürer's Heller Altarpiece, to which Grünewald himself contributed four paintings. Otto Benesch even calls the last decades before the Reformation "the Age of the Great Altarpieces." The Isenheim Altar consisted of a sculpted shrine and predella with two fixed wings, with two pairs of movable wings mounted on hinges on the side, and two wings that could close over the predella. The

limewood panels were generally kept closed, and were closed during Lent, but were opened to what I will call the second or third position when the liturgical occasion warranted (figs. 7-9). To preserve them during the Reign of Terror they were clumsily removed from their original setting in the choir of the Antonine church in Isenheim and taken to the Musée d'Unterlinden in Colmar, where they were mounted separately, so that the modern viewer must try to imagine how they looked as part of a unified design.[6]

With the wings closed, in the first position (figs. 7, 10–14), the viewer confronts a gigantic Crucifixion, which J.-K. Huysmans, in a famous description of the work in *Trois Primitifs*, calls "a typhoon of art." Against a dismal, blue-black background cut by a brownish-green river, Grünewald portrays in brilliant light both the Passion of Christ and the "*Compassio*" of the Madonna (figs. 10, 12). In an "iconographical anomaly of the first order" (Pevsner 14), she is robed in white, and looks, as one commentator says, like a "dead nun," a characterization nonetheless in keeping with Mary's traditional role as a patroness or exempla of the monastic life. Swooning, she is kept from pitching backwards by St. John the Apostle, a graceless but pathetic and inconsolable Mary Magdalene on her knees at their feet (fig. 13). Huysmans's description of the figure of Christ (figs. 10, 11), which stands out from the rest almost like a sculpture, brings out the repellent corporeality of the representation:

> The body looks . . . pale and shiny, dotted with spots of blood, and bristling like a chestnut-burr with splinters that the rods have left in the wounds; at the ends of the unnaturally long arms the hands twist convulsively and claw the air; the knees are turned in so that the bulbous knee-caps almost touch; while the feet, nailed one on top of the other, are just a jumbled heap of muscles underneath rotting, discoloured flesh and blue toenails; as for the head, it lolls on the bulging, sack-like chest patterned with stripes by the cage of the ribs. [The jaw] hangs loosely, with open mouth and slavering lips. (3; trans. Baldick)

This colossal scene might be seen as a nerve-shattering appeal to the viewer, or as a mystical rendering of boundless feeling surpassing measure in the manner of mystical meditations on the death of Christ. Mystical writing, and medieval preaching in general, is extraordinarily sensuous: the reader/listener is enjoined to imagine the rip and sting of the lash during the mocking of Christ, the crunch and bite of the nails as they were driven between the bones of Christ's hands and feet, the pouring forth of the dark blood when the long iron spear was withdrawn from his side, the horrible decomposition of the flesh.

Church rhetoric appealed to "the passionate and violent soul of the age," in Huizinga's phrase, in order to engage and rivet not just the understanding but the passions. Some popular preachers performed their task so effectively that the Fifth Lateran Council of 1512–17 took measures to suppress them. And the details of bodily processes, especially the processes of decay, were commonplaces of mystic writings (fig. 11; see Huizinga, esp. 138–77). Drawing many of its images from such texts as St. Bridget of Sweden's *Revelations* and Ludolphus of Saxonia's *Vita Christi*, the Isenheim Altar seems well placed in this context. And yet the mystic tradition and the conventions of preaching cannot account wholly for this painting, for they cannot explain the stoic figure of John the Baptist, who stands in superhuman imperturbability, with the Lamb, an image drawn not from the grieving world but from the inventory of symbols, its sacrificial blood pouring into the chalice of the Holy Communion, at his feet.

The meaning of "He must increase, but I must decrease" is not perfectly clear. According to Bernard of Clairvaux, God "grew" by taking on human form in Christ. But John's statement must refer to a further growth after Christ sheds that form. Having "pointed the way," John now comes back to ratify his prophecy and to declare its continuing truth. Having prophesied the Nativity, John now returns to proclaim Christ's further "increase" in heaven. The "decrease" may be a sharply angled Antonine reference to the Johannites, a rival order of Hospitalers. But it is more likely that John is honored here as the precursor not only of Christ but of Anthony, for John was honored throughout the Middle Ages as the first anchorite. The "decrease," then, most likely refers to ascesis and humiliation. A contemporary audience would probably have assimilated John's utterance to the ascetic dictum: "Not I, but Christ liveth in me." Augustine discovers refractions of John's statement throughout the Bible, and attributes even the change of seasons to its principle; but concludes, "Now let me round it off in a nutshell. Man must be humbled, God must be exalted."[7] Already "dead to the world," John the Baptist would be the perfect figure to make this case from his position beyond grief, beyond amazement, beyond everything except the exactness of the language of the book.

Below the Crucifixion scene Grünewald placed a Lamentation, in which a yellow Christ, at the lowest point of his human career, is prepared for the tomb. On the panels flanking the Crucifixion he has portrayed a small St. Sebastian and a larger St. Anthony, figures associated respectively with the warding off and miraculous cure of disease, and with the "bloody" and "bloodless" sacrifices of martyrdom

and asceticism. The symmetry of their positions implies affinity, but the asymmetry of other elements—angels bearing a crown to Sebastian and the demon crashing through the window above Anthony's head (fig. 14)—suggests a difference, and implies that the ascetic life, as opposed to the martyr's death, is always attended by uncertainty and violence.

When the wings were opened to the second position (figs. 8, 15–23), the viewer beheld a scene of incomparable complexity and visual richness, a disrupted but functional narrative of the Word becoming flesh and then returning finally to spirit. With the conspicuous exception of the Nativity scene, everything in these panels, including the architectural detail and ornament, is in motion, twisting, writhing, floating, and tumbling with an elastic and brilliant vitality. The Annunciation (fig. 15) has always been regarded as the least problematic picture in the entire work, and its obviousness, its apparent evasion of complexity, its dullness of form, is even offensive to Huysmans:

> . . . on her knees in front of the book we see a fair-haired, puffy-faced woman, with a complexion reddened by the cooking-stove, pouting somewhat peevishly at a great lout with a no less ruddy complexion who is pointing two extremely long fingers at her in a truly comical attitude of reproach. It must be admitted that the Precursor's solemn gesture in the *Crucifixion* is utterly ridiculous in this unhappy imitation, where the two fingers are extended in what looks like insolent derision. As for the curly-wigged fellow himself, with that coarse, fat, red face you would take him for a grocer rather than an angel, if it were not for the sceptre he is holding in one hand and the green-and-red wings stuck to his back. And one can but wonder how the artist who created the little white Virgin could possibly represent Our Lord's Mother in the guise of this disagreeable slut with a smirk on her swollen lips, all rigged up in her Sunday best, a rich green dress set off by a bright vermilion lining. (5; trans. Baldick)

Beyond Huysmans's aesthetic disdain for the figures ("bred on beer and sausages," as he says elsewhere), two elements demand attention. The first is the verse to which Mary's Bible is opened, Isaiah 7:14: ECCE VIRGO CONCIPIET ET PARIET FILIVM (Behold, a young woman shall conceive and bear a son). One version of the Annunciation current in the Middle Ages held that Mary conceived in mystical contemplation of the salvation of mankind as she was reading this passage, an account that strengthened her position as exponent of the ascetical *vita contemplativa*.[8] In addition, Grünewald has introduced a representational oddity in the form of a stretched and pallid figure standing in the crook of a pseudo-branch, an incongruous part of the carved foliation over the arch. This is an Oriental-looking Isaiah, both ornament and

living body, holding up the text of his own prophecy in a gesture of confirmation much the same as that of John the Baptist.

It is the Resurrection (fig. 23) that most deeply impresses Huysmans:

> In it Grünewald shows himself to be the boldest painter who has ever lived, the first artist who has tried to convey, through the wretched colours of this earth, a vision of the Godhead in abeyance on the cross and then renewed, visible to the naked eye, on rising from the tomb. With him we are, mystically speaking, in at the death, contemplating an art with its back to the wall and forced further into the beyond, this time, than any theologian could have instructed the artist to go. . . .
>
> This is a strong and handsome Christ, fair-haired and brown-eyed, with nothing in common with the Goliath whom we watched decomposing a moment ago, fastened by nails to the still green wood of a gibbet. All round this soaring body are rays emanating from it which have begun to blur its outline; already the contours of the face are fluctuating, the features hazing over, the hair dissolving into a halo of melting gold. The light spreads out in immense curves ranging from bright yellow to purple, and finally shading off little by little into a pale blue which in turn merges with the dark blue of the night.
>
> We witness here the revival of a Godhead ablaze with life; the formation of a glorified body gradually escaping from the carnal shell, which is disappearing in an apotheosis of flames of which it is itself the source and seat. (6)

As Huysmans suggests, the colors of this painting, which unhappily cannot be reproduced here, are its most remarkable feature. Grünewald's colors are themselves transfigured, volatilized in the metamorphoses of the shroud. Dingy off-white in the Lamentation, the shroud rises white from the grave, turns ice green, then violet, and deep lilac in the shadows; surrounding the body of Christ, it is rose, then scarlet, and a brilliant yellow the closer it approaches to the Godhead, finally losing itself in the aureole. The sharp tonal contrasts of the tumultuous scene below—and the violence of the event is an iconographical invention of Grünewald's—with soldiers crashing in every direction as Christ soars from the tomb ("apparently without thighs," as one writer puts it [Burkhard 34]), intensify the difference between the transfigured Christ and the world from which he departs.[9] Aesthetically bold, even unprecedented, Grünewald's colors are also theologically and philosophically conservative, deriving from a long tradition of Hellenic, Patristic, and medievel thought. According to the ontic theory of light of medieval philosophy, the human experience of God can be likened to the bursting forth of intelligible light, with the sun serving as a

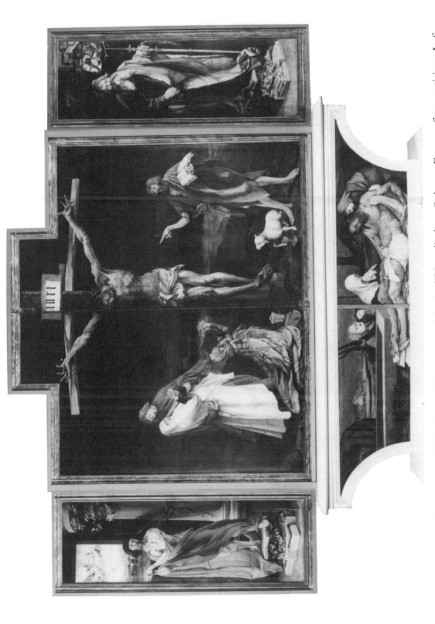

Figure 7. Matthias Grünewald, Isenheim Altar, 1512–15, Musée d'Unterlinden, Colmar, France, first position. Left, St. Sebastian; center, "The Crucifixion"; right, St. Anthony; below, "The Lamentation." Photo, O. Zimmerman.

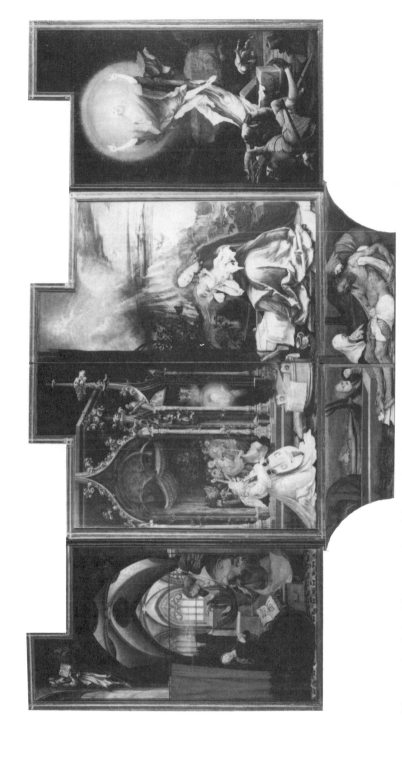

Figure 8. Isenheim Altar, second position. Left, "The Annunciation"; center, "The Heavenly Choir" and "The Nativity"; right, "The Resurrection." Photo, O. Zimmerman.

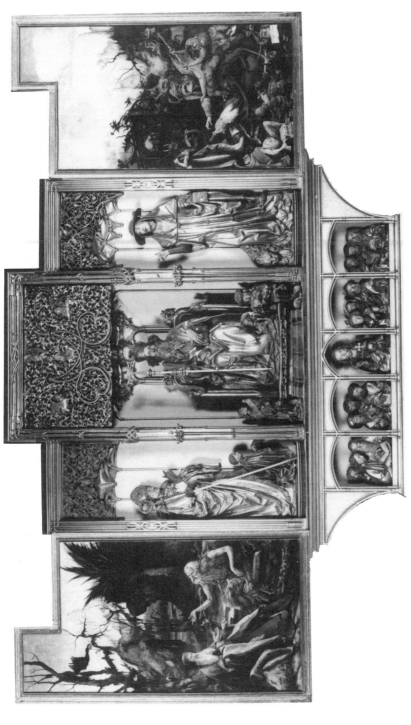

Figure 9. Isenheim Altar, third position. Left, "The Meeting of Paul and Anthony"; center, carved shrine with Anthony enthroned, flanked by St. Jerome on the right and St. Augustine on the left, and Christ and the Apostles below; right, "The Temptations of St. Anthony." Photo, O. Zimmerman.

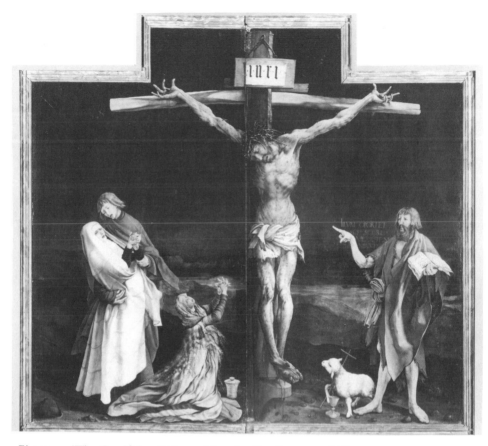

Figure 10. "The Crucifixion." Photo, Giraudon/Art Resource, N.Y.

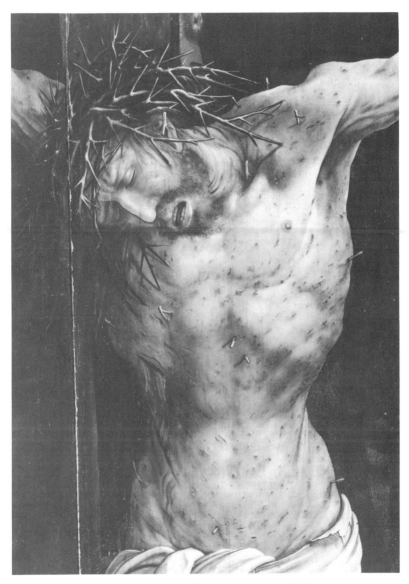

Figure 11. Detail of 10. Photo, Giraudon/Art Resource, N.Y.

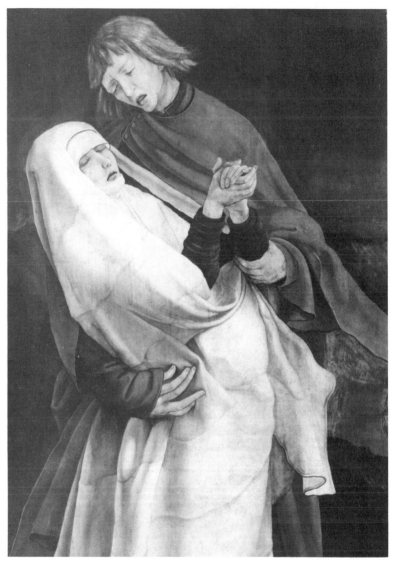

Figure 12. St. John Evangelist and Virgin; detail of 10. Photo, Giraudon/Art Resource, N.Y.

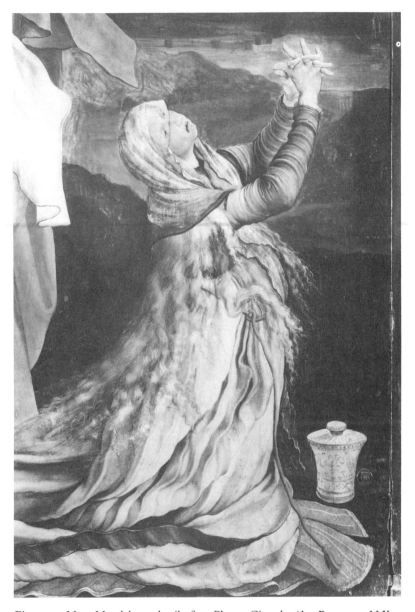

Figure 13. Mary Magdalene; detail of 10. Photo, Giraudon/Art Resource, N.Y.

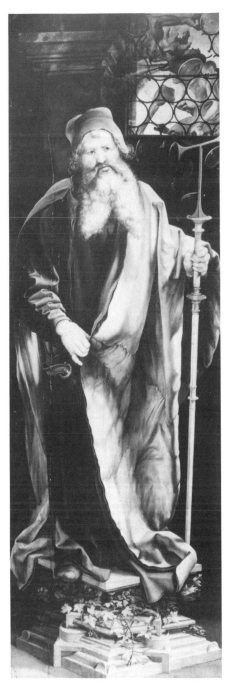

Figure 14. St. Anthony; detail of 7.
Photo Giraudon/Art Resource, N.Y.

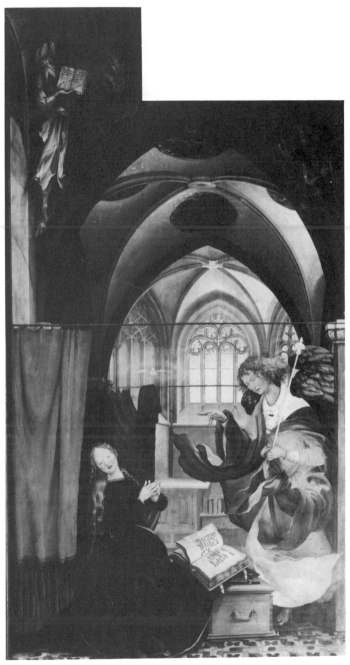

Figure 15. "The Annunciation." Photo, O. Zimmerman.

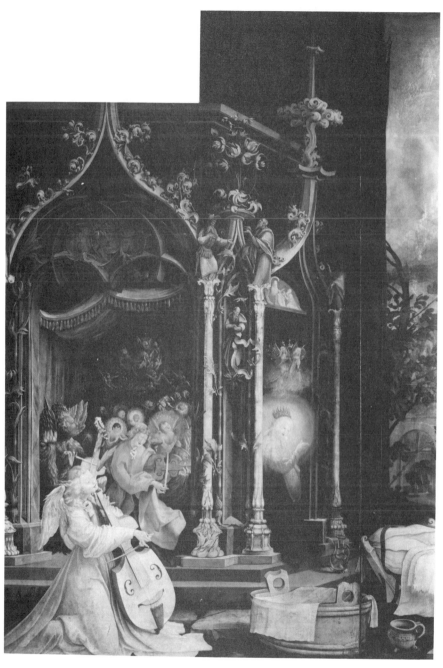

Figure 16. "The Heavenly Choir." Photo, O. Zimmerman.

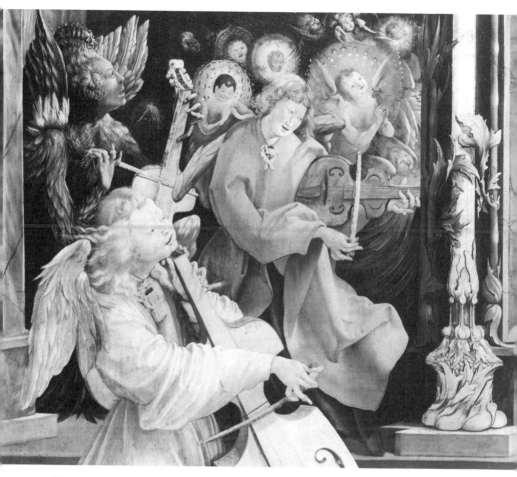

Figure 17. Detail of 16. Photo, Giraudon/Art Resource, N.Y.

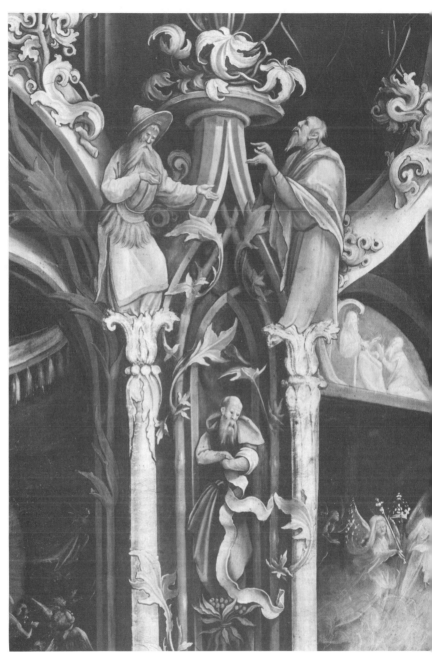

Figure 18. Detail of 16. Photo, Giraudon/Art Resource, N.Y.

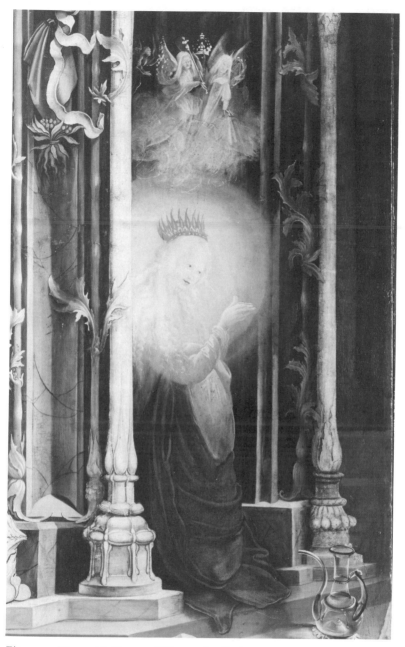

Figure 19. Mary with Crown of Flames; detail of 16. Photo, Giraudon/Art Resource, N.Y.

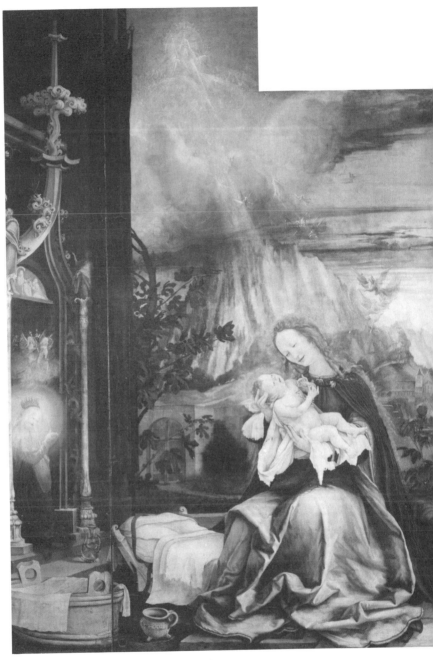

Figure 20. "The Nativity." Photo, O. Zimmerman.

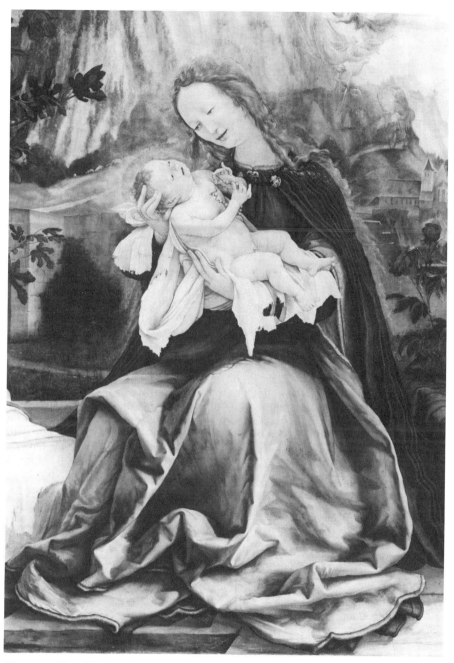

Figure 21. Detail of 20. Photo, Giraudon/Art Resource, N.Y.

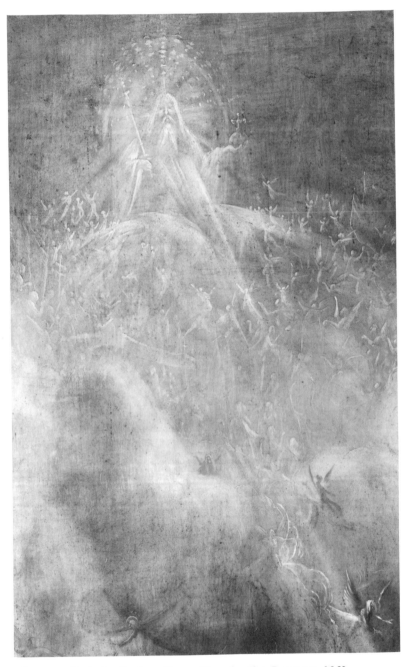

Figure 22. God; detail of 20. Photo, Giraudon/Art Resource, N.Y.

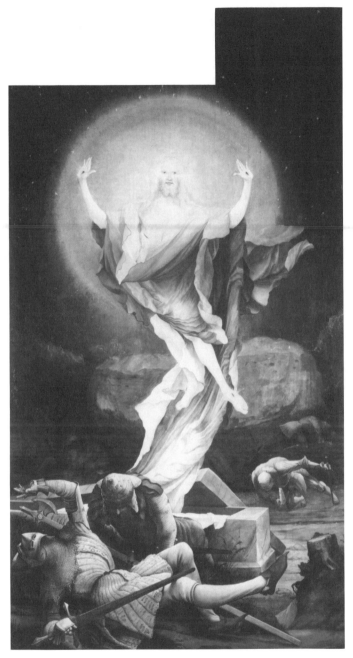

Figure 23. "The Resurrection." Photo, O. Zimmerman.

theological metaphor for Christ.[10] Grünewald has applied this symbol literally. He does not, like Dürer and others, represent the transfigured body in terms of classical canons of beauty, a beauty whose *form* is revealed by light; instead, he shows the human integument dissolving into light.[11]

In every way the center of the entire work, the middle two panels of the second position comprise a mystifying spectacle. On the right there is a serene, if densely packed, Nativity; but the scene on the left, and its relation to the Nativity, can only be matters for speculation. This speculation has, nevertheless, become highly articulated, with positions clearly staked out.

Between the humanization of the divine in the Annunciation and the divinization of the human in the Resurrection (actually, the Transfiguration, Resurrection, and Ascension all in one), the Nativity is represented, untroubled and monumental (fig. 20). For once, nothing is being transformed, nothing interrupted. An enormous Virgin, as large as the Christ of the Crucifixion, gazes at her child ("a sturdy little Swabian peasant," according to Huysmans) in what some see as a celebration of eternal Motherhood, others as the glory of the human race epitomized in Mary, and still others as the apocalyptic renewal of the earth. Swarming with angels, the brilliant, vapory, mauve-pink light of God the Father spills down over the paradisal landscape. God, from whom this light issues, is nearly beyond form and can only be represented by cartoonish strokes whose symmetry and crudity call attention to their own representational inadequacy (fig. 22).

Two other elements, one iconographical and the other representational, also draw attention to the work itself rather than to any referent. The representational element is the rendering of the nearly transparent peasants standing on the hill behind the church and gazing stupidly at the surprisingly adult angels hanging heavily in the air directly over their heads (fig. 21). Especially considering the mastery of spatial depth demonstrated in the vaulting of the Annunciation, these gigantic figures—larger than the monastery in front of them—seem evidence of an abandoned design, a mistake which the artist for some reason failed to paint over. The iconographical element consists of the incongruity between the Nativity scene, the outdoors setting, and the objects belonging to the lying-in room—the bed, the basin, and the small pot. As an explanation I accept Scheja's striking argument that the scene, set before a monastery in the symbolic landscape of the *vita contemplativa*, indicates a monastic practice in which the nuns tended Christ Child dolls, washing them in tubs and putting them to bed (52). But in any

event, this representation is, as Benesch says, a "modern touch," stressing the humanity of Christ (94).

This firmly terrestrial scene is not self-contained, for the washbasin at Mary's right crosses over to the left panel, and the glass pitcher used to bathe the child sits on the step of a fairy-Gothic dream structure. These crossover forms make it difficult to separate the two halves of this composition, however strenuously they seem to repel each other. And they do: while the Nativity is both a traditional and a "realistic" scene, there is no scriptural precedent and indeed no satisfactory explanation of any kind for what is generally referred to as the Angelic Concert or the Heavenly Choir (fig. 16). What can we make of it? The fantastic architecture of the baldachin surpasses even the most "Flamboyant" or decadent Gothic (fig. 18). The architectural historian Nikolaus Pevsner has described its "nodding ogee arches, extremely attenuated shafts with twisted bases, curly and frilly crockets and sudden sprays of completely naturalistic foliage" (16). Amid this "foliage," a number of impossibly supple and animated figures, of indeterminate identity except for Moses on the far left, disport. Below them, a gauzy, cretinous figure who may be either seated or kneeling in front of the baldachin leads an ensemble that consists of angels and other creatures (fig. 17). These include the ontologically conventional string player in the foreground as well as a variety of indefinables behind him. The grotesque greenish bird-man to the left is far from angelic, and in fact appears slack-jowled and dissipated, reprehensibly distracted from the Nativity he serenades by a buzzing circle of angelic activity above him. Many others appear simply as heads inserted into solid-looking haloes, or attached to wings. Remarkably, one scholar discovers in these tiny monsters certain ethnic facial types (see J. Bernhart 42).

The most uncertain element in this group, and the one richest in significative possibilities, is the radiant figure of Mary, with her brilliant halo and crown of flames, poised in prayer at the right of the baldachin (fig. 19). Her aureole and the transformations of the color of her robe recall the Christ of the Resurrection, but there is no scriptural or iconographical precedent for her, no way to affix her impact; indeed, some writers speculate that this figure is not Mary at all, but some saint or even the Queen of Sheba. In a patient, exhaustive discussion, Scheja assesses, serially, theories that the Madonna on the left awaits the birth of Christ fulfilled in the Madonna on the right; that the left stands to the right in the relation of Old Testament to New Testament; that the fiery Madonna is an image of the apocalyptic bride of the sun; and that the two halves of the picture represent the Adoration of the Madonna as Queen of Heaven and the Christmas episodes as seen from earth; and

that Mary on the right is Woman while the Mary on the left is "Idea, eternal thought . . . Mary before time, who gazes on herself [at the right] as the fulfillment of time."[12] He concludes that it is impossible to maintain any interpretation which depends on the temporal anteriority of the left-hand Mary: one might represent the "essence" of Mary, or Mary as Queen of Angels, but one could not then insert this essential figure into a narrative sequence that continues beyond the moment it represents. Instead, Scheja argues against the left-to-right flow of the picture, and against all previous interpretations, that Mary as Mother is not the object of contemplation of the crowned and transfigured Mary, but rather the subject; Mary as Mother glimpses the Queen of Heaven as a vision of her own destiny, the terminus of her career on earth. Her gaze thus completes the contemplative *imitatio Christi*: "in the contemplation of the passage from Isaiah she learns of her role in the Incarnation of Christ, in contemplating the Redeemer become Man she has a vision of her own Transfiguration" (55). I cannot arbitrate the conflicting claims of this discussion, but I can point out that there is a fairly obvious suggestion of pregnancy in the fall of the left-hand Mary's robe. If she is pregnant then she is not represented as Queen of Heaven, but as an "essential" Mother; and she is not anticipated by the Virgin with her baby, but rather recalled by her. This interpretation would make of the entire second position of the altar a clean left-to-right temporal sweep.

The predella is in the same position here as in the first position, but while it connects the two positions, its narrative function is different here. Whereas it provided a pathetic closure to the Crucifixion, a "lowering" in all respects, it inserts itself into the sequence of the second position as a reminder of the necessary disaster to follow. In the first position the Lamentation leads to the Transfiguration; in the second, it recalls the Crucifixion.

St. Anthony himself dominates the third, or open position (fig. 9). The scene on the left illustrates the account in Jerome's *Life of Paul* of a meeting between Anthony and Paul, his only predecessor in the desert (fig. 24). the story is legendary and the incident here depicted typifies the insipid side of hagiography: a raven descends with bread, provoking a "holy dispute" between the two as to who should break it. This desert is not the abode of demons, but rather the mystical "blossoming desert" of the Old Testament (see Isaiah 35:5–7); indeed, Grünewald has used the occasion to portray one of the earliest landscapes in German painting.

With the Temptations of St. Anthony on the right panel (fig. 25), we are pitched into a demoniac rather than a paradisal terrain. This

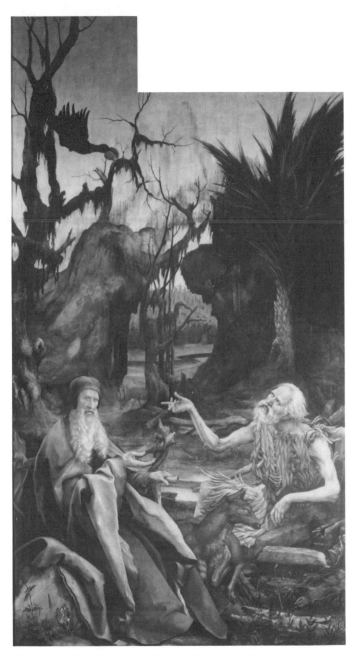

Figure 24. "The Meeting of Paul and Anthony." Photo,
O. Zimmerman.

167

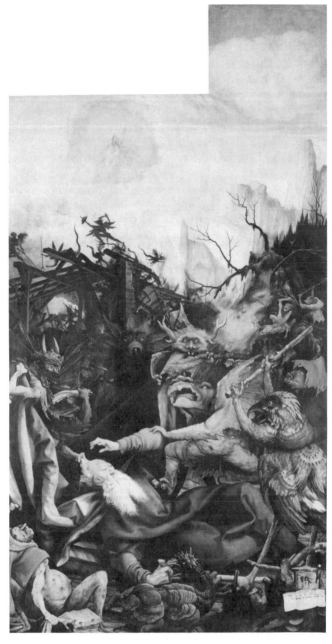

Figure 25. "The Temptations of St. Anthony." Photo,
O. Zimmerman.

turbulent scene is taken from a passage in Athanasius in which Anthony, at the very beginning of his career in the desert, is assailed by monstrous apparitions. In Athanasius it is uncertain whether the monstrous forms possess physical density; one of the "temptations" they offer is the temptation to believe in their reality, to believe that God could permit such things to exist. Beyond this issue, it is uncertain whether they represent an aspect of his chastisement or a testament to his fortitude. Grünewald leaves these uncertainties in suspension, portraying Anthony as the victim of a frantic demonic attack, in the midst of a sickening jumble of paws, wings, beaks, horns, antlers, muzzles, and scales. The scrap of paper at the lower right quotes Anthony's plea: "Where were you, good Jesus, where were you? And why did you not come and dress my wounds?" Again, the representation of God is minimal and cartoonish, a few red strokes in a blotch of yellow. But his representability is in inverse proportion to his power, for he has sent forth angels, who are already doing battle with some of the demons on top of the burning hut.

In this scene of simple assault a great deal remains indeterminate. The middle of the three crossbeams of Anthony's hut is unsupported by any vertical beam. Indeed, no coherent structure can be inferred from the ruins left by the demons. And the demons themselves are often ambivalent in function and status. The creature at the base of the stone figure, a dark bestial force just beyond the ring of Anthony's attackers, seems curiously removed from the central action as he glances off to the right, where two small humanoid figures enact what appears to be a miniature of the central scene of torment (see fig. 26). In an almost exact quotation of the posture of one of Anthony's main assailants, the bestial figure on the right grips a stick, apparently to strike a figure who is astride some kind of animal in an attitude more appropriate to attacker than to victim. In the foreground, where the action would appear to be the least ambiguous, the limbs cannot reliably be assigned to bodies, and the "hand" on Anthony's elbow seems almost solicitous. A general blurring of the action is reinforced by the eyes of the demons, which glare intensely but without focus. The overall impression is one of tremendous dynamism paralyzed by a powerful principle of form, of nightmarish distortion amid a sense of repose. Huysmans speculates that the painting must have given the artist enormous transgressive pleasure, as the colors are extreme, the postures convulsive, and the figures both violent and ludicrous.

Early viewers of the Isenheim Altar may have directed their most intense regard to the figure at the lower left (fig. 27). The appeal for help may have come from him rather than Anthony, and may be

directed to Anthony rather than to God. The Antonines were formed in the Dauphiné in the late eleventh century as an order of Hospitalers dedicated to combatting gangrene, the new disease of syphilis, and particularly ergotism, or "St. Anthony's Fire." This disease, an intestinal disorder resulting from spoiled grain, was capable of spreading in epidemic fashion, producing hideous suffering, including bloating, eruptions of the skin, and even the rotting of entire limbs. The convent at Isenheim belonged to this order, and included a hospital for the isolation and treatment of victims of such diseases; and its Perceptor, Guido Guersi, commissioned the work from Grünewald. While many interpreters treat the figure at the lower left as just one more ontologically incongruous demon—an interpretation that might be justified by its webbed feet and froglike leg spread—others contend that it is a victim of St. Anthony's Fire. Huysmans says that "This bloated body, moulded in greasy white soap mottled with blue, and mamillated with boils and carbuncles, is the hosanna of gangrene, the song of triumph of decay!" (9; trans. Baldick). If Huysmans is right, this creature is a figure of empathetic identification, a representative of the viewer in the picture, calling out to Anthony for aid as Anthony had called out to God—and perhaps taking comfort from the fact that Anthony's cry was heeded. Huysmans asserts (with no evidence) that this figure was modeled on the invalids in the convent hospital, and even suggests that the Christ in the Crucifixion was also based on corpses in the hospital mortuary, a possibility that would provide a more complex solace for the suffering people brought to see it. They may have been comforted to think that Christ had taken on flesh as repulsive as their own; and as they contemplated Christ's eventual triumph and transfiguration, they could feel the forsaken power of the outcast, accomplished for them through a mystical union with the body of Christ. Taking note of the fact that many amputations were performed at the hospital, Kurt Bauch has even suggested that the panels of the Lamentation did not open on hinges, but slid apart on a tracking mechanism, cutting Christ's legs off and making of him a model amputee. And Scheja believes he has identified in the "blossoming desert" several herbs, including ribwort, plantain, vervain, crowfoot, spelt, white dead-nettle, and cross-gential , which were used as medicinal treatments against St. Anthony's Fire.[13]

The late Gothic sculpted base was probably executed by Nicholas von Hugenau between 1500 and 1505, but it seems actually to be later than the paintings because of its promotion, even exaltation of the human.[14] The sculptures are less extravagant, less disturbed: they are not, as one writer puts it, "*hors de la mésur*" (Recht 46). Anthony is enthroned in the position of judge, secure in the "fame" God had

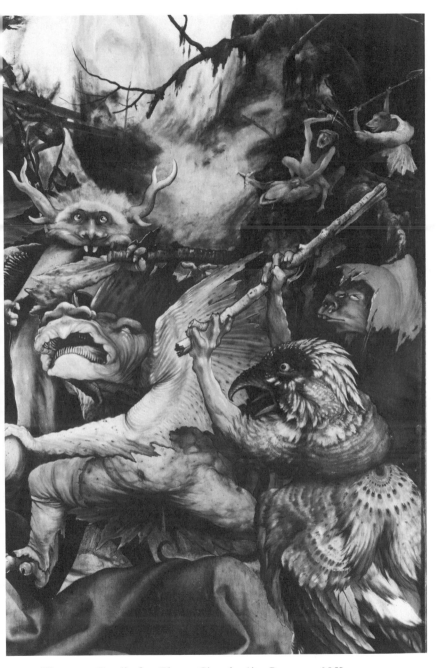

Figure 26. Detail of 25. Photo, Giraudon/Art Resource, N.Y.

Figure 27. Detail of 25. Photo, Giraudon/Art Resource, N.Y.

promised. On the left stands a slightly smaller Augustine, whose monastic rule the Antonines had adopted in 1298, and whose conversion owed so much to the example of Anthony; and on the right, Jerome. Anthony is massive and melancholic, with his iconographical companion the pig (an emblem of Saturn, and melancholy) at his feet.[15] However, the stasis of the postures belies a deeper unease in the composition. Above the saints, von Hugenau has created an exuberant ornamental foliage in which are placed symbols of the four evangelists. While the enthronement of Anthony itself may have been seen, especially by those outside the convent, as extraordinary and potentially subversive—in general, only God is shown in this position—the placement of the evangelists above a mere saint comes, as Scheja says, "perilously close to sacrilege" (27). Sacrilege, or at least impiously bad taste, may also have been perceived by some in the placement of the figures on the predella, which was opened when the panels were in the third position. In the sculpted predella, Christ and his apostles are represented on an even smaller scale, so that not only is Anthony in the position generally reserved for God, but he is also above and larger than Christ.

And yet this shrine provided the basis of the entire altar, the material with which Grünewald had to work. It also provides a background against which his rendering can be measured, for in its three-dimensional solidity it appears almost as nonrepresentational—as "the calm of firm reality" (Burkhard 26), in contrast to the manifestly aesthetic inventions that elaborate it.

Conceptual Narrative 2

*E*ven when the Isenheim Altar was in the possession of the Antonines (until the late eighteenth century), nobody ever experienced the progressive unfolding of the panels as a way of reading the entire work. The ecclesiastical calendar dictated which position was to be exposed on any given day, and there is no evidence of any serial viewing of more than one position. Nevertheless, internal evidence suggests that Grünewald and his patron were sensitive to the composition of the work as a whole and ensured that it would cohere as a unified entity through the repetition or quotation of forms or colors. For example, the resemblance in the position of the soldier at the bottom of the Resurrection and that of Anthony in the Temptations of St. Anthony encourages a reading in which the two are related, perhaps as problem and solution: the soldier is bowled over by transcendence, while Anthony is saved by it; or, Anthony bears witness to bodily torture, while the soldier bears witness to bodily transfiguration. Other such carryovers include the Lamentation, visible in both first and second positions; the torn cloth worn by the dying Christ and wrapped around the infant Christ; the black and blasted trees in the meeting of Paul and Anthony and in the Temptations of St. Anthony; and the architectural ornament in the Annunciation and the Heavenly Choir. The Isenheim Altar is full of such gestures of cohesion, through which the pictures intersect, modify, and problematize each other. These gestures ensure that the work will exist, if only in the synchronizing

memories of its beholders, as a mighty book, a totality rather than as a set of discrete compositions.

They also encourage the audience to interpret the work as the product of an intention working itself out in a certain order over time, and to try to discover and follow the directions of that intention rather than "lingering" on individual pictures or "wandering" from picture to picture in an unstructured and self-indulgent way. The form and setting of the work require us to view it as an engine of devotion, in the Thomistic sense: the conscious and willed turning of the mind to God whose special means was meditation and whose effect was mingled joy at God's goodness and sadness (the sadness on the face of the sculpted Anthony) at man's inadequacy (*Summa Theologica*, 2a-2ae, q. 180, aa. 1 and 7). Considered as a device for spiritual guidance, the whole work might even assume in the minds of its audience the form of an itinerary, tracing, in the words of Bonaventura's famous work, *The Soul's Journey into God*. Through works such as Bonaventura's, which traces the soul's "ascent," Christian spiritualism adapted the act of contemplation to temporality and began to accommodate itself to narrative.

It appears at first glance that Grünewald is unwilling to make this accommodation. He has systematically thwarted the narrativizing impulses of his viewers by including in almost every picture an element that cannot be assimilated to narrative. John the Baptist in the Crucifixion, the small figure of Mary in the Heavenly Choir (which itself has an indeterminate temporal existence), and the images of God in the Nativity and the Temptations of St. Anthony—these figures exist either in a different time than that of the other elements in their pictures, or out of time altogether. But while the entire work does not represent a unified narrative sequence, it does constitute another kind of narrative, a "conceptual narrative," which would take the "form" of the reading of the work itself as the beholder progresses from one image to the next in a sequence that takes time and structures time, but does not depend upon the representation of causality in time. The conceptual narrative is the narrative of the narratee, whose reflection, whose "spiritual itinerary," is guided and shaped by the work.

I have discussed the work according to one possible order, moving from the Crucifixion to the shrine, from front to back, from "a typhoon of art" (Huysmans) to "the calm of firm reality" (Burkhard). According to this convention, the reader begins with the catastrophe of the Crucifixion; moves through the glorious mysteries of the Incarnation and the Resurrection, which ameliorate Christ's death and reclaim it as redemption; and concludes with the human legacy and reenactment of the Christological drama, the *vita contemplativa* of the monastic life as

exemplified in its majestic hero, Anthony. This sequence is conventional, and the reading it produces has a satisfying clarity and completeness, but nothing other than convention warrants it. We are under no obligation to follow this sequence, and must be alive to the ways in which such a reading arbitrarily thematizes the work and may even neutralize the work.

Let us speculatively assume the position of the artist himself upon being given the commission to create the altarpiece. Commissioned by Guersi's predecessor Johann von Orliac (who is represented in the position of the donor at the feet of St. Augustine), the shrine had already been in place for at least ten years and maybe for as long as thirty, and had become traditional and integral to the church itself. The task, therefore, would not be to create a new work but rather to complement a work already essentially complete. Although Scheja and most others seem to presume that "the work" begins and ends with the paintings of Grünewald, this presumption would have been foreign to both Grünewald and his contemporaries, who, the evidence suggests, regarded the fantastic, glittering ensemble of sculptures equally important as the paintings (see Scheja 26, and Recht 33). Grünewald's assignment must have been to devise a work that continued the direction and filled out the implications of the shrine. One authority asserts that Grünewald "merely sought new creative scope within the existing form [of the shrine altarpiece with wings], without developing it any further as such" (Landolt 138). But the scope he discovered in narrative expands the form enormously over the limits of, for example, Pacher's St. Wolfgang Altar, which has only one set of wings with all paintings devoted to scenes from the life of the Virgin.

When we consider the shrine as the origin of Grünewald's composition, the work becomes re-narrativized in an entirely new way. Earlier, I noted the iconographical irregularity of a representation of a mere saint in the seated position, flanked by other saints, with symbols of the four evangelists on top—particularly in massive, three-dimensional sculpture. Such irregularity, which became more common in German art in later decades, must surely have been apparent to Grünewald, whose iconographical sympathies were more traditionally medieval. To him, the shrine might have appeared doctrinally questionable in several respects. Honoring the ascetic in the position generally reserved for the deity, the sculpture begins to compromise the crucial distinctions between the divine and the human, the original and the repetition, the transcendent by nature and the transcendent by discipline. The predella compounds the difficulty by herding Christ and his apostles into a space so confused and overcrowded as to make them look incarcerated.

The difference in scale between the figures in the predella and those in the shrine strikingly suggests the possibility of the perversion of the will to power implicit in ascetic self-transcendence. Through asceticism, the sculpture implies, one can grow even greater than Christ, who, after all, did not transcend himself, but actually descended from divinity in taking on corporal form. The shrine magnifies a certain resistance to transcendence within an ideology centered not on God himself but rather on the human heroism in honoring God despite a "natural" and constant impulse not to. The woe in Anthony's expression might imply, if we wish to pursue this line, an uneasiness with enthronement and a recognition that in overcoming his desires through asceticism he has usurped the position of judge that rightfully belongs to the Father; and a further recognition that the ascetic ideology leaves him no choice but to do so. In short, while the sculptures glorify the founder of the ascetic life, they run the risk of paying him an excessive honor through a misplaced attention to the man, rather than to the origin of his capacity for self-transcendence, to the "I" rather than to the "Christ in me."

If Grünewald was alive to the "humanistic" tendencies of the shrine, he may have conceived his task as both to complete it and to try to hedge its more subversive implications, to recuperate from its imbalances a more genuine asceticism. At least, such a double project might be inferred from the first elaborations he made on the shrine, the paintings of the third position. (There is no certain way to tell what order he worked in, but Mary Magdalene's ointment jar in the Crucifixion bears the date 1515; as Grünewald entered the service of Cardinal Albrecht von Brandenburg in 1516, the date probably marks the end of the work. I am using the term "first elaboration" not only as a probable compositional fact but also as a fact of the viewer's experience [Benesch 87].) As paintings, they surrender the third dimension of sculpture, and with it one source of the sense of worldly "reality." In doing so they interfere with the naive identification of sign and referent, which Barthes termed "*l'effet du réel*," the "reality-effect" that asserts itself in the form of a "resistance to meaning" ("*L'effet de réel*" 87–88). The paintings, in other words, appropriate the image for contemplation. Just as important, they volatilize the image of Anthony by representing scenes from narratives in which he figures. Sacrilegiously "gathered" in the shrine, Anthony is "scattered" in the paintings. The narratives referred to document Anthony's venerability; and yet, through narrative itself, a pride that has regarded itself as monumentally beyond temptation is humbled. The paintings thus reclaim Anthony for the human experience of trial.

The paintings do not just contradict the shrine, nor do they simply compete with it. They change the shrine itself by implicating it in temporal and causal relations. According to Barthes, narrative is a "hierarchy of instances" the understanding of which entails the passage from one level to another on "an implicitly vertical axis" ("Structural Analysis of Narratives" 87). The word is gathered into the sentence, the sentence into the paragraph, and so forth. This principle also applies to the way in which the narrative as a whole ascends through its temporality and uncertainty into formal and thematic closure at the end. The paintings of the third position narrativize the shrine by occupying a position before and "below" it: one must *ascend* from the paintings to the shrine, and this movement temporalizes the shrine itself by placing it at the end of the narrative of Anthony's life. Recalled by the paintings to the texts of Athanasius and Jerome, the viewer is led to see the shrine as a representation of narrative closure, a picture of the "treasure in heaven" earned by ascesis. Moreover, because the paintings refer to texts, the viewer is recalled even more forcefully to a thickness of textual, sculpted, and painted representation, and discouraged from identifying the shrine with Anthony, or with any condition actually attainable in a life defined by temptation.

The two pictures themselves make this definition explicit. On the right Grünewald represents an intensification of the ascetic life itself, a warfare, a trial. The scene on the left would seem to be its opposite, but there is no opposite to temptation, only a masking or sublimation. The blasted tree from the right reappears on the left as a cautionary device warning against complacency. Even in the anchoritic "blooming desert," even between two holy men, temptation may arise, has already arisen. (In a painting now hanging in the Appartamento Borgia in the Vatican, Pinturicchio has even depicted temptations in the form of horned women standing behind Anthony as he breaks bread with Paul.) For in the conversation, the "holy debate," what Bakhtin calls heteroglossia or dialogization reigns. In place of single-mindedness, there is now contestation and the intersection of views. Order has been shattered through excess, custom ruptured by uncertainty—the raven brings *more* than ever before; *who* will break the bread?—in a tiny, muffled carnival.

Do the paintings repair the damage of the shrine? Yes and no. They "decenter the image," and yet they may also carnivalize asceticism itself. From a rigorously ascetical point of view, both paintings constitute species of temptation. The temptations on the right are manifestly orgiastic and ecstatic. Paul's peaceable kingdom, by contrast, shelters what seems to be a nostalgic and, as it were, pre-psychological life of

"bodily" discipline that seems simply an intensive form of hygiene. This is the only picture in which no token of the divine appears at all, and this is the temptation, the carnivalization. In this painting, the world of humans and animals is dubiously self-sufficient.

The ascetic life is a life of contemplation, in which we must try to "remain as we were made"; and yet it is also a life of action, a constant struggle to "advance to what lies ahead." Each of these imperatives constitutes a temptation to ignore the other. Together they exist in a state of resistance whose strongest and most exemplary expression is narrative, in which a series of compromises vertical and horizontal, logical and temporal, is negotiated—compromises whose unsatisfactoriness in an ideology of noncompromise motivates progress, the quest for an end to compromise, the drive towards closure. And yet this end itself is a compromise, for what must not above all be compromised is the condition of resistance that marks the state of temptation. The shrine threatens to place human life beyond resistance in static venerability; the paintings, on the other hand, threaten to place it short of resistance in the dynamic flow of events. Moreover, the paintings continue the concentration on the human that asceticism seeks to displace in the first place. They treat Anthony not as a representation, an imitation of Christ, but as the origin of representations. So neither the shrine, nor the paintings, nor the combination of paintings and shrine, are entirely "safe" objects of contemplation. More work is needed.

As we turn the panels over to the second position, the drama of the Annunciation, Nativity, and Resurrection redirects our attention from the secondary figure of Anthony to the deity in its manifold forms—the angel Gabriel and the Holy Spirit hovering above the head of Mary in the Annunciation, the "essential" Mary and the angels in the Heavenly Choir, the barely indicated God and the infant Christ in the Nativity, and the transfigured Christ in the Resurrection. In the second position, then, we do not see the deity as a perfectly centered and transcendent force, but rather as a principle of necessity implicated in the world of forms. Itself undergoing constant mutation, divinity dictates the narrative action, compelling it towards closure: the Resurrection, Ascension, and Transfiguration of Christ. The perfect closure of narratability and the end of trial, divinity conceals itself in its forms, and yet reveals itself in its effects. Under it, or within it, human life proceeds on its "own" course, yet is never allowed to wander. In the paintings of the second position, divinity is scattered and decentered in the same way that Anthony is decentered in the paintings of the third position; here,

divinity condescends to mortality so that human life can acquire direction and purpose.

In fact the paintings of the second position comprise a narrative that allegorizes on another level the operations of narrative itself. In the beginning—at the left—necessity enters into human life, encountering the resistance signaled by Mary's startled and half-repelled posture. Life acquires plot and configuration, and time takes on an ordering. In the central painting, humanity and divinity coexist in a scene at once self-explanatory and illegible, serene and bewildering. The Nativity is both central and in between; the condition it represents, eternal and transitional. In resurrection, transcendence and intelligibility triumph as the entire narrative is gathered up into a higher level in which time, causality, and representation itself both culminate and come to an end.

If the second position allegorizes narrative, it should express the essence of asceticism, which I have described as the ideological form of narrative. But this does not appear to be the case, for while the pictures in the central position displace attention from Anthony to the deity, they do so by introducing sexuality and specifically maternal values, replacing the Saint with the Mother, the sterile with the fertile. The definition of Mary as an exemplary contemplative, the patroness of the ascetic life, deforms asceticism itself insofar as asceticism is founded on the repudiation of sexuality, especially the productive feminine. Nevertheless, maternity and the mother-child relation are both spatially and conceptually centered in the second position, and placed at the heart of the entire work. We must not overlook the decentering of the maternal figured by the two-part composition of the Heavenly Choir and the Nativity, but even this decentering has its subversive effects. In the Nativity, the figure of God is almost washed away in its effects, diminished nearly to the point of nonrepresentation. The "essential" Mary of the Heavenly Choir is a much more powerful figure, and, with her aureole, stands as a principle of immanent necessity *within* human life, a nonnarrative and possibly atemporal force that nearly renders the distant and sketchy God redundant. The deep attractiveness of this figure to the eye and to the mind not only decenters maternity but decenters divinity as well. The God who would redeem and reorient the gaze of the "devouring mother" by providing an Other in which it would seek completion has a competitor.

As a practice, asceticism seeks to mediate the separation between God and man through a discipline that both "imitates" Christ and emphasizes the nontranscendence of the human. Mary stands in medieval thought, and in the Isenheim Altar, as a seductive possibility

for ascetic conceptualization, her cult the trace of pagan beliefs in Christianity. Julia Kristeva describes the mystical "assimilation" of Mary to Christ in thinkers such as Meister Eckhart, who held that

> Mary is only the image (fantasy?) of Christ himself, to the extent that, although a man (but like a woman?) he belongs to the Father. Another quite revealing Orthodox conception of the Virgin defines her as . . . privileged *space*, living *area*, *ladder* (of Jacob), or *door* (of the Temple, in Ezekiel's vision)—*dwelling*, in short; she is thus seen as a *union*, a *contact without gap*, *without separation*, and these functions make of her a metaphor for the Holy Ghost. ("Motherhood according to Bellini" 251)

Considered in this light, Mary represents the overcoming of the "gaps" of representation, and of signs in general: she is her own signified, and requires no transcendental other—no *other* transcendental other—to complete or ground her meaning.

While the "orthodox conception" jeopardizes Mary's humanity, the same orthodoxy grants mystical insight only to those such as Augustine, Bernard, or Meister Eckhart who take on the role of the feminine, becoming "brides" or "lovers" of Christ. For the mystic, the insight that comes to the man sufficiently feminine to be worthy operates in an ascetic tension with the act of writing about that insight, an oscillation of a humbling "loss of self" with prideful self-sufficiency. Blanchot articulates this tension, writing of the "power of enchantment" in the maternal gaze, the "fascination" of the Mother for the child, a fascination "linked to the neutral and impersonal presence of the indeterminate One, the immense faceless someone To write is to enter into an affirmation of solitude where fascination operates as a threatening element" (*L'Espace littéraire* 24). For Blanchot, the Mother is a plenitude that requires no signs, that exposes the improverishment of signs and the futility of their rigor, their attempt to signify beyond themselves. What the Reformation denounced above all was the twisting of Christian idealism into opulence and self-sufficiency, a perversion centered in the cult of the Mother.

In its apparent anti-asceticism, maternity actually focuses the conflicts within asceticism itself. The maternal functions within asceticism both as a check on "solitude" and as a bracing temptation to the forgetting of self. The gaze of the Mother so compellingly represented in Grünewald's Nativity negates signification not by erecting some countercommunicative mode, but rather by being so perfectly and "naturally" communicative. Within the Mother's gaze the full density of the world becomes intelligible to the child, and the space between mother and child becomes a zone of silent dazzlement, which may be

indicated by Barthes's terms "infra- or ultra-language" (*Writing Degree Zero* 20). In its rigor, specificity, and substitutiveness, writing signals the inaccessibility of the Mother. In the swoon of the child, his head flung back in an ecstasy of infantile dependence, Grünewald represents the short-circuiting of the resistance to the Mother epitomized by writing. Mary here is the self-signifying Mother of Images, Mother of the intelligible and ripened world. If writing is an ascetic discipline, the mother's gaze is the origin and reward of such discipline. In the Resurrection-Transfiguration Grünewald portrays the end of discipline, the dissolution of signs into understanding. The transfigured flesh of Christ, grown strange in the zone of ultra-language on the margins of representation, melts back, this time under the sign of the death-decreeing Father, into the condition achieved so effortlessly and blissfully in the Nativity, of perfect knowledge without gaps.

While the paintings of the second position succeed, then, in isolating narrative—including the narrative of signification—as the essence of the ascetic life, and in deflecting attention from the human and temporal, they make radical thematic concessions to the power of the feminine, casting narrative and representation itself in terms of the sublime drama of motherhood.

Close those panels, then, and attend to the traditional image of Christian mediatation, the Crucifixion. What the contemplatives con-template, as virtually all mystic writings attest, is the Cross: "*Optimum est semper in cruce meditari*" (How wholesome it is, always to meditate on the Cross of Christ). The cross of Grünewald, with which German religious painting reaches its culmination, has been wrenched from the temporal narrative of the second position, to which it provides the climax or pivot; it has been detemporalized through the inclusion of John the Baptist, and derealized through the allegorical figure of the Lamb. The narrative of Christ, like the world, is washed in the blood of the Lamb, to emerge cleansed of time and reference. Reflection comes to rest. The entire work assumes cathedral form, the form of a cross, with the back to front conceptual narrative intersected by the "tran-septs" of the representational temporal narrative.[1]

Thematically, the Crucifixion restores paternal dominance over the maternal-temporal irruption of the second position. Here Mary is a startling but marginal figure, virtually broken by grief; and Magdalene seems hysterical, shortsighted, spasmodic, sentimental, and even impi-ous, gripped by a mourning implicitly devalued by the figures on the right. Mary and the Magdalene would deflect meaning diagonally through their inability to look beyond the event, beyond time, beyond

the intersubjective or biological, their inability to align themselves with the stern angles of the Cross.

With the triumph of the perpendicular and the restoration of the contemplative values on which a true asceticism is based, the disproportion in size between the human and the divine is reversed and righted: in contrast to the shrine, Christ has assumed here a size proportional, as most scholars comment, to his importance. He has "increased," while John, the proto-ascetic, has "decreased." Anthony, too, has decreased, being relegated to the margin, paired with Sebastian, and "aestheticized" by being represented as a work of art. In fact, the disorder of the pale foliage beneath Anthony's feet compared to the tidy order beneath Sebastian's, and the fact that a demon crashes through the window above him while angels bear Sebastian a crown, might even suggest an anti-Antonine conclusion, that the man of temptation is inadequately ascetic, that the only true resistance to temptation is perfect contemplation, or death. Is this, then, the end and closure of the conceptual narrative devised by Grünewald to articulate and modify, to complete and subvert, the shrine with which he began? Is this an image with which we can rest?

If it were, the image would have to be altogether alien to narrative, out of time and luminously complete in itself. But although Grünewald has tried, through the two figures to the right of Christ, to create a nonnarrative image, he has not done so; he has merely created an image in which multiple temporalities intersect. And their intersection is ungainly: John, who has risen from the dead, announces his diminution in favor of Christ, who is at the point of death. If we contemplate this image without narrative connection to any other, it seems as though John has gotten it exactly wrong. If we only attend to the image of the cross without thinking of the Resurrection, then Christ is merely an object of mourning, an enormous corpse, to be loaded into the grave, as we see in the Lamentation. In order for the Crucifixion to mean what it means, or to mean anything at all, it must be spun round and returned to its context in the narrative of the second position. Huysmans comments that at first the viewer is transfixed by the figure of Christ, and then repelled by it and attracted to the dazzling whiteness of the Virgin's cloak, which almost makes her the center of the work. Then, Huysmans says, the balance, about to be upset, is maintained by the unexpected gesture of the Baptist, "who in his turn seizes your attention, only to direct it towards the Son." "One might say," Huysmans concludes, "that, coming to this Calvary, one goes from left to right before arriving at the centre" (4; trans. Baldick).[2]

The exceptional tension of Christian thought is nowhere more

evident than in the fact that its unchanging center, its constant object of contemplation, is a corpse; for in many respects the corpse epitomizes a dimension of existence on which it is impossible to focus. Kristeva has also written on the corpse as the epitome (or nadir) of the "powers of horror," of "the abject." Corpses, she writes, "*show me* what I permanently thrust aside in order to live," "a border that has encroached upon everything" (*Powers of Horror* 3). Abjection is above all a figure of rejection, ejection, or even dejection: "A decaying body, lifeless, completely turned into dejection, blurred between the inanimate and the inorganic, a transitional swarming . . . is fundamental pollution" (109). Contemplating the sickening waste of the corpse, one is "deprived of world": "I *fall in a faint*" (4). Clearly, Mary is the only one who truly *sees* the corpse.

Even after arriving at this repellent center the viewer feels an elaborate reluctance on the part of the artist to represent any centered image. In order to portray Christ whole and complete, without the panel division running through his body, the cross has been placed just off-center, to the right. Paradoxically, the necessity of preserving the inviolate centrality of the image has forced it to be decentered. But to this merely technical necessity Grünewald has improvised another decentering element. Although many have noted that the cross is turned slightly to the right at the bottom, nobody to my knowledge has pointed out that it is turned slightly to the left at the top, so that we see this central and centering image only "perspectively," from the right and the left. A "typhoon of art," the cross is *twisted*, preempting the settled gaze, the unblinking attention of the interior eye, spinning it round and forcing it back into the temporality of the narrative.

Back in the second position we encounter the image of triumph, the Resurrection, but again we do so only in the context of the maternal-reproductive. The Cross achieves its meaning within the story of Mary, "unique among all women"; and abjection becomes a function of maternity rather than an aspect of the miracle of the crucified God. And so, in order, once again, to re-paternalize, universalize, and "sterilize" asceticism, the viewer is driven back to the third position, and finally to the shrine, in which ascetic effort and endeavor in the human, historical world stand forth for the first time not as an unmotivated assertion of the power and glory of the righteous human, but as a reactive, corrective assertion of the humility of the human, a reassertion of the ascetic priority of the impoverished masculine, and the *sub rosa* subject of the entire work.

The fact that this terminus is only another beginning reminds us that while representational narratives may, indeed must end, the conceptual

narratives structured by them cannot. In tracking a paternal conceptual narrative that intersects and resists the maternal temporal narrative of the second position, I have sought to identify an ascetic practice of reading that may, in its ambition to achieve a stable object of contemplation, appear antipathetic to literature and causality. The conceptual narrative betokens a readerly act that exceeds formalism, an act that conceives itself in terms of understanding rather than perception. But narrative itself, as the temporal narrative of the second position reveals, also seeks to go "beyond narrative," to dissolve into thought, thought which enriches, informs, and transforms human history. Thus the clumsy and impure category of "life" surrounds narrative as its referent and ground. Just as all writing harbors, as Barthes says, "a 'circumstance' foreign to language," a nonlinguistic essence which it tries to "communicate" (*Writing Degree Zero* 20), all narrative harbors a circumstance foreign to itself, "life," whose interminability conditions the infinite and endless conceptual narrative. The conceptual narrative does not exceed narrative; it simply isolates the "foreignness" of narrative itself. Concluding, narrative seeks to move from discourse to silence, exterior to interior, superficial multiplicity to profound unity, from event to memory and reflection. In so doing it both transcends itself and plunges back into the rich mud from which it arose. The recognition of a conceptual narrative to which the representational narrative provides a momentary configuration serves as an antidote to the metaphysical pretensions of narrative and recalls us to a life of unending trial.

Although I have called it "paternal," the conceptual narrative is not "higher" or more "abstract" than the representational narrative, for it is bound to images and situated in the reader's world. We confront, then, not narrative and anti-narrative, world and other-world, but rather enlarged and more complex understandings of narrative and the world as self-transcendent. The question that must now be addressed is how representation can accomplish this self-transcendence, this self-abolition.

"*I*n glory and splendor shall he come," the Psalm says; and Christian art accepts the burden of representing that glory and splendor in images that bear witness to the incarnation of spirit, reinforce the notion of the body as signifier, and in a larger sense testify to the visible beauty of God's creation.

But Christian art also labors under another burden, expressed in the prohibition in Exodus against images of worldly things, an injunction which, if followed as rigorously as Luther, for example, wished, would intervene against the very idea of Christian art. This ban on images was directed at what Heidegger called "representational thinking," the uncritical and essentially magical identification of sign with referent. Representational thinking stabilizes the subject in its worldliness, as Heidegger understood; and it provides the basis of idolatry, as Moses understood. Idolatry was a standing preoccupation, especially in medieval Germany, where the veneration of images became a public scandal.

Very early in the history of the Church the institution, recognizing that the instructional powers of pictures compensated for the temptations they created, reached an accommodation. Gregory the Great wrote in 787 that art should be encouraged as a way of educating the illiterate: "Because in a picture even the unlearned may see what example they should follow; in a picture they who know no letters may yet read" (*Epistulae* ii. 13). Clearly a concession, this dictum still did not concede the basis of the Exodus injunction, the literal or referential

unrepresentability of the divine. Gregory was frequently cited by Renaissance writers in the course of cautious endorsements of images as means of arousing the sluggish and imprinting devotional images in the memory. But it was precisely the unlearned, the sluggish, and the distracted who were most likely to confuse the image for the thing, or to fall back on representational thinking. So at the beginning of the Renaissance, when the the techniques of visual realism began to be systematically explored and developed, art found itself vexed by its own expertise: it could either represent unworthy subjects in a faithful and accurate way, or depict worthy and divine subjects in an inaccurate and untrustworthy way.

A Christian art that appropriates the techniques of visual realism confronts a crisis of the subject, both the apprehending subject in danger of representational thinking, and the subject or content of the representation itself. The range of possible "topics" under such conditions is quite restricted. For the orthodox artist, only the events of or somehow contiguous to the life of Christ and, to a lesser and somewhat "riskier" extent, the events from the lives of saints, were both representable and worth representing. This restriction seems to have inspired ingenuity rather than resentment, and the portrayal of the infinite variety of the merely human was a border that art crossed, at first, only with great reluctance. Giotto could depict St. Francis during the saint's lifetime only because of the unprecedented public recognition of Francis's sanctity.

From the depths of his piety, Grünewald conducts a sustained exploration, testing, and questioning of traditional iconography. Every painting contains some anomaly, some novelty, some baffling and original contribution to the inventory of artistic possibilities. His language of form has a sovereign disregard for those considerations of accuracy that occupied Dürer. But Grünewald is not simply expanding the repertoire; he is exploring the limits and conditions of representation itself. One phase of his exploration produces images "beyond" representation, particularly the manifestly "inadequate" representations of God in the Nativity and the Temptations of St. Anthony, images unlike any representations of the divine in any nation's art, either before or since. On the relatively rare occasions when the deity was represented before Grünewald, artists—Piero della Francesca, Masaccio, Andrea del Castagno; or in German painting the Master of the St. Bartholomew Altar and Dürer—generally depicted a distinguished old man, compensating for the violation of taboo through the strength and nobility of the appearance. Before the end of the Middle Ages (which were laid to rest in Italy around 1410, but lingered on in Germany until

the beginning of the sixteenth century, when Dürer made the sudden and belated break), painters, adhering to the second Commandment, avoided portrayals of God, gradually accommodating themselves to a representation first of a hand issuing from a cloud, then of a head, and finally, as in Michelangelo, of the entire form (see G. Ferguson 157 ff.). Unwilling to make that bold and secularizing leap, Grünewald stands virtually alone in his compromised attempt to *render* the incapacity of art to depict the presence of God. If the commonplace that Catholic cultures valorized the sense of sight while Protestant cultures distrusted images in favor of the word holds true, then Grünewald's representations of God may betray Lutheran (or perhaps "postmodern") sympathies, for they force the viewer to consider, and to consider as a visual experience, the category of the unrepresentable.

As if subjected to a kind of gravity, some forms in the Isenheim Altar grade towards the divine, edging out of representability as they do so. Well along on the soul's journey into God, Christ is figured in the Resurrection at the moment when he passes from representability, a passage visible in the arc from bottom to top, from sophisticated foreshortening and brilliantly defined surfaces to the renunciation of perspective, realism, and form itself. The quasi-"realistic" bearded pink and blue angels hanging heavily in the air over the astonished peasants on the hill in the Nativity have a certain filmy density and seem unable to ascend higher; those clustering around God in the Nativity are minimal and sketchy, indicated by red or yellow paint that does not bother to conceal itself as something else.

The other phase of Grünewald's exploration produces images "beneath" or "outside" of representation and subverts representational thinking through the depiction of incomplete, incomprehensible, mobile, mutant forms that grade out of representation through deficiency rather than excess. The outsized figures of the peasants behind the church in the Nativity are as transparent and insubstantial as the angels swimming above them. Despite their resemblance to the angels, however, these figures have a totally different impact. For they betoken the voluntary surrender of those techniques whose command was so persuasively demonstrated in the Annunciation and the Nativity—perspective and mimetic realism, a thorough knowledge of Italian conventions such as the triangle made by the Virgin and child, and even including the convention by which the opacity of color indicates three-dimensionality. They may appear as a "mistake" left in the completed work by oversight, but their effect is to discredit the techniques of art altogether. The *failure* of art, not its perfection, produces human figures that resemble angels: in such defeats we are closest to God.

Anthony's temptations provide another instance of the failure of art. Vividly rendered and yet formally clotted and confused, they are at once distinct and incoherent. Art cannot unscramble them, cannot make them intelligible. It can only depict their unintelligibility, which ultimately reflects a certain unintelligibility in desire, its inability to achieve formal coherence by itself, without the resistance of matter. The "trial" of the subject in this painting arises in the confrontation with a state of nondifferentiation. The creatures are imperfectly differentiated from each other and from Anthony; one of them even snatches Anthony's cloak and covers itself with it. Claiming them as his own— as he must—Anthony places himself at the margin of the human and the nonhuman, the intelligible and the chaotic, longing and revulsion. This margin defines the grotesque and marks the obsession of asceticism with illegitimate minglings, bastard forms, and taboo defilements. Logocentrism itself, Derrida argues, maintains the purity of its metaphysics by employing the sensation of disgust as a means of rejecting, or ejecting, sources of defilement. Through temptation, asceticism both rejects and admits defilement, comprehending metaphysics and its opposite, culture and its negation.[1] If we accept Kristeva's contention that art situates the subject "between *desire* and the *law*," then we can see that this "failure" of art only reflects art's inability to transfigure or re-present a subject so proximate to it, one whose configuration is already so "artistic" ("How Does One Speak to Literature?" 97).

Art is figured differently through the image of Mary in the Heavenly Choir. She is not, like the transfigured Christ, becoming unrepresentable; nor is she, like God, defiled by representation; nor is she, like her own earthly incarnation, merely human. She is situated precisely within the almost inconceivable sliver of existence truly amenable to representation. She alone (unique among all women)— invented, unprecedented, unsanctioned—is both fully representable and wholly worth representing. Kristeva discusses the act of giving birth as a "threshold" of instinctual drive and language, a border between silent *jouissance* and discourse as the special province of aesthetics ("Motherhood according to Bellini" 240–41). In these terms, this Mary, at the margin between the "cultural" Heavenly Choir and the "mute" Nativity, pregnant and yet complete, actual and yet abstract, epitomizes art itself, pressing against its limits.

Grünewald represents artifacts throughout the work, most conspicuously in the baldachin of the Heavenly Choir. Here again, the aesthetic is shown in distress, its forms lapsing from and crossing out of their proper sphere or function. While the structure that houses this iridescent dream-world itself seems ornamental, its ornament seems

half-alive, outraging what Gombrich defines as the essence of orna-
ment, the "sense of order."² The arches have a secret life of their own,
like a wild plant, and the gesticulating prophets that adorn them
provoke a sense of disorder, of clashing functions and conventions.
Ornament not only overwhelms structure in the baldachin, but spills
over its own boundaries into representation, and seems to harbor some
other, nearly legible system of countermeaning. In this nonornamental
ornament, whimsy and fantasy mingle with the "business" of function
and meaning in a way that compromises both. Contemplating the
baladachin as the proper seat of art (the music of the choir), the viewer
is awakened to the role of art in honoring God and his creation, and
also to the conventional and necessary division of functions between the
mimetic and the fantastic, nonmimetic, or antimimetic, a division on
which art and especially the interpretation of art depend.

A similar compromise frames the "living sculpture" of Anthony and
Sebastian, which invoke an art appropriate to no function at all, an
aestheticization of the living human form that leaves the viewer in a
state of interpretive suspension. The undecidability of these forms is
compounded by the floral bases on which the figures stand, orderly in
Sebastian's case and somewhat more ragged in Anthony's. These
straddle the border between mineral and vegetable while defying the
stress capacities of both, and so invoke not only the presymbolic
natural, but also, once again, the undifferentiated. As natural forms
whose naturalness has been overcome by art they suggest both the
triumph of the ascetic struggle in acculturation and the constant
implication of the ascetic in the natural.

While a work such as Pacher's St. Wolfgang Altarpiece sustains a
uniform degree of verisimilitude, a level of representation at the same
remove, as it were, from illusionism so that the entire composition is "in
phase," Grünewald has taken pains to throw everything out of phase.
Throughout, he has set up dialogues, or dialectics, between an untrou-
bled practice of representation and a disturbed or contorted represen-
tation that either portrays an impossible world or simply confuses
representational conventions within the familiar canons. An oscillation,
a kind of rhythm, pulses through the entire work, balancing, for
example, the serenity of the Meeting of St. Anthony and St. Paul with
the turbulent incoherence of the Temptations of St. Anthony; or the
living statuary with the Crucifixion; or, most clearly, in the confronta-
tion of the heavenly choir, an impossible, incongruous scene in which
angels make harmony with monsters, with the eminently representable
Nativity, in which representation seems most at peace with itself and
with the familiar world.

Through this rhythm a double aspect, or double destiny, of representation is thematized: on the one hand, a mimetic recreation and transfiguration of the world; and on the other, a process of counterfeit that operates through an ethically and symbolically neutral technique. Within this rhythm, which Lyotard might define as the dialectic of pre-Modernism and Modernism, art emerges as a domain in which the image is both fetishized and discredited in the name of the unrepresentable. Within the privileged sphere of meaning and symbolicity that constitutes the piety of representation, this rhythm institutes a counterforce of unintelligibility. It is this doubleness that defines the ascetic as distinct from both the metaphysical and the worldly.

The counterforce is most distinct in the double scene of the Heavenly Choir and the Nativity, which celebrates the glory and splendor of maternity against the background of a monastery. How could the medieval Church define Mary as the patroness of an asceticism that sought to exclude the maternal, the biological, the temporal? If we define asceticism only in this way the question will remain unanswerable. The real issue lies elsewhere, in the realm of what Kristeva calls abjection. According to Kristeva, the process that culminates in symbolization, acculturation, and articulation exists in a dialectical conflict with a process prior to it, a "semiotic" mapping of instinctual drives. The subject becomes articulate by separating from an apparently anterior state of undifferentiation, the state of abjection. The abject is what is not, or not yet, an object; it exists before the constitution of subject and object. The separation of subject and object, the entry of the subject into speech and culture, follows a "demarcating imperative" that operates according to the "simple logic of excluding filth" and is epitomized by the expulsion or exclusion of something from the body such as waste, menstrual blood, or phlegm. Abjection is thus a "figure" of expulsion through an orifice mapped, as Kristeva says, by the mother; ultimately, "There is language instead of the good breasts" (*Powers of Horror* 68, 45).

But abjection is not simply the image of defilement as anthropologists such as Edmund Leach and Mary Douglas have defined it, for it also includes any figural transformation of that act of jettison: abjection survives, for example, in the rhythmic and phonic dimensions of poetic language, and also in the very fact of figuration, to which it provides a "lining." Poetic language is marked for Kristeva by the susceptibility of its boundaries to upheaval, transformation, and dissolution, in which she sees traces of the struggle between symbolicity and semiosis. This struggle is virtually enacted by Grünewald's work not only in the dialectical contrasts I have been discussing, but also within some of the

figures themselves; for example, the green bird-man with flowers sprouting from his head, playing the viola in the Heavenly Choir—a riot of species in the act of producing culture. Art is distinguished among cultural forms in that it invokes ancient fusions and primitive drives, "memories" of man's indistinctness as a species. But all symbolic, cultural, and linguistic phenomena retain vestiges of the horror of undifferentiation which has been vanquished or surpassed in the repression that produces them.

The Isenheim Altar gives us much more than a vestige of this horror, but it also suggests much more than mere linguisticality. The degree of repulsiveness in certain of its forms seems to be in proportion to the massive symbolicity of others. In fact, the dead body of Christ is at once the most abject (in the Lamentation) and the most densely symbolic form (in the Resurrection) in the whole composition. The body of Christ is actually ejected from a state of undifferentiation twice, once in birth and again when it bursts from the tomb. With the first ejection, it allegorizes the emergence of language through separation from the mother. But what can we make of the second? At this point we must turn away from Kristeva and the abject for a moment, and towards Derrida's meditation on mourning. Commenting on Nicolas Abraham and Maria Torok's work on "introjection," Derrida describes mourning as a process through which the ego takes into itself or introjects a lost object or "corpse," which it preserves in a fantasmatic crypt, a hermetically sealed psychic space. Derrida insists that this space is linguistic, its secret nature producing "cryptic" utterances—such as, perhaps, John the Baptist's "He must increase, but I must decrease," the speech of a man in mourning. Even Christ's parables might be seen as the discourse of a man mourning himself, or the race of sinners whose collective death he has introjected. Christ's self-sacrifice for this race provides a theologized and imitable model for the repression essential to language, especially language that in some way repeats Scripture. The passage through death to transcendence in the second expulsion, then, allegorizes and empowers not just language in the abstract but the specifically cryptic language of mourning—for Christ, for the lost object which the word memorializes—an ascetic language undertaken in "imitation" of Christ, which Christianity promotes as the basis of all true symbolicity.[3]

Many feminists are troubled by Kristeva's linking of the abject and the maternal, with its concession to the point of view in which "every body is . . . homologous to a male speaking body" ("Motherhood according to Bellini" 242), but this link enables us to reconceive the narrative of maternity in the second position.[4] What these paintings

depict, from this point of view, is the "expulsion" of the Word from the maternal body. In a figural transformation of this expulsion, Anthony's body can be seen as at once jettisoned from the maternal "world" and itself "maternal" with respect to his temptations. Thus the proximity of the maternal makes ethics bearable by coiling the law in desire, raising, as Kristeva says in a recent article, "female masochism to the level of a structural stabilizer" ("Stabat Mater" 150).

Repressing the maternal, asceticism always invokes maternal figures; excluding the maternal, the ascetic replicates it. Anthony's trials are encounters with abjection, for what he rejects and renounces is his own body and ego, whose insides become visible in the form of monsters. In conceiving a body of orifices and interiorities, the maternal conceives an ascetic body, an exteriority of form and symbolic value, with a semiotic "lining" close to instinctual drives, to the temptation/ trial of maternal engulfment and the surrender of one's own body. Such a "lining" is in fact mysteriously emblematized by the pinkish lining of Anthony's cape, which is clutched by a demon in the third position, barely visible in the meeting with St. Paul, and drawn across Anthony's body in the first position in a gesture that both modestly conceals and creates a suggestively vaginal interiority as well. The putatively "phallogocentric" paternal both suppresses *and exemplifies* the force of the feminine as that-which-is-overcome, that-which-must-be-resisted, that-which-remains.

The double destiny of representation as it operates towards intelligibility and mimesis on the one hand, and towards unintelligibility and the dissolution of forms on the other, affects particularly the form of narrative exemplified by the paintings of the second position. This form maintains itself only through its ability to indicate beyond its own limits: its climax lies "beyond" it, out of its sequence in the Crucifixion; its incidental details resist coherence and meaning; and its conclusion reaches up to a zone as nonnarratable in one way as Hell is in another. Narrative here invokes its own erosion, in which representation aspires to the transcendence of forms or recalls its origins in abjection, pointing in both instances to a kind of knowledge in terms of which narrative is no knowledge at all. Instructed by the paintings of the second position, we could say that narrative asserts a transcendental ideal against and through worldly wandering, the pressure of necessity against and through circumstance, the intelligibility of form against and through abjection, timelessness against and through time. Narrative here is the means by which meaning emerges through a process, as Kristeva says, "turned graphic while permitting and integrating its transgressions" ("Giotto's Joy" 215).

The most conspicuous method of integrating transgression in the Isenheim Altar is through color. In the essay just cited Kristeva describes the ways in which the "One Meaning" authorized by the Church is constantly transgressed in Christian painting, especially through the subversive force of color, which scatters meaning into a chromatic pluralism, recalling it to instinctual drives which piety would repress. "Color," she writes, "might therefore be the space where the prohibition foresees and gives rise to its own immediate transgression. It achieves the momentary dialectic of law—the laying down of One Meaning so that it might at once be pulverized, multiplied into plural meanings. Color is the shattering of unity" (221). Establishing the terms of representation by outlining forms, color also acts as an agent of eroticization. "In a painting color is pulled from the unconscious into a symbolic order" (220). Grünewald is an exceptionally bold and inventive colorist, so remarkable that he may even have influenced Dürer in this area.⁵ Speculating about a possible meeting between the two in Frankfort in 1508, Panofsky notes an abrupt shift toward "luminarism and tonality" at that time in Dürer's style. "It is tempting," he concludes, "to think that this crisis was precipitated by an encounter with his antipode" (147). Even while turning Dürer towards color, however, Grünewald may well have been uneasy with color's corrosive power; and it may be significant that he chose Dürer's Heller Altar (1512) to explore the possibilities of colorless representation in grisailles on wings affixed to the altar. The attempt was unsuccessful: the figures are still thick, fleshy, even vulgar and coy. But the gesture towards an ascesis of color remains suggestive. In fact, the ubiquitous presence of books, written messages, script, and the reference to texts in the Isenheim Altar suggests an interest in exploring a "Protestant" alternative to painting within the painting, a colorless and abstract representation more consonant with the Word.

And yet Grünewald's color signifies. I do not mean to suggest a secret code according to which certain colors had theological, astrological, heraldic, or other meanings, although such systems abounded. I simply want to draw attention to the apparently systematic use of color to suggest patterns of significance that do not depend on the thematic interpretation of representational forms. Through color we can apprehend relationships and identifications that would be otherwise inarticulate. Reds, in many shades and levels of saturation but particularly those without any trace of yellow, seem in this work to constitute a principle of protective enclosure or enfolding, from the various cloaks and garments of Anthony, John the Apostle, John the Baptist, and Mary, to the curtain in the Annunciation. Yellow is the color of

transcendence, the color nearest to no-color, the color in which the forms established by all color appear to dissolve. The blue of Anthony's cape suggests a functional or thematic affinity with the book Anthony holds in the shrine: the cape covers and delineates Anthony's body, protecting him from "temptations"; and the book mediates between Anthony and Christ. Kandinsky, incidentally, describes blue as "the typical heavenly color" (38).

It is especially interesting that the blue cape is so voluptuously "lined," for according to Kristeva, blue can be identified with a "noncentered or decentering effect, lessening both object identification and phenomenal fixation" ("Giotto's Joy" 225). The first color recognized by the infant (at about sixteen months, the time of the Lacanian "mirror stage," the formation of the ego), blue is the most "primitive" color, and returns the subject to the archaic moment of its initial dialectic, at the point of breakaway from instinctual, biological, and maternal dependence.[6] Hence, for Kristeva, blue is the most instinctual, and therefore in a sense the most colored of colors.

Kandinsky makes the further point that "If two circles are drawn and painted respectively yellow and blue, brief concentration will reveal in the yellow a spreading movement out from the centre, and a noticeable approach to the spectator. The blue, on the other hand, moves in upon itself, like a snail retreating into its shell, and draws away from the spectator" (36–37). This suggests a dialectic between the garments covering Anthony and Mary (whose cape is also lined in vermilion, most opulently displayed in the Nativity), and those yellows that indicate the divine. The yellow of the divinized figures "approaches" the spectator but surrenders form, while the blue establishes and protects form, but "withdraws," indicating, for example, Anthony's self-protectiveness during the hour of temptation, or Mary's maternal swoon. Blue implodes, threatening form through a collapse on itself. All colors establish form and therefore the subject of representational thinking; but both yellow and blue, through different means, also decenter the subject.

Of course, color is not infinite, but bound to particular formal condensations. All form arrests the play of color and subjects it to restraint. In a sense, then, color is subordinate to light, and so to Idea, light's traditional analog. And yet, color also compromises the meaningful forms that outlines establish, scattering and diversifying the "simple" substance of light, and splintering the idea into colored surfaces. As Edgar de Bruyne notes, color and light exist in a state of tension: "The fact is that light becomes diversified in accordance with the variable resistance of material objects" (59). Color, therefore, is the

bodily and potentially transgressive form of light. While forms can be subject to ideological control by Church, guild, patron, and so forth, pictorial color has generally escaped such censorship, being accepted as the domain of taste, whim, pleasure, preference. Color is the resistance between light and bodies, idea and surface.

Color is not the only agent in this work of transgression. While the numerous texts represented may call attention from painting back to the Word, the gorgeous, alluring, repulsive, and preeminently distracting representation of the Heavenly Choir signals a loss of signs, an even closer approach to instinctual drives. This scene suggests the view of Pater that painting has "no more definite message for us than an accidental play of sunlight and shadow for a few moments on the wall or floor: is itself, in truth, a space of such fallen light" According to Pater, "*All art constantly aspires toward the condition of music*" (94, 95). An incomprehensible and musical scene, the Heavenly Choir considered by itself is art as "accident," art as sensuous presentation without "definite message."

One correlate—rather than "referent"—for the Isenheim Altar is representation in its agonies, as the unity of the work shatters into fragments that resist naturalization, parts that belong to no wholes, details that signify and central subjects that do not, shattering meaning into the boundless range of the chromatic plural. Through such means representation acknowledges its complicity with instinctual drives, with distraction, pleasure, accident, the entire domain of the nonrigorous. But this indulgence does not render art anti-ascetic; indeed, the discrediting of its own methods and pretensions establishes the claims of art to authenticity by serving the ascetic functions of self-criticism and confession. If representation stages its own carnivalization, it is not thereby cast out from institutional function or favor. For through such carnivalization, the Church itself—but also more than the Church, the entire cultural network in all its forms and codes—combats its own entropy by courting its own hypothetical destruction, by sponsoring art, engaging it in a reciprocity at once subversive and rejuvenative, stabilizing and transformative. The transgressive and rejuvenative resistance staged by the Isenheim Altar through a "Passion of representation" not only sustains a particular ascetic institution, an Antonine Christian church, but indicates an ascetic dimension in the ways in which all institutions preserve themselves.

Asceticism and the Sublime 4

*T*he raw force, the nearly physical power of the Isenheim Alter impresses every beholder, who must feel something of Huysmans's reaction: "It is as if a typhoon of art had been let loose and was sweeping you away, and you need a few moments to recover from the impact, to surmount the impression of awful horror . . ." (3; Baldick trans.). Others speak of the work's "sublimity," a notion derived from Longinus's third-century treatise *On the Sublime*. Longinus defines sublimity in terms of an emotive force marked by a disruption of the subject through a traumatic imprinting or inscription. Not only is the orator or author of the sublime text overwhelmed by his subject, as Homer is "swept away by the whirlwind" (151) of the battles he describes, but the listener or reader is overpowered by an effect that does not persuade as much as "transport" readers "out of themselves" (125). This transport occurs in two phases, first a sense of being "scattered," and second of being "uplifted with a sense of proud possession . . . filled with joyful pride, as if we had ourselves produced the very thing we heard" (139). In the ecstatic moment of sublimity, readers feel first decentered and dispossessed of themselves, and then reconstituted virtually as the author of the work.

If we search in the Isenheim Altar for a representation of the sublimity-effect, an obvious site emerges in the Crucifixion, not in the assured and articulate John the Baptist, but rather in Mary Magdalene, who is manifestly "swept away" by the scene she witnesses. But perhaps Mary, especially in the paintings of the second position, is a better

instance. Longinus even refers to the "impregnation" of sublimity through a forcible inscription in the memory of (to use Jakobson's term) the addressee, the receiver of the message.[1] For Mary, the text of Isaiah and the message of Gabriel are sublime texts that impress upon her their "meaning," the body of Christ.

Recently, Suzanne Guerlac has argued that the effect of sublimity consists precisely in the suspension or neutralization of such distinctions as that between the reader or addressee and author or addresser. She locates the force of the sublime even in the humble act of citation, in which the reader claims the message as his own "proud possession," achieving a "fictive identification with the speaker" (275). Producing in the reader the impression of authorship, Guerlac writes, sublimity "dramatizes a division within the subject, exhibiting the gap between the subject of enunciation and the subject of the *énoncé*" [the statement uttered] (286). Responding to this argument, Frances Ferguson suggests a slightly different emphasis:

> Longinus counts particularly in any account of the development of aesthetic thought in the last three centuries precisely because he points the way toward an aesthetics of individuation that rests on a promotion of the reader and a suppression of the author. . . . [Longinus's] text has more obvious import when one considers its connections with such cornerstones of New Critical theory like Wimsatt and Beardsley's intentional and affective fallacies. The affective fallacy represents a holding action, a policy statement that no individual reader can simply make up whatever version of the text he likes, but the necessity for such an effort to rein in a potentially rampant subjectivism stems quite directly, I would argue, from the implications of identifying such a thing as an intentional fallacy, precisely because the subjectivity of the author is rendered in purely formal terms, the form of the text, while the burden of subjectivity thus inevitably falls to the reader. (295)

Ferguson concludes that the position fundamental to Guerlac's argument is not a merging of author and reader, but rather an identification of the text as the reader's, an identification even more explicit in Kant's characterization of the natural sublime, in which "authorial intention is totally irrelevant" (296). The tradition that appropriates Longinus, she says, "culminates in a dissolution of the subject in the person of the author and in a reinscription of the subject in the person of the reader, hearer, or viewer" (297).[2]

Ferguson's argument leads us to consider another site of the sublimity-effect in the third position, in which Anthony is dispossessed

of himself by the temptations that claim him as their own, and also massively centered in the shrine; while Christ, the Word, the original of whom Anthony is a "citation," is "suppressed" down below. In the right panel, Anthony even *sends* a message to God—the script in the lower right beseeching aid—claiming for himself the role of addresser. In representing the addressee as "scattered" (Anthony tempted), "impregnated" (Mary), "overwhelmed" (Mary Magdalene), and "uplifted" (Anthony enthroned, John the Baptist), the Isenheim Altar would seem to constitute an encyclopedia of possibilities of the sublime. The problem with treating the sublime as a controlling category for this work is not that there is no evidence for it, but that there is ample evidence in the work for incompatible accounts of the sublime. There is no contradiction between the different phases of sublimity, but there can be no reconciliation between Guerlac's claim that sublimity produces a divided reading subject and a fictive identification of reader and author, and Ferguson's claim that sublimity unifies the reading subject by suppressing the author altogether. If one is right, the other must be wrong.

At this point the sublime loses its usefulness and must drop out, to be replaced by another Late-Roman concept, asceticism, which far exceeds sublimity in terms of comprehensiveness and profundity. As figured in the Isenheim Altar, asceticism accommodates Guerlac's sublime in the first and second positions, and Ferguson's in the third. More important, it accommodates what the sublime cannot. Guerlac points out that sublimity can operate through a suspension of the opposition between art and nature: according to Longinus, "art is only perfect when it looks like nature" (193); on which Guerlac comments that sublime figures are obliged to conceal their figurality, so that they appear to be "natural": "considered as a function of nature, the sublime implies nobility and sincerity. Considered as a function of art, it implies the reverse" (279). The "living ornament" of the Isenheim Altar, as well as the sculpted figures of Anthony and Sebastian, the radically antinaturalistic effects asociated with the appearance of divinity, and even the "firm reality" of the figures on the shrine, all address the issue of the distinction between art and nature, but do not routinely mask art as nature or require it to confess its artificiality. Indeed, in many instances the artificiality of the presentation is insisted upon. Within the ascetic, art can represent, can mask itself; but it can also refuse to do so: it is not condemned to habitual embarrassment. This independence of art from a servile mimesis, which had to await proclamation by a Modernism unembarrassed about its asceticism despite its repudiation of theology, is implicit and fully operative even in the traditional, medieval, ortho-

dox practice of Grünewald. The ascetic, in short, produces effects appropriate to the sublime and effects contrary to the sublime.

In the history of aesthetics, the descendants of Longinus who stress the identification of author and reader, or the cooptation of author by reader are ranged with their opponents, those formalists and intentionalists who insist on the primacy of the author or text: they all coexist in the spacious context of an ascetical tradition that does not settle oppositions for us as much as it simply structures them, defining the terms within which our thinking occurs.

Philosophy and the Resistance to Asceticism

Nietzsche: Weakness and I
the Will to Power

When I am weak, then I am strong.

2 Corinthians 12:10

"*A*part from the fact that I am a decadent," Nietzsche says at the
beginning of *Ecce Homo* (written 1888), " I am also the
opposite" (224).[1] Healthy by nature, decadent "as a specialty," Nietz-
sche proclaims himself a "*Dopplegänger*," a condition traceable in one
respect to his parents: "I am, to express it in the form of a riddle, already
dead as my father, while as my mother I am still living and becoming
old" (222). But Nietzsche sees in himself not only his parents but also
his entire genetic history. Meditating on the ever-dilating, ever-diluting
genealogical network he determines, finally, his own racial essence.
Born of Germans themselves born of Germans, Nietzsche yet conceives
himself "a good European" merely "*sprinkled* with what is German," a
man whose ancestors must have been "Polish noblemen" (225). This
account testifies to Nietzsche's continuing interest in genealogy since
the publication, the year before, of *On The Genealogy of Morals*. But the
extravagant praise here of his father, a clergyman who died when
Nietzsche was four years old, would seem radically out of place in the
violently anti-religious, materialistic, and vitalistic atmosphere of the
Genealogy, a text crucial to the Nietzschean attack on ideality, meta-
physics, and "the ascetic ideal." Are we in the presence of one of the
subversive "contradictions" that have made Nietzsche such a charis-
matic figure in contemporary critical theory? If so, we do not stay there
for long, for what Nietzsche praises in his father is not his piety but his
connection to royalty and power. Herr Nietzsche had taught for a few
years in the castle of Altenburg, numbering among his pupils girls who

became "the Queen of Hanover, the Grand Duchess Constantine, the Grand Duchess of Altenburg, and the Princess Therese of Saxe-Altenburg" (226). Thus Nietzsche portrays himself as being genealogically implicated in nobility; and so an ancestry that might have been construed in the value-system of the *Genealogy* as weakness actually augments his claims to strength.

On *The Genealogy of Morals* is a pivotal text in several respects. The most systematic, least aphoristic, and most "mastered" of all Nietzsche's works, it is also a key text in the contemporary demystification of system, coherence, and idealization. It accomplishes this double agency partly by exploiting the Doppelgänger character of genealogy itself, which consists, as Nietzsche says in his "Preface," of an inquiry into the *"origin* of our moral prejudices" (2). So stated, genealogy is a business-as-usual activity that supports if not our moral prejudices at least our conventional way of finding out the truth about things. But genealogy has another face. For a number of (predominantly) French thinkers, genealogy provides a method for a critique of all signs, all meaningful structures, all appearances, all idealized forms. Morality enters into this project as a master-sign, "since the ethical ideal is the archetype and source of every ideal, and especially of truth" (Haar 19).

Nietzsche's contemporary students stress the critique of ideality at the expense of the inquiry into origins, perhaps because such a critique seems, to invoke a Nietzschean category, more interesting. As a principle of modernity, genealogical analysis is a process of de-signification that seeks beneath every appearance, every surface, the traces of a prior struggle between unequal forces, a process Nietzsche describes in the middle section of the middle essay:

> all events in the organic world are a subduing, a *becoming master*, and all subduing and becoming master involves a fresh interpretation, an adaptation through which any previous "meaning" and "purpose" are necessarily obscured or even obliterated. . . . purposes and utilities are only *signs* that a will to power has become master of something less powerful and imposed upon it the character of a function; and the entire history of a "thing," an organ, a custom can in this way be a continuous sign-chain of ever new interpretations and adaptations whose causes do not even have to be related to one another but, on the contrary, in some cases succeed and alternate with one another in a purely chance fashion. The "evolution" of a thing, a custom, an organ is thus by no means its *progressus* toward a goal, even less a logical *progressus* by the shortest route and with the smallest expenditure of force—but a succession of more or less profound, more or less mutually independent processes of subduing, plus the resistances they encounter (2.12).

According to this majestic passage, the Will to Power, which Nietzsche calls the "genealogical element of force," produces all forms through domination and mastery of resistance, so that every appearance is the factored product of processes of overcoming and resistance which are not compromised as much as "obliterated" in the appearance itself. Behind the surface, however smooth, of every sign lies the crossing of lines of unequal force.

Genealogy in this mode departs most radically from traditional scholarship in its resistance to any settled formulation. The forces it discovers are themselves only relational, the signs of other forces whose origin ultimately is simply the Will to Power itself. Interrogating these signs, genealogy not only searches for traces of struggle but is itself a struggle, a mastery and subduing of signs, an overcoming and dissimulation of appearance. Relentlessly differential, genealogy is, according to Michel Haar, "necessarily hostile to all codification of its own results," revealing "a world scattered in pieces, covered with explosions; a world freed from the ties of gravity (i.e., from relationship with a foundation); a world made of moving and light surfaces where the incessant shifting of masks is named laughter, dance, game" (7). Nietzsche argues in the first essay of his text that genealogy's insistent disclosure of a world in masks is supported by etymology and linguistics in general, inasmuch as the study of language reveals the methods by which moral concepts have become embedded in culture through the imposition of the values of those in power, so that terms for "good" and "evil" originally characterized groups in and out of power. In general, language serves as the focus and horizon of genealogical inquiry, an inquiry which excludes from the beginning any "transcendental signified," any object beyond perspectivism or the play of appearances.

For many, this version of genealogy has mastered and subdued that dimension of Nietzsche's thought that insists, as he says in the "Preface" to the *Genealogy*, on determining "what is documented, what can actually be confirmed and has actually existed" (7); it has obscured, too, the "centered" character of the text of the *Genealogy* itself, whose numerous references to contemporary events and to the work of other philosophers appear to reinforce scholarly conventions grounded in linguistic reference and the systematic search for truth. This mastery has not, however, been absolute. Despite Nietzsche's frequent insistence that "There is no will," no universal Will to Power, even his apologists sometimes worry that he has invented a covertly "metaphysical" term, a "unique and ultimate word" that designates presence. Introducing a volume of essays written mostly by French *nouveaux* Nietzscheans,

David Allison concedes that genealogy finds it difficult to avoid the truth it banishes: "genealogical analysis quickly encounters its own limits" because its "critical capacity" depends "on the system it holds in question" (xxii). To treat language as the horizon of inquiry may disseminate the object, but insofar as it communicates, all language, including Nietzsche's, refers, names, orders. Almost regretfully it seems, Allison concludes that "Nietzsche's conflicting and oftentimes contradictory interpretations of a particular subject matter indeed make sense" (xxiii).

Genealogy's ambivalence epitomizes certain features in Nietzsche's work in general, an ambivalence that produces effects ranging from banal conundrums—If all knowledge is "perspectival," how do you know that?—to the uncanny. The shrewdest of Nietzsche's contemporary readers, Paul de Man, argues that the resistance between mastery and unmasterability, the system and its deconstruction, actually drives and determines the Nietzschean text. His brilliant analysis of *The Birth of Tragedy* in *Allegories of Reading* identifies two narrators, one who argues against representational realism and the other for whom Dionysian insight is the tragic perception of an original truth. The "semantic dissonance" thus created leaves a "residue of meaning" that "remains beyond the reach of the text's own logic and compels the reader to enter into an apparently endless process of deconstruction" (99). The intervolution of the two senses of genealogy might serve as a model for this endless process: a double resistance to both the infinite regress of differential forces, which would render helpless language itself, and the stabilizing illusions of certain knowledge, unquestioned appearances, causality, and identity.

How is this double resistance accomplished? The most obvious method—and yet one that has still not been fully appreciated—is through the unresolved opposition of local instances of causality and identity, the unmediated clash of declarative statements. The text begins with a knotty instance: "We are unknown to ourselves, we men of knowledge"; from which point Nietzsche will continually insist on his own acute self-awareness, while denigrating knowledge in favor of force. The second section of the "Preface" affords another example, when Nietzsche describes the origin of his thoughts on morality. On the one hand, they are organic, sown long ago and ripening with time, growing out of him "not as isolated, capricious, or sporadic things but from a common root, from a *fundamental will* of knowledge" and "with the necessity with which a tree bears fruit—related and each with an affinity to each, and evidence of *one* will, *one* soil, *one* sun." The philosopher as tree knows himself but slenderly, that is his strength; but

the third section begins abruptly on an altogether different note, with a totally different account in which philosophical ideas do not grow on trees, but come from "a scruple peculiar to me that I am loth [sic] to admit to—for it is concerned with *morality* . . . a scruple that entered my life so early, so uninvited, so irresistibly, so much in conflict with my environment, age, precedents, and descent that I might almost have the right to call it my '*a priori*. . . .'" And not only morality, but also "a certain amount of historical and philological schooling, together with an inborn fastidiousness of taste."

What has befallen the philosopher's arboreal oblivion in this account of shameful secrets, rigorous schooling, and fastidiousness? Nietzsche does not simply hesitate between accounts but constructs multiple definite and incompatible accounts. Moreover, the same strategy, if that's what it is, characterizes in general the attack on morality, which is cast in the form of the imperative to resist the temptation of morality, mankind's "sublimest enticement and seduction" ("Preface" 5). Revaluing the value of morality, Nietzsche still reinforces "the system he holds in question." The "seduction" of life by morality can only occur in a situation where morality, whose mark is temptation, is firmly in place. To stress the contradictory character of the critique we could say that the seduction cannot occur because it must already have occurred.

Nietzsche's contradictions have always troubled and excited his exegetes, beginning with his sister and those around her who regarded him as simply incapable of systematic thought. Eventually a more intelligent reading practice informed by Jaspers and Heidegger came to see contradiction as a central structuring principle in Nietzsche's thought. For Heidegger, Nietzsche is the last Platonist, and his contradictions are assimilable to Hegel's antitheses. In this tradition, Howard Eiland speaks of Nietzsche's "antipodal logic" as a legacy of a Platonism that is (and has, according to Heidegger, always been) "turned on its head" ("Beyond Psychology" 82). Heidegger's seminal study of Nietzsche accomplishes the task of meaning-making in an exemplary way by hovering over the texts themselves, extracting from them elements congenial to his own meditation on Being and descending to a detailed consideration only of *The Will to Power* and *Zarathustra*.[2] Like those who have followed him, Heidegger sublates Nietzsche's antitheses by isolating an essential preoccupation, which he describes as an unsystematic "openness" that reveals "*the realm of his genuine questioning*"; he is therefore impatient with efforts "to flush out particular disagreements, contradictions, oversights, and overhasty and often superficial and contingent remarks in Nietzsche's presentations"

(*Nietzsche* 1: 66). Even in the "anti-metaphysical" and anti-Hegelian French appropriation of Nietzsche a powerful centering and mastering tendency often produces a critique that elides, suppresses, ignores, or harmonizes dissonance in the interests of meaning.[3] But it is not always apparent which contradictions are the result of oversight and which are structural and essential. Zarathustra, we may recall, is continually dogged by his ape, his buffoon, and cannot be understood apart from it. Without questioning the wisdom, productivity, and even necessity of the synthetic approach—which is in effect sanctioned by the aphoristic style itself—I would like to read this one crucial and exceptionally influential and systematic text at close quarters, without recourse to clarifying passages in such texts as *The Will to Power, The Antichrist*, and *Human, All-Too-Human*, bringing out rather than supressing its internal conflicts on the assumption that they, too, will reveal "genuine questioning."[4]

One point at which the suppression of conflict in the discussion of the *Genealogy* has been particularly energetic is on the issue of power. Nietzsche constantly appeals to such terms as "strong" and "weak" as the historical and conceptual reality behind any mask of appearance. But what *are* strength and weakness? Can we go no further than these terms?

To answer these questions we need to consider the process of the argument as well as its conclusions, something which, surprisingly, has never been adequately done.[5] According to the familiar argument of the first essay, "'Good and Evil,' 'Good and Bad,'" moral values originate in power rather than in intrinsic qualities or in utility: the noble, the victorious, the strong impose an ethical terminology on their own interests, a terminology which, as its origin is forgotten, eventually comes to seem the basis of a neutral and "disinterested" morality. This form of analysis offers an alternative for contemporary critics who find, for example, Derrida's description of the hierarchization of binary oppositions altogether too ideal, too removed from social praxis to be of compelling interest. "Not metaphysics but ethics is the informing ideology of the binary opposition," Fredric Jameson writes; "and we have forgotten the thrust of Nietzsche's thought and lost everything scandalous and virulent about it if we cannot understand how it is ethics itself which is the ideological vehicle and the legitimation of concrete structures of power and domination" (114). Many others, led by Deleuze and Foucault, have seen genealogy as an analytic of power manifested as effective force. But Nietzsche's analysis does not rest with a description of the steady force of superior power. The Jews inter-

rupted the history of power-ethics through a "slave revolt in morals" epitomized by Christ, that figure of a priestly *ressentiment* through which aristocratic values have been subverted and displaced. An antipower, a principle of weakness, emerges, according to this first essay, when a "reactive" *ressentiment*, denied expression in deeds, falsifies its enemies in acts of imaginary revenge, when it "becomes creative and gives birth to values" by saying "No to what is 'outside'" (1.10). It is not superior force, but the stratagems of inferior force, that draw Nietzsche's attention.

In *Nietzsche and Philosophy* Deleuze concedes the "distressing conclusion" that for Nietzsche *all* active forces appear to become reactive, but he does not question why this should be. Indeed, he insists that Nietzsche's subject is the power of power; or, as he says in the conclusion, "Affirmation remains as the sole quality of the will to power, action as the sole quality of force, becoming-active as the creative identity of power and willing" (64, 198). Nietzsche has been read this way so persistently that it requires a certain scandalous virulence to pose the question, Why do the weak triumph? What is strength if it does not prevail? And what is weakness if from the first moment of its arrival it has vanquished strength, producing Judaism, Christianity, the Reformation, the French Revolution, until the present, when it virtually blankets the globe with the symptoms of a diseased and perverted "modernity"? We miss the point if we fail to see the dirty work done by ethics, yes; but we also miss the point if we fail to ask why strength, which Jameson characterizes as an "unassailable power center" (117), always loses.

The text does not provide answers to these questions, nor does it even acknowledge the condition that provokes them. This silence enables many clearheaded readers to infer that, as David Allison says, "the whole argumentation" of the *Genealogy* is based on "the distinction between two fundamentally different kinds of humanity—active and reactive" (xii). But in 1.10, the argument as it has been mounted is systematically dismantled, and the characteristics of strength and weakness redistributed through a series of concessions: sometimes, we learn in this section, the nobles negate and falsify their enemies, but in "a much less serious" way than the slaves do; on occasion the nobles, too, are reactive, and are even motivated by a *ressentiment* which, however, does not persist but "exhausts itself in an immediate reaction"; and the noble man, like his inferior, defines himself by his opposite and "desires his enemy for himself." Despite the rhetorical posture of conviction, the analysis is unable to keep the terms of its opposition segregated. The categories exchange attributes as though they were condemned to

define themselves in terms of their enemies. This fate is also suffered by the author, who repeatedly and pointedly characterizes himself in precisely the terms applied to the base and ignoble—silence, cleverness, and the tendency to caricature enemies as evil.[6] No attribute is truly foreign to any term; any noun can accommodate all adjectives in a text whose salient characteristic is not finally its polemical certitude but rather its radical evasiveness.

We cannot escape the sense of unraveling here. What is coming unstuck, however, is not strength or weakness per se, but rather their situation in primitive cultural groups, or what Allison calls "kinds of humanity." While the ethnological model has the advantage of providing dramatic clarity and pseudo-historical verification, genealogy encounters its own limits in the first essay because it cannot account for the triumph of the weak—something has to happen to the strong in order for them to be defeated, but their strength should preclude such disasters. Paradoxically, what ethnology teaches is the inadequacy of ethnology as an explanation of the origin of moral ideas.[7]

Many of Nietzsche's contemporary admirers would argue that this hardly constitutes a criticism because Nietzsche already accepts and even embraces such slippages, which lie at the heart of genealogy itself. Moreover, they might argue, such features are nothing other than the mark of rhetoric, which Nietzsche, (according to de Man) defined in terms of "arbitrary substitutions and even reversals" of names. If the strong are weak and the weak strong, then the text *enacts* in an exemplary way what the essay "On Truth and Lie in an Extra-Moral Sense" merely states, the "necessary subversion of truth by rhetoric" (*Allegories of Reading* 112, 110). Deleuze, for example, describes Nietzsche's language as antireferential, a flux of "pulsional intensities" operating through perpetual displacement, interpenetration and mobile inscription. For Deleuze not even the proper name—"Jews, Christ, Antichrist, Julius Caesar, Borgia, Zarathustra"—is proper, for it too is a momentary pulsional configuration of what he calls "nomad thought," which pitches its tents anywhere in a desert devoid of signifieds ("Nomad Thought" 146, 148). The contemporary devaluation of literal language in favor of principles of "interpretation," "rhetoric," or "dissemination" often grounds itself in a reading of Nietzsche, particularly the *Genealogy*.[8] But infinite rhetoricity does not produce a genealogical analysis, which depends upon a determination of differential force. If strength is not active and does not dominate, if weakness rules, this determination cannot be made; and genealogy, rendered impotent as a critical method, dissolves into just another linguistic mirage.

The "rhetorical" reading of Nietzsche has produced this remarkable and, from his point of view, highly undesirable result not by an excessive emphasis on rhetoric and its slippages and reversals, but rather through an *underestimation* of the force of rhetoric in Nietzsche. What's wrong with Deleuze's analysis is that it is not rhetorical enough. To see Nietzsche's language as operating under a special Bedouin dispensation does not, for Deleuze, mean that all terms are in flux. It rather means that those elements in conflict with the principles of affirmation, action, domination, creation, and will may be suppressed or ignored because Nietzsche doesn't mean what he says, or because his language is incapable of reference. Ironically, the effect of this argument is that truth as a function of reference is strengthened because Nietzsche's position can be cleansed of its accidents, contingencies, and confusions. In the end, the settled community of philosophy overcomes or domesticates the shifting sands of rhetoric.

The possibility shimmering on the horizon is that philosophy and rhetoric are themselves terms as nomadic as strength and weakness, that they cannot be used either by Nietzsche or by Deleuze against the other because they exist only in resistance to each other. The term de Man uses to express their relation is seduction: rhetoric for de Man is a set of "dangerously seductive figural properties" to which philosophy continually falls prey (*Allegories of Reading* 110). In this perpetually successful seduction, rhetoric repeats the triumphs of weakness and morality over strength. But what sort of seduction is *invariably* successful? Is seduction the proper model to apply? Or have we been seduced by the figure of seduction into believing that there is a clean ontological distinction between philosophy and rhetoric? In a famous passage in the first essay, Nietzsche does not distinguish between rhetorical and philosophical language; he claims instead that language in its entirety seduces by creating the "weak" impression that the strong need not possess "a desire to overcome, a desire to throw down, a desire to become master, a thirst for enemies and resistances and triumphs." Language "doubles the deed" by separating the act from the agent, the strong from their strength, "as if there were a neutral substratum behind the strong man, which was *free* to express strength or not to do so" (1.13). Through a kind of judo that turns strength against itself the weak hold the strong morally accountable for their strength, and delude themselves that they could be strong if they chose. Through the "fiction" or "lie" of the neutral independent subject, the weak interpret strength as a fault and weakness as freedom.

The tone is polemical, but what position does the text actually take? On this point Deleuze is, as usual, emphatic: "Critique is not a re-action

of *re-sentiment* but the active expression of an active mode of existence; attack and not revenge, the natural aggression of a way of being" (*Nietzsche and Philosophy* 3). But Deleuze has forgotten that the language that extols strength is still linguistic. To remember this fact is to see that the text is condemned by its own terms to a repetition of what Nietzsche calls the "fundamental errors of reason that are petrified" in language, and can only define itself as a Cretan liar (1.13). If, regardless of its thematic content, language cannot fail to function as the agent of weakness, then nothing it says can be disinterested. Attacking, for example, Kant's ("weak") notion of disinterestedness in the appreciation of beauty, the text must covertly but necessarily serve its own interest. But while interest itself is defined *contra* Kant as "strong," the interests of language are always "weak." Either the analysis is in error or it demonstrates the truth of the "weak" position, although its subject is the falseness of that position.

Let us abide in this thicket a bit longer. If language must epitomize weakness, and must serve the Will to Power of the weak, it must also replicate the essential fact of strength that it seeks to refute, the incapacity to do otherwise. We do not have to look far for the source of the deconstruction of strong and weak, for a "weak" strength and "strong" weakness inhere in language itself.[9]

As a preliminary response, therefore, to the question Nietzsche proposes as the subject of "a series of academic prize-essays," "*What light does linguistics, and especially the study of etymology, throw on the history of the evolution of moral concepts?*" (1.17), we can say that power, the origin of both language and moral concepts, operates oxymoronically, that is, on the principle of internal resistance.

This principle is most conspicuous in the area where ethnology is most irrelevant, the conscience. But genealogy must turn to the conscience in order to repair the damage done by the false clarity of ethnology. For what the ethnological arguments of the first essay had suggested, as opposed to what they had stated, was the reversibility of master and slave, a reversibility most apparent in the self-critical, self-observing psyche. The second essay, on the origin of guilt and bad conscience, can be seen, therefore, as an attempt to rescue genealogy by shifting the site of analysis from ethnology to psychology.

At first, however, the genealogy of conscience seems to raise the same questions as the genealogy of culture. The opening sentence describes the "paradoxical task that nature has set itself in the case of man": the breeding of memory, the basis of conscience, in a naturally forgetful animal. Opposing "robust health," memory enables man to make promises, to become "*calculable, regular, necessary,* even in his own

image of himself" (2.1). Once again, a force of weakness, even a morbidity, inexplicably corrupts a state of power and natural strength impotent to protect itself. But a crucial difference lies in the paradox, at this point little more than a figure of speech, that nature opposes itself in the creation of memory. No longer does nature suffer the insurrection of the antinatural. Conscience arises in the minds of debtors legally tortured by their creditors; after countless generations of blood and pain people begin to link transgression with punishment and take measures to avoid them. Anticipating the lash, conscience imposes an acquired but apparently "instinctive" shame in the presence of instincts. Gradually, humiliation issues in a new source of power, a mastery of the self over its instincts. At last, the indebted and tortured man finally emerges in the form of a fully human being, a "sovereign subject," "like only to himself, liberated again from the morality of custom, autonomous and supramoral." This is mankind "come to completion," possessor at last of a genuinely "free will," not simply the fictive freedom of the linguistic weak in the first essay (2.2).

So while conscience originates in subjection it ends in mastery. Many readers, looking only at the end product, regard mastery as an unequivocal form of strength. Michel Haar writes, for example, that "The master is the individual who gives himself his own law, and whose ethic is built on pure self-affirmation"(22). But we cannot forget the genealogy of conscience, which discourages such songs of simple selfhood and individual autonomy. Torture produces a force that is asceticized, that is to say ironized and exercised against itself.

In fact, the second essay in general turns on the first. Consider the ethnology of the second essay. Although the critique is still prehistoric, there is in the second essay no mention of a victorious *ressentiment*. Gone, too, is the differentiation of force, for the punishers and punished are unequal only in circumstance. Nietzsche does not revise or modify his analysis, but simply abandons the terms of the previous analysis and proposes an entirely new version, with new groups.[10] In the second essay the noble and lordly whose only law is their own interest have been replaced by the memorious, who have mastered themselves and have become "impersonal" lawgivers, "putting an end to the senseless raging of *ressentiment* among the weaker powers" that stand under them, mastering them more as a service than out of a thirst for victories and resistances (2.11). In fact, even within the second essay differing and contradictory accounts struggle for supremacy. In 2.17 Nietzsche proposes a scenario in which a conquering race of blonde beasts "lays its terrible claws upon a populace perhaps tremendously superior in numbers but still formless and nomad," imprinting form on

them and driving their "instinct for freedom" underground into la-
tency. According to this narrative, it all happens in an instant through
an act that precludes "all struggle and even all *ressentiment*." The
form-givers then vanish, leaving the formed with a violent and re-
pressed will to power which operates through self-mortification to
produce the whole range of ideal and imaginative phenomena, includ-
ing the state, religion, and all representation (2.18). This is an entirely
new ethnological set in which the strong imprint strength on others
who acquire form without ever having been precisely weak."

It would be possible to demonstrate how, within the various
narratives of the second essay, the attributes of weakness in the first
essay—adherence to law, disinterestedness, discipline, self-criticism—
are shifted over to the "strong" side of the ledger; while the attributes
of strength—violence, indifference to law, freedom from conscience—
are displaced to the weak side. Nietzsche's most systematic book, the
Genealogy is also spectacularly improvisational.

At times the argument even strategically "forgets" its previous
positions. Much of the second essay argues, for example, that guilt is
the residue of punishment. And many of Nietzsche's readers and critics
have assumed, with good reason, that, "according to Nietzsche,"
conscience originates with the creditor-debtor relation. But in 2.14 the
second essay turns on itself with the pronouncement that punishment
actually hinders the development of guilt: the punished see wickedness
practiced with a clean conscience by the powerful, and cannot under
these circumstances learn bad conscience themselves. So, Nietzsche
emphasizes, bad conscience "did *not* grow on this soil."

Then where did it grow? Some twenty-five pages and thirteen
sections after the elaborately worked punishment hypothesis, we read,
"I can no longer avoid giving a first, provisional statement of my own
hypothesis concerning the origin of 'bad conscience'" (2.16). This new
"first hypothesis" has nothing to do with torture or with the creditor-
debtor relation; now, bad conscience is an "illness" consequent on
man's being "finally enclosed within the walls of society and peace";
whereupon, deprived of enemies, a homesick man "had to turn himself
into an adventure, a torture chamber, an uncertain and dangerous
wilderness," declaring war on his old animal instincts. This animal-
with-a-conscience was "something so new, profound, unheard of,
enigmatic, contradictory, *and pregnant with a future* that the aspect of
the earth was essentially altered." In the second essay, bad conscience
originates in torture, or in socialization; among unfortunate debtors, or
among homesick animals; as a mark of degeneracy, or of heroism; as a
memory or as an anticipation.

Whatever relation contradiction or rhetorical instability has to Nietzsche's intentions, the reversals are so pervasive, so thorough and oddly systematic that they cannot be considered merely contingent or accidental. They form an integral part of an argument that not only persuades but performs, not only articulates but exemplifies.[12] The *Genealogy* embodies its own thematics: it subdues or masters itself as it goes, providing continually "new interpretations" that obscure and even obliterate their predecessors. As an allegory of strength-weakness reciprocity, the text—as mastering force, rebellious energy, and self-conquering "psyche"—dramatizes a critique both subtler and more comprehensive than any of its numerous particulars.

By the third essay, Nietzsche can say anything: that "modern life," which he had attacked as the triumph of *ressentiment*, low spirits, and impotence, is "not weakness but power and consciousness of power" (3.9); or that the Jews of the Old Testament, the slaves of the first essay, are in fact "great human beings" inhabiting "a heroic landscape," with "something of the very rarest quality in the world, the incomparable naïveté of the *strong heart*" (3.22).[13] But one opposition remains, and is in fact strengthened in the third essay: the opposition between the values of the text and asceticism. The object of caricature and contempt in essays one and two, asceticism is confronted directly for the first time in the third.

Immediately, a series of concessions and reattributions. In the second essay, for example, conscience is an ascetic self-torture, but here the Kantian pose of "disinterestedness" signifies the asceticism of the philosopher who "wants *to gain release from a torture*" (3.6). Once an agony, asceticism is now a release. Moreover, poverty, chastity, and humility do not deny life but constitute the optimal conditions of life, "the most appropriate and natural conditions of [the philosophers'] *best* existence, their *fairest* fruitfulness" (3.8). A legacy from the "power-hungry hermit" (3.10), philosophy is a way of converting asceticism to vitalism, impotence to power. But the hermit is not the only proto-philosopher—the case is actually much broader. In a startling reformulation, asceticism is rehabilitated as an instinctual activity, even a necessary antidepressant for savages. Primitive men feel an habitual heaviness, even a self-revulsion, which the ascetic priest "cures" by prescribing "cautious doses" of the will to power in "mechanical activity." Such activity paradoxically both deadens life by reducing it to minimal conditions, and produces *"orgies of feeling"*: "The old depression, heaviness, and weariness were indeed *overcome* through this system of procedures; life again became *very* interesting: awake, everlastingly

awake, sleepless, glowing, charred, spent and yet not weary" (3.20). Asceticism is held responsible—credited or blamed, it can no longer be determined—for self-hatred and for self-approval, for mechanistic deadening and for orgiastic ecstasies, for order and for wild disorder, for poisoning the race and for curing it, for revulsion against instincts and their origin. In the third essay, asceticism is an avalanche that carries all before it, finally producing everything that is the case on this "distinctively *ascetic planet*" (3.11).

Suppose the ascetic impulse is induced to express itself: what will it produce if not philosophy? And upon what will this "incarnate will to contradiction and antinaturalness . . . vent its innermost contrariness?"

> Upon what is felt most certainly to be real and actual: it will look for error precisely where the instinct of life most unconditionally posits truth. It will, for example, like the ascetics of the Vedanta philosophy, downgrade physicality to an illusion; likewise pain, multiplicity, the entire conceptual antithesis "subject" and "object"—errors, nothing but errors! To renounce belief in one's ego, to deny one's own "reality"—what a triumph! not merely over the senses, over appearance, but a much higher kind of triumph, a violation and cruelty against *reason*—a voluptuous pleasure that reaches its height when the ascetic self-contempt and self-mockery of reason declares: "*there is* a realm of truth and being, but reason is *excluded* from it!" (3.12)

There is no better description anywhere of the genealogical method, or of this text, which indicts the subject-object distinction as one of the "seductions of language," seeks out error where "instinct" would posit truth, denies the reality and particularly the rule of reason in all appearances, and even, remarkably, "downgrades" pain. Essay two, section 7: "Perhaps in those [prehistoric] days . . . pain did not hurt as much as it does now; at least that is the conclusion a doctor may arrive at who has treated Negroes (taken as representatives of prehistoric man—) for severe internal inflammations that would drive even the best constituted European to distraction—in the case of Negroes they do *not* do so."

Heidegger points out that "everything Nietzsche wanted to attain with his writings turned into its opposite" ("Nietzsche as Metaphysician" 108). And Deleuze speculates that if Nietzsche had lived longer he would have seen "his most critical notions serving and turning into the most insipid and base ideological conformism" (*Nietzsche and Philosophy* 55). This capacity to become turned inside out must betray a certain reversibility in the text itself, an element we should not hesitate to call

ascetical despite the apparently anti-ascetic position of the text. Nietzsche's contradictions are not, then, merely a token of mental instability; nor are they, as de Man would contend, marks of the "literariness" of Nietzsche's rhetoric; nor do they, as Eiland (somewhat surprisingly) says, describe a "reality" which, "on multiple levels, is double" ("Beyond Psychology" 82). They are the inevitable gestures of an asceticism turned philosophical, and a philosophy that purchases its "greatness" and even its "meaning" through acts of "self-overcoming" (3.27, 28). Indeed, if genealogy is the ascetic face of philosophy, and always focuses ultimately on morals, then the "position" of this text on its subject is difficult to determine. In one sense the attack on asceticism lies in ruins, for the text is implicated in its subject and, so, vulnerable to its own thrusts, a symptom masked as a diagnosis. But this is not a disabling criticism. What would an ascetical philosophy *do* if not attack itself?

Haven't we neglected perspectivism, which Nietzsche explicitly opposes to the Kantian philosophy of "castration"? Consult once again 3.12:

> Henceforth, my dear philosophers, let us be on guard against the dangerous old conceptual fiction that posited a "pure, will-less, painless, timeless knowing subject"; let us guard against the snares of such contradictory concepts as "pure reason," "absolute spirituality," "knowledge in itself": these always demand that we should think of an eye that is completely unthinkable, an eye turned in no particular direction, in which the active and interpreting forces, through which alone seeing becomes seeing *something*, are supposed to be lacking; these always demand of the eye an absurdity and a nonsense. There is *only* a perspective seeing, *only* a perspective "knowing"; and the *more* affects we allow to speak about one thing, the *more* eyes, different eyes, we can use to observe one thing, the more complete will our "concept" of this thing, our "objectivity," be.

Does perspectivism escape philosophy—or merely resist it? Nietzsche does not say that there is no "sight," and so retains the dualism of subject and object, knower and known. A thoroughgoing materialism would seek to eliminate such notions, but Nietzsche is not a thoroughgoing materialist despite Heidegger's complaint that he systematically avoids the question of Being in favor of beings (*Nietzsche* 67–68). Nor, of course, is he an idealist despite Heidegger's claim that he is the last great metaphysician. He is a genealogist who "rigorously" dissolves appearances into antecedent struggles, and struggle itself into the sign of a quasi-abstract, quasi-material "will to power" which is both essence

and instance, whose ambivalence perfectly captures the structure of resistance in Nietzsche's asceticism.

In fact, Nietzsche can only attack asceticism through a misreading of it as "the ascetic *ideal*." As his own text shows, asceticism conjoins ideality and praxis, coupling in resistance the "beyond" with such instrumentalities as "mechanical activity" and such transgressions as "orgies of feeling." So when Nietzsche asks near the end, "What is the meaning of the *power* of this ideal, the monstrous nature of its power? Why has it been allowed to flourish to this extent? Why has it not rather been resisted?" (3.23), the answer emerges without coaxing: it resists itself, and so coopts external resistance. Examining a more limited candidate for resistance, science, Nietzsche arrives at precisely this conclusion. Science is, indeed, "a genuine philosophy of reality," believing "in itself alone" without notions of God or the beyond; and yet, because *"they still have faith in truth"* (3.24) scientists are closet ascetics and science is *"the last and noblest form"* of the ascetic ideal (3.23). Eiland writes that "If the knife of conscience is progressively turned, first, on Christian dogma and, then, on Judaic-Christian morality itself—all in the interests of pursuing truth and eradicating illusion, no matter the cost to animal confidence—this means that asceticism, having undermined its doctrinal and liturgical foundations, finds a new doctrine and liturgy in *science*" ("Nietzsche's Jew" 115). Like perspectivism, science is only a resistance to asceticism, not an opposition; it is therefore simply one of asceticism's gestures. If we are to go beyond the ascetic ideal, "the value of truth must for once be experimentally *called into question*" (3.25), and science is no help in this project.

But what could serve in this respect? More to the point, wouldn't this questioning merely constitute an ascetic resistance to the temptation of truth? And—the question has been delayed long enough—what is truth? One of Nietzsche's memorable answers is:

> A moving army of metaphors, metonymies and anthropomorphisms, in short a summa of human relationships that are being poetically and rhetorically sublimated, transposed, and beautified until, after long and repeated use, a people considers them as solid, canonical, and unavoidable. Truths are illusions whose illusionary nature has been forgotten, metaphors that have been used up and have lost their imprint and that now operate as mere metal, no longer as coins. ("On Truth and Lie in an Extra-Moral Sense," pt. 1)

De Man interprets this passage as a statement about "the necessary subversion of truth by rhetoric," which is a principle of "un-truth, the

lie that the metaphor was in the first place" (*Allegories of Reading* 110, 111). Eric Blondel derives from it the notion that "culture is always interpreted: to understand a culture is to interpret an interpretation" (168). Allison deduces from it the basis of an economy of linguistic substitution that is "open-ended" and "infinite" (xvi). All these readings emphasize epistemological uncertainty, which they put to polemic use against the positivism of literal reading. But the Nietzschean passage also stresses a resistance to this uncertainty. Truth is a moving army. Armies have generals and move in formation; they advance against both guerrila perspectivism and fortress objectivity.

Nietzsche's other memorable characterization of truth is, of course, the beginning of *Beyond Good and Evil*: "Suppose truth to be a woman. . . ." A woman for whom, Derrida writes, the philosopher renounces his very sex, making his appeal by a self-castration that seeks to demonstrate his worthiness, to exhibit his own "feminization," his own truthfulness (see "The Question of Style" 183). As army, truth engages the philosopher in a trial, an "*Anfechtung*"; as woman, truth is a seduction, a "*Versuchung*." English condenses appropriately: truth is a temptation, one that must, and cannot be, resisted.

Nietzsche says in *The Will to Power* that he wants "to make asceticism natural again" (no. 915), a contradictory project that yet manages to reflect the uncertain and unstable status of the natural within human life. Although Nietzsche tries in the *Genealogy* to imagine the nonascetic, he can only replicate it. This might cause dismay among those who have sought a guiding spirit in the attempt to place language and particularly textuality outside metaphysics and the "ascetic ideal." But Nietzsche, master and slave of his own critique, will not guide. Certainly not in a text that concludes, "All honor to the ascetic ideal *insofar as it is honest!*" (3.26).

Saint Foucault

*I*n an account of the career of Foucault that (with the help of
Foucault himself, who indicated his satisfaction with it in *The
Use of Pleasure*) threatens to become conventional, Hubert Dreyfus and
Paul Rabinow argue that Foucault's career was defined by an extended
series of resistances to temptation. While Foucault was never a struc-
turalist he had, they claim, been sorely "tempted by structuralism"
during the sixties. But structuralism "led, by its own logic and against
Foucault's better judgment," away from a concentration on social
practices and institutions and towards the "illusion of autonomous
discourse" operating through transcendental rules. Recognizing and
resisting this illusion, Foucault then became tempted by, or as they put
it, newly "sensitive to [the] attractions" of hermeneutics, with its
promise of "deep meanings." Finally, having resisted both structural-
ism and hermeneutics, Foucault developed during the seventies a new
method combining the distancing effects of structuralism and "an
interpretive dimension," a method they call "interpretive analytics"
(xiii). What is striking in this account is not only how Hegelian it is—
an incongruous feature in a description of so rigorously anti-Hegelian
a thinker—but also how ethical.

Nor are Dreyfus and Rabinow alone in seeing Foucault in terms of
his confrontation with temptations. Derrida's 1963 critique of *Madness
and Civilization*, "Cogito and the History of Madness," accuses Fou-
cault of an imperfect resistance to the attractions of an idea of madness
as "an inaccessible primitive purity," of the mad themselves as "the

bearers of sense, the *true* bearers of the *true* and *good* sense," and even of the methodological allurements of a "structuralist totalitarianism" (57). This last charge, of a culpable assent to the powerful sterility of structuralism, was for the last fifteen years of his life the main vehicle for a "humanist" resistance to Foucault.[1] In a 1982 essay called "Travelling Theory," Edward Said supports Derrida's basic argument that Foucault assents to, rather than resists temptation, contending that Foucault "succumbed to hermeticism" in formulating a theory of power that justifies a "sophisticated" political quietism, a theory "which has *captivated* not only Foucault himself but many of his readers . . ." (60, 64). Indeed, a 1985 issue of *Raritan* leaves no doubt that the trope of desire has become the standard approach to Foucault, for it contains an outraged essay by Leo Bersani (to which I shall return) that charges Foucault with a "willingness to be tempted by the illusion . . . that philosophy and history are free, nonconditioned exercises of the mind" ("Pedagogy and Pederasty" 20); and another by Denis Hollier that argues that the "most significant part" of Foucault's work can be seen as a result of his "attempts to escape" the "fascination of textuality and of self-referential writing" (25).

As we can already see, Foucault's work has always seemed susceptible to a critique predicated on the imperative to resist temptation—to an ascetical critique. The responsibility for this surely lies with the various but often covert forms of asceticism in his work itself. Take as one example the neo-Nietzschean project of "archeology." As defined in *The Archeology of Knowledge* (1969), archeology is the interrogation of discursive practices in an attempt to uncover their regularities. All notions of expression, of historical or epistemological continuity, of presence, of "genius," of freedom, of formalism, of the "tender, consoling certainty of being able to change, if not the world, if not life, at least their 'meaning,' simply with a fresh word that can come only from" ourselves (211)—all this is excluded from the outset as irrelevant, nonproductive, and illusionary. Language, as he says in "The Discourse on Language" (1970), appended to the English translation of *The Archeology of Knowledge*, is to be treated as a "system of exclusions" according to a radical textual materialism that excludes above all the "presence" of the creative, expressive author-speaker whose intentions determine the text. What is sought instead of these pre-textual intentions is the "obscure set of anonymous rules" governing the discourses that govern us. The sovereign subject is revealed by archeology as subject to the discursive practices that establish only the death of the subject, not its fertile presence (210). Renouncing the Logos and all notions of proximity to the source of meaning, archeology seeks "to

cleanse" the "history of thought" from all "transcendental narcissism" (203), rigorously to remain within the discourses it interrogates, producing a "rewriting," a "regulated transformation of what has already been written" (140). Archeology is thus undertaken in the spirit of Nietzsche's attack on the ascetic ideal. And like that attack, it is self-compromised: the archeologist seeks only "a *pure description of discursive events*"—an ascetic imitation, a humbling and depersonalizing submission to the Rule of Discourse.

Of course, such a project must be haunted at every moment by the unities, continuities, syntheses, and idealizations it banishes, for they, too, are discursive functions; they might even be glimpsed in the notion of a "series" linking discursive events, or in the "fellowships of discourse" described in "The Discourse on Language." These are temptations, threats to the archeologist's negative innocence, which is tenuously, and tenaciously, preserved at every moment through resistances to totalization, unity, and even what the vulgar may call coherence inscribed in the text itself. Such resistances appear not only on the thematic or statement level, but also in the stylistic aberrations and disruptions that constitute the "difficulty" of the Foucauldian text: definition by multiple negation (archeology is neither the history of ideas, nor intellectual history, nor the history of mind); the insistence on reversing the constant tendency of interpretation to eliminate doubt and produce certainty; and even his own pronounced disinclination to "idealizations" (interpretations, applications) of his work. The mighty disfiguring force of resistance to regularized or predictable meaning embedded in the style produces what Said, in a generous postmortem tribute, describes as "the almost terrifying stalemate one feels in his work between the anonymity of discourse and 'discursive regularity,' on one side, and on the other side, the pressures of 'infamous' egos, including Foucault's own, whose will to powerful knowledge challenges the formidable establishment of impersonal rules, authorless statements, disciplined enunciations" ("Michel Foucault, 1927–1984" 6).[2] The idiosyncrasy of Foucault's writing is a resistance arising at the stylistic level to his own insistence on the mere contingency or even impossibility of a truly productive idiosyncrasy.

Some of the most powerful effects of Foucault's style arise through its insistence on its own eccentric and self-rewarding singularity. Hayden White has caught this feature well, describing Foucault's style as "a rhetoric apparently designed to frustrate summary, paraphrase, economical quotation for illustrative purposes, or translation into traditional critical terminology. . . . His interminable sentences, parentheses, repetitions, neologisms, paradoxes, oxymorons, alternation of

analytical with lyrical passages, and his combination of scientistic with mythic terminology—all this appears to be consciously designed to render his discourse impenetrable to any critical technique based on ideological principles other than his own. . . . Foucault's discourse is willfully superficial" (81–82). Above all, for White, Foucault's discourse is willful, a pure product of the will to power-knowledge. Accepting White's characterization, we can begin to understand how complex are the implications of Foucauldian idiosyncrasy: as a resistance to the temptations of illusion and ideality, idiosyncrasy is an ethical gesture serving the interests of truth; while as a resistance to appropriation and an assertion of power, it is beyond good and evil, and beyond truth as well.

Even before he becomes a theoretician of resistance in the first volume of *The History of Sexuality*, then, Foucault is a practitioner of resistance. To insist on this point is to bring to light the network of avoidances and exclusions that runs through Foucault's work. But it is also necessarily to run against one tendency of Foucault's work by crediting it with a dimension of the "unexpressed," and therefore with the kind of "depth" that Foucault often seeks to discredit as a methodological perversion. Moreover, to read those resistances as specifically ascetic in character is to place his work in precisely the context he seeks to "rewrite." Such a reading might seem to invoke the ultra-pragmatic definition of the "*essence* in interpreting" offered by Nietzsche at the conclusion of *The Genealogy of Morals*: ". . . forcing, adjusting, abbreviating, omitting, padding, inventing, falsifying . . ." (3.24). Nietzsche charged that the French "hectics of the spirit" in particular resisted interpretation in order to claim moral superiority over the Germans; but in a Nietzschean gesture typical of his work in the seventies, Foucault surrenders this claim, arguing in his essay on Nietzsche for an anti-ascetic practice of interpretation through "the violent or surreptitious appropriation of a system of rules, which in itself has no essential meaning, in order to impose a direction, to bend it to a new will, to force its participation in a different game . . ." ("Nietzsche, Genealogy, History" 151–52). In other words, Foucault himself accepts in principle a powerful, even coercive, practice of interpretation. Reading the resistances, we are only following a Nietzschean, and even a Foucauldian imperative.

Let us begin by positing two species of resistance, based on cenobitic and eremitic principles. The Rule of Discourse has a cenobitic emphasis: routine, anonymous, nontranscendent, "external." Within the Rule, all notions of consciousness are subjugated to a mortification. The Rule is most formulaically enunciated in the famous 1969 essay,

"What Is an Author?" in which the classical conception of authorship is reduced to a discursive function in the service of nostalgic demands for unity and coherence: "the author" is not an expressive subject but a check on interpretation, a principle of thrift set against the possible proliferation of meaning; or, conversely, a fiction that fills up the interstices or gaps of signification with "meaning," a term for which Foucault reserves a special contempt. Arguing against the exegetical desire to reinscribe the "sacred origin" of the moment of creation through interpretation, Foucault insists that the "author-function" is an effect rather than a cause of the text. Writing "no longer" guarantees the immortality of the self, as the Greeks thought, but serves as an instrument of cenobitic ascesis: "Writing is now linked to sacrifice and to the sacrifice of life itself; it is a voluntary obliteration of the self that does not require representation in books because it takes place in the everyday existence of the writer" (117).

The 1971 essay on "Nietzsche, Genealogy, History" could be emblematically opposed to "What Is an Author?" in its daring abandonment of all the continuities and coherences associated with the author-function, its focus on "the singularity of events" as the subject of "genealogical" inquiry, and its positing of the body as the perpetually disintegrating but "inscribed surface of events" (148). In this essay archeology gives way to genealogy, the text to the body, and rules to the eruption of conflicting, random forces. Here, too, the notion of the death of writing is supplanted by that of the "proper individuality" that stands opposed to the "faceless anonymity" of "the family of ascetics" (158). But the case is not anti-ascetic; it is merely anticenobitic. In changing the direction of his work of the year before, Foucault did not discover a form of history without denial, but rather advanced a new mode of denial predicated not on "knowledge" but on "creativity," multiplicity of being, the body, and irregularity—in short, on eremitic asceticism. The saint in temptation epitomizes the multiplicity of being in the singularity of the event.

Both forms are actually described in the 1967 essay on Flaubert in which Foucault makes the unlikely-seeming comparison between *The Temptation of Saint Anthony* and "its grotesque shadow," *Bouvard and Pécuchet*. *The Temptation*, Foucault says, occupied Flaubert for his entire creative life, standing, with its "scenes of violence, nightmares, phantasmagoria, chimeras, nightmares, slapstick," beside all his other works as a prodigious reserve ("Fantasia of the Library" 88). The language of *The Temptation* itself, a "conflagration" of primary discourse, presents a constant temptation to Flaubert, an ambiguous spectacle to which all his other works constitute a resistance. Anthony's

final, wild utterance—"*être matière!*"—betrays what Foucault calls the "highest temptation," "the longing to be another, to be all others" (101). In Anthony, Foucault reads an allegory of the radical body, a material flux irreducible to the rule of discourse, the body that discourse must repress, the body that it cannot hope to be. The materiality Anthony would assume is both redemptive in that it is indifferent to desire, and transgressive in its anchorage in the body. And this resistance-transgression complex defines the project of genealogy.

If Anthony is a genealogical figure, Bouvard and Pécuchet are tropes of archeology. Also withdrawing from the world, they undertake a tireless routine of labor, wishing, as Foucault says, "to put into practice everything they read" (106). Their temptation is not to become their others, nor to fail in belief; it is to "believe in the things they read." They end not as matter, but as a tiny fold in redoubled discourse. "They will occupy themselves by copying books, copying their own books, copying every book. . . . Because to copy is *to do* nothing; it is *to be* the books being copied" (109). In Bouvard and Pécuchet, then, Foucault reads the particular resistance-transgression complex that defines archeology: Flaubert's heroes resist life and the world through their will to discourse, their repression of the nondiscursive, the irregular, the bodily; but like Anthony's resistance, this one too has a demonic dimension. As Foucault points out in *The Order of Things*, a language "folded back upon the enigma of its own origin and existing wholly in reference to the pure act of writing" is the ultimately transgressive discourse, a discourse explicitly associated with literature, and with "the death of the author."[3]

This essay not only anticipates Foucault's later projects but also suggests a fundamental unity between them, a unity often denied. What Alan Sheridan describes as the mutually exclusive phases of Foucault's career, "the archeology of knowledge" and "the genealogy of power," and what Rabinow and Dreyfus characterize as the temptations of "structuralism" and "hermeneutics" should be seen as two forms of ascesis, two versions of sainthood.

So far I have been forcing, adjusting, omitting, abbreviating—perhaps even violently and surreptitiously appropriating—Foucault's work, reading it according to my own preoccupations. But Foucault takes a dramatic step closer to these preoccupations in *La Volonté de savior* (1976), translated as *The History of Sexuality* although it is the first volume of what Foucault projected as a six-volume series by that name. Foucault immediately demonstrates in this most Nietzschean book that he has solved Nietzsche's most intractable problem, the reversibility of

power-terms. The initial target is "the repressive hypothesis," according to which sexuality, the object of repression, is conceived as the reservoir of a secret or essential selfhood. This hypothesis holds that the forces responsible for repression had, in alliance with the rise of capitalism, enforced a ritual, and, since the seventeenth century, increasingly effective, denial of the body, a subjugation of everything incompatible with the work ethic. Moreover (according to this hypothesis) any truthful discourse—about sex, for example—resists established power, and the rise in the quantity of discourse about sex since the nineteenth century constitutes a massive and effective resistance. As an alternative to the repressive hypothesis Foucault proposes a new theory of the relation between power, truth, and the body, in which all power is a material force operating on the body, and yet producing knowledge, which in turn produces not resistances but only new forms of power.

The repressive hypothesis is not an especially formidable opponent—Dreyfus and Rabinow call it a "parody of current received opinion—at least for French leftist circles" (127)—but Foucault's theory of power-knowledge does respond brilliantly to the Nietzschean problem of how to account for knowledge within the framework of force. Foucault does what Nietzsche cannot: he avoids attributing knowledge to weakness and opposing knowledge to strength.

In fact, he avoids the notion of weakness altogether through an analysis of power as an omnipresent force issuing not from a central point but from innumerable points in a play of differential and mobile relations. Foucauldian power is "intentional and nonsubjective" (94), a "moving substrate of force relations" operating locally and constantly in every relation. The nonsubjective character of Foucauldian power contrasts sharply not only with Nietzsche's power but with that of nearly all other analysts (perhaps most sharply with that of Leo Bersani). Hannah Arendt, for example, regards power as the product of a voluntary agreement by free subjects. For Arendt, power is opposed to coercion, and therefore to tyranny; true power "preserves the public realm and the space of appearance, and as such it is also the lifeblood of the human artifice, which, unless it is the scene of action and speech, of the web of human affairs and relationships and the stories engendered by them, lacks its ultimate *raison d'être*" (204). Arendt's power depends upon an unimpaired public realm, but Foucault's power has no such conditions and no opposite; it is ubiquitous, the exclusive property neither of heroes struggling against massive force, nor of an enlightened populace, nor of crafty little vermin applying judo to Animal Man.

Foucault avoids the difficulties connected with the strength of weakness by focusing not on the miserable and immutable character of

the weak, but on the moment of reversal itself, when the weak have overcome their own weakness. Hence, in the essay on Nietzsche, the definition of "the event": "not a decision, a treaty, a reign, or a battle, but the reversal of a relationship of forces, the usurpation of power, the appropriation of a vocabulary turned against those who had once used it, a feeble domination that poisons itself as it grows lax, the entry of a masked 'other'" (154). Foucault claims Nietzschean authority for this definition, but a stronger case could be made that Nietzsche situated his critique in prehistory precisely in order to escape such a definition of the event. Speculating about prehistory, Nietzsche can imagine the dominance of strength in a "natural" setting, a world in which there should be no such "events," no reversals. What troubles the argument of the *Genealogy* is the intrusion of the events of history into the prehistoric, an intrusion that repeats the Fall. Foucault posits no such natural condition, but while he has thereby accommodated reversibility in his theory of power, he is still scandalized by another aspect of power—its pleasure. What reversibility is for Nietzsche, pleasure is for Foucault: an incomprehensible and regrettable accident of power.

According to the repressive hypothesis, sex is robbed of its pleasure by being transformed into discourse through the confession of the flesh. Foucault notes that some time in the seventeenth century the confession of the flesh became a universal imperative to transform all desire into discourse, an imperative used, Foucault argues, not to liberate sexuality but to control, dominate, and normalize it. But the directive to resist sexuality through discursive conversion carried with it a species of assent even more transgressively thrilling than the transgressions themselves. Or, as Foucault puts it, "the Christian pastoral also sought to produce specific effects on desire, by the mere fact of transforming it—fully and deliberately—into discourse: effects of mastery and detachment, to be sure, but also an effect of spiritual reconversion, of turning back to God, a physical effect of blissful suffering from feeling in one's body the pangs of temptation and the love that resists it" (*History of Sexuality* 23). The bliss of confession ensured both its effectiveness and its continuation: confession and other forms of discursive compulsion spread and proliferated, defining and classifying forms of desire, "implanting" and multiplying species of perversion. Thus a great number of techniques of control and administration were set in place, and kept there—by "*perpetual spirals of power and pleasure*" (45). Sexuality was subject to scrutiny and judgment through a web of power-laden discourses that were suffered not because they served the interests of capitalism but because, in addition to serving a host of regulatory and disciplinary functions, they felt good.

For example: the incident in 1867 in which a simple-minded farm hand "obtained a few caresses from a little girl, just as he had done before and seen done by the village urchins round about him" (31). Instantly discourses flocked to the site to define the "degenerescence" of the farm hand (fortuitously named Jouy) through techniques of scientific, legal, medical, and psychological investigation. Foucault appears outraged by this "regulated and polymorphous incitement to discourse" (34), which multiplied forms of perversion even as it purported to define and "constitute a sexuality that is economically useful and politically conservative" (37). But he is particularly scandalized by the perversion of the discursive activity itself. By a kind of contagious magic, the discourse of sexuality produces "a sensualization of power and a gain of pleasure" that rewards the overseeing control and reinvigorates the process of investigation: "Pleasure spread to the power that harried it; power anchored the pleasure it uncovered" (44–45).[4] By comparison with the innocent fondlings of Jouy and his fellow village pederasts, the discourses radiated at them—and the culture that warranted these discourses—represented an unprincipled abandon, an uncivil refusal to respect boundaries, a violation of privacy that was "in actual fact, and directly, perverse." Perversion is thus a consequence not of degeneration in the racial stock but of "the encroachment of a type of power on bodies and their pleasures" (47, 48).

One of the many remarkable features of this account is the way in which the category of perversion, virtually ruled out as an analytical category of the discredited power-discourses in the case of Jouy himself, is reintroduced in the case of the Jouy-discourses. Foucault is no less certain of the definition of perversion than any of his Victorian analysts, but his target is discourse rather than body-pleasures. While Foucault understands in a fundamentally new way the relation between sexuality and discourse, and has gone a very long way toward the defetishization of sexuality, he is still capable of considering perverted the pleasure that attends the exercise of power, the sexuality of discourse, or, to put a finer point on it, the "sexuality of history." In other words, Foucault, apparently in full consciousness, replicates the strategy he analyzes and censures.

Why would Foucault so willingly participate in the activity he calls perverse? The answer may be provided by the section in which Foucault opposes the Western "*scientia sexualis*" which sustains the will to knowledge and truth primarily through the form of confession, to the "*ars erotica*" of certain non-Western societies. Such societies draw truth "from pleasure itself, understood as a practice and accumulated as

experience," while the Western confessing cultures systematically vio-
late the sanctity of silent practice. Perversely, this violation procures a
new and intense form of pleasure. Nietzsche, it will be recalled, invoked
science as the last possible resistance to asceticism only to conclude that
it was in fact the greatest ascetical force in the modern world. Here
Foucault does the opposite, assimilating the ascetical West to the
liberated East, conceding at last that the will to controlling knowledge
is only an exaggerated form of *ars erotica* (*History of Sexuality* 70).
Western techniques of control, then, do not deny pleasure as much as
they appropriate and complicate it. Within Western discourse, pleasure
is pre-perverted.

The "event," in Foucault's definition, entails "the entry of a masked
'other.' "[5] In this respect power is a true event, "tolerable only on
condition that it mask a substantial part of itself" (*History of Sexuality*
86). What power masks is, however, not only its "mechanisms," as
Foucault says, nor its indifference to Law, its capricious imposition of
brute force; power masks its pleasure, the source of its perversion.
Moreover, the proposition may be reversed. Pleasure itself, we could
say, always masks an "other"—power—in order to please. Even in the
case of the hapless Jouy, the little girl is forced to submit to subjugation,
dominance, appropriation, and exploitation. These functions are
heightened in de Sade, in whose work sex is subjected to an unrestricted
exercise of power that "knows no other law but its own." As Foucault
reads him, de Sade writes of a sexuality utterly subordinated to "a
unique and naked sovereignty: an unlimited right of all-powerful
monstrosity" (149). In the Sadean event, the pleasure of sex can be
altogether obliterated by its triumphant "other." At their extremes,
both power and pleasure are exemplary events, and may even, in their
masking operations, be said to define the terms of all events. If so, then
we can be more specific than Foucault about what is masked, and can
even conclude that what the "other" masks is precisely its identity with
that which is being "entered"; the "other" is masked *as* an other.

Foucault's text itself sustains a more or less continual "monstrosity"
through what might be called "dialogic moments" in which "other"
voices are heard in contrast to the dominant voice. In "What Is an
Author?" Foucault had applauded the way in which Marx and Freud, as
"initiators of discursive practices," had "cleared a space for the intro-
duction of elements other than their own" (132), creating and validating
differences rather than seeking to eliminate them. If that is the criterion,
Foucault himself belongs in that august company. Balancing the
negations and exclusions that so frequently characterize his rhetoric,
Foucault frequently opens up the text to objections, questions, attacks,

counterarguments. In *The History of Sexuality*, these take the form alternatively of confession, with an "other" voice serving as the conscience; and of a display of conceptual might, with the "other" voices captured and paraded through the streets. "Why these investigations?" Foucault begins one chapter:

> I am well aware that an uncertainty runs through the sketches I have drawn thus far, one that threatens to invalidate the more detailed inquiries that I have projected. . . . I based my argument on the disqualification of [the repressive hypothesis] while feigning ignorance of the fact that a critique has been mounted from another quarter and doubtless in a more radical fashion: a critique conducted at the level of the theory of desire. . . . But in an obstinately confused way, I sometimes spoke, as though I were dealing with equivalent notions, of *repression*, and sometimes of *law*, of prohibition or censorship. Through stubbornness or neglect, I failed to consider everything that can distinguish their theoretical implications. And I grant that one might justifiably say to me: By constantly referring to positive technologies of power, you are playing a double game where you hope to win on all counts; you confuse your adversaries by appearing to take the weaker position, and, discussing repression alone, you would have us believe, wrongly, that you have rid yourself of the problem of law; and yet you keep the essential practical consequence of the principle of power-as-law, namely the fact that there is no escaping from power, that it is always-already present, constituting the very thing which one attempts to counter it with. (81–82)

This strategy is found throughout Foucault, most conspicuously in the "Conclusion" to *The Archeology of Knowledge*, which is cast as a dialogue; but it has special force here since the subject of much of the text is confessional practices as a form of domination and control. From one point of view the entire text of *The History of Sexuality* is a machine for the incorporation of alien elements. This machine works to dominate and control both those alien elements and the "self"; and to purchase pleasure, which issues from a sort of inter-vocal friction, and from the quivering destabilization of the argument. In this case the charges are never answered but are simply left to fester, more like cancer than a cyst; other such confessional moments conclude, some with gestures of containment or neutralization, and others with weak replies, abrupt changes of the subject, contemptuous dismissal, or even acceptance of the charges.

In the passage quoted above, the issue is the site of power—is it exercised internally through repression or externally through law? This question summons an answer that seems to take even Foucault by surprise. For this is the point at which the concept of resistance

suddenly emerges—as one of Foucault's harshest critics, Jean Baudrillard says, resistance appears as "a divine surprise on page 126" (*Oublier Foucault* 51; in the English translation of Foucault's book, the surprise occurs on p. 95): "Where there is power, there is resistance, and yet, or rather consequently, this resistance is never in a position of exteriority in relation to power." Resistance seems almost to spring from the necessity of accounting for the "unexpressed" element in power, as a designation for the pleasure of power and the power of pleasure. Not quite a simple reaction to power, nor yet an inevitable mirroring, nor even something one might consciously will, resistances are "the odd term in relations of power; they are inscribed in the latter as an irreducible opposite" (96). Not simply, as Said asserts, the "ceaseless, but regularly defeated" ("Foucault" 5) antagonist of triumphant power, resistance is the odd man in, crucial to Foucault's critique because it mediates between the "inside" and "outside" of power-relations, providing a way of articulating the relation between sexuality and the power-knowledge network, a way that is at once intrinsic and extrinsic. Arising with power itself, resistances are the points of pleasurable friction, of painful opposition.

Resisted power is doubled, mirrored, self-contradicted, self-confirmed—as multiple, relational, and unstable in its being as it is in its functioning. And yet only resistance can make power coherent. Without resistance power is omnipotent and infinitely efficient; without resistance power has no possible connection to pleasure because no domination or "friction"; without resistance power has no "other" and no need to conceal a part of itself; without resistance power is formless, theoretical, an impossible singularity on a denuded, radically simplified landscape—indeed, on no landscape at all. Without resistance, in short, power is inconceivable. Resistance is neither an addition to nor an aspect of power; it is the site and condition of power. We cannot, to retrieve a figure used earlier, think of power without resistance any more than we can think of an electrical impulse without the circuit that provides its resistance. In this sense, all power is electrical. Even to speak of "power" and "resistance" as though they were independent terms may be a case of what Nietzsche calls language "doubling the deed," but we cannot correct language's error by resolving the two terms into one. Power-resistance condition(s) thought in the same way as "narrativity-closure," to seeing that one and two are not necessarily the only choices we have. There is, in addition, a figure of relation that is neither single nor double but both, a figure within which notions of single and double arise. Foucault's political "position" is complicated and somewhat softened by the fact that resistance to instituted power is

necessary not so much on ideological or ethical grounds, but on a far more fundamental basis. Resistance can be desired, planned, and undertaken, but it does not originate with the conscious will of the intending subject, for the power-situation testifies to its presence from the first.[6] People and groups can modify and direct resistance as a counter to power, just as they can modify and direct power as a counter to resistance; but they can neither invent nor fully control either power or resistance.

Man's life on earth is power. And with the belated introduction of resistance to the power-knowledge network, Foucault's work becomes assimilable—entering into explicit resistance—to the ascetic task of the management of desire. In fact, it complements it. Power-knowledge-pleasure; each providing the "unspoken" or "masked" resistance to the other two.

At the most revealing of his dialogic moments, Foucault accuses himself of suppressing sex itself. In his critique of "groundless effects, ramifications without roots," he has, his "other" insists, produced an account of sexuality without sex; and "What is [such an account] if not castration again?" (*History of Sexuality* 151). Accusing himself of asceticism—a charge he resists by saying that "I think we can reply in the negative" (who is "we"?)—he then repeats his contention that sex is "a problem of truth," "a complex idea that was formed inside the deployment of sexuality" (152). With one voice arguing for sex and another constantly deflecting or transposing sex into the power-knowledge registers, the text itself is in resistance. The force of the final pages is that power produces sex, that sex has "an essential and positive relation to power," that sex is not simply that-which-is-dominated, not an autonomous agency, that "liberation" is not at issue here. To think so is to "evade what gives 'power' its power" (155), namely, its complicity with desire. We have not, he insists, "broken free of a long period of harsh repression, a protracted Christian asceticism, greedily and fastidiously adapted to the imperatives of bourgeois economy" (158).[7] Freedom is not the point. Sex is a fraud, historically subordinate to a larger deployment of sexuality that interprets, controls, normalizes, and disciplines; resistance to this deployment now must rally around bodies and pleasures, not sex.

In this crucial but problematic formulation of a nonsexual economy of pleasure (why should bodies and pleasures be any more historically or conceptually substantial than sex?), Foucault conceives of a resistance to ascetic power-strategies in general. Having earlier urged a new conceptualization of "sex without the law" (91), he now sees that sex in any form will not serve, for it has been, "from the dawn of time, under

the sway of law and right" (110). The "austere monarchy of sex" (159) is a "shadow" which we have forced to confess itself as though it were genuinely opposed to power and allied with truth. Having begun, then, by speaking for the simplicity of "pleasure itself" in the *ars erotica*, Foucault ends by renouncing "this idea of sex *in itself*" (152) and indeed the idea of sex as anything other than an ideal, speculative entity created by power-mechanisms. The new species of pleasure will issue from such sources as writing about oneself. While the "introduction of the individual into the realm of documentation" is described in *Discipline and Punish* (1975) as a coercive instrument of normalization, it is rehabilitated at the beginning of *The Use of Pleasure*, in which writing about the self is seen as a "kind of curiosity" that "enables one to get free of oneself." The philosophical essay, Foucault notes, may serve as a kind of confession, "an *askesis*, an exercise of oneself in the activity of thought" [*un exercice de soi dans la pensée*] (8, 9). It is tempting to think that the hinge for this sonnet-like turn in Foucault's thinking about writing occurred with the passage in *The History of Sexuality* in which resistance was for the first time situated within power. At that point, writing became conceivable as both an instrument of and an opposition to power—as a resistance, a means of self-immobilization and of liberation, figured now in terms of detachment rather than freedom. From this point on, writing's power is bound up with its capacity to remove the subject from the world and even from itself, to achieve an exhilarating weightlessness.

After the first volume of the sexuality series Foucault suspended the project for several years before writing *Les Aveux de la chair* (the confessions of the flesh). Largely a study of the relation of writing to the technique of the self in early Christian culture, this fourth volume in the series—second in order of composition, though apparently incomplete and still unpublished—indicates a suddenly heightened interest in the methods and preoccupations of institutional asceticism. He finds even in the fanaticism of the early Christians a more expansive economy than he had supposed when he wrote in the first volume that asceticism was marked by a "renunciation of pleasure or a disqualifica-tion of the flesh" (123); he now recognizes that each such renunciation or disqualification is attended by pleasure in another key.[8] Moreover, as the project sinks deeper into the past, pleasure as an end seems to recede, to become subject to "use." In volume 2, *The Use of Pleasure*, all the attention is focused on forms of moral subjectivization among the Greeks and the ascetic practices that ensured it, practices that secured not a sensation but a form, "a precisely measured conduct that was plainly visible to all and deserving to be long remembered" (91). The

turn taken in the middle of the first volume, then, continues through the end of the volume, and carries through the next three volumes, which deal with Christians, Greeks, and Romans (*Le Souci de Soi*, vol. 3), as an exploration and appreciation of ascetic strategies of temperence, exercise, regulation, and resistance in defining a "style" of selfhood.[9]

The idea that philosophy can serve as confession, and that confession can replace sex might be Foucault's greatest perversion. It certainly seems that way to Leo Bersani, who accuses Foucault of having been "seduced by a structure of domination which, while obviously different from what Volume 1 had analyzed as the contemporary model of sexuality normalized by confession, can hardly be thought of as a less restrictive economy of the body's pleasure" ("Pedagogy and Pederasty" 18). Subscribing to "an exceptionally parsimonious economy of the self designed to center the self and to subjugate the other," Foucault has, according to Bersani, perversely aligned his own writing with "the Greek ethic of sexual asceticism" in order to conceal a deeper perversion, "to paganize and thereby to render somewhat less problematic a perhaps ambivalent interest in Christian self-mortification" (19). What Bersani really objects to is the new element of the second and third volumes of the sexuality series, the "notion of history as an object of study, the view of the historian as distinct from his material, and finally, the image of the philosopher as someone capable of thinking himself out of his own thought." All this seems to him not a resistance but "a new kind of surrender" to "the fundamental assumptions of Western humanistic culture." "Nothing is more ominous," Bersani writes, "than the unanimous reverence with which Volumes 2 and 3 have been received in France, or the hagiographical industry already at work on—really against—Foucault's life and writing" (20). Opposing humanism and hagiography with the Lacanian idea of the phallic character of the signifier, Bersani concludes by recalling the scandalous vitality of an earlier Foucault whose language was "anything but an ascesis" (20), and who would never have attempted "to detach language from the excitement of its performance . . . to elude the exuberant despair of being had, of being penetrated, and possessed, by a language at once inescapably intimate and inescapably alien" (21).

More than disgust, Bersani feels betrayed by the new aesthetics, which contrast so sharply with what he had in 1977 called the "dazzling display of controlled power" in the "succulent orders of Foucault's prose" ("The Subject of Power" 5). Throughout this essay Bersani is extremely excited by this prose, in which he finds exuberance, excess, delectability, ruthlessness, and even "indolence": "The thrill is of course

crucial, for every resistance to power is an exciting counter-exercise of power" (6), and this "rejoicing strength" is nowhere more in evidence than in Foucault's analytics of power. But even if we grant that these qualities are available in Foucault's work, Bersani crucially misunderstands both asceticism and, to that extent, the force of Foucault's style itself. Foucault's prose is not only, as Bersani points out, an "act of resistance"; it is "in" resistance, with the power, thrills, and succulence being resisted by what Bersani identifies as the "sustained impersonality" of the manner. Unable to think his way out of perversion, Bersani is still resisting resistance.

Just as Nietzsche had begun by attacking the delusions of the ascetic ideal and ended by praising the honesty of that very ideal, so now Foucault, the most trenchant modern critic of the ascetic denial of body-pleasures, advances, in this text and in others more recent, ascetic practices precisely as means of securing a complex species of pleasure. Nietzsche resisted the consolations of ideality, and Foucault the control and normalization of the subject; but as resistances, both gestures were implicated in a larger ascesis, at which they both eventually arrived. They arrived not despite their resistances but through them, as a reward for their own rigor. The task "of our days," Foucault said in a late essay on "The Subject and Power," "is not to discover what we are but to refuse what we are" (216).[10] A task for all days, and yet a hopeless assignment; for on this "*distinctively ascetic planet*" (to recall Nietzsche's phrase), this refusal *is* what we are.

The Ascetics of Interpretation

5

The Ascetics of Interpretation

> But critical activity is an activity of selection; a given experience, declaration, work, political initiative, libidinal position is exhibited in its insufficiency; denied, therefore, viewed under the angle of its limit and not from its affirmation, placed in default from its equality before the critical object of desire, that is to say with infinity, with universality, with necessity. . . . An activity of negation, this activity is profoundly rational, profoundly conformed to a system. Profoundly reformist; the critique remains in the sphere of the criticized.
>
> Jean-François Lyotard, *Derive á partir de Marx et Freud*

*I*n its dense-pack idiosyncrasy, this passage from Jean-François Lyotard (14) may seem to exemplify nothing other than a rhetorical perniciousness prevalent in contemporary critical theory. But I am going to argue that in certain senses it is entirely representative not only of continental theory, but of critical theory in general, of all accounts, at least in the Western tradition, of the activity of interpretation and criticism. I am not arguing that every reader would agree with Lyotard's description, only that this passage indicates in a thoroughly typical way the essential project of interpretation as our tradition has defined it.

What I regard as typical in the Lyotard passage can be unpacked through the following paraphrase. A properly "critical" act of reading or writing is marked by the confrontation of a certain impulse or "libidinal position" with a limit. This limit is provided by the text, a token of "infinity," "universality," and "necessity" to which the impulse must accommodate itself if the reading is to qualify as "critical." Understanding becomes "critical" not upon the unqualified victory or defeat of the impulse—not with a perfect narcissistic identification or with a blank of utter nonrecognition—but upon the submission of prejudice to the text, upon the subject's engagement with and partial or provisional conformation to the "sphere of the criticized." We yearn towards the text, which engages our wishes and longings only to regulate, systematize, direct, and perhaps even to reformulate them: libido is "exhibited" only in its "insufficiency." The issue of interpreta-

tion can thus be conceived as an issue of desire; and as Lyotard frames it, it is an issue of ascesis, of the double energy of impulse and limit, self and nonself.

Speaking earlier about Augustine's hermeneutical practice, I suggested that the progress of ascesis came to a logical conclusion in textual interpretation. In so doing I meant to invoke a suddenly concentrated view of interpretation and a suddenly expanded view of ascesis. Now I would like to argue this case from the other end, claiming that professional textual interpretation is invariably conceived in terms of an ascesis. No number of examples will support that "invariably," but we can get a sense of the range of positions within which ascesis is a primary and fundamental imperative by comparing comments by critics at both ends of some hypothetical critical spectrum. In *Criticism in the Wilderness*, Geoffrey Hartman writes suggestively of "the *work* of reading*," a work that sets itself *"against nature,"* and "spoils our (more idle) enjoyment of literature" even as it produces "the famous acedia" of the critic (163). At the other end, René Wellek argues in *The Attack on Literature* against criticism like Hartman's that serves as "an excuse for self-definition, for a display of one's ingenuity and cleverness in battering the object or, in ambition, a pretext for 'vision' " and an unprincipled and hedonistic abandonment of "the old ideals of submission to a text" (84–85). The subject of both comments is the interpretation of literary texts, but the domain of the ascetic imperative in the area of knowledge is far broader, its limits exceedingly difficult to determine; at times, indeed, it appears to define the institution of knowledge, serving as a precondition of valuable meaning itself. Within the institution of knowledge, procedures must be "rigorous," conclusions must be "earned," and authority must be impersonal.

I will begin with several hypotheses: that any general account of interpretation at least implicitly prescribes the management of desire through the engagement, restriction, and direction of the interpreter's will or impulse; that any such account opposes the free and unrestricted movements of the individual reader's subjectivity, just as it insists on a certain latitude to interpretive liberty; that literary theory, especially as it concerns interpretation, is therefore a covertly but constantly ethical activity predicated on the ascetic imperative to resist temptation; and that various theories differ only in the forms of temptation they define and the strategies of resistance they prescribe.

Criticism exerts an ethical force not by arguing explicit propositions about values or by challenging some values with others more fundamental, but by offering imitable models of understanding, models generalized and systematized by interpretation theory. The constants in

interpretation theory, as in the formal discussion of ethics, are some form of imperative, provided by the text, the author, the interpretive community, the reader's class, race, gender, and so forth; and some scope for the exercise of free will, individuality, interest, or idiosyncrasy—in other words, the copresence of what Kant called duty and noumenal freedom, although these are not necessarily defined in Kant's terms. The issues that have structured philosophical discussion, such as the epistemological basis for the recognition of duty, the role of perspective or interest in the determination of truth, the role of individual purpose in the activity of selection, the existence of the a priori, the criteria for distinguishing right from wrong, all have their equivalents in literary discussion, where the issue is not the evaluation of behavior or dispositions but interpretation. Setting aside for the moment differences that appear crucial in other contexts, we can say that in general, literary ethics, like the formal theory of ethics articulated by Aquinas, Kant, Hegel, James, Dewey, C. I. Lewis, G. H. Mead, Stephen Pepper, Alasdair MacIntyre, and others, defines moral conduct in terms of the application of an apparently fixed or transindividual standard to the movements of interest or impulse. Virtue is the free, uncoerced pursuit of an obligation. From an ethical point of view, this is the primary subject and unifying "theme" of literary theory as it tries to determine what must be said about texts, or what may be said about them for certain, and to distinguish these from what merely can be said about them.

Curiously, the institution of criticism has not addressed itself in any sustained way to the question of ethics. Among professionals, ethics is radically and perennially unfashionable, an untouchable topic. The few discussions of the ethics of interpretation are generally hindered by a reactionary primitivism, or concerned with special usages or private definitions such as the one employed by Northrop Frye in the essay on "Ethical Criticism" in *Anatomy of Criticism*. That essay is not an analysis but an instance of such criticism, a speculative narrative of the maturation of the literary consciousness from "anagogy" or "bare myth," through "archetype," on up to "high" and "low" mimesis, culminating in the ironic subversion of representation and the general distrust of the symbol. Frye's ethical criticism combines "historical criticism" and formalist or "tropical criticism." Interesting as this is, the force of ethics is severely limited by the idiosyncrasy of the usage: it is extremely difficult to connect ethical criticism so defined with problems of ethical conduct. Even more typical of the approach to ethics by literary critics is the exclusionary gesture by which E. D. Hirsch distinguishes, in *The Aims of Interpretation*, between what Frege called

Sinn and *Bedeutung*, the objective "meaning" of a text disclosed by "interpretation" and the "ethical" evaluation of a text's "relevance" or "significance" as disclosed by "criticism." This distinction might be a beginning for a critique of the ethics of criticism, but Hirsch uses it instead to bracket the question of ethics in order to focus on "intrinsic" analysis, where literary critics can apprehend the truth.

In opposite ways, Frye and Hirsch exemplify a general reticence on the part of literary theory to address the issue, a reticence all the more striking in light of the profound relation between criticism and ethical prescriptions and ethical judgments. Fredric Jameson writes in *The Political Unconscious* that "*ethical* criticism" is the leading contemporary form of literary and cultural criticism, constituting "the predominant code in terms of which the question 'What does it mean?' tends to be answered" (59). In Jameson's view, ethical thought eternalizes and naturalizes circumstances that are actually historical, specific, and class-determined; ethical thought lives by the law of exclusion, predicating oppositions and defining "certain types of Otherness or evil," among which is typically politics itself. Ethical thought constantly confronts, and according to Jameson succumbs to, the "temptation . . . to recontain itself by assigning hostile and more properly political impulses to the ultimate negative category of *ressentiment*." The trouble with ethics is that it is unable to free itself from the idea that the "centered" (and necessarily self-centered) individual is the only relevant unit of consciousness or action. Ethics is also implicated for Jameson in authoritarian closures, not only because the essence of ethics is, as Dewey says, "the element of obligation in conduct," but also because ethics "deals with conduct in its entirety, with reference, that is, to what makes it conduct, its *end*, its real meaning" (1). As a destabilizing alternative to ethics, Jameson proposes the "concrete decentering" of the subject that occurs only on the level of "the political and the collective" (60).

But has ethical thought really been destabilized? It seems that the attack on ethical criticism is itself ethically motivated, for it takes the form of an indictment of ethical criticism's inability to resist temptation. Indeed, it is hard to see the threat to ethics in a book that begins with the commandment, "*Always historicize!*" a slogan described as "the one absolute and we may even say 'transhistorical' imperative of all dialectical thought," and "the moral of *The Political Unconscious* as well" (9). From another point of view, the reason that Marxism finds it hard to oppose ethics might be that there is no true conflict of interest. The basis of the objection to ethics is its promotion and validation of the individual through what is generally called the conscience. But con-

science, as Dewey, Heidegger, and others have recognized, is the voice of the community speaking in the individual, the virtual site of collectivity and class consciousness. Conscience may hold up a common, objective, and even "transcendent" standard; but that standard, as Dewey argues, is "embodied in social relationships" (188).

What Jameson so efficiently epitomizes is an attitude of fascinated suspicion, a guilty hostility towards the presumed certainty and bromidic ease of the rhetoric of ethics. However admirable and necessary ethical judgments are, they appear to the professional literary critic somehow anti-intellectual in their binary decisiveness and decidedly anti-fictional or anti-aesthetic in their worldliness. Literary criticism becomes professional partly through the insistence that it is not ethics. Still, it justifies itself in its most earnest moments by characterizing the critical activity, especially what Edward Said calls the "unstoppable predilection for alternatives" ("Travelling Theory" 67) whose leading contemporary form is the poststructuralist celebration of discontinuity and heterogeneity, as one on which ethical judgment depends for its ethical status. Liberal humanism tells us that without a principled consideration of other possibilities, judgment must be arbitrary and illegitimate. Without what Dewey calls the "possibility and necessity of advance" through the critical questioning of existing ethical standards, ethics could not be progressive and therefore could not be ethical (189; see Dewey 183–214).

When criticism characterizes itself as the ethical basis of ethics, an activity even more ethical than ethics, we are not far from the perverse-sounding statement that ethics is criticism's temptation, a seduction it programmatically resists. Criticism tends towards ethics, produces ethics, enables ethics, yet refuses to be ethics, and refuses on ethical grounds. Ethics, however, has a symmetrical counterargument. If the profusion of alternatives is not brought to a halt by the stern hand of judgment, criticism is frivolous and pointless. If it does not aid in the production of reasoned and principled judgments, criticism is neither ethical nor even properly critical. Ethics provides criticism with its only possible rationale in the eventual return of art to the standards and norms of the world, the resolution of indeterminacy into certainty, and the distillation of multiplicity into unity. In its idle and interminable dalliance with the fictive, criticism can also tempt ethics away from itself.

One of the most obvious signs of criticism's ethical energy is its tendency to legislate against "heresies" and "fallacies." A short list of the most influential would include the "didactic heresy" (Poe), the "pathetic fallacy" (Ruskin), the "historic fallacy" and the "personal fallacy"

(Arnold), the "affective" and "intentional" fallacies (Wimsatt and Beardsley), the "personal heresy" (C. S. Lewis), the "fallacy of communication" and the "fallacy of denotation" (Tate), the heresy of "omnipossibilism" (Hirsch), the "fallacy of unmediated expression" and the "fallacy of finite interpretation" (de Man). This energy is often marshalled in polemical disputes, where it becomes clear that the issue of interpretation is charged with an ethical force. When a theory or method falls under attack, the issue is typically its failure to prescribe a state of resistance between the free readerly impulse and the constraints on that impulse. We can consider in this light Wellek's attack on "visionary" criticism, the New Critical attack on "impressionism," and Yvor Winters's attack on John Crowe Ransom for "hedonism." The main features of these polemics have been repeated in more contemporary assaults on Stanley Fish, Paul de Man, Roland Barthes, Jacques Derrida, and on poststructuralism, feminism, and reader-response criticism in general. All these charge their objects with an ethically or politically shameful assent to desire. But we should not imagine that critical virtue is entirely negative, for similar polemics have been mounted against those who deny desire. In the same essay in which he complains of critical self-indulgence, Wellek also bemoans the "scientific" ascesis of structuralism. Frank Lentricchia, Gerald Graff, Meyer Abrams, and Eugene Goodheart all attack deconstruction for a nihilistic or sterile "asceticism." Others deplore what Harold Bloom has called the "current flight from individuality in literary critical circles," a flight nowhere more in evidence than in Foucault's "sacrifice of the subject of knowledge," a manifestly ascetic martyrdom. Barbara Herrnstein Smith is explicit in criticizing the belief in historically determinate meanings as an impoverished and stultifyingly "ascetic view of interpretation" (*On the Margins of Discourse* 154). For Smith and the others of this persuasion, asceticism is the name for a perverted, willed shrinking of the subject, an antihumanistic and inhuman subjugation to forms of objectivity.

Countless instances could be adduced, but the point would be the same: the collapsing of the tension of resistance, whether through an accession to "desire" or through a boring and inhuman "asceticism," is seen as a betrayal of the nature or true function of criticism. If we combine for an impossible moment all such polemics, a picture will emerge of the institution of literary criticism constantly correcting imbalances on one side or another, implicitly insisting on a kind of tension between impulse and prohibition, freedom and constraint—a tension I have been calling ascetic, in a larger definition than that presumed by Smith—as the proper model of the critical activity and the

proper critical frame of mind. This institutional insistence may account for the ubiquity of the trope of temptation in critical writing. "It would be tempting to think that . . . ," "We may be tempted to interpret this as . . . ," "It is tempting to regard this as evidence of . . . ," and so forth. Such innocent phrases enable the critic and his readers to gaze at a forbidden possibility, to entertain a thought that is already sternly refused, to indulge a desire that is safe because already canceled. To the extent that criticism depends on this trope (and sensitized eyes will notice a remarkable frequency in criticism of all schools), criticism is a discourse of resistance.

Every competent student of the history of criticism can see the differences between Longinus and Dr. Johnson, Aristotle and Derrida, Arnold and Nietzsche, Leavis and Fish. These differences seem so immediate and interesting that we may be tempted to conceive of critical theory as a succession of clearly framed and irreconcilable positions, and of critical history as a succession of unpredicted eruptions, breaks or leaps, great cracks suddenly cleaving the earth. But a history based on such principles alone is no history at all. If we are to see the continuity of criticism we need to be able to formulate the constants in the critical activity, the infinitely renewable task that defines an activity as critical. This essay will be devoted to only a few relatively recent moments chiefly in Anglo-American criticism, and my approach will lump together many things that would in another kind of analysis require to be treated separately. But I am arguing for a principle of unity in criticism, a principle that can be seen only if we consider critical activity as ascesis. The ultimate adequacy of this hypothesis can be proven, of course, only by testing it against every critical act.

One revealing way to approach literary theory is by asking what account of desire it presupposes, what temptations it foresees, and how it proposes to resist them: how does it conceive the relation between the imperative and the potentially transgressive subject? If I am right, any description of critical activity will yield some form of answer to such a question, including the following:

> The rule [for criticism] may be summed up in one word—*disinterestedness.* And how is criticism to show disinterestedness? By keeping aloof from what is called "the practical view of things"; by resolutely following the law of its own nature, which is to be a free play of the mind on all subjects which it touches. By steadily refusing to lend itself to any of those ulterior, political, practical considerations about ideas, which plenty of people will be sure to attach to them. . . . Its business is to do this with inflexible honesty, with due ability; but its business is to do no more, and to leave

alone all questions of practical consequences and applications, questions which will never fail to have due prominence given to them.

This passage from Arnold's "The Function of Criticism at the Present Time" (1864) describes a subject set in resistance to its political, practical, or historical circumstances. The critical mind as defined here also resists both the erudite mind of classical philology and the impressionistic mind of the criticism of "appreciation." The possibility of this acontextual, politically neutral, responsive but not too responsive subject, floating in its perfect freedom from all pragmatic or worldly considerations, provides the cornerstone of liberal humanism and underwrites many of the most cherished notions of the academy, including the idea of "value-free inquiry" and of "academic freedom" in general. The "disinterested subject" also stands behind the view of culture that the academy tends to promote, a view typically based on the "free development" of human potential, the unrestricted exercise of curiosity, the unimpeded flow of information. For Arnold, criticism is a free play of the mind, and freedom is defined by its infinitude, its perfect mobility, its resistance to closure, certitude, or definition. Arnoldian criticism even betrays an unexpected consonance with Derridean *différance* in that it differs from the judgments of the world and defers action and consequences through the multiplication of alternatives.

Behind the notion of critical disinterestedness lies a long tradition of European aesthetics anchored in Kant and Hegel. For Kant, the aesthetic is that force in a work that is irreducible to use or purpose; it is "that representation of the imagination which induces much thought, yet without the possibility of any definite thought whatever, i.e. *concept*, being adequate to it, and which language, consequently, can never get quite on level terms with or render completely intelligible" (*Critique of Judgment*, "The Faculties of the Mind Which Constitute Genius"). In this tradition (continued in the work of Jan Mukarovsky, I. A. Richards, and Michael Riffaterre), the aesthetic difference enforces disinterestedness by resisting worldly appropriation, exceeding any possible description or interpretation.

On these terms, the aesthetic is easily adaptable to an ethical characterization of criticism. We can see such a move in Arnold's text, and even more specifically in Hartman's essay on "Criticism, Indeterminacy, Irony." Hartman attributes the deferral of critical certainty not to the specialness of the aesthetic, but to an "indeterminacy" intrinsic to "the commentary process" itself. "The apparently opposite demands for *objective interpretation* on the part of E. D. Hirsch and for *subjective*

criticism on the part of Norman Holland," Hartman writes, "ignore equally the resistance of art to the meanings it provokes." Art for Hartman is a principle of resistance to determinate meaning, a resistance that produces a systematic form of *interference* or *interruption* of the movement from thought to praxis. "As a guiding concept," he writes, "indeterminacy does not merely *delay* the determination of meaning, that is, suspend premature judgments and allow greater thoughtfulness. The delay is not heuristic alone, a device to slow the act of reading until we appreciate . . . its complexity. The delay is intrinsic: from a certain point of view, it is thoughtfulness itself, Keats's 'negative capability,' a labor that aims not to overcome the negative or indeterminate but to stay within it as long as is necessary" (269–70). Nobody can say, of course, how long this is, or even precisely what the delay is necessary for: delay is its own purpose, its own reward. To the critic, the resolution of the poem into a meaning is a constant temptation, encountered with particular force in "the propaedeutics of scholarly interpretation as well as [in] the positivity of applied teacherly interpretation" (274); but essential criticism is a "suspensive discourse" in which possibilities and alternatives float in buoyant resistance to the world's demands for certainty, action, or closure. The ethics of criticism emerge in precisely this suspension, during the "hour of temptation" when possible interpretations are considered and resisted. As long as this suspension can be prolonged, the critic retains his virtue, for he has not assented.

But then again, he has. Hartman calls this delay "ethically unserious" because of its deferral of urgent and legitimate worldly concerns. Arnold, too, realizes the ethical defect of disinterestedness. The passage cited above comes in the middle of the essay and mediates between the essay's inaugural imperative— "to see the object as in itself it really is"— and its terminal definition of criticism—"*a disinterested endeavor to learn and propagate the best that is known and thought in the world.*" What Arnold describes as the free play of critical intelligence is enclosed by both the rigorously neutral epistemology of the beginning and the purposive enthusiasm of the end. Arnold is no libertarian: the critical mind may be "free" but it is also "inflexible," its "honesty" measured by its fidelity to the object and to its service on behalf of the impersonal standard of "the best."

In short, disinterestedness is doubly determined by the object, to which it must submit, and by the world, which it must save. Both these imperatives constitute resistances to the "temptations to go with the stream, to make one of the party movement"; but each by itself is an assent that requires correction by the other. The mere sight of the

object will not produce meaning or value, and criticism that seeks only to record or describe would be reprehensibly passive, perhaps even prideful in its mortified "objectivity." Merely to proselytize, however, would be dangerously exhibitionistic. The publication of value must be complemented by the sight of the object, and the career of cultural salvation must be grounded in visible facts. For Arnold, criticism's "own nature" is a complex form of (in)activity that effects an ascesis of the world through a "cenobitic" reduction to form (ocularity) and an "eremitic" mission of evangelical reform. This kind of ambivalence about the "function of criticism" sometimes appears in the form of a double insistence that a proposed interpretation is no interpretation at all, merely a description that does not change the object; and yet that the object is only truly itself, and only truly valuable, when seen as the critic wants us to see it. The doctrine of the "touchstone" argued in "The Study of Poetry" may be an attempt to mediate the "objective" and "subjective" imperatives. Luminous fragments of canonical verse, touchstones provide unarguable and transcendent standards of value that glow in the memory, serving the critic as prayer serves the ascetic, as a stabilizing transfiguration of the mind, at once an affective radiance and a dike against the dangerous flooding-out of feeling.

Arnold is nowhere more exemplary for Anglo-American criticism than in the concluding passage to "The Function of Criticism," in which he invokes the poignant sense of derivation and dependency felt by the critic, who can merely "beckon" towards "the promised land" in which artists dwell by natural right. "That promised land it will not be ours to enter, and we shall die in the wilderness; but to have saluted it from afar, is already, perhaps, the best distinction among contemporaries. . . ." It has been the best distinction for over a century since, for those who have felt criticism to be synoymous with a certain kind of humility, a keen awareness of limitations and duties, and a sharp sense of the differences—all disadvantages—between poetry and criticism.

Critical humility seems an Anglo-American specialty for which the most ambitious claims have been made by T. S. Eliot, and, in our time, such critics as E. D. Hirsch, Donald Davie, Meyer Abrams, Walter Ong, and Murray Krieger. As can be seen from this brief list itself, humility can take many forms. But it is not incompatible with power; in fact, critical humility is the condition of critical power. Through certain forms—largely matters of rhetorical or forensic convention—of self-denial the critic can obscure even to himself his own participation in the production of meaning, embedding himself in nonsubjective structures, and taking on whatever authority might be attached to the author, the text, language, history. It is in fact rare to find an injunction

to humility that does not carry with it a license for the will to power. A 1963 article by Krieger on "The Play and Place of Criticism," for example, begins with a definition of literary criticism as an "analytic, and thus rationally ordered set of disciplines" distinct in nature from the free rhapsodic invention of the poet. Krieger's critic must try with merely rational means to account for "the *totally* free creation, the utter self-realization, of the poet," to grasp the "contextual within the terms of the propositional while trying to avoid the generic, conceptual world of experience to which this discourse, as propositional, must lead" (10). The necessity of avoiding a reduction to worldly discourse leads Krieger to a perhaps surprising sensitivity to the critic's "victory," "daring," "rhapsody," and even to "the free, self-indulgent practice of criticism as a masterful enterprise" (16). He concludes with a compact and exemplary definition of critical temptation when he says that criticism may "freely play but criticism must know its place" (13).

The "play" of criticism has traditionally been conducted on European fields. But since the time of Krieger's essay American criticism has found the idea of the critic's freedom increasingly attractive. Hartman argues against Arnold's separation of the superior-aesthetic-inventive from the subordinate-rational-critical on behalf of a more frankly creative criticism that is always potentially a "demonstration of freedom," even if it must be conducted in the Arnoldian "wilderness." If Krieger's concession to the "play" of criticism was surprising, however, Hartman's conclusion to *Criticism in the Wilderness* is even more so, for he ends with a plea for "practical criticism," an end to internecine warfare among critics, and a reunification of literary criticism with other disciplines and even with other professions. We have suffered from a too-narrow conception of the practical, Hartman argues, and must now turn to "the material culture (including texts) in which everyone has always lived" (301), a culture for whom "the inspiring teacher" will be "incurably a redeemer" (300). Having begun, then, with a self-consciously scandalous declaration of independence from Arnoldian humility, he concludes with a critique of critical freedom and a recommendation that the critic refashion his interests in line with those of the rest of the world. Most surprisingly of all, this most un-Arnoldian conclusion contains the most Arnoldian rhetoric of all, for it invokes once again the image of the critic-as-culture-hero.

With this conclusion, then, Hartman returns to the "Arnoldian Concordat" he had rejected, and signals his return by completing the critical ascesis: the freely creative critic must check his impulses to self-display, to hubris, to dialectical victory; he must serve the interests of a material culture sadly in need of a clear sight of the best that is

known and thought. Here, Hartman testifies not only to his own worldly responsibility, but also to the comprehensive suggestiveness of Arnold's version of critical theory. In fact, while I have spoken of "the Arnoldian tradition," it is apparent that Arnold's work can sponsor a number of traditions, even the traditions in which anti-Arnoldians such as Hartman and Krieger situate themselves. It might almost be claimed that Anglo-American critical theory since Arnold is constituted of an extended series of "commentaries on Arnold." It would be misleading, however, to attribute this fact to Arnold's "influence," because it is not a matter of persuasion or authority. Arnold simply recognized and gave voice to the forms of ascesis intrinsic to literary criticism itself: the text, the task of culture-redemption, the author, the community, and literary and cultural value. These are powers to which the critic must subject himself in order to exercise power at all; they provide the sources of self-transcendence in criticism. The condition of criticism is that the critic can exercise power and produce the meaning of the text only if he does not claim either the power or the meaning as his own.

To see the object clearly and to see it whole. This task has dominated so much criticism that it's difficult to know how to assess it: it seems nearly synonymous with criticism itself, insofar as criticism seeks to adequate, imitate, or "match" the work of art. The task of vision is especially evident in the several species of formalism, which begin with a presumption of the formal or even "organic" wholeness of the work of art. The formal unity of the work of art does not, however, make the work instantly accessible to the understanding; it does not make it "visible." French structuralism, while considered by many a kind of formalism, defined the task of criticism as one of "decomposing the object" to make the "rules of its functioning," rather than its "meaning" apparent. Structuralism mounted a resistance to what Barthes calls "full meanings" and tried instead to discover "how meaning is possible—at what price and along what tracks" ("L'Activité structuraliste" 218) The "price" was clearly moral because the "tracks" were interpretive or subjective rather than rigorously descriptive.

The New Critical concentration on the organization of the work of art is similarly motivated, for the organization is held to be precisely what complicates art, preventing it from communicating in a simple way. Indeed, the paradox of New Criticism's promotion of formal unity is that its description of aesthetic unity concentrated almost exclusively on species of disunity—irony, tension, ambiguity, and paradox—all means by which a "contextual" meaning is achieved through internal friction and the "union of opposites." This last phrase is from Cleanth

Brooks's famous essay "The Heresy of Paraphrase," which also includes a quotation from Robert Penn Warren that defines the ascetical function of contextual meaning for New Criticism: "The poet, somewhat less spectacularly [than the saint], proves his vision by submitting it to the fires of irony—to the drama of the structure—in the hope that the fires will refine it" (194). (As fire proves iron[y], so temptation proves the just man.) Irony, through which the poem admits "what is apparently hostile to its dominant tone," is a corrosive safeguard against self-indulgence, sentimentalism, any nonproblematic gratification of desire; it stimulates the capacity for humility, and even serves as a test of value, as when Brooks offers as a criterion of poetic achievement the question, "Does the speaker seem carried away with his own emotions? Or does he seem to have won to a kind of detachment and objectivity?" ("Irony as a Principle of Structure" 1043). As long as the text is ironic or ambiguous it resists an expressive reading.

Formalists are constitutionally cynical about the reading process, which they presume to be governed by the narcissistic search for tokens of the self, the covert reassertions of prejudices, the pseudo-discovery of meanings already known. To see the object clearly and whole often meant to refuse a well-formed interpretation as a resistance to a necessarily prejudicial, speculative, subjective, and anti-ocular element in critical exposition itself. In this spirit, Russian Formalism proposed that criticism strive for a systematic defamiliarization of the object, a representation of the work not in terms of an ethically and epistemologically dubious meaning but in terms of its enabling conditions, a representation that made of the poetic text a sort of scourge or hairshirt.

It is remarkable how little concerned with form most formalist criticism is. What formalism means by form is, more typically, the nonsubjectivity of the text, the differences between the "impersonality" of the text and the desiring mind. Formalism interdicts a reading process that comforts, that presumes coherence, continuity, or presence, that repeats in whatever form the pre-knowledge of the reader. The formalist critic, therefore, stands between the reader and his desire for meaning, insisting on the obstacles or barriers between text, author, and world. "Meaning," an accommodation of the text to some view of authorial intention or some picture of the world, is a temptation to which a rigorous reading will refuse to succumb. At its most rigorous, formalism insists, in fact, precisely on the systematic invalidity of the reader's response, which it stigmatizes as "psychologistic," impressionistic, relativistic, sentimental, or at least unreliable. The formalist attitude towards the reader is expressed in the notion of the "affective fallacy," which warns against a rampant subjectivism—a warning

necessitated, as Frances Ferguson says, partly by the symmetrical "intentional fallacy," which warned against positing any necessary or intrinsic connection between the author's subjectivity and the text. According to formalism, the text itself provides the only truly common ground, the only "object of specifically critical judgment," as Wimsatt and Beardsley say, the only possible site of rigor in a process of expression and understanding everywhere threatened by a self-indulgent and self-inscribing subjectivity.

The critical premises of American New Criticism, called Formalism after Brooks's 1950 essay "The Formalist Critic," stressed the virtues of imitation, anonymity, systematization. "The Enabling Act of Criticism," according to R. P. Blackmur, "consists in submitting, at least provisionally, to whatever authority your attention brings to light in the words. In doing this you will be following in pretty close parallel the procedure which the writer followed" (417). The program of "criticism" is here virtually identical to that of the cenobite, who imitates in perfect obedience the Rule of the Master, honoring in his secondary imitation the primary imitation of the eremite/poet.

Cenobitism is most apparent in some of the New Critical descriptions of the "concreteness" of the image, which John Crowe Ransom opposes to the "abstraction" of science. For Ransom poetry expresses the "bodiliness of the world" in all its presentational immediacy: "[The image] cannot be dispossessed of a primordial freshness which idea can never claim. An idea is derivative and tamed. The image is in the natural or wild state and it has to be discovered there, not put there, obeying its own law and none of ours" (*The World's Body* 115). None of ours: embodying the world, the image attracts desire but stands outside all our concepts, rebuffing the naturalizing attempts of the hopeful subject, and humbling the mind before its "original innocence." Above all, the poem commands the evacuation of willed thought. Poetry, Ransom writes, "is pure exhibit; it is to be contemplated; perhaps it is to be enjoyed. The art of poetry depends more frequently on this faculty than on any other in its repertory; the faculty of presenting images so whole and clean that they resist the catalysis of thought" (118). Through poetry we can, according to Ransom, be restored to some original precognitive (and certainly preskeptical) condition.

The effect of such a description of poetry is to fence off a species of language, to accord it a privilege and special character which chastens the critic, who must imitate and honor it with a language tainted with abstraction, a language, as Allen Tate says, somewhere "in the middle position between imagination and philosophy" (*Forlorn Demon* 111). Imaginative discourse "indulges," as Brooks revealingly puts it, "in no

ethical *generalizations*." But it enforces ascesis on the part of the critic in the form of what Brooks calls the "discipline and habit within ourselves which would prompt the proper attitude" (*Well Wrought Urn* 231). For the New Critics, the poem was an instrument of discipline. Readers could enter into the world of the poem only on the poem's terms; "within" the poem, all readers were identical, distinguished from each other only in terms of their negative capability, their capacity for self-forgetfulness.

Ransom's claim that poems "resist" thought is crucial, for it concedes the partial effectiveness of criticism to appropriate the image. Without this appropriation the image would stand outside coherence and value altogether, and this is not what New Criticism believed. Anglo-American formalism tried to direct attention to a level of linguistic performance at which reference was complicated (by irony, paradox, ambiguity), a level at which language took leave of the world in which readerly desire would situate it. Formalism did not claim that language was unreadable or incoherent, just that it stood in "the middle position" between the world and the vertigo of self-referentiality. New Criticism proposed that "what the poem *really* says," to use a phrase from Brooks, was neither about the world nor about language, but about some confusion of the two, somewhere between reference and self-reference, as the molecular is between the cellular and the atomic. The linguistic "tension" so valued by New Criticism correlated with a critical effort to sustain a gaze that resisted the temptations to forget language in favor of the world and to forget the world in favor of language. The interpretive context for the New Critics was provided not only by "the poem itself" but also by their particular view of poetic language, a view predicated on the imperative to resist temptation, and structured by the double negative that that imperative requires.

This necessarily synthetic portrait is intended to foreground a tendency of formalism to restrict and regulate the reader's desire by positing obstacles in the form of linguistic features between the reader and the text's meaning. While the New Critics had their own particular concerns they exemplified formalistic strategies in their emphasis on the effacement of the reader, or rather, the oxymoronic empowerment of the reader only in terms of his effacement. For what New Criticism claimed was that only through such sacrifices as it demanded was anyone truly qualified to read; and, further, that the readership to which one qualified was centered on a principle of unreadability, on the obstruction between sign and referent. It has been for several decades a routine gesture of dismissal to draw attention to the religious orientation of New Criticism, whose originary genius was T. S. Eliot and whose chief practitioners and theoreticians were explicitly religious

men. In this, New Criticism seems covertly transcendental and therefore imperfectly formalist. When, for example, Allen Tate speaks of "the moral obligation to judge," we may feel that formalism has mistaken its mission (*Essays of Four Decades* 153). Even the New Critical characterization of literary language is complicitous with a religious impulse to believe in a knowledge beyond reason. But while there is tension there is no absolute discontinuity between formalism and metaphysics, for they collaborate in a critical ascesis that contains and exceeds them both, setting them in resistance to each other.

Formalism persists primarily in the university as a pedagogical corrective to impressionism, but it is dead in the water as far as the profession of criticism goes because it is incapable of answering the fundamental questions which it raises, incapable of seeming nonreductive, incapable of defining a reward for its ascesis. Its insistence on the special, nonreferential quality of literary language as opposed to ordinary language was already falling out of favor when it began (a falling marked by I. A. Richards's 1924 *Principles of Literary Criticism*, which characterized the "phantom aesthetic state" as an "irresistible temptation," and Dewey's 1934 *Art and Experience*). And Eliot's idea of historical decline, to which many formalists implicitly adhered, did not survive the end of World War II. After the war, moreover, formalism was subjected to direct attacks by myth-critics, by the "Geneva school" of the "criticism of consciousness," and by the Chicago School, which argued for genre, character, and plot as the true centers of critical activity. Nor was formalism able to withstand the more recent objections of those who argue for a revised and enlarged view of "contextual" meaning—not just the internal context provided by the "text itself," but the "intertextual," cultural, psychoanalytic, class, gender, race, and historical contexts within which the work and the reader are situated. Deconstruction, too, works against formalist positivism and towards a recognition of the merely differential character of the literary sign, which, like the sign in general, is treated as a species of "absence" inaccessible to intrinsic criticism.

Thus, although literature calls extraordinary attention to its complex and often enigmatic code, formalism by itself is incapable of specifying the terms of literary or aesthetic experience. In its preoccupation with the ways in which the autonomous or essential text "leaves the world," formalism is at a disadvantage in dealing with these enlarged worldly contexts in which the creation and interpretion of the text occur. Moreover, the concern with "poetics" to the exclusion of "hermeneutics" implies an indifference to the reader (or assumes a

neutral, constant reader) that makes formalism vulnerable to the "Humanist" charge of critics such as Douglas Bush that it is anti-ethical. But a project emerging within formalism seeks to confront the temptations that lie "beyond formalism" in developing what Geoffrey Hartman, in a 1970 essay by that name, heralds as a "daring and conscious" mature criticism capable precisely of "humanizing" the word through a conscious emphasis on the act of interpretation.

Paul de Man suggests that for many critics, interpretation is a reward for formalist discipline, "the fruits of the ascetic concentration on techniques" ("Semiology and Rhetoric" 3). Certainly by 1970 there was a widespread discontent with a concept of criticism seen as an infinitely prolonged and ultimately sterile exercise in self-denial, and a sense that the focus of criticism needed to be shifted from the object to the subject; or, less crudely, from the mystified object to the creation of meaning in the historical and circumstantial confrontation of the text and its readers.

Hermeneutics emerged not only as a payoff but also as an antidote to the formalist ascesis through what one of its leading proponents, Hans-Georg Gadamer, called the "fundamental rehabilitation of the concept of prejudice" (*Truth and Method* 246) or "foreknowledge" as the ground of all understanding. Opposing formalism's "eunuch-like objectivity," Gadamer argues for the fertilizing, engendering activity of the reader. His attention to the interaction between text and reader has endeared him to American critics looking for a non-French, non-poststructuralist way out of formalism, but Gadamer is no relativist, and not even a true anti-formalist, if such a creature could be imagined. He insists on the unarguable visibility of the object as the basis for even prejudicial interpretation, warning, for example, that

> All correct interpretation must be on guard against the arbitrary fancies and the limitations imposed by imperceptible habits of thought and direct its gaze "on the things themselves" (which, in the case of the literary critic, are meaningful texts, which themselves are again concerned with objects). It is clear that to let the object take over in this way is not a matter for the interpreter of a single decision, but is "the first, last and constant task." For it is necessary to keep one's gaze fixed on the thing throughout all the distractions that the interpreter will constantly experience in the process and which originate in himself (236).

Gadamer's case against formalism is, then, not that it is overly ascetic, but that it is insufficiently so because it requires no self-interrogation, no rigorous "training" of the kind that will enable the interpreter to

distinguish between "false prejudices" and "true" or "objective" prejudices. At this point we may sense a difficulty in the concept of prejudice, which Gadamer defines as "a judgment that is given before all the elements that determine a situation have been finally examined" (240). It is, bluntly, impossible with this definition to imagine a judgment that is not prejudicial—in fact, Gadamer concedes as much when he says that understanding "is never finished; it is in fact an infinite process" (266). But this means that prejudice has ceased to mean anything, for it has simply replaced the term understanding, or the even less conclusive term apprehension. Despite a hopeful gesture towards a dynamic readerly relativism, Gadamer finally preserves the formalist distinctions between real and apparent, true and false, objective and subjective.

Nor does Gadamer escape formalism's ethic of self-denial. The ceaseless labor of introspection imposed by hermeneutical reflection is only one sign of a persistent cenobitism that speaks more directly in terms such as "belonging," "the fusion of horizons," "loss of self," and "tradition." The particular understandings Gadamer would sanction are those held by the group within the tradition, not those spontaneously achieved by the isolated subject—who in fact is said to "vanish" in the act of understanding. Gadamer's history is not a nightmare from which we are trying to escape, but an enfolding and consoling force that "fuses" the subject in its temporal moment with the community in its univocal tradition. Authority, he writes in *Philosophical Hermeneutics*, "is not *always* wrong" (33).

In practice, it is never wrong, for determinations of right and wrong always reflect authority, and tend to reflect on it well. At this point in Gadamer's critique, however, the problem of worldly power itself vanishes as it is fused with the problem of knowledge. Gadamer is at his feeblest in his account of power, which he says is granted by the inferior party to the superior in "recognition and knowledge" of the fact that the superior "has a wider view of things or is better informed" (*Truth and Method* 248). Gadamer has proven vulnerable to Marxists (such as Terry Eagleton in *Literary Theory: An Introduction*) who deplore the "gross complacency" of his sense of history. He is equally vulnerable to a neo-Freudian critique of the ways in which all drives or impulses unresponsive to a certain kind of cultural mediation are sublimated or ruled out of order as being beyond the scope of "hermeneutical reflection," an essentially unperturbed process which is exemplified as well as described by Gadamer's magisterial, relentlessly abstract and theoretical text. But Gadamer's most distinctive achievement is in one respect entirely typical of all interpretation theory: he provides an account of the excitation of the reader's interest, and

prescribes the discipline or regulation of that interest by a force that transcends mere subjectivism or individual concern.

Inevitably, as a "purer" correction to the formalist ascesis, the mind of the reader emerged as the site of a new investigation of the dynamics of meaning-making. This orientation is most apparent in the work of the Geneva school, whose leading critic, Georges Poulet, holds out the possibility of a perfect union of the critical and creative consciousnesses through a transcendence of forms, in a nearly mystical apprehension of the "mind" manifested in the creative act. The referents of literature, Poulet claims, are "subjectified," and literature itself erases the incompatibility between consciousness and objects ("Criticism and Interiority" 58). Others, including Merleau-Ponty and, in very different keys, Walter Ong and Wayne Booth, have had similar ambitions for "interiority," which carries the burden for phenomenology that signs carried for formalism, of perpetuating the Arnoldian goal of "leaving the world."

Under the pressure of this decidedly more "humanistic" critique of formalism, the institution of criticism moved to other areas, prominently including an investigation of the reading process itself. Formalism itself gave birth to the figure of the "mock-reader," a putative subject who apprehended the formal structures of the artifact; and then this figure gave way to a more systematic concentration on "reader-response" criticism, aided by the very different work of Roland Barthes. How potentially radical a shift this was can be measured by Barthes's description in *The Rustle of Language* of the reading process as "the permanent hemorrhage by which structure—patiently and usefully described by Structural Analysis—collapses, opens, is lost [and is] thereby consonant with any logical system which *ultimately* nothing can close—leaving intact what we must call the movement of the subject and of history: reading is the site where structure is made hysterical." In this description, the text swims in time and subjectivity, its structures collapsing into self-parody.

It would seem that reader-response criticism operating under such a dispensation would have powerful claims to having escaped the ascesis I have described as the condition of criticism itself. Where, after all, is the rigor in hysteria? If the reader is empowered and set loose on a defenseless and passive text, how can we say that the meaning produced is the result of the containment or limitation of desire? In other words, doesn't Barthes's version of reader-response criticism jeopardize both the theory of criticism advanced here and the more general theory of desire and meaning advanced in this book? The shortest answer is that this utterance is atypical in the context of interpretation theory, and

even in a sense incoherent. Barthes himself did not sustain the cele-
bration of unconditioned readerly invention; and in fact in *S/Z* defined
as "readerly" the impulse to reduce or unify the text according to a
model of intelligibility and representational transparency (an impulse
treated by Barthes as a temptation, to which freeplay is presumably an
"ethical" resistance). Barthes becomes coherent only when his utter-
ances are combined to produce an account of the emergence of meaning
through the friction or tension between authority, stability, totaliza-
tion, and origin on one side, and "desire," mobility, and invention on
the other. If this were done, the manifestly ethical objections of others
such as Hans Robert Jauss, who complains bitterly of Barthes's
"impressionism" and "subjectivity," as well as his elevation of the
"merely original" interpretation as opposed to those "that are formative
of a norm," might be considerably moderated (Jauss 147–48). The
shrillness of Jauss's attack testifies to the interest of conservative
reader-oriented criticism in preserving the regulated or disciplined
subject, the reader who is empowered only on the condition that he is
dispossessed of his "own" response. Like formalism, and, I am arguing,
like every other theory of interpretation, reader-response theory accords
no privilege to—indeed, has no place for—a private or singular
interpretation that remains unassimilable to what Gadamer would call
tradition and what Jauss calls "consensus."

In a statement altogether representative of the position of reader-
oriented criticism on the individual reader, Jonathan Culler notes that
"One reads as a reader, becomes a reader for the time of reading, and
is caught up in a social activity that one does not wholly control. In the
study of reading, as in most areas of what the French call the 'human
sciences,' there is a central axiom which modern research has estab-
lished: that the individuality of the individual cannot function as a
principle of explanation, for it is itself a highly complex cultural
construct—a result rather than a cause" ("Prolegomena to a Theory of
Reading" 56). For Culler and others, Augustine's axiom is still true:
error is one's own while truth is common.

What is at stake is the very status of literary criticism as a
"discipline," a status jeopardized by any account of interpretation that
promises an escape into the all-licensed subjective. The very existence
of the profession constitutes an act of faith "that a reading can
constitute an advance in knowledge and that there are standards of
adequacy which will enable others to see why the reading one proposes
is superior to others. Interpretation is inseparable from notions of
method and validity. It offers no escape from the conception of criti-
cism as a discipline oriented toward knowledge" ("Prolegomena" 47).

The problem is, how to sustain this view of interpretive discipline when the object becomes hysterical under the interpreter's gaze? What, precisely, do "standards" standardize when both text and interpreter are afloat in subjectivity and history? It seems that only formalism can save method, discipline, and knowledge; which makes Culler's commitment to reader-response, his resistance to any notion of determinate form as "a temptation to which the unwary can easily succumb," all the more interesting (54). His essay is in fact a polemic against Norman Holland who, in *Five Readers Reading*, had asserted that readers simply recreated themselves in reading, projecting their "identity themes" onto texts—a claim which, in Culler's view, simply displaced the idea of determinate meaning from the text to the reader, with the further undesirable result that interpretation became radically unsystematic.

What is most interesting is that Culler does not contest this account of readerly activity; he simply argues that the profession of criticism cannot sustain itself on this basis. Culler ingeniously proposes that the profession must now turn to meta-interpretive studies of reading competence that will leave both text and reader in their indeterminacy, taking particular interpretations not as the end of inquiry but as the beginning, as "facts that need to be explained" ("Prolegomena" 48). The question for the discipline of criticism now becomes not, what does *King Lear* mean but what constitutes an acceptable or defensible reading of *King Lear*, and what constitutes the readerly competence necessary to produce such a reading? Culler's version of reader-response criticism, then (like his version of structuralism in *Structuralist Poetics*), finally rescues both the visible object and the neutral analytic subject by taking interpretations themselves as chastening facts for the analytic mind when the text will not serve.

But it is in the work of Stanley Fish that we find most fully developed the idea that criticism is a discipline aimed at knowledge. By the same token, no one has more ingeniously and relentlessly elaborated the critical ascesis, the covert ethical dimension of the theory of interpretation that operates through the definition of temptations and modes of resistance. Fish's distinctive counterpunching style exploits the tendency of theory to specify the conditions of desire, that is, the latitude accorded to a putatively "free" interpretive impulse and the power attributed to a force of constraint or prohibition. The sites of these forces have been shifted, but these two conditions of rigor have never been absent.

Nevertheless, for nearly twenty years Fish has been attacked as an apostle of solipsism, relativism, hedonism, and other forms of moral

decay. A characteristic attack on his work will argue that he has broken the "rule" of criticism by assenting to, rather than resisting, a temptation. Curiously, his work has been been subject to such attacks even when he has argued a position that would seem to be "against desire." Indeed, if his work is read ethically, that is, for its definitions of impulse and constraint, it will be noticed that he has always argued against the free exercise of will, the unimpeded or unchecked interpretive impulse to discover the meanings one wants. Coming in the wake of *Surprised by Sin*, which described the entanglement of the reader in Milton's tempting arguments, Fish's early theoretical articles entered the ethical field defined by formalism, which portrayed the danger to the text and to analytical thought itself from unchecked subjectivity, in order to argue that the literary object achieves its meaning only in the subject through the process or event of reading.

But the reader depicted in these articles ("Literature in the Reader: Affective Stylistics," and "What is Stylistics and Why Are They Saying Such Terrible Things about It?" 1970, 1973) was scarcely free or unconditioned; the reader may be "decertainized," but he is not whimsically or capriciously free, as the formalists feared. He is in fact. subject to all manner of "regularizing constraints," "informed" and determined in an elaborately detailed way by the reading of the text, left in the end with virtually no room for interpretive maneuvering. "Affective stylistics" does not even do away with the objectivity so cherished by formalism; it simply relocates it in the act of reading, analysis of which is a "rigorous and disinterested" practice, confining itself to "what is objectively true" in the production of meaning ("Literature in the Reader" (26–27, 44). It demands of the critic that he suppress, "in so far as that is possible . . . what is personal and idiosyncratic and 1970ish in my response" (49): although the mind "seems unable to resist the impulse to investigate its own processes . . . [the least] we can do is proceed in such a way as to permit as little distortion as possible" (66). Making a liberational break from formalism by volatilizing the text, Fish has found a way to preserve rules, forms, objectivity, and self-discipline through a redescription of the reader.

Affective stylistics is not, therefore, a simple assent to temptation, for it imposes its own rigors. More recently, Fish has argued in an apparently perfect reversal that the reader determines the text; but the view of the reader is in the crucial respect the same, for the reader is, once again, thoroughly determined, not by the text but by the "interpretive community" to which he belongs. This community sanctions, determines, and enforces interpretations, structuring preunder-

standing or tacit knowledge and dispossessing the reader of what is "his own." By far Fish's most powerful such argument to date is the one mounted in "Anti-Professionalism" (1985), where he identifies professionalism with the forces of history, culture, and interest, pointing out that anti-professionalism whether from the "right" or the "left" invariably tries to affirm the rights of the free subject in disinterested pursuit of genuine values and an acontextual, transcendent truth. For this subject, "interest," especially the partial and partisan "self-interest" inculcated by professionalism, is a temptation "one must resist or turn away from" (93). Only through such a resistance, this argument goes, can the integrity of knowledge and the critical subject be preserved; only through such institutional choices can literary criticism aspire to the status of a discipline.

The issue, in other words, is identified by the anti-professionalists (E. D. Hirsch, Stephen Toulmin, Richard Levin, M. S. Larson, Burton Bledstein, Richard Ohmann, Terry Eagleton) as ethical and situated in the Arnoldian tension between human freedom and the temptation to settle for a limitation of that freedom through an acceptance of some immediate, practical, and circumstantial benefit. In claiming that action and its valuation always occur within institutions, and that the self is never free, Fish appears to argue for an anti-ethical determinism according to which no significant resistance can be made to temptation. This is certainly the position of Martha Nussbaum, who records in her response to Fish's article a by-now traditional "alarm" about the "loose and not fully earned extreme relativism and even subjectivism" of his position as well as the "disdain for rigor, patience, and clarity" in his argumentative style. For Nussbaum, life is real, and "much though we may regret the fact, [it] is not simply a matter of free play and unconstrained making." From the pro-life perspective, "it is worth taking the pains to do years of undramatic, possibly tedious, rigorous work to get it right" ("Sophistry about Conventions" 129).

Does Fish's attack on anti-professionalism deny the ascetic imperative? Not at all; or as Fish likes to say, precisely the opposite. His institutionalization of norms, standards, and rules has left the ethical situation intact, for he insists that within the horizon of interest, certain conventions grip us with an ethical "absoluteness" similar to that which others might claim for "conscience," "truth," or "duty." Interpretation, he says in response to Gerald Graff's attack on "Anti-professionalism," does not stand "*in need of* constraints" because it is "a structure of constraints." Indeed, ascesis is the very condition of meaning itself. While an interpreter may "be tempted by an interpretive strategy that bypasses the constraints inherent in the enterprise . . . to yield to the

temptation—to shortcircuit the work mandated by a tradition of practice—would be at once to deprive the enterprise *and himself* of meaning" ("Resistance and Independence" 123). Perhaps the clearest demonstration that Fish's position does not threaten to pitch the profession into an orgy of foolish pleasure is not to be found in Fish's assurances, but in a work such as the earnest conclusion to William Cain's recent study of *The Crisis in Criticism*. A student of Fish's (especially of the position of "Anti-professionalism"), Cain ends his long survey of contemporary critical theory with a call for explication, historical research, intertextual analysis, political and social engagement, all of which can be achieved through the critical ascesis: "It is the rigorous pursuit of these matters that will enable us to make our practice worldly, defend the discipline with renewed confidence, and at last speak 'the language of resistance,' a critically trained and tempered resistance to exploitation, intolerance, and oppression" (274).

Regardless of whether Fish is right about professionalism's relation to truth, values, and interpretation—and, if professionalism is taken as a synechdoche for "interest," I believe that he is—he has not advocated or described an abandonment of rigor or ethics. Nor has he advocated or described the circumvention of objectivity or truth; he has simply characterized these higher values as the product of prior interpretive decisions by the interpretive community, decisions whose nature is to conceal their interpretive origins. The most stunning instance of this concealment is suggested at the end of "Anti-Professionalism," where Fish accounts for the ubiquity of the anti-professional sentiment. He cites M. S. Larson's argument in *The Rise of Professionalism* that the "ideology of professionalism" is identical to that of democratic liberalism and depends, as Larson puts it, on the notion that "the individual is essentially the proprietor of his own person and capacities, for which he owes nothing to society" (222). The figure of the free subject rising by merit alone centers the professional ideology, producing, among other effects, a paradoxical anti-professionalism as a way of sustaining, within the network of professional concerns, interests, and constraints, a sense of dedication to transcendental values. Anti-professionalism turns out to be professionalism's most typical gesture.

It is in the interest of interest to conceal its interest; and professionalism, especially among literary critics, whose profession is based on the "anti-professional" tendency of literature as Arnold conceived of it, depends on the effectiveness of this concealment. Fish's description of this situation actually radicalizes the ethics of criticism by bringing resistance to the contingent and relative into the heart of professionalism itself rather than claiming for it the transcendental status of "deep

truths," as Nussbaum says, "that any thinking being must hold" ("Sophistry" 134). Nussbaum's position would make it difficult for thinking beings to hold deep truths and be professional at the same time; Fish situates those truths within the profession. In this respect, his work on professionalism is consistent with his other theories of reading, which emphasize constraints rather than liberties. The transgressive thrill many have found in this work derives chiefly from its "masochistic" articulation of a previously unrecognized discipline, not from its liberation of impulse. Just as formalism begins by holding up the object in its purity and ends by licensing ambiguity, the critique of the reader that promises to liberate the subject is unable to avoid focusing on constraints, discipline, resistance to the ephemeral or idiosyncratic in the name of consensus. The critique of the reader is most traditional precisely where it seeks, and seems, to be most radical.

The most quintessentially professional discourse currently being practiced (if it *is* still being practiced) is deconstruction. Rhetorically inaccessible to nonprofessional readers, deconstruction also exhibits its professional credentials by systematically offending the "deep values" of the profession itself. Against nonprofessionals, it argues for an iron textual determinism, an irreducible "grammatological" *techne* that inhabits and inhibits the movement from the text to any area of reference, including political action and ethical valuation insofar as they purport to be reliably based on textual directives. It insists on the "absence" of the signified in the signifier. The relation of deconstruction to professional practices of reading is just as oppositional. More thoroughly and profoundly than formalism, deconstruction obstructs the act of reading, especially the reading that produces the formal apprehension itself. This process it stigmatizes as "naive reading" devoted to covertly "metaphysical" totalizations such as themes, characters, intention, closure, or unity in general. Deconstruction, Derrida has asserted, "blocks every relationship to theology" (*Positions* 40), with theology very broadly defined. Indeed, deconstruction blocks every value or assumption that has traditionally sustained the professional institution of criticism, including the assumption that interpretive skill or a knowledge of context will produce superior understanding. Against professionals, then, it offers a dismaying picture of "freeplay" in which reading can be a lateral tracking of the chain of signs that are differentially "present" in any sign, a process unintimidated and uncontained by professional scruples or even by "common sense." Finally, with regard to itself, it methodically, systematically, even paranoiacally, resists all suggestions that it can be systematized into a method.

Deconstruction seems to have sprung from a passage in Nietzsche's *Beyond Good and Evil* which describes a "new species of philosopher" who *"want* to remain a riddle": these "philosophers of the future might rightly, but perhaps also wrongly, be described as *attempters*. This name itself is in the end only an attempt and, if you will, a temptation" (no. 42). We can actually see Derrida resisting in a passage in *Writing and Difference*:

> Emancipation from this language must be attempted. But not as an *attempt* at emancipation from it, for this is impossible unless we forget *our* history. Rather, as the dream of emancipation. Nor as emancipation from it, which would be meaningless and would deprive us of the light of meaning. Rather, as resistance to it, as far as is possible (28).

Deconstruction's most distinctive achievement is the elaboration of such resistance, the discovery/creation of a discursive mode that operates both inside and outside not only of the oppositions that structure philosophic discourse, but other oppositions as well, including theory and practice, autonomy and dependence, rigor and freedom. In its purest instances—those that play off a dialectic between ideas of purity and impurity—deconstruction combines the logic of neither/nor with that of both/and. This exotic double logic seems to many to block every relation to coherence, or to any value founded on coherence. But as Nietzsche's passage also suggests, it does presume an imperative and the most traditional of values, that of the critical ascesis. *"Différance,"* the enabling trope of deconstruction, is, in Derrida's words, "neither a *word* nor a *concept,*" but rather a principle of "resistance" to "philosophy's founding opposition between the sensible and the intelligible" (*Speech and Phenomena* (130, 133).

This resistance actually extends to all conceptually simple terms that participate in oppositions. It is deconstruction's ambivalent "ambition" to *remain* within the situation of temptation/resistance: it refuses on the one hand to choose, decide, or affirm, on the basis that all signs are ungrounded and differential; while it claims on the other hand that choice, decision, and affirmation have already occurred, that the play is never pure or infinite. Each position resists the other and cannot be considered apart from that resistance. Deconstruction justifies its subversive will to power as a resistance to mystification by some "originary" or "primary" text; while its will to impotence, its manifest dependency on some other text, is justified as a resistance to a presumptuous and self-mystified sense of agency. Thus Derrida concludes "The Law of Genre" by insisting that "I have let myself be

commanded by the law of our encounter, by the convention of our subject, notably the genre, the law of genre"; but quickly adds that, whatever its pretensions to a regulative sanity, "The law is mad, is madness" (76, 77). In a gesture even more characteristic of this double resistance, Derrida begins *Of Grammatology* by first renouncing as "the temptation of a cheap seduction, the passive yielding to fashion" the contemporary extension of the term "language" to a global horizon, so that it absorbs all other problems or fields into itself; and then, within a few sentences, working himself around to the edict that our epoch "*must* finally determine as language the totality of its problematic horizon" (6).

So thoroughgoing is deconstruction's commitment to resistance that it even argues for a resistance to resistance, as when Derrida ridicules the view of Lévi-Strauss and others that writing comes to primitive communities as a "tragic fatality" come to prey upon natural innocence. Writing—and perhaps grammatology as a science of writing; and perhaps deconstruction itself—cannot be resisted. The moment has passed, it is always already too late.

Deconstruction is devoted to an exact, patient, and minute specification of the impossibility of certainty, the futility of exactitude. It explores a crucial fact about language, that the sign, which is defined as anything that points beyond itself, is and is not an idealization. Something is pointed to, yet the pointer is never fully abolished. The pointer is, moreover, determined not simply as itself, but through its differences from other pointers. We are, in short, always en route, never setting out and never arriving. The analysis of this phenomenon must be haunted at every point by the pretensions of its own rigor. The deconstructor seeks the truth about writing even though the truth he seeks is that, as Derrida says, "writing literally mean[s] nothing." Under this tension, deconstruction "simply tempts itself, tenders itself, attempts to keep itself at the point of the exhaustion of meaning" (*Positions* 14). This point is the ambivalent origin of both determination and "play," meaning and its undoing; and it defines the internal resistance, the famous "rigor," that keeps deconstruction (dis)honest. Derrida describes the ascetic character of this resistance as it ravels and unravels the closure of meaning, in an interview with Julia Kristeva in which he says that the necessity of deconstructing "everything that ties the concept and norms of scientificity to onto-theology, logocentrism, phonologism" dictates "an immense and interminable work that must ceaselessly avoid letting the transgression of the classical project of science fall back into a prescientific empiricism"; or when, in another interview, he suggests a resistance to Hegel that would frustrate the

movement beyond opposition through "an interminable analysis . . . resisting and disorganizing [opposition], *without ever* constituting a third term" (*Positions* 35; 42, 43).

Critics uncomfortable with this peculiar nonposition have pointed accusingly to occasional polemical overstatements on both sides of deconstruction. Some claim that it paralyzes responsible political or moral action by making of every utterance, whether true or false, a mere dishevelled play of signs; others complain that it makes it impossible to say anything new or original, impossible to avoid repetition. (Deconstruction might like to imagine that all charges are true, which is to say that none is.) What seems understandably difficult to grasp is the fundamental illogic (used here in a nonpejorative sense) of a discourse that goes nowhere, insisting on remaining in temptation.

Deconstruction places itself in temptation in another, far subtler and more uncanny way. When discussing texts of Husserl, Rousseau, Artaud, Freud, Benveniste, Lévi-Strauss, Derrida assumes a position at once more internal and more external than that commonly presumed by the term "discussion." Not exactly sympathetic to the arguments advanced by his subjects, he is not exactly antagonistic either. Patiently, triumphantly discovering unity where opposition had been posited, or discovering oppositions where unity had been claimed, Derrida constitutes himself—or his text constitutes *it*self; deconstruction is phobic with regard to persons—as the other's temptation. The deconstruction in *Speech and Phenomena* of Husserl's opposition between indication and expression reveals a pattern of counterindication all but conceded by Husserl himself. The entire text concerns itself with what Husserl may have wanted to say but for the power of the will to believe in the integrity of the signless interior life, the independence of understanding from signs. Its subject is what Husserl's metaphysical rigor prevented him from saying, but which his "grammatological" rigor compelled him to say nevertheless. Derrida describes how he tries "to respect as rigorously as possible the internal, regulated play of philosophemes or epistimemes by making them slide—without mistreating them—to the point of their nonpertinence, their exhaustion, their closure" (*Positions* 6). Thus, while preserving the impression that he is doing nothing other than reading Husserl's account of phenomenology, Derrida can demolish phenomenology itself, concluding that although "our desire cannot fail to be tempted" into believing in presence and irreducible intuitive knowledge, writing remains while "the thing itself always escapes" (*Speech and Phenomena* 104).

What Derrida calls writing, de Man generally calls rhetoric. The point of de Man's "Semiology and Rhetoric," which begins with the

statement that the move "beyond formalism" is a reaping of the fruits of the ascetic concentration on techniques, is that rhetoric prevents us from making this move or reaping these rewards with a clean conscience. Many of de Man's essays conclude with a refusal to arbitrate the claims of opposed terms such as literature and philosophy, form and meaning, literal and figurative, terms represented as aspects of an overarching rhetoric, which he defines in "Rhetoric of Persuasion (Nietzche)" as "a *text* in that it allows for two incompatible, mutually self-destructive points of view and therefore puts an insurmountable obstacle in the way of any reading or understanding" (131). In "Semiology and Rhetoric," a reading whose rigor is proven by the fact that it "is not 'our' reading, since it uses only the linguistic elements provided by the text itself," produces not a "reading" at all, but only a "state of suspended ignorance" between undecidable propositions, incompatible registers of meaning. This is why, as de Man says in a famous passage, literature—the boundaries of which are uncertain—"is condemned (or privileged) to be forever the most rigorous and, consequently, the most unreliable language in terms of which man names and transforms himself" (17, 19). It seems almost impossible simply to "agree" or to "disagree" with statements whose sheer self-confidence stands in exquisite tension with their message of unmasterability. But attacks on his work commonly make the mistake of thinking that his constantly duplicitous utterances can be reduced to univocity; he was reproached for pointless sterility by some and for "hedonism" and "sentimentality" by others in a long series of energetic and contradictory attacks that would try the patience of a saint.

The attacks must have been especially trying inasmuch as they accused him of betraying the true nature of criticism, whether through hedonism, amorality, ahistoricism, or apoliticism. The ritual charge is that he has succumbed to something like what Husserl called the "seduction of thought" presented by language, presenting the quirks of signs as the object of criticism in what one critic calls "an unnecessary ascesis of critical power." Repeated in various forms, this charge is incoherent as an account both of de Man's work and of critical power in general. Ascesis, in the mysterious form of what one of his admirers has called "the eternal return of the moral imperative to resist reading," does indeed drive de Man's critical practice (Johnson, "Rigorous Unreliability" 28). But power, the power to determine truth, is precisely what is gained, not what is surrendered; for ascesis is *always* the condition of critical empowerment.

The imperative to resist reading governs criticism as a whole, even the forms opposed to deconstruction. In a remarkable conclusion to a

generally hostile estimate of de Man's work, Lentricchia says that while "it is necessary to agree" with de Man's premises, "we must resist" his conclusions nevertheless, unless we wish to betray our commitments to "politics, economics, and other languages of social manipulation" (*After the New Criticism* 317). Lentricchia is here behaving like the "responsible critic" as defined by a responsible traditionalist, Murray Krieger: a person who "is always tempted to posit 'out there' an object that, formally sovereign, draws him to it, resisting his tendency to draw it to the contours of his own personality" (*Theory of Criticism* 39). But he is also behaving like a responsible critic as defined by Derrida in resisting "that temptation which leads *all* of us to recognize *ourselves* in the program of this very situation or in the partition of this very piece" ("All Ears: Nietzsche's Otobiography" 249). Indeed, Krieger and Derrida are not truly opposed. They are one in insisting on the critical ascesis, through which the critic impersonates the impersonality of the sovereign object, becoming object-like so that he may recognize himself in the object. For de Man, the text is such a tempting object, always alluring yet always dashing—through its stubborn and deep neutralities, its formal autonomy, "inhumanity," and mode of "non-being"— any attempt to "humanize" or "naturalize" it. For Lentricchia and others, that object is de Man.

Why are theoreticians so contentious, so moral even in debates with each other? And why are these debates never resolved; why do they continue until the energy required to sustain them flags, or is directed elsewhere? It is because the issues are always urgent, and always in a sense identical. The resistance to professionalism discussed by Fish is the same as the "Resistance to Theory" discussed by de Man in a late, exasperated essay. And just as Fish situated resistance at the heart of professionalism, de Man, in a startling move, concedes that the project of literary theory calls forth objections through its own unresolved "complications." The resistance to theory, de Man says, is finally "a resistance to the use of language about language. It is therefore a resistance to language itself or to the possibility that language contains factors or functions that cannot be reduced to intuition." One might also call it "a resistance to reading" or "a resistance to the rhetorical or tropological dimension of language" (12–13, 15, 17). Especially considering that literary theory "contains a necessarily pragmatic moment" (8), all theory suffers a nontheoretical element, and so resists itself. Even a purely rhetorical reading is selfsubverting, for rhetoric is a principle of unreliability that is undercut by the premise that any reading can ever be pure. Hence the assault on theory from "without" is a displaced

version of an internal disjunction: "Nothing can overcome the resistance to theory since theory *is* itself this resistance" and speaks only "the language of self-resistance" (19, 20).

The history of critical theory suggests that this is a rich, flexible, dynamic language. We might wonder, in fact, whether de Man's subject is not theory but language itself, for, as heretical as this sounds, language, too, is inhabited, structured, determined by the nonlinguistic in the form of referents or understanding; the idea of language is incoherent without the concept of the resistant nonlinguistic. At this reach, however, we may have lost sight of what has been called, perhaps too hastily, the "ethics of criticism." It may now be appropriate, in fact, to insist even more strongly on the "ascetics of interpretation," a term whose extension is indeterminate. It is appropriate for other reasons as well. Ethics implies closure and decision, an end to temptation; asceticism repudiates such a possibility. Ethics honors the distinction between "being tempted" and "resisting"; asceticism acknowledges no such distinction. Ethics worries the differences between *what* you might resist; asceticism demands only *that* you resist. Asceticism, then, is the resistance to ethics as well as the basis for ethics. On its ambivalent imperative all critical theory, and much else, is founded. This imperative is, in the end, both a generous and exacting one. From theoreticians, for whom language is subject as well as instrument, all it requires, and unfailingly exacts, is what Heidegger described as the tactic for a "Resistance to Humanism," a formula for resistance in general: "rigor of meditation, carefulness in saying, frugality with words" (241).

Notes

Part 1. The Ideology of Asceticism

Chapter 1. Ascetic Linguistics

1. According to Fisher, "art appears on an emergency basis when a multiplication of crises intrudes hesitation everywhere into the processes of production." The fourth crisis, "the lack of obvious continuity with predecessors," poses particular problems for hagiographers. While Scripture provides an unquestioned precedent for writing in one respect, the *literary* tradition of pagan biography is a source of great anxiety in another. See Fisher 71.

2. References are to section and page numbers of the Gregg translation unless "Keenan" is indicated.

3. Athanasius was writing before the "discovery" of silent reading. In 384 Augustine is amazed to see Ambrose reading silently: "his eyes scanned the page and his heart explored the meaning, but his voice was silent and his tongue was still" (*Confessions* 6.3: 114).

4. For Aristotle, the voice creates the first symbols from intuition, just as, in a Christian context, Christ constitutes the first division of the Godhead. Writing, like humanity, constitutes a derivation of derivation. In "The Seventh Letter," Plato argues for the inexpressibility of contemplation, saying that "owing to the inadequacy of language . . . no intelligent man will ever dare to commit his thoughts to words, still less to words that cannot be changed, as is the case with what is expressed in written characters" (138). Such an argument may be qualified by being itself written. On the passage referred to in the text from the *Phaedrus* see Derrida, "The Pharmacy of Plato" in *Dissemination*.

5. See *Confessions* 7.19: 153.

6. This contempt was not uncomplicated. In *The Teacher*, for example, Augustine concludes that "we learn nothing through those signs which are termed words. For it is more correct, as I have said, that we learn the meaning of the word, that is, the signification which is hidden in the sound when the thing itself which it signifies has been recognized, than that we perceive the thing through such signification" (10.34: 45). Augustine concludes that truth, in the form of Christ the Teacher, teaches internally and does not require signs. The powerful Father-Son metaphorics of ascetic linguistics accords with what has been called "phallogocentrism." There were, as Peter Brown points out, local resonances to this rhetoric. The rise of the "Holy Man," epitomized by the career of Anthony, was, Brown says, "a victory of men over women, who had been the previous guardians of the diffuse occult traditions of their neighborhood. The blessing of the holy man, and not an amulet prepared by a wise woman, was what was now supposed to protect you from the effects of a green lizard that had fallen into your soup" ("The Rise and Function of the Holy Man in Antiquity" 100).

7. Derrida has discussed the work of Husserl at length in *Speech and Phenomena*, a work which is pertinent to this discussion throughout, but in particular chapter 6, "The Voice That Keeps Silence," which discusses the silent interior voice of intuition.

8. For Derrida's own description of his "method," see the interview with Julia Kristeva, "Semiology and Grammatology," in *Positions*.

9. Demons were, for Origen, emblematic of the arbitrariness of the sign as well as of mere repetition. In an essay on "The Importance of Names," he refutes the claim that "the names of things are entirely arbitrary and have no natural relation to the objects of which they are the names." His reply is that the science of names "is both very profound and very subtle":

> A man versed in it will see that if these names were a matter of convention merely, the demons or whatever powers there are invisible to us, would not respond when addressed by such as mean to address them, but do so on the understanding that the names are but arbitrarily given. But in fact certain sounds, syllables, and names pronounced with a rough or smooth breathing, or with lengthening or shortening, bring to us them that are summoned—in virtue, doubtless, of some natural factor which we cannot discern.

Whatever this elusive "natural factor" is, it compels us, he says, to call God "by no other name but that which His Servant and the Prophets and Our Lord and Saviour Himself used—for example, *Sabaoth, Adonai, Saddai*; or, again, the *God of Abraham, God of Isaac, God of Jacob*." With this proliferation of names, Origen undoes the natural connection he had sought to establish; and in so doing, reaffirms the character of ascetic linguistics I have been defining, its ability to embrace both terms of a contradiction. See *Exhortation to Martyrdom*, 6.46: 189.

10. Susan Stewart compares parody interestingly to "serious" allusion by

saying that in allusion the "text of origin" is recontextualized and its pastness made present, while in parody the process is inverted: "for in parody the repetition denotes and then suppresses the text of origin. While the 'serious' allusion generates tradition [as in the reading of Scripture to an audience of the faithful], the parodying allusion generates further parody" ("The Pickpocket" 1142). Stewart seems to suggest here that parody does not generate tradition, a suggestion which cannot account for a great deal of tradition, particularly the tradition handed down by Modernism, which is a tradition *of* parody. Moreover, to attribute a nonrepeatable uniqueness to the "text of origin" is to ignore the fact that the origin is a text, consisting of repeatable signs and coherent only within a prior tradition. What Stewart denies, in other words, is that the beginning is the Word, already a repetition. If it were not, it could not be repeated. When Derrida says things like this he sounds radical, but Gadamer has employed a friendlier-sounding rhetoric to say that "in truth we are always already at home in language, just as much as we are in the world" ("Man and Language" 63). And the contemporary ascetic E. M. Cioran has said, "Literature reaches far back in time since we have not feared to impute to it the first convulsions of matter" (*The Temptation to Exist* 195). For Derrida's views of originary repetition see "The Pharmacy of Plato" 167–69.

11. Susan Stewart employs the term "*anti-linguistics*, a systematic questioning and inverting of the basic premises and arguments of traditional linguistic theory" in "Shouts on the Street: Bakhtin's Anti-Linguistics" 266. This paragraph is in debt to Stewart's discussion.

12. According to Walter Benjamin's analysis, Anthony is invoking here the power of fallen language. In an essay "On Language as Such and on the Language of Man," Benjamin suggests that perfect knowledge is expressed exclusively in the act of naming. After the fall, we know only "from outside"— again, the metaphor of exteriority—and stand in a posture not of creation but of judgment towards the objects of our knowledge: "For in reality there exists a fundamental identity between the word that, after the promise of the snake, knows good and evil, and the externally communicating word" (327). "In the Fall, since the eternal purity of names was violated, the sterner purity of the judging word arose" (328). Naming does exclude time and repetition, but unfortunately it also excludes meaning. Meaning begins in predication and in judgment—after the Fall.

13. Rousseau notes that institutional asceticism grew increasingly dependent on texts as the movement grew and required codified models and rules. See chapter 5, "The Written Word" 68–76. This dependence intensified in the Middle Ages, as Eugene Vance says: "Even in the twelfth century such leading churchmen as John of Salisbury and Thomas Aquinas argued very clearly for the text as the privileged device by which society conserved its memories of the past and by which men distant in time and space remained 'present' to each other" ("Roland and the Poetics of Memory" 402).

14. The notion of writing as redemption is not as far from traditional (Aristotelian) concepts of mimesis as might be supposed. Paul Ricoeur has recently proposed a view of mimesis that harmonizes it with martyrdom.

Mimesis, he says, cannot be confined to the text itself, but extends to action on one side and to understanding on the other. Ricoeur calls Mimesis₁ the dimension of "prefiguration" in life, an element structured by signs, norms, conventions, rules—by everything in existence that makes representation possible. Mimesis₂ is the emblem of "the semantic autonomy of the text"; it is the action of the text in bringing prefiguration to "configuration." The one ceaseless action of mimesis is completed in Mimesis₃, in which configuration is subjected to "transfiguration" in understanding. Mimesis₃ is the action of the reader in reclaiming the figure borrowed from life by the text. This idea of mimesis as a single process staging itself in action, text, and understanding enables us to appreciate the value and position of textuality in ascetic linguistics. That which is intelligible in human existence is rendered by the text, which is not just analogous but virtually equivalent to martyrdom. That dimension of Anthony configured in Athanasius's text is what *requires to be said*. The pressure of this requirement is a torment and a torture to Anthony and to Athanasius, for its saying imposes a discipline of self-denial in the interest of the steadfast and coherent. Incarnate in life, this interior necessity is configured, and then transfigured in the action of its readers, who begin the process again in their aspiration to become imitations of Anthony, or of his prototype, Christ. See Ricoeur, "Mimesis and Representation."

15. A pun that requires to be said: as ascetics seek to profit from the denial of desire, they are themselves "whores of the text."

16. See note 14 above. In the essay on "Language," Heidegger defends his own unsystematic approach in particular and criticizes the systematic inquiry into language in the following way:

> According to the opening of the Prologue of the Gospel of St. John, in the Beginning the Word was with God. The attempt is made not only to free the question of origin from the fetters of a rational-logical expla-nation, but also to set aside the limits of a merely logical description of language. (192–93)

Chapter 2. Technique and the Self

1. See Origen, *In Num. hom.* 7: 3–4. For a discussion of this and many other sources on the connection between conscience and martyrdom, see E. E. Malone, "The Monk and the Martyr." Parenthetically, it may be added that the eremites and cenobites were not the only games in town. Jerome comments scornfully on the "Remoboths," a "very inferior and little regarded type" who have apparently borrowed features from both the major variants. "These live together in twos and threes, but seldom in larger numbers, and are bound by no rule, but do exactly as they choose. . . . They often quarrel because they are unwilling, while supplying their own food, to be subordinate to others. . . . In everything they study effect: their sleeves are loose, their boots bulge, their garb is of the coarsest. They are always sighing, or visiting virgins, or sneering at the

clergy; yet when a holiday comes, they make themselves sick—they eat so much." ("Letter 22" 34: 37).

2. From Iamblichus, *De mysteriis* 1.8 (28.6). Quoted and trans. in Peter Brown, *The Making of Late Antiquity* 101.

3. "The sweet savour . . .": from W. K. Lowther Clarke, "Introduction" to *The Lausiac History of Palladius* 31; "a subconscious wish . . .": Walter de Gruyter, *Die Askese*, quoted in James Wellard, *Desert Pilgrimage* 83.

4. See especially *The Cult of Saints*, "The Rise of the Holy Man," and *The Making of Late Antiquity*, particularly chapter 4, "From the Heavens to the Desert: Anthony and Pachomius" 81–101.

5. Brown quotes an incident from the *Apophthegmata Patrum* (Anthony 30, 85B): "Some say of Abba Anthony that he became a bearer of the Holy Spirit, but he did not wish to speak of this because of men, for he could see all that passed in this world and could tell all that would come to pass."

6. *Historia Religiosa* 1481B. An incident in the career of Benedict, in the early sixth century, clarifies the ambivalent status of the eremite. "Some shepherds, wandering through the valley, espied him among the bushes, and at first mistook him for some wild animal. When they learnt their mistake, however, they began to revere him as a saint, and spread abroad the report of him throughout the district." From F. Homes Dutton, *Gregory the Great*, 2: 164.

7. Origen took this point from 1 Thess. 5:17. For a complete discussion of this argument see Michael J. Marx, "Incessant Prayer in the *Vita Antonii*."

8. Interestingly, the correspondance between the desert and feeling was revived in this century by Kasimir Malevich, who proselytized for "Suprematism" in art, in which the objective world would be disregarded in favor of pure feeling:

> Feeling is the determining factor . . . and thus art arrives at non-objective representation—at Suprematism.
>
> It reaches a "desert" in which nothing can be perceived but feeling
>
>
>
> No more "likeness of reality," no idealistic images—nothing but a desert!
>
> . . . a blissful sense of liberating nonobjectivity drew me forth into the "desert," where nothing is real except feeling (*Non-Objective World* 67–100)

9. The device most useful in achieving this end came to be confession, in which, according to Bonaventura, the penitent should "accuse" himself to his confessor, making known "all your defects, unravelling all in order, integrally, truly and simply without any veiling excuses, concealment or palliation . . ." ("Twenty-Five Points to Remember," no. 24). Obviously, confession represented both a display and an ordering of the disorderly and fugitive elements of the self.

10. *Acedia* threatens all those who leave "the world," regardless of the

circumstances. Compare, for example, Claude Lévi-Strauss's depiction of the anthropologist in the field:

> . . . the anthropologist must get up at first light and remain alert until the last of the natives has gone to sleep He must try to pass unnoticed, and yet always be at hand. He must see everything . . . he hangs about endlessly, marks time, turns aimlessly round and round he sets himself some pointless and minutely detailed task, a caricature of his professional activity It is, above all, a time of self-interrogation. Why did he come to such a place? With what hopes? And to what end? (*Tristes Tropiques* 427–28).

11. The phrase "athlete of Christ" appears in Eusebius, *Ecclesiastical History* 5, pt. 1, 4. See Malone, "The Monk and the Martyr" 211. For subsequent use of this metaphor see Colin Eisler, "The Athlete of Virtue; The Iconography of Asceticism."

12. C. Butler, ed., *Lausiac History of Palladius*, 2:115.

13. Asceticism, or *travail éthique*, is the third aspect of ethics, according to Foucault's system. The other three are (1) the *substance éthique*, or ethical substance, the portion of the self that is relevant for ethical judgment; (2) the *mode d'assujettissement*, or mode of subjection—the way in which people are incited to recognize their moral obligations; and (4) the *telos* or *téléologie*, the kind of being to which we aspire. See *The Use of Pleasure* 26–27.

14. Ascetic discipline concentrates on thoughts almost more intently than on behavior. Throughout ascetic literature we find such counsels as Basil's: "Challenge your reason which, by specious assurances, is contriving to make a robber of you; by misrepresenting the good, it disposes you to evil" ("On Renunciation of the World" 20). Thus the rejection of reason on ethical grounds, which in our time is commonly associated with neo-Nietzschean vitalism, is actually an ascetic invention. The problem of desire and its "misrepresentations" will be treated in the next section.

15. E. R. Dodds cites the *Sentences of Sextus*, a collection of moral aphorisms that survives both in the form given to it by a Christian redactor and in several earlier pagan versions. "The asceticism of the pagan aphorisms is moderate, not to say banal: self-control is the foundation of piety; we should eat only when hungry, sleep only when we must, avoid getting drunk, and have sex relations only for child-getting. But on the last point the Christian redactor takes a much grimmer view: marriage, if ventured on at all, should be 'a competition in continence,' and self-castration is preferable to impurity" (quoted in *Pagan and Christian in an Age of Anxiety* 32).

16. According to Durkheim, the "negative cult" is "one of the essential elements" of all religious life, and serves to prevent "undue mixings" of sacred and profane. Normally, it serves to prepare the way for a "positive cult," but sometimes it "frees itself from this subordination and passes to the first place, and . . . the system of interdicts swells and exaggerates itself to the point of usurping the entire existence. Thus a systematic asceticism is born which is

consequently nothing more than a hypertrophy of the negative cult" (*Elementary Forms of Religious Life* 3.1: 311). All asceticism is difficult, and cenobitism, a clear example of the hypertrophy of the negative cult, seems especially so; but its attractiveness as a way of life must not be underestimated. Cenobitic communities, much like the American colonies in the seventh and eighteenth centuries, drew their recruits from many different classes of people, who came to them for varying motives—religious persecution, excessive taxation, judicial oppression, etc. It seems that whatever discontents faced a fourth-century Christian could be alleviated by joining one of these communities. One contemporary observer claimed that there were ten thousand monks in the region of Arsinoë; another ten thousand lived with twenty thousand nuns at Oxyrynchus. Elsewhere "the land so swarmed with monks that their chaunts and hymns by day and by night made the whole country one church of God" (quoted in Wellard 82). It was not uncommon for entire villages suddenly to vanish. In 312 Theadelphia abruptly became "utterly deserted"; in 359, Philadelphia followed suit (see Clarke's "Introduction" to *Lausiac History* 22). Christianity may have portrayed the world as a desert, but the exodus of Christians from the villages had, in the proud words of Athanasius, made "the desert a city."

17. From the *Vita Hypatii*, ch. 42; quoted and translated in Brown, "The Rise of the Holy Man" 94.

18. Dodds quotes a revealing passage from Marcus Aurelius: "All the life of man's body is a stream that flows, all the life of his mind, dream and delirium; his existence a warfare and a sojourn in a strange land; his after-fame, oblivion" (*Pagan and Christian* 21).

19. Origen makes his comments in his discussion of the Gospel of Matthew (*Matt. comm.* 15.15); see Michael J. Marx 132.

20. Occasionally this unattainability was openly discussed. In the *Exposition de Trinitate*, Aquinas writes that "no one moves towards God as ever to be his equal; nor yet is he our goal precisely as being infinitely beyond us. Yet we are meant to become more and more like him, and according to our condition should ever be set on knowing him. Hence Hilary says that he who reverently pursues the Infinite, even though he may never attain it, will yet advance by pressing on" (ii.1, ad. 7).

Chapter 3. The Signs of Temptation

1. Kafka's allegory of asceticism, "A Hunger Artist," makes this plain. Although the performance of the Hunger Artist is a display of self-denial, his motives are entirely worldly. He wants to be admired, he wants to be observed, he is a creature of display. Moreover, he can't help himself—self-denial is in his nature. Had he been able to find the food he liked, he would have "made no fuss" and eaten his fill "like you or anyone else."

2. Recent inquiries into the nature of desire by literary theoreticians have produced surprising conclusions regarding the relation between desire and representation. Holly Wallace Boucher has argued that "desire itself is a

metonomy, for metonomy expresses itself as 'eternally stretching forth towards the desire for something else.' This stretching forth . . . is expressed on the linguistic level as a seeking of word to follow word in prose, or specifically, in metonomy" ("Metonomy . . . ," in *Allegory, Myth, and Symbol* 141). In "Representation and Its Discontents," Leo Bersani suggests that sexuality itself is a function of mimesis: "sexuality should be understood in terms of the reflexive pleasure of desire's representations; *desire produces sexuality*" (in *Allegory and Representation* 153).

3. Curiously, asceticism provides an exemplary model both for psychological aberration and normality. In the 1924 essay on "The Loss of Reality in Neurosis and Psychosis," Freud said that "in neurosis a part of reality is avoided by a sort of flight, but in psychosis it is remodelled. Or one may say that in psychosis flight at the beginning is succeeded by an active phase of reconstruction, while in neurosis obedience at the beginning is followed by a subsequent attempt at flight." With its emphases on flight and obedience, asceticism is easy to place on the map of abnormality. But in the next paragraph Freud characterizes the "normal" or "healthy" response: "it denies reality as little as neurosis, but then, like a psychosis, is concerned with effecting a change in it. This expedient normal attitude leads naturally to some active achievement in the outer world and is not content, like a psychosis, with establishing the alteration within itself; it is no longer *auto-plastic* but *allo-plastic*" (185). If "active achievement in the outer world" is the criterion for normality, then medieval Christian asceticism, which Weber, that thoroughgoing realist, described as having "already ruled the world which it had renounced from the monastery" (154), qualifies as normal. Needless to say, the variants of asceticism Weber discusses are, by this standard, super-normal.

4. The final cry of Flaubert's St. Anthony is "*être matière*," a plaint whose rich ambivalence lies in its being both a resistance and an assent to the temptations which have assailed him.

5. The necessity-impossibility of resistance is written into Genesis, according to Ricoeur. In *The Symbolism of Evil* Ricoeur says that the figure of Adam is virtually forgotten by Biblical writers until St. Paul speaks of Christ as a "second Adam," suddenly elevating the first Adam to a height from which he must have "fallen." This gesture rewrites Genesis, which says nothing of a fall in its narrative of what Ricoeur prefers to call "deviance." Even this less dramatic narrative is far from univocal, for the first chapters of Genesis contain two distinct accounts of the creation of humanity. The more primitive version in 2:7 antedates the Exile while the one in 1:26ff. was written much later and reflects the Post-Exile trauma and guilt. The "original man" of the first story "must have been an adult, sexually awakened"; while in the second story, the creation-man becomes "a sort of child-man, innocent in every sense of the word, who had only to stretch out his hands to gather the fruits of the wonderful garden, and who was awakened sexually only after the fall and in shame" (60). It is loss, then, that produces the myth of innocence, an element not present in the more archaic, or innocent, account. This technique of "overwriting" issues in the Old Testament concept of a species "destined" for

good yet "inclined" to evil; temptation arises in the gap of contradiction between the two stories of creation.

6. In an extremely interesting reading of Freud, Leo Bersani characterizes the superego, which is charged with self-observation, self-judgment, and the creation of ideals, as a "spectral id," an id which has become a mirror of itself. According to Bersani, the negation of desire can be as pleasurable as its satisfaction, providing both sadistic and masochistic gratifications: "For in the superego the id, separated from itself, finds pleasure in attacking itself" (*Baudelaire and Freud* 93). But in accounting for the superego by an expanded pleasure principle, Bersani has, I think, just barely missed the real point, which is that superego and id together create desire, which is therefore always both gratified and negated.

7. The connection between miserliness and certain extreme ascetic forms is not difficult to establish. Walter Benn Michaels provides an interesting account of miserliness in terms of Krafft-Ebing's descriptions of masochism in "The Phenomenology of Contract."

8. Ricoeur describes an equivalent to this ethical formulation in the phenomenology of Husserl, for whom the unconscious or unreflected is "reciprocal to consciousness as a field of inattention or as an implicit consciousness in relation to explicit consciousness" ("Consciousness and the Unconscious" 102).

Chapter 4. Narrative on Trial

1. Athanasius provides a revealingly Edenic description of Anthony's retreat: "Below the hill there was water—perfectly clear, sweet and quite cold, and beyond there were plains, and a few untended date palms" (49: 68). See also Helen Waddell's collection of stories from the *Apophthegmata Patrum*, *Beasts and Saints*. Medieval writers even describe God in terms of the desert's vastness, unchangeableness, and featurelessness.

2. The figure of "God's bookkeeping" became standard with the Puritans. For a polemic on this trope, see *The Protestant Ethic and the Spirit of Capitalism* 124.

3. And yet this Utopia of language is haunted by a guilty nostalgia for the world. As Barthes puts it, literary language "hastens towards a dreamed-of language whose freshness, by a kind of ideal anticipation, might portray the perfection of some new Adamic world where language would no longer be alienated" (*Writing Degree Zero* 88). According to Barthes, modern art "in its entirety" is dedicated to this project, which is implicit in the notion of literary language.

4. Not even the temptation to follow the prefabricated precedent is simple, for hagiographers could follow structural examples from pagan biographies as well as from the Bible. In particular, two kinds of models were available, the narrative of the hero and that of the sage. According to Johannes Quasten, Athanasius blended Christian models of spirituality with these pagan forms, revealing "the same heroism [as the pagan hero] in the imitator of Christ

aided by the power of Grace" (*Patrology* 3: 43). Of course, while such a method of composition may have made Christianity accessible to educated pagans, it ran the risk of accommodating Christianity to paganism rather than the other way round. The commonly accepted Christian models are the temptation story in the Gospels, the description of primitive Christian communities in Acts 2: 42–47, the Old Testament accounts of prophets, and, later, the various "Acts" of the martyrs. Among the pagan predecessors are Tacitus's *Life of Agricola*, the *Lives* of Plutarch and Suetonius, Philostratus's *Life of Apollonius of Tyana*, Porphyry's *Life of Plotinus*, and Xenophon's *Life of King Agesilaus*. See L. Bouyer, *La Spiritualité du Nouveau Testament et des Péres*, ch. 13.

5. For Benveniste, see his *Problems of General Linguistics* 2: 208–12. For Todorov, see in particular *The Poetics of Prose*.

6. Thomas begins with the assertion that every sin is voluntary, the result of an interior motion rather than of coercion from without. But how to account for temptation, which "usually denotes a provocation to sin"? How, if we have suffered no coercion and committed no sin, do we manifest our sinfulness by feeling tempted, as if we wanted to sin? We feel this impulse, according to Thomas, when our reason is clouded by "some pleasurable sensation or some vicious habit" so that evil appears to be "something good and suitable to nature." Our reason cannot cloud itself; it must be confused by some exterior evil principle, and if ethics is to make sense this cannot happen without cause: we must deserve our confusion. At this point Thomas turns to temporality: "Now it is evident that the will begins to will something, which previously it did not will. Therefore it must, of necessity, be moved by something to will it. . . . Now it cannot do this without the aid of counsel. . . . But this process could not go on to infinity. Therefore we must, of necessity, suppose that the will advanced to its first movement in virtue of the instigation of some exterior mover, as Aristotle concludes in a chapter of the *Eudemian Ethics*." The syllogistic form, the reiterated invocation of necessity, the reference to Aristotle, all contribute to a characteristic sense of inevitability that obscures the central fact: that, seeking the manifest and unambiguous *structure* of sin, Thomas has found it necessary to posit a sequence. Still, he is frustrated by the chicken-egg relation between the will and some "exterior power," the two of which bat responsibility back and forth in a process that threatens to "go on to infinity." In short, neither structure nor sequence makes sense by itself.

The only way Thomas can get his narrative moving in the right direction is by dividing the mind according to a complex neo-Aristotelian scheme in which the intellect and will are semidistinct from the appetites and imagination. Working on the soft underbelly, the devil presents forms to the imagination, inciting the senses to desire, and so the impulse to sin percolates upward from the wanton imagination to the will. "Although a demon cannot change the will, yet . . . he can change the inferior powers of man, in a certain degree; and by these powers, though the will cannot be forced, it can nevertheless be inclined." Judgment can in this way be "impeded" by an upsurge of "sensile elements"; and with this discovery Thomas can at last say that while when a man sins the principle of action is within his own will, yet the devil is the author of

temptation. ("usually denotes a provocation to sin": *ST*, 1–2, vol. 2, q. 79, art. 1, obj. 2: 651; "some pleasurable sensation . . ." *ST* 1–2, vol. 2, q. 6, art. 4: reply obj 3:232; "Now it is evident . . . " *ST* 1–2, vol. 2, q. 9, art 4: 254–55; "Although a demon . . ." *ST* 1–2, vol. 1, q. 114, art. 2, reply obj. 3: 1050).

7. The term "memorial synthesis" is taken from the work of Cesare Segre, who argues that as we read we continually build up such synthetic and comprehensive understandings, based not only on plot elements but on all aspects of the text that we comprehend. W. J. T. Mitchell suggests that the provisional synthesis formulated by the reader constitutes a kind of ongoing "spatial form" in the experience of the work. See Segre, *Structures and Time: Narrative, Poetry, Models* 11–20; and Mitchell, "Spatial Form in Literature" 554. The distinction between the spatial and the temporal in the experience of narrative does not, incidentally, follow directly from the example of Saussure. Although Saussure recognized that nothing in language is atemporal, he proposed that the *langue* be studied as though it were synchronic, and indeed the privilege accorded to *langue* is based on the presumption that it can be grasped and understood in a way that the *parole*, whose performance is necessarily temporal, cannot. The relation of temporality to Saussurean linguistics is vexed indeed. The *langue* is to be studied as though it were synchronous, and yet it is in history and so is constantly changing. The *parole*, on the other hand, takes time to perform; and yet, unlike *langue*, it does not suffer structural change over time. It seems that both *langue* and *parole* accommodate time and timelessness in different and complementary ways, rather than being either wholly temporal or wholly atemporal. We might speculate that structuralism in all its forms fell of its own weight when it found that it could not define its synchronies, and could not say whether simultaneity meant an instant, a day, a year, a decade.

8. On the last page of his essay on "The Structural Analysis of Narratives," in which he tries to rule out any but "logical time" or "semiotic time," Barthes finally makes what I would argue is a necessary concession to temporality by describing narrative as "the model of a process of becoming" (124).

9. In a discussion of Stendhal, Peter Brooks describes the concept of "monster" in very similar terms. Near the end of *Le Rouge et le noir* Julian Sorel says, "*mon roman est fini,*" and, a few lines later, "*Je ne serais plus un monstre.*" Brooks comments that "'monster' refers to ingratitude, especially toward figures of paternal authority, and also to erotic transgression, usurpation, class conflict, and the stance of the 'plebeian in revolt'. . . . 'monster' hence connotes ambition, mobility, the desire to rise and to change places, to be somewhere one does not belong, to become (as by seduction and usurpation) something one cannot be by definition (by birth). The monster is the figure of displacement, transgression, desire, deviance, instability." See "The Novel and the Guillotine; or, Fathers and Sons in *Le Rouge et le noir*" in *Reading for the Plot* 80–81, 84.

Part 2. *Discipline and Desire in Augustine's* Confessions

Chapter 1. The Language of Conversion

1. As Gerald Bruns has written,

> From Socrates to Derrida the philosophers have always defined themselves by their opposition to what can be put publically into words. Philosophy is secretive, whereas rhetoric is full of public exclamation. Rhetoric, to be sure, is the art of concealing motives, designs, or ulterior purposes—but not doctrines or meanings; rather one should say that rhetoric uses meanings for the concealment of practical objectives, whereas philosophy is secretive precisely in respect of what it knows (or what it seeks), as was Socrates, who made it part of his self-definition, part of the whole justification of his life, that he never spoke in public. (*Inventions* 40)

If the distinction between rhetoric and philosophy is questionable (does rhetoric not conceal "what it knows"; does philosophy not obscure its own "practical objectives"?), the insistence on the way in which classical philosophy condescends to language is unarguable.

2. See in this context Arthur Darby Nock, *Conversion* 179–80. Brown and others have argued recently that Augustine's "conversion to the heart," to inwardness, is similar to and perhaps modeled on similar themes in Plotinus's *Enneads*. Interestingly, this theme is not to be found in the work of Origen. See Brown, *Augustine of Hippo* 169. Brown cites V. P. Aubin, *Le problème de la "conversion"* 186–87; and R. J. O'Connell, "The Riddle of Augustine's 'Confessions': A Plotinian Key" 327–72.

3. Spengemann divides the text into three sections as well, but his divisions seem skewed. They are 1–9, 10–12, and 13. But 10 is the anomalous book and must stand alone; 13 is of a piece with 11 and 12.

4. Theresa of Avila, a veteran of *conversatio*, writes, "perfect souls are in no way repelled by trials, but rather desire them and pray for them and love them. They are like soldiers: the more wars there are, the better they are pleased, because they hope to emerge from them with the greater riches. If there are no wars, they serve for their pay, but they know they will not get very far on that" (*The Way of Perfection*, ch. 38: 249).

5. In *The Rhetoric of Religion*, Burke notes that Augustine uses the same word (*inhaerere*) to describe the child's "clinging" to its mother and his own adult wish to "cleave unto God." See 129–33.

6. The relation between Father and Son is thus structured on what Lacan has discussed as the paradox of repetition, "the real numerical genesis of two": "It is necessary that this two constitute the first integer which is not yet born as a number before the two appears. You have made this two possible because the *two* is here to grant existence to the first *one*; put *two* in the place of *one*, and consequently in the place of *two* you see *three* appear." Thus, while one can be

made in the image and likeness of God, one cannot imitate God without the figure of Christ, who carries imitation into the heart of transcendence and exports transcendence out to other imitations. To use Lacan's terms, Christ creates God as a number from which further numbers can issue. See "Of Structure as an Inmixing of an Otherness Prerequisite to Any Subject Whatever" 191.

7. Borrowing from Gadamer, Ricoeur continues this line of thought, discussing the "dispossession of the self" as it appropriates a text, moving towards previously undisclosed possibilities of its own being. See *Interpretation Theory*, esp. ch. 4 and the conclusion.

8. In general, the found text appears as an aspect of the self that has acquired legibility in the world: it therefore tends to blur the distinction between text and self, and to serve as an anodyne demonstration of their mutually constitutive character. When theoreticians forget this character they run into trouble, as for example in Donald Marshall's recent description of the tension between literary plot and real life in terms of "the insertion of closed form into the open process of our lives." Marshall's is a romantic, or at least a "preconversion" point of view, for what the conversion means to Augustine is precisely that the closed form is open *to him,* and that his open, wandering life, his "free will," has been closed, unbeknownst to him, all along. See "Plot as Trap, Plot as Mediation" 71.

9. Susan Stewart's discussion of nostalgia suggests that the goal of conversion is thwarted from the outset: "The impossibility of repetition precludes an authentic engagement with the text of the event The impossibility of recapturing the point of origin produces a desire which is sublimated by a transformation of the self." Perhaps conversion is a sublimation of an impossible desire; but since the origin is already structured by repetition, the origin is not so unrecuperable as Stewart implies, for every repetition, fostering further repetitions, has some originary power. See "The Pickpocket" 1128.

10. See Derrida's extraordinary and important analysis of the idea of imitation in Rousseau's *Essay on the Origin of Languages.* For Rousseau, as Derrida shows, imitation enters all considerations of pedagogy and nature, for the child naturally wants to learn, and naturally does so by imitating its elders. But "already within imitation, the gap between the thing and its double, that is to say between the sense and its image, assures a lodging for falsehood, falsification, and vice"; even "good imitation already carries within itself the premises of its corruption." (*Grammatology* 205)

11. See Courcelles, *Recherches sur les* Confessions *de Saint Augustin* 188–202.

12. While Foucault sees the roots of psychoanalysis in the rituals of institutionalized confession, Theodore Reik proposes a broader view of confession as a universal human impulse to self-disclosure. See Foucault, "The Confession of the Flesh"; and Reik, *The Compulsion to Confess.* Freud, incidentally, links conscience, essential to confession, with paranoia as the origin of "delusions of 'being noticed,' or, more correctly, of being *watched.*" ("On Narcissism: An Introduction" 95)

Chapter 2. Profit and Loss in the Ascesis of Discourse

1. Vance suggests that the narrative of Aeneas on the fall of Troy was crucial in forming Augustine's view of narrative in general. The analysis offered here does not differ from this conclusion, but depends on no external poetic context.

2. Spengemann describes the preconversion representational mode as involving "two Augustines, one trapped in time and the other standing outside it" (2). Interestingly, Burke says that the *effect* of the conversion is precisely to enable Augustine to place his sins outside himself, to replace an inner controversy with an outer controversy: instead of being consumed by his own doubts, the converted Augustine turns to polemics against the Pelagians, the Donatists, and the Manicheans (see *Rhetoric of Religion* 115). What this means, I believe, is that the conversion had enabled Augustine to write the narrative. What is interesting about the conversion of narrative into discourse, then, is that he surrenders his "godlike" narrating self and focuses on his internal condition once again.

3. Augustine conceives of perfect knowledge in terms of the "face-to-face" encounter; see 12.13: 289 and 12.15: 292. The moment of conversion, and the narrative that follows it, provides him with a face-to-face encounter with himself. But in Book 10 he concedes not just that the visible self might yet be imperfectly known, but that "there are some things in man which even his own spirit within him does not know" (10.5: 210–211).

4. Having renounced "mastery over words" (see 1.16: 36) through pagan rhetoric, Augustine reclaims rhetoric as a necessary tool for unlocking the secrets of Scripture. See *On Christian Doctrine* 3.29–37 for his explication and defense of the rhetorical rules of Tichonius the Donatist.

5. In the *Phaedrus* Theuth gives men the gift of writing as a "cure for forgetfulness and folly," but his friend Thammus anticipates that writing will induce forgetfulness because men "will trust to the external written characters, and not remember of themselves. You have found a specific not for memory, but for reminiscence, and you give your disciples only the pretence of wisdom" (sec. 275).

6. Aristotle claimed that memory occurred by three kinds of mental association: similarity, contiguity, and opposition. See *De memoria*, 451b 18. See also Eugene Vance, "Roland and the Poetics of Memory" passim.

Chapter 3. The Fertile Word

1. Gerald Bruns describes the "I" of Rousseau's *Discourse on Method* in terms equally applicable to the Augustinian "I" of books 11–13:

> . . . it is both odd and necessary that the *Discourse* should take the form of an autobiography. It is odd, because its chief figure proves to be a mind without a history—a mind that obliterates its autobiographical portion; and it is necessary, because without autobiography no such

mind would be up to its task, for it is a mind, after all, that has to be arrived at; it doesn't just happen. . . . autobiography provides the material by which to construct a philosophical self, but only in the odd sense that it is not material which goes *into* the construction of the self but rather material which defines the construction by being kept out of it. . . . [The philosophical self] exists in order to disappear at precisely that inaugural moment when history ceases and philosophy begins. (*Inventions* 65)

The philosophical self, we may add, is a converted self and a self without a memory, a self whose natural mode is exegesis. Speaking of natural modes: if discourse is, as Genette asserts, the most natural and inclusive form of language, then exegesis is the most natural mode of language, for it is the exemplary form of discourse in being entirely preoccupied with its own occasion. The naturalness of exegesis presents, as I will argue later in this section, its own form of temptation.

2. Vance, who says virtually nothing about Augustine's hermeneutics, actually complains about others who "systematically sidestep the conclusion of that text almost as if it were not there . . ." ("Grammar of Selfhood" 6). For an essay that does not sidestep these books see John C. Cooper, "Why Did Augustine Write Books XI–XIII of the *Confessions?*"

3. This account does not begin to do justice to the methods of commentary employed by Scriptural exegetes over the centuries, but it is, I believe, accurate as far as it goes. I have drawn the notion of the text's "desire" for commentary—which on occasion had the effect of making the text more obscure rather than clearer—from Gerald Bruns, whose essay on "Secrecy and Understanding" (*Inventions* 17–43) is an excellent discussion of the methods of Scriptural exegesis. According to Bruns, commentary until Luther was "versional" rather than "systematic," effecting understanding through literal rewriting rather than through attention to an immobile text.

4. I have not discussed the "allegorical" method of interpretation through typological substitution, but Fredric Jameson's treatment of typology is interesting on this subject. He concedes that to see the New Testament as a fulfillment of a hidden prophecies of the Old Testament opens the text up to multiplicity in the form of further rewritings and continual ideological reinvestment, but comments that this opening up takes place only through the collapsing of the story of the collective struggle of Israel into the personal struggle of Jesus. Thus the *literal* story of the Jews is seen just as an *allegory* of the life of Jesus, whose story we must then read in a *moral* or *psychological* light. Finally, on the fourth or *analogical* level of interpretation, the subject of the story is conceived as the destiny of the human race as a whole. Thus collectivity is restored but only "by way of the detour of the sacrifice of Christ and the drama of the individual believer" (*Political Unconscious* 31). Jameson relies on de Lubac's *Exégèse médiévale* and Daniélou's *From Shadows to Reality: Studies in the Biblical Typology of the Fathers.*

5. Augustine's innocent deer summon another Barthesian image, that of

the anti-hero of readership described at the beginning of *The Pleasure of the Text*, "who abolishes within himself all barriers, all classes, all exclusions, not by syncretism but by simple discard of that old specter: *logical contradiction*; who mixes every language, even those said to be incompatible; who silently accepts every charge of illogicality, of incongruity . . ." (3).

6. Ginzburg 8. Gadamer has compared the interpretation of the Bible to "the ability of myth to change and its openness for ever new interpretations" ("Self-Understanding" 51). For Gadamer, this openness suggests that it is irrelevant to ask in what sense the myths were "believed." And he makes the final, radical point, *contra* Bultmann's notion that the Bible brought a new "demythologizing" spirit into the world, that "the relation of a Christian theologian to the biblical tradition does not appear to be so fundamentally different from the relation of the Greek to his myths" (52). Augustine would surely repudiate this suggestion, and yet Book 12 demonstrates how a personal "belief" in the Bible is imperiled by the multiplicity of the Bible's truth.

7. Augustine betrays a keen awareness of the comedy of exegesis when he says in *The Teacher* that "discussing words with words is as entangled as interlocking and rubbing the fingers with the fingers, in which case it may scarcely be distinguished, except by the one himself who does it, which fingers itch and which give aid to the itching" (5.14: 20).

8. Compare the following passage from Donne's sermon "The Physicians . . .":

My God, my God, Thou art a direct God, may I not say a literall God, a God that wouldest bee understood literally, and according to the plaine sense of all that thou saiest? But thou art also (Lord I intend it to thy glory, and let no prophane misinterpreter abuse it to thy diminution) thou art a figurative, a metaphoricall God too; A God in whose words there is such a height of figures, such voyages, such peregrinations to fetch remote and precious metaphors, such extentions, such spreadings, such Curtaines of Allegories, such third Heavens of Hyperboles, so harmonious eloquutions, so retired and so reserved expressions, so commanding perswasions, so perswading commandments, such sinewes even in thy milk, and such things in thy words, as all prophane Authors, seeme of the seed of the Serpent, that creepes, thou art the Dove, that flies. O, what words but thine, can expresse the inexpressible texture, and composition of thy word; in which, to one man, that argument that binds his faith to beleeve that to bee the Word of God, is the reverent simplicity of the Word, and to another, the majesty of the Word, and in which two men, equally pious, may meet, and one wonder, that all should not understand it, and the other, as much, that any man should.

9. *Ennarrationes in Psalmos* 101.3; translated and quoted in Peter Brown, *Augustine of Hippo* 178.

10. This submission of the subjective to the extrasubjective is conceded

even by proponents of the recently deceased "subjective paradigm." As its leading proponent, David Bleich, saw it, "The reasons for the shape and content of *both* my response and my interpretation are subjective," and the subjective/objective division is treated as absolute. And yet, interpretation "is a subjective act, framed in objective terms, whose success, rather than truth, is measured by its capacity for reassimilation by other readers" (151–52).

Part 3. Passion of Representation: Grünewald's Isenheim Altar

Chapter 1. Anonymity, Modernity, and the Medieval

1. See von Sandrart, vol. 2.3: 236 ff. See Schoenberger 51–56 for a reproduction of all the sources of the life of Grünewald. These are taken from Zülch; for more historical documentation, see also H. A. Schmid. For an account of Grünewald's evolving, or devolving, reputation before the nineteenth century, see Louis Réau: xxii–xxxii.

2. According to Arthur Burkhard, "He was apparently hostile to everything that Humanism and the newly awakened classical traditional stood for, and the Renaissance, therefore, had less influence on him than on any of his contemporaries" (78). By contrast, Andree Hayum discerns a profound sympathy on Grünewald's part for the patients of the hospital, and from this a larger responsiveness to the Reformation, if not to the classical tradition: "We see in it, first of all, the effort to wrest essential meaning from the model of the gospels and the concomitant formulation of a language that is directly expressive. . . . If we take a primary goal of reformational thought to be establishing the direct link between man and God . . . might we not assume that these patients became inspiring models in Grünewald's private attempt at reexperiencing and redefining the nature of a Christian universe?" (89).

3. For a more systematic expression of aesthetic asceticism see Wassily Kandinsky, *Concerning the Spiritual in Art*, which defends the artist's "secret power of vision" in the service of a "movement forwards and upwards" (4). In terms that invoke the artist's *imitatio Christi*, Kandinsky warns that "The artist is not born to a life of pleasure. He must not live idle; he has a hard work to perform, and one which often proves a cross to be borne. He must realize that his every deed, feeling, and thought are raw but sure material from which his work is to arise, that he is free in art not in life" (54).

4. See Gilman's excellent discussion of the seventeenth-century emblembook, in which, ideally, "image melts into speech, speech crystallizes the immediacy of the image" (389). Gilman astutely shows the strains placed on this form by an English Protestant culture formed on the primacy of the Word.

5. Georg Scheja provides the most complete description of the program, argument, and sources of the Isenheim Altar currently available in English. Huysmans's is the best written and the most sensitive to the actual impression made by the panels in their setting at Colmar. The most comprehensive bibliography of the remarkable amount of scholarship on Grünewald done in this century—most of it in German—is in *Grünewald en 1974* 201–57. Wilhelm

Fraenger's massive tome, *Matthias Grünewald*, has not yet been translated from the German.

6. See Chatelet for a discussion of the original setting of the Isenheim Altar.

7. *Miscellanea Agostiniana*, i: 515 (1930); quoted in Peter Brown, *Augustine of Hippo* 255.

8. Some authorities argue, in defense of the idea that Mary is presented as the representative or advocate of the monastic life, that the Mary of the Nativity is dressed as a nun. On the conception as an act of monastic contemplation Grünewald may have been instructed by chapter 5 of Ludolphus's *Vita Christi*.

9. On the glory of the transfigured body of Christ there are several Scriptural texts, including Eccles. 6:32 and Apoc. 7:9.

10. In his thorough and careful analysis of the Isenheim Altar, Georg Scheja argues that the auerole reflects the Plotinian image of the world-system as three concentric circles, and the mystic adaptation of Plotinus's circles to symbolize the Trinity (36–37). Scheja notes that Dante, in *Paradiso* 33, draws on a common medieval conception of gigantic concentric circles of light as a manifestation of the divine. See also Edgar de Bruyne, *The Esthetics of the Middle Ages*: 16–18; 55–61, and Otto von Simson, *The Gothic Cathedral* for medieval theories of light.

11. Chatelet contends that in this panel Grünewald tried to illustrate the conception of Christ's transfigured body as described by Ludolphus, who lists *claritas, impassibilitas, agilitas, subtilitas*—splendor, invulnerability, quickness, and keenness—as the four principle prerogatives of grace (66). He may be right, but the qualities listed were described as the Four Corporeal Gifts of the Blessed in any of a number of such fourteenth- or fifteenth-century works. This panel may also have had specific implications for the inmates of the hospital who could see in it a recommendation for an "active participation in the body of Christ towards an imaginative recreation of life" (Hayum 84).

12. These words are quoted by Scheja from Feurstein's *Matthias Grünewald*; see Scheja 75 n.74. Scheja's own favored source is again Dante, the *Paradiso* 23.

13. P. 33. The text consulted is the *Hortus sanitatis*, Mainz, 1457.

14. Although Roland Recht disputes von Hugenau's attribution and nominates half a dozen others who might have executed the commission, even as early as 1480.

15. On Anthony as a melancholic, see Chastel. The pig has a humbler explanation: the pigs owned by the Antonines were in many communities granted the privilege of running freely through the town as a gesture of gratitude towards their owners. The lard of pigs was also used in treating disease. The association of the pig with Anthony has, therefore, nothing to do with Egypt or with Anthony himself. For the association of Saturn, melancholia, and monk, see Panofsky and Saxl.

Chapter 2. Conceptual Narrative

1. The "cathedral" form of Grünewald's narrative actually reflects Greimas's definition of narrative meaning in general. According to Greimas,

meaning is diacritical and depends upon oppositions, specifically on the correlation of two pairs of opposed terms: "To have meaning a narrative must form a signifying whole and thus is organized as an elementary semantic structure" in which a temporal opposition is correlated with the homologous thematic opposition (187). "In other words," Jonathan Culler comments, "the relation between an initial state and a final state is correlated with the opposition between an initial thematic situation or problem and a thematic conclusion or resolution" (*Structuralist Poetics* 93). In yet other words, Grünewald's idiosyncratic work still reflects the structure of all narratives, in which temporality is crossed or correlated by the reversal, the increase-decrease, of a thematic situation.

2. Huysmans actually says "*de droite à gauche*," and throughout his description of the Crucifixion reverses right and left, as though he were studying a photograph in which the image had been reversed. I have here reversed his reversal.

Chapter 3. A Passion of Representation

1. On the role of disgust in grotesque art in general, see Harpham, *On the Grotesque* 180–85. This discussion centers on certain passages in Kant's *Critique of Judgment*, which are treated by Derrida from a point of view closer to the present argument in "Economimesis." Derrida argues that the logocentric system which sustains the idea of a hierarchy of arts (with the "Fine Arts" at the top) is virtually founded upon the sensation of disgust, of "vomit," to eject the non-idealisable and unnameable and therefore to maintain the system as a whole. Disgust, Derrida writes, "is determined by the system of the beautiful, 'the symbol of morality,' as *its* other; it is then for philosophy, still, an elixir, even in the very quintessence of its bad taste" (25). Derrida also suggests that disgust is connected in Kant's thought with the unrepresentable, and this enables us to speculate on the motivation for Grünewald's (disgusting) Crucifixion. According to Kant, the disgusting object cannot be represented as beautiful, for the representation provokes the same feeling as the object. It therefore, Derrida adds, "prevents mourning": "Let it be understood in all senses that what the word 'disgusting' denominates is what one cannot resign oneself to mourn" (24–25). In representing Christ as disgusting, the artist encourages a reaction closer to John the Baptist's than to Mary Magdalene's.

2. A companion volume to the earlier study of representation, *Art and Illusion, The Sense of Order* focuses not on signs but on designs. Gombrich argues that while figural art stimulates and gratifies our sense of meaning, ornamental art gratifies a more primitive demand for a sense of order. Analogies in biology and the logic of scientific discovery underlie this distinction. Even the simplest organisms, Gombrich argues, appear to have innate "hypotheses" which they continually test against the world, and this testing corresponds with our own scanning of the work of art for principles of order, which alone can enable meaningfulness. One of the chief functions of ornament, therefore, is

literally to frame the painting, reassuring the viewer that what is bordered by it corresponds to our assumptions of orderliness and can be rationally tested.

3. See Derrida, "Fors," and Abraham and Torok, *Cryptonomie: Le Verbier de l'Homme aux loups*; for an introduction in English to this latter work, see Abraham, "The Shell and the Kernel." For a useful account of Derrida's relation to Abraham and Torok I am indebted to Sharon Cameron's "Representing Grief: Emerson's 'Experience.'"

4. In a perceptive review of Kristeva's work, Cynthia Chase asks, "What aside from institutionalized force makes a given form of patriarchy hold up? To feminists, Kristeva's answers may look dangerously like an apologia for the foundation of culture upon the suppression of women; the 'benefits that accrue to the speaking subject' may seem to accrue overwhelmingly to subjects who are male" (195). In her description of the symbolization of the feminine by any speaking subject, Kristeva leaves what Chase calls "a crying omission" by ignoring the social practices associated with the taboos and rituals that also control articulation.

5. On Grünewald's use of color see Dittmann.

6. Kristeva suggests that "the perception of blue entails not identifying the object; that blue is, precisely, on this side of or beyond the object's fixed form; that it is the zone where phenomenal identity vanishes" (225). On the capacity of the infant to distinguish color before form she cites I. C. Mann's *The Development of the Human Eye* 68. The "instinctual" character of blue may have played a part in the high valuation placed on it, especially in its ultramarine shade, by Renaissance patrons. See Baxandall 11–14.

Chapter 4. Asceticism and the Sublime

1. The terms addresser (author or speaker) and addressee (reader or hearer) come from Roman Jakobson's "Closing Statements: Linguistics and Poetics." These functions are sometimes designated, following Greimas, as "*Destinateur*" and "*Destinataire*."

2. Both Guerlac and Ferguson draw attention to the ultimate moment in the reader's appropriation of a text, when the reader recognizes a "mistake" in the work and credits the author with strategically planning the mistake in order to produce a certain effect. I have, I suppose, testified to the sublimity-effect of the Isenheim Altar by suggesting such a strategic mistake in the representation of the peasants standing behind the church in the Nativity.

Part 4. Philosophy and the Resistance to Asceticism

Chapter 1. Nietzsche: Weakness and the Will to Power

1. I have used the Kaufmann translations of *Ecce Homo* and *On the Genealogy of Morals*. The numbers given in the text refer to page numbers of *Ecce Homo*, and to essay and section numbers, not pages, of *On the Genealogy of Morals*.

2. In making sense of Nietzsche by providing the continuities his text does not, Nietzsche's critics are following what is described in *The Will to Power* as a *Wille zur Gleichheit*, a will to identity or equality, a making same of the various and multiple, as the essence of *value* through the formation of "structures of dominion"—an honorable, if anti-Nietzschean, task. See *Will to Power* no.501.

3. But the interested reader might begin by consulting the "Appendix" to Kaufmann's translation of the *Genealogy*, and to "The Strong and the Weak," bk. 4, sec. 2 of *The Will to Power* (pp. 459–93), in which many of the questions raised in the *Genealogy*, including *"Why the weak conquer"* (no.864) are discussed directly.

4. Gilles Deleuze's *Nietzsche and Philosophy* is the most relentlessly synthetic of the recent readings of the *Genealogy*; he writes, in stark opposition to Heidegger, that "There is no possible compromise between Hegel and Nietzsche" (195). Howard Eiland's elegant essay "Nietzsche's Jew" is to my mind the most sensitive and genuinely sympathetic such effort.

5. Deleuze states bluntly that the *Genealogy* is "Nietzsche's most systematic book," and proceeds to characterize the formal structure of the work as an analysis of (1) the ways in which *ressentiment* separates force from what it can do, (2) bad conscience as inversion and antimony, and (3) the ascetic ideal as the will to nothingness (*Nietzsche and Philosophy* 87–88). I do not argue with this characterization, only with the assumption that this formal structure is unresisted by discontinuities at lower levels.

6. In 1.9, Nietzsche depicts himself as "a man of silence," with "much to be silent about"; but in 1.10 he comments that the "man of *ressentiment*" "understands how to keep silent." The authors of slave-morality are inevitably "cleverer" or "more interesting" than the noble; but throughout the *Genealogy* and *Ecce Homo* these attributes are applied to his own character. Most intriguingly, the man of *ressentiment* is said to caricature his enemies as " 'the evil enemy,' 'the Evil One' " (1.10); but Nietzsche has already portrayed the ascetic priests themselves as *"the most evil enemies"* (1.7). On silence, see the extremely interesting meditation by Carl Pletsch, "The Self-Sufficient Text in Nietzsche and Kierkegaard."

7. The conclusion we must come to is that ethnology must be abandoned, but we could not have known that without going through the ethnological argument. Paul de Man makes a similar point about narrative in *The Birth of Tragedy*: "it is instructive to see a genetic narrative function as a step leading to insights that destroy the claims on which the genetic continuity was founded, but that could not have been formulated if the fallacy had not been allowed to unfold" (*Allegories of Reading* 101–02).

8. Sarah Kofman, for example, contrasts Nietzsche's early dependence on a "truthful" form of language with his later formulations in which the notion of a "proper" meaning is replaced by that of "interpretation" (78). Philippe Lacoue-Labarthe also argues for the logocentrism of the early Nietzsche, for whom "the labor of truth goes on" (73). De Man argues against this account of the early Nietzsche, insisting that even in *The Birth of Tragedy* Nietzsche is already a full-fledged deconstructionist.

9. Compare Blanchot: "When we speak, we gain control over things with satisfying ease. . . . speech is life's ease and security" ("Littérature et le droit à la mort" 41); on which Gerald Bruns comments that "What interests Blanchot, however, is that this is not a case of the strong bringing the weak under subjection, rather it is the other way around. The discourse of governance and dominion is rooted in the essential weakness of the one who speaks, that is, the one who is compelled to speak out of necessity, or because reality is intractable" ("Language and Power" 27).

10. In one particularly forced effort to harmonize Nietzsche's positions, Alphonso Lingis says that the sovereign individuals of the second essay "remember" not the past but the future, while the noble of essay 1 forget the past; therefore, there is no discontinuity. See Lingis, "The Will to Power" 55.

11. One of the brilliant synthesis in Eiland's "Neitzsche's Jew" is the argument that despite Nietzsche's contention that historical change occurs in "leaps" or breaks, the ascetic ideal itself evolves through a long and dismal process. "The slow imposition of custom on the shapeless 'raw material' of the semi-animal is the work, Nietzsche says, of conquering races like the Aryans; they do not themselves conceive the 'active bad conscience'—the work of the conquered Jews—but instead prepare the ground for it by forging a sense of futurity. In fine, the ancient political state must evolve before conscience explodes into being. Or, in the terms of Nietzsche's personal mythology, the blonde beast opens the way for the Jew" (112). Throughout this essay Eiland does Nietzsche the favor of systematizing and rationalizing arguments which in the text are left discontinuous. Nietzsche nowhere says that one of his prehistoric events precedes another, but Eiland's version is attractive because in making sense he does not sacrifice a Nietzchean spirit of audacity.

12. For an interesting reading of *Ecce Homo* in terms of "Nietzsche's undertaking as a moment of undecidability between knowledge—the question of being understood—and performance—the exemplary renaming," see Michael Ryan, "The Act" (85).

13. As Eiland has pointed out, the Jews are, like the Germans, a structurally cloven idea for Nietzsche, the representatives of "an uncanny psychic doubleness" (107), dangerous in their holiness and in their decadence (109). Eiland concludes that the Jews serve Nietzsche as a "*meta-ethnic* ideal, a universal human and cultural possibility" (116).

Chapter 2. Saint Foucault

1. Foucault's relation to structuralism is difficult to define. In *The Archeology of Knowledge* in 1969 he states that his method is "not entirely foreign to what is called structural analysis" (15). He then says, however, that "this kind of analysis is not specifically used." Later in the book he insists that the methods of archeology "cannot possibly be confused with structuralism" (204). The "Conclusion" to this book takes the form of a debate over whether he had ever called his work "structuralist," with an interlocutor accusing him of structuralist tendencies and the defensive respondant forcing him to "admit that I never

once used the word 'structure' in *The Order of Things*" (200–201). In the foreword written a year later for the English translation of *The Order of Things* he bemoans the fact that "certain half-witted 'commentators' [perhaps Lucien Goldmann, who had charged him with structuralist affinities after hearing his paper "What Is an Author?" in 1969] persist in labelling me a 'structuralist.' I have been unable to get it into their tiny minds that I have used none of the methods, concepts, or key terms that characterize structural analysis" (xiv). Here he seems to have forgotten the passage in the 1970 essay "The Discourse on Language" in which he advises his readers—or auditors, as it was first delivered as lecture—to "let those who are weak on vocabulary, let those with little comprehension of theory call all this—if its appeal is stronger than its meaning for them—structuralism" (234). On many occasions since he has reiterated this distancing gesture. He has not been persuasive to all. Alan Sheridan, who translated the *Archeology*, has written, "There is a sense in which [Foucault's] work is profoundly anti-Structuralist" (*Will to Truth* 90); but others, such as Lawrence Stone, argue that "his true originality lies in his structuralist mode of explanation" (43).

2. Foucault was actually born in 1926.

3. Denis Hollier applies the concept of the death of the author to the "self-referentiality" of literature, and comments approvingly on Foucault's refusal "to endorse the academic victory which thought it could reduce every event to a text, and which produced the restless and monotonous spreading of textuality, with its ultimate academic transgression, the tedious equation of sexuality to textuality" (27).

4. In a 1977 interview Foucault speaks about "the way in which different instances and stages in the transmission of power were caught up in the very pleasure of their exercise. There is," he says, "something in surveillance, or more accurately in the gaze of those involved in the act of surveillance, which is no stranger to the pleasure of surveillance, the pleasure of the surveillance of pleasure, and so on" ("The History of Sexuality" 186).

5. Despite the severity of its terms, much of Foucault's theoretical discourse has an ambivalently erotic character. As an example, see the concluding words of *The Order of Things*: "The unthought (whatever name we give it) is not lodged in man like a shrivelled-up nature or a stratified history; it is, in relation to man, the Other; the Other that is not only a brother but a twin, not of man, nor in man, but beside him and at the same time, in an identical newness, in an unavoidable duality."

6. See, as an example of discontent with Foucauldian resistance, Dana Polan on "Fables of Transgression": ". . . it's commendable that Foucault's discourse on power also talks of resistance but this resistance, like Foucault's power, is so automatized, biologized, that it seems to allow little entry in for an active praxis" (368–69). Polan laments the fact that in the work of some of Foucault's more "radical" followers, power is dominance, and resistance "is no more than something one should be cautious about, rather than something one should try to develop" (370). But if Foucault is right, the development of resistance would also constitute a development of power, and so maybe we

should be cautious. To those such as Polan who believe that resistance is useless as a dimension or reflex of power, and useful as an opposing force, Foucault is a tantalizing but frustrating figure. In, for example, a 1971 interview entitled "Revolutionary Action: 'Until Now,'" Foucault is asked, "On what level do you plan to act? Can you address yourself to social workers?" To which he replies, "No. We would like to work with students in lycée, those whose education has been supervised, anyone who has been subjected to psychological or psychiatric repression in their choice of studies, in their relationships to their family, in their response to sexuality or drugs. We wish to know how they were divided, distributed, selected, and excluded in the name of psychiatry and of the normal individual, that is, in the name of humanism" (229). He would certainly not have to look far for people to talk to, but it's hard to see what else other than talk would occur. In a 1977 interview Foucault is asked, "So who ultimately, in your view, are the subjects who oppose each other?" The reply: "This is just a hypothesis, but I would say it's all against all." Foucault even invokes "sub-individuals" as participants in struggle. "Sub-individuals?" his amazed interviewer interjects. Foucault: "Why not?" No objection being immediately available, the interview proceeds to other issues. ("The Confession of the Flesh" 208).

7. Dreyfus and Rabinow give a lucid account of Foucault's views on the "production" of sex: "Sex is the alleged object which unifies our modern discussions of sexuality, making it possible to group together anatomical elements, biological functions, comportments, sensations, knowledges, and pleasures. Without this deep, hidden, and significant 'something,' all of these discourses would fly off in different directions, or, more accurately, and this is the crux of Foucault's argument, they would not have been produced in anything resembling their current form. . . . Sex is the historical function which provides the link between the biological sciences and the normative practices of bio-power" (177–78).

8. Foucault argues on 122 of volume one of *The History of Sexuality* that the ruling classes first tried the limitation of sexuality on themselves, but this limitation was not an asceticism because it did not entail a "renunciation of pleasure or a disqualification of the flesh, but on the contrary an intensification of the body, a problematization of health and its operational terms: it was a question of techniques for maximizing life" (123). But this *is* asceticism, and so is what he calls "*bio-history*," "the pressures through which the movements of life and the processes of history interfere with each other" (143).

9. In an important 1983 interview Foucault confirms this new appreciation: "No technique, no professional skill can be acquired without exercise; neither can one learn the art of living, the *techne tou biou*, without an *askesis* which must be taken as a training of oneself by oneself: this was one of the traditional principles to which the Pythagoreans, the Socratics, the Cynics had for a long time attributed great importance. Amongst all the forms this training took . . . it seems that writing—the fact of writing for oneself and for others— came quite late to play a sizable role" (In Dreyfus and Rabinow 246–47). In a recently translated "Final Interview" (originally published 28 June 1984)

Foucault even says that his usage of "style" in the analysis of historical individuals "is to a large extent borrowed from Peter Brown" (3). Such borrowings antagonize specialists, who would prefer reverential citation to the inevitable deflection of received wisdom that accompanies them. Martha Nussbaum, writing of the second volume in the sexuality series, takes Foucault to task for lacking "all the usual scholarly tools, including knowledge of Greek and Latin." She wonders why Foucault would be moved "to take this long detour away from periods in which he was more comfortable as a scholar" ("Affections of the Greeks" 14, 13). Without in any way denigrating the usual tools, I want to assert that entirely too much work is produced by comfortable scholars. Any speculative formulation can be thrown out of court by some comfortable scholar who could insist, for example, that this is not what the Greeks were about. But no intelligent person could care *only* about the Greeks. The pursuit of the essence of Greek thought and action is, unless accompanied by an equally intense concern for our own culture, not a serious subject of inquiry; it betrays both a scholarly superficiality in its indifference to the present, and a scholarly naiveté in its optimism about recuperating the past.

10. Foucault's last comments on power bring it even closer to the vocabulary of asceticism, to the point where whatever differences between resistance to power and resistance to desire there were begin to dissolve. In "The Subject and Power" (1982) power is characterized not as a "something called Power," but in terms of a "power relationship" between "two elements which are each indispensable" (219, 220). The formulation here is surprisingly close, for example, to Thomas Aquinas's meditations on temptation, discussed in the notes to part 1, chapter 4. For Foucault's "power" in the following sentences, simply read "temptation" in order to make the adjustment. Power relations do "not exclude the use of violence any more than it does the obtaining of consent . . . [but] they do not constitute the principle or the basic nature of power." Power "incites, it induces, it seduces, it makes easier or more difficult; in the extreme it constrains or forbids absolutely; it is nevertheless always a way of acting upon an acting subject or acting subjects by virtue of their acting or being capable of action" (220). "Power is exercised only over free subjects, and only insofar as they are free." "Rather than speaking of an essential freedom, it would be better to speak of an 'agonism' [a combat]—of a relationship which is at the same time reciprocal incitation and struggle, less of a face-to-face confrontation which paralyzes both sides than a permanent provocation" (221, 222). "Every power relationship implies . . . a strategy of struggle, in which the two forces are not superimposed, do not lose their specific nature, or do not finally become confused. Each constitutes for the other a kind of permanent limit, a point of possible reversal" (225).

Works Cited

Abraham, Karl. "The Shell and the Kernel." *Diacritics* 9, no. 1 (1979): 16–28.

Abraham, Karl, and Maria Torok. *Cryptonomie: Le Verbier de l'Homme aux loups.* Paris: Aubier Flammarion, 1976.

Allison, David B., ed. *The New Nietzsche.* Cambridge, Mass., and London: MIT Press, 1985.

———. "Introduction." In Allison, *The New Nietzsche*, xi–xxviii.

Althusser, Louis. *Reading Capital.* Trans. Ben Brewster. London: New Left Books, 1970.

Aquinas, Thomas. See Thomas Aquinas.

Arendt, Hannah. *The Human Condition.* Chicago and London: Univ. of Chicago Press, 1958.

Aristotle. *Aristotle on Memory* [*De memoria*]. Trans. Richard Sorabji. Providence: Brown Univ. Press, 1972.

Aristotle. *On Interpretation, Commentary by St. Thomas and Cajetan.* Trans. J. Oesterle. Milwaukee: Marquette Univ. Press, 1962.

———. *Poetics.* Trans. Kenneth A. Telford. Chicago: Gateway, 1970.

Arnold, Matthew. "The Function of Criticism at the Present Time." In *Essays in Criticism* (first series), 1–30. New York: A. C. Burt, n.d.

———. "The Study of Poetry." In *Essays in Criticism* (second series), 279–307. New York: A. C. Burt, n.d.

Athanasius. *The Life of Anthony.* Trans. Sister Mary Emily Keenan, in *Early Christian Biographies*, vol. 15 of Roy J. Deferrari et al., eds., *Fathers of the Church*, 133–216. New York: Fathers of the Church, 1952.

———. *The Life of Anthony and The Letter to Marcellinus.* Trans. and ed. Robert C. Gregg. New York: Ramsey; Toronto: Paulist Press, 1980. Migne, *Patrologia Graeca* 26, cols. 835–976. (1887).

Works Cited

Aubin, P. *Le problème de "conversion"*. Paris: Beauchesne, 1963.
Augustine. *Concerning the Teacher (De magistro) and On the Immortality of the Soul (De immortalitate animae)*. Trans. George G. Leckie. New York: Appleton-Century-Crofts, 1938.
―――. *Confessions*. Trans. R. S. Pine-Coffin. Harmondsworth: Penguin, 1979.
―――. *Ennarrationes in Psalmos*. Trans. and quoted in Peter Brown, *Augustine of Hippo*.
―――. *On Christian Doctrine*. In *The Confessions. The City of God. On Christian Doctrine*. Chicago: Encyclopedia Britannica, 1952.
―――. *On the Trinity*. In *Augustine: The Later Works*, trans. John Burnaby. Philadelphia: Westminster Press, 1955.
Bakhtin, Mikhail. *The Dialogic Imagination*. Ed. Michael Holquist; trans. Caryl Emerson and Michael Holquist, Univ. of Texas Press Slavic Series, no. 1. Austin, Tex.: Univ. of Texas Press, 1981.
―――. [V. N. Voloshinov]. *Marxism and the Philosophy of Language*. Trans. Ladislav Matejka and I. R. Titunik. Vol. 1 of *Studies in Language*. New York: Seminar Press, 1973; orig. pub., 1930.
―――. *Rabelais and His World*. Trans. Hélène Iswolsky. Cambridge: MIT Press, 1968.
Barthes, Roland. "L'Activité structuraliste." In *Essais Critiques*, 213–20. Paris: Seuil, 1964.
―――. *Critique et vérité*. Paris: Seuil, 1966.
―――. "The Death of the Author." In *Image, Music, Text*, trans. Stephen Heath, 142–48. New York: Hill and Wang, 1977.
―――. "From Work to Text." In *Image, Music, Text*, 155–64.
―――. "L'effet de réel." *Communications* 11 (1968): 84–89.
―――. "Introduction to the Structural Analysis of Narratives." In *Image, Music, Text*, 79–124.
―――. *The Pleasure of the Text*. Trans. Richard Miller. New York: Hill and Wang, 1975.
―――. *The Rustle of Language*. Trans. Richard Howard. New York: Hill and Wang/Farrar Straus and Giroux, 1986.
―――. *Writing Degree Zero and Elements of Semiology*. Trans. Annette Lavers and Colin Smith. Boston: Beacon Press, 1970.
Basil. "An Ascetical Discourse and Exhortation on the Renunciation of the World and Spiritual Perfection." In *Saint Basil: Ascetical Works*, trans. Sister M. Monica Wagner; vol. 1 of Roy J. Deferrari et al., eds. *The Fathers of the Church*, 15–31. New York: Fathers of the Church, 1950.
Baudrillard, Jean. "Forgetting Foucault." Trans. Nicole Dufresne. *Humanities in Society*, 3, no. 1 (1980): 87–111. Orig. pub. *Oublier Foucault*. Paris: Editions Galilee, 1977.
Baxandall, Michael. *Painting and Experience in Fifteenth-Century Italy: A Primer in the Social History of Pictorial Style*. Oxford, New York, Melbourne, Toronto: Oxford Univ. Press, 1982.
Beardsley, Monroe. "The Concept of Literature." In *Literary Theory and*

Structure: Essays in Honor of William K. Wimsatt, ed. Frank Brady, John Palmer, and Martin Price, 23–39. New Haven: Yale Univ. Press, 1973.

Bell, Rudolph. *Holy Anorexia*. Chicago: Univ. of Chicago Press, 1985.

Benesch, Otto. *German Painting from Dürer to Holbein*. Trans. H. S. B. Harrison. Cleveland: World Publishing Company, n. d.; orig. pub., 1966.

Benjamin, Walter. "On Language as Such and on the Language of Man." In *Reflections: Essays, Aphorisms, Autobiographical Writings*, trans. Edmund Jephcott, ed. Peter Demetz, 314–32. New York and London: Harcourt Brace Jovanovich, 1978.

Benveniste, Emile. "The Correlations of Tense in the French Verb." In vol. 1 of *Problems in General Linguistics*, trans. Mary Elizabeth Meek, 205–15. Coral Gables, Fla.: Univ. of Miami Press, 1971.

Bernhart, J. *Die Symbolik im Menschwerdungsbild des Isenheimer Altar*. Munich: Patmos-Verlag, 1921.

Bersani, Leo. *Baudelaire and Freud*. Berkeley, Los Angeles, London: Univ of California Press, Quantum, 1977.

———. "Pedagogy and Pederasty." *Raritan* 5, no. 1 (1985): 14–21.

———. "Rejoinder to Walter Benn Michaels." *Critical Inquiry* 8, no. 1 (1981): 158–64.

———. "Representations and Its Discontents." In Stephen J. Greenblatt, ed., *Allegory and Representation*, Essays from the English Institute 1979–80, Series 5, 145–62. Baltimore: Johns Hopkins Univ. Press, 1981.

———. "The Subject of Power." *Diacritics* 7, no. 3 (1977): 2–21.

Bersani, Leo, and Ulysse Dutoit. *The Forms of Violence: Narrative in Assyrian Art and Modern Culture*. New York: Schocken, 1985.

Blackmur, R. P. "The Enabling Act of Criticism." In R. W. Stallman, ed., *Critiques and Essays in Criticism, 1920–48*, 412–17. New York: Ronald Press Co., 1949.

Blanchot, Maurice. *L'Espace littéraire*. Paris: Gallimard, 1955.

———. "Littérature et le droit à la mort." Trans. Lydia David, in P. Adams Sitney, ed., *The Gaze of Orpheus and Other Literary Essays*, 21–62. Barrytown, N.Y.: Station Hill Press, 1981.

Bleich, David. *Readings and Feelings: An Introduction to Subjective Criticism*. Urbana, Ill.: NCTE, 1975.

Blondel, Eric. "Nietzsche: Life as Metaphor." Trans. Mairi Macrae, in Allison, *The New Nietzsche*, 150–75.

Bok, Sissela. *Secrets: On the Ethics of Concealment and Revelation*. New York: Vintage, 1984.

Bonaventure. "Letter Containing Twenty-five Points to Remember." In vol. 3 of *The Works of Bonaventure*, trans. José de Vinck, 247–63. Paterson, N.J.: St. Anthony Guild Press, 1966.

———. *The Soul's Journey into God*. In *Bonaventure*, trans. Ewert Cousins, 51–116. New York, Ramsey, Toronto: Paulist Press, 1978.

Bonhoeffer, Dietrich. *Creation and Fall and Temptation*. New York: Macmillan, 1966.

————. *Life Together*. Trans. John W. Doberstein. New York: Harper and Row, 1954.

Boucher, Holly Wallace. "Metonymy in Typology and Allegory, with a Consideration of Dante's *Comedy*." In Morton W. Bloomfield, ed., *Allegory, Myth, and Symbol*, Harvard English Studies, 129–46. Cambridge: Harvard Univ. Press, 1981.

Bouyer, L. *La Spiritualité du Nouveau Testament et des Pères*. Vol. 1 of *Histoire de la Spiritualité Chrétienne*. Paris: Aubier, 1966.

Brooks, Cleanth. "The Heresy of Paraphrase." In *The Well Wrought Urn*, 176–96. New York: Reynal and Hitchcock, 1947.

————. "Irony as a Principle of Structure." In Hazard Adams, ed., *Critical Theory since Plato*, 1041–48. New York: Harcourt Brace Jovanovich, 1971.

Brooks, Peter. "Freud's Masterplot." In *Reading for the Plot: Design and Intention in Narrative*, 90–112. New York: Vintage, 1985.

————. "The Novel and the Guillotine." In *Reading for the Plot*, 62–89.

————. "Reading for the Plot." In *Reading for the Plot*, 3–36.

Brown, Peter. *Augustine of Hippo*. Berkeley and Los Angeles: Univ. of California Press, 1969.

————. *The Cult of the Saints, Its Rise and Function in Latin Christianity*. Chicago: Univ. of Chicago Press, 1981.

————. *The Making of Late Antiquity*. Cambridge and London: Harvard Univ. Press, 1978.

————. *The World of Late Antiquity, A.D. 150–750*. New York: Harcourt Brace Jovanovich. 1971.

————. "The Rise and Function of the Holy Man in Antiquity." *Journal of Roman Studies* 61 (1971): 80–101.

Bruns, Gerald. *Inventions: Writing, Textuality, and Understanding in Literary History*. New Haven: Yale Univ. Press, 1982.

————. "Language and Power." *Chicago Review* 34, no. 2 (1984): 27–44.

Buber, Martin. *Eclipse of God*. New York and Evanston: Harper and Row, 1957.

Burckhardt, Jacob. *The Civilization of the Renaissance*, vol. 1 of 2. New York: Harper and Bros., 1929.

Burke, Kenneth. *The Rhetoric of Religion: Studies in Logology*. Boston: Beacon Press, 1961.

Burkhard, Arthur. *Matthias Grünewald: Personality and Accomplishment*. Cambridge: Harvard Univ. Press, 1936.

Butler, C. ed., *Lausiac History of Palladius*, 2 vols. Cambridge: Cambridge Univ. Press, 1898, 1904. Migne, *Patrologia Graeca* 34.

Cain, William. *The Crisis in Criticism: Theory, Literature and Reform in English Studies*. Baltimore and London: Johns Hopkins Univ. Press, 1984.

Cameron, Sharon. "Representing Grief: Emerson's 'Experience.'" *Representations* 15 (1986): 15–41.

Cassian. *Institutes*. Trans. E. C. S. Gibson, vol. 11 of Philip Schaff and Henry Wace, eds., *A Select Library of Nicene and Post-Nicene Fathers of the Christian Church*, second series. New York: Christian Literature Company; Oxford and London: Parker and Company, 1894.

Cassirer, Ernst. "The Influence of Language upon the Development of Scientific Thought." *Journal of Philosophy* 39 (1942): 301–29.

Chase, Cynthia. Review of Kristeva, *Powers of Horror, Desire in Language*, and "L'Abject d'amour." *Criticism* 26, no. 2 (1984): 193–201.

Chastel, André. "La Tentation de Saint-Antoine ou le songe du mélancholique." *Gazette des Beaux-Arts* 15 (April, 1936): 218–29.

Chatelet, Albert. "Unité ou diversité du retable d'Issenheim," in *Grünewald en 1974*: 61–68.

Chatman, Seymour. "Reply to Barbara Herrnstein Smith." In Mitchell, *On Narrative*, 258–65.

———. *Story and Discourse.* Ithaca, N.Y.: Cornell Univ. Press, 1978.

John Chrysostom. *Exegesis of Phil.*, quoted in John Alexander Sawhill, *The Use of Athletic Metaphors in the Biblical Homilies of Saint John Chrysostom*, 15–16. Princeton: Princeton Univ. Press, 1928.

Cioran, E. M. *The Temptation to Exist.* Trans. Richard Howard. Chicago: Quadrangle Books, 1968.

Clark, Kenneth. *Civilisation; A Personal View.* New York and Evanston: Harper and Row, 1969.

Lowther Clarke, W. K. "Introduction" to *The Lausiac History of Palladius.* In W. J. S. Simpson and W. K. L. Clarke, eds., *Translations of Christian Literature*, series 1, Greek Texts. London and New York: Macmillan, 1918.

Cooper, John C. "Why Did Augustine Write Books 11–13 of the *Confessions?*" *Augustinian Studies* 2 (1971): 37–46.

Courcelles, Pierre. *Recherches sur les Confessions de Saint Augustin.* Paris: E. de Boccard, 1950.

Culler, Jonathan. "Prolegomena to a Theory of Reading." In Suleiman and Crosman, *The Reader in the Text*, 46–66.

———. "Story and Discourse in the Analysis of Narratives." In *The Pursuit of Signs*, 169–87. Ithaca, N.Y.: Cornell Univ. Press, 1981.

———. *Structuralist Poetics: Structuralism, Linguistics, and the Study of Literature.* Ithaca, N.Y.: Cornell Univ. Press, 1975.

Curran, Stuart. "*Paradise Regained*: Implications of Epic." *Milton Studies* 17 (1983): 209–24.

Cuttler, Charles D. "Some Grünewald Sources." *Art Quarterly* 19, no. 2 (1956): 101–24.

de Bruyne, Edgar. *The Esthetics of the Middle Ages.* Trans. Eileen B. Hennessy. New York: Frederick Ungar, 1969.

Daniélou, Jean. *From Shadows to Reality: Studies in the Biblical Typology of the Fathers.* Trans. Wulston Hibberd. London: Burns and Oates, 1960.

de Lauretis, Theresa. *Alice Doesn't; Feminism, Semiotics, Cinema.* Bloomington: Indiana Univ. Press, 1984.

Delehaye, Hippolyte. *The Legends of the Saints: An Introduction to Hagiography.* Trans. V. M. Crawford. London: Longmans, Green and Co., 1907.

Deleuze, Gilles. *Nietzsche and Philosophy.* Trans. Hugh Tomlinson. New York: Columbia Univ. Press, 1983).

————. "Nomad Thought." Trans. David. B. Allison, in Allison, *The New Nietzsche*, 142–49. Orig. pub. in *Nietzsche aujourd'hui?*, 1973.

Deleuze, Gilles, and Felix Guattari. *The Anti-Oedipus: Capitalism and Schizophrenia*. Trans. Robert Hurley, Mark Seem, and Peter R. Lane. New York: Viking, 1977.

de Lubac, Henri. *Exégèse mediévale*, 4 vols. Paris: Aubier, 1959–64.

de Man, Paul. *Allegories of Reading: Figural Language in Rousseau, Nietzsche, Rilke, and Proust*. New Haven: Yale Univ. Press, 1979.

————. *Blindness and Insight: Essays in the Rhetoric of Contemporary Criticism*. New York: Oxford Univ. Press, 1971.

————. "The Resistance to Theory." In *The Resistance to Theory*, 3–20. Theory and History of Literature 33. Minneapolis: Univ. of Minnesota Press, 1986.

————. "Rhetoric of Persuasion (Nietzsche)." In *Allegories of Reading*, 119–31.

————. "Semiology and Rhetoric." In *Allegories of Reading*, 3–19.

Derrida, Jacques. "All Ears: Nietzsche's Otobiography." *Yale French Studies* 63 (1982): 245–50.

————. "Cogito and the History of Madness." In *Writing and Difference*, trans. Alan Bass, 31–63. Chicago: Univ. of Chicago Press, 1978.

————. "Economimesis." Trans. R. Klein in *Diacritics* 11, no. 2 (1981): 3–25. Orig. pub. in *Mimesis des articulations*, 1975.

————. "Fors." *Georgia Review* 31 (1977): 64–116.

————. "The Law of Genre." In Mitchell, ed., *On Narrative*. Chicago and London: Univ. of Chicago Press, 1981: 51–78.

————. *Of Grammatology*. Trans. Gayatri Chakravorty Spivak. Baltimore and London: The Johns Hopkins Univ. Press, 1978.

————. "The Pharmacy of Plato." In *Dissemination*, trans. Barbara Johnson, 61–171. Chicago: Univ. of Chicago Press, 1981.

————. *Positions*. Trans. Alan Bass. Chicago: Univ. of Chicago Press, 1981.

————. "The Question of Style." Trans. Ruben Berezdivin, in Allison, *The New Nietzsche*, 176–89. Orig. pub. in *Nietzsche aujourd'hui?*, 1973.

————. "Semiology and Grammatology." Interview with Julia Kristeva in *Positions*, 15–36.

————. *Speech and Phenomena and Other Essays on Husserl's Theory of Signs*. Trans. David B. Allison. Evanston, Ill.: Northwestern Univ. Press, 1973.

————. *Writing and Difference*. Trans. Alan Bass. Chicago: Univ. of Chicago Press, 1978.

de Saussure, Ferdinand. *The Course in General Linguistics*. Ed. Charles Bally and Albert Sechehaye, in collaboration with Albert Riedlinger; trans. Wade Baskin. New York: Philosophical Library, 1966.

Dewey, John. *Outlines of a Critical Theory of Ethics*. New York: Hilary House, 1957. Orig. pub. 1891.

Dittmann, Lorenz. *Die Farbe bei Grünewald*. Munich: C. Wolf, 1955.

Dodds, E. R. *Pagan and Christian in an Age of Anxiety*. New York and London: W. W. Norton, 1970.

Donne, John. "The physicians, after a long and stormy voyage, see land." In "Devotions upon Emergent Occasions," in *John Donne, Selected Prose*, ed. Helen Gardner and Timothy Healy, 102–3. Oxford: Clarendon Press, 1967.

Dreyfus, Hubert L., and Paul Rabinow. *Michel Foucault: Beyond Structuralism and Hermeneutics*, 2d ed. Chicago: Univ. of Chicago Press, 1983.

Durkheim, Émile. *The Elementary Forms of the Religious Life: A Study in Religious Sociology*. Trans. Joseph Ward Swain. London: George Allen and Unwin, Ltd., n.d.

Dutton, F. Homes. *Gregory the Great*, 2 vols. London: Longmans, Green and Co., 1905.

Eagleton, Terry. *Literary Theory: An Introduction*. Minneapolis: Univ. of Minnesota Press, 1983.

Eiland, Howard. "Beyond Psychology: Heidegger on Nietzsche." *Kenyon Review* 6, no. 1 (Winter, 1984): 74–86.

———. "Nietzsche's Jew." *Salmagundi* 66 (Winter–Spring, 1985): 104–17.

Eisler, Colin. "The Athlete of Virtue; The Iconography of Asceticism." In Millard Meiss, ed., *De Artibus Opuscula XL: Essays in Honor of Erwin Panofsky*, 2 vols. New York: New York Univ. Press, 1961.

Eliot, T. S. "Tradition and the Individual Talent." In *The Sacred Wood; Essays in Poetry and Criticism*, 3–11. London: Methuen, 1964; orig. pub., 1920.

Eusebius. *Ecclesiastical History*. Trans. Roy J. Deferrari, vols. 19 and 29 of Roy J. Deferrari et al., eds., *Fathers of the Church*. New York: Fathers of the Church, 1953, 1955.

Ferguson, Frances. "A Commentary on Suzanne Guerlac's 'Longinus and the Subject of the Sublime.'" *New Literary History* 16, no. 2 (1985): 291–97.

Ferguson, George. *Signs and Symbols in Christian Art*. New York: Oxford Univ. Press, 1955.

Feurstein, Heinrich. *Matthias Grünewald*. Bonn: Buchgemeinde, 1930.

Fish, Stanley. "Anti-Professionalism." *New Literary History* 17, no. 1 (1985): 89–108.

———. *Is There a Text in This Class? The Authority of Interpretive Communities*. Cambridge and London: Harvard Univ. Press, 1980.

———. "Literature in the Reader: Affective Stylistics." In *Is There a Text in This Class?* 21–67.

———. "Resistance and Independence: A Reply to Gerald Graff." *New Literary History* 17, no. 1 (1985): 119–27.

Fisher, Philip. "A Museum with One Work Inside: Keats's 'Ode on a Grecian Urn.'" In John Hazel Smith, ed., *Brandeis Essays in Literature*, 69–84. Waltham, Mass.: Brandeis Univ. Press, 1983.

Flaubert, Gustave. *The Letters of Gustave Flaubert, 1830–57*. Trans. and ed. Francis Steegmuller. Cambridge and London: Harvard Univ. Press, 1980.

Fleming, Juliet. "Found Texts in John Barth's *Lost in the Funhouse*." Photocopy.

Flores, Ralph. "Doubling and the *Speculum Aenigmate* in St. Augustine's *Confessions*." *New Orleans Review* 8 (Fall 1981): 288–94.

Foucault, Michel. *The Archeology of Knowledge and the Discourse on Language.* Trans. A. M. Sheridan. New York, Hagerstown, San Francisco, London: Harper and Row, 1972.

———. *Les Aveux de la Chair. The History of Sexuality,* vol. 4. Unpub.

———. "The Confession of the Flesh." In *Power/Knowledge: Selected Interviews and Other Writings 1972–77,* ed. Colin Gordon, trans. Colin Gordon et al., 194–228. New York: Pantheon Books, 1980.

———. "Fantasia of the Library." In *Language, Counter-Memory, Practice: Selected Essays and Interviews,* ed. Donald F. Bouchard, trans. Donald F. Bouchard and Sherry Simon, 87–109. (Ithaca, N.Y.: Cornell Univ. Press, 1977.

———. "Final Interview." Trans. Thomas Levin and Isabelle Lorenz. *Raritan* 5, no. 1 (1985): 1–13.

———. *The History of Sexuality. Volume 1: An Introduction.* Trans. Robert Hurley. New York: Vintage Books, 1980. Orig. pub., *La Volonté de savoir,* 1976.

———. "The History of Sexuality." In *Power/Knowledge,* 183–93.

———. "Nietzsche, Genealogy, History." In *Language, Counter-Memory, Practice,* 139–64.

———. *The Order of Things: An Archeology of the Human Sciences,* with a "Foreword to the English edition." (New York: Vintage, 1973); Orig. pub., *Les Mots et les choses: une archéologie des sciences humaines,* 1966.

———. "A Preface to Transgression." In *Language, Counter-Memory, Practice,* 29–52.

———. "Revolutionary Action: 'Until Now,'" in *Language, Counter-Memory, Practice,* 218–33.

———. *Le Souci de Soi* (the care of the self). *The History of Sexuality,* vol. 3. Paris: Gallimard, 1984.

———. "The Subject and Power." Trans. Leslie Sawyer, in Dreyfus and Rabinow, *Michel Foucault,* 208–26.

———. *The Use of Pleasure. The History of Sexuality,* vol. 2. Trans. Robert Hurley. New York: Pantheon, 1985. Orig. pub., *L'Usage des plaisirs,* 1984.

———. "What Is an Author?" In Harari 141–60.

Fraenger, Wilhelm. *Matthias Grünewald.* Munich: C. H. Beck, 1983.

Freud, Sigmund. *Beyond the Pleasure Principle.* Trans. James Strachey, in vol. 18 (1960) of *The Standard Edition of the Complete Psychological Works of Sigmund Freud* (hereafter referred to as *SE*), 7–64. London: Hogarth Press and the Institute for Psycho-Analysis, 1953–74.

———. *The Ego and the Id.* Trans. Joan Rivière, revised James Strachey in *SE* 19 (1961), 12–59.

———. "The Loss of Reality in Neurosis and Psychosis." Trans. Joan Rivière in *SE* 19 (1961), 183–87.

———. "Negation." Trans. Joan Rivière in *SE* 19 (1961), 235–39.

———. "On Narcissism: An Introduction." Trans. C. M. Baines in *SE* 14 (1957), 73–102.

———. "Repression." Trans. C. M. Baines in *General Psychological Theory; Papers on Metapsychology*, ed. Philip Rieff, 104–15. New York: Collier, 1963. This essay is newly translated by James Strachey in *SE* 14 (1957), 146–58.

———. "Resistance and Repression." Trans. James Strachey in *SE* 16 (1963), 286–302.

———. *Totem and Taboo: Some Points of Agreement between the Mental Lives of Savages and Neurotics*. Trans. James Strachey in *SE* 13 (1955), 1–162.

———. "The 'Uncanny.'" Trans. Alix Strachey in *SE* 17 (1955), 219–52.

Frye, Northrop. *Anatomy of Criticism*. New York: Atheneum, 1969.

Gadamer, Hans-Georg. "Man and Language." In *Philosophical Hermeneutics*, trans. and ed. David E. Linge, 59–68. Berkeley, Los Angeles, London: Univ. Of California Press, 1976.

———. "Martin Heidegger and Marburg Theology." In *Philosophical Hermeneutics*, 198–212.

———. "On the Problem of Self-Understanding." In *Philosophical Hermeneutics*, 44–58.

———. *Truth and Method*. New York: Seabury Press, 1975. Orig. pub. as *Wahrheit und Methode*, 1960.

Genette, Gérard. "Frontiers of Narrative." In *Figures of Literary Discourse*, trans. Alan Sheridan, 126–44. New York: Columbia Univ. Press, 1982.

———. *Narrative Discourse*. Trans. Jane E. Lewin. Ithaca, N.Y., Cornell Univ. Press, 1980.

———. "The Obverse of Signs." In *Figures of Literary Discourse*, 27–44.

Gibbon, Edward. *The Decline and Fall of the Roman Empire*, 3 vols., New York: Heritage Press, 1946. Orig. pub. 1776–88.

Gilman, Ernest B. "Word and Image in Quarles' Emblems." *Critical Inquiry* 6, no. 3 (1980): 385–401.

Ginzburg, Carlo. "Clues and the Scientific Method." *History Workshop Journal* 9 (Spring 1980): 5–36.

Girard, René. *Deceit, Desire, and the Novel*. Trans. Yvonne Freccero. Baltimore and London: Johns Hopkins Univ. Press, 1980.

Gombrich, E. H. *The Sense of Order*. (Ithaca, N.Y.: Cornell Univ. Press, 1979.

———. *The Story of Art*. New York: Phaidon, 1951.

Graff, Gerald. "Interpretation on Tlön: A Response to Stanley Fish." *New Literary History* 17, no. 1 (1985): 109–17.

Gregory of Nyssa. "On Perfection." In *Ascetical Works*, trans. V. W. Callahan; vol. 58 in Roy J. Deferrari et al., eds., *The Fathers of the Church*, 95–122. Washington, D.C.: Catholic Univ. of America Press, 1967.

Gregory the Great. *Epistulae* II. Migne, *Patrologia Latina* 76, col. 1128.

Greimas, A. J. *Du Sens*. Paris: Seuil, 1970.

Grünewald en 1974. Vol. 19 of *Cahiers Alsaciens D'Archéologie et D'Histoire*. Strasbourg: Société pour la conservation des monuments historiques d'Alsace, 1975–76.

Guerlac, Suzanne. "Longinus and the Subject of the Sublime." *New Literary History* 16, no. 2 (1985): 275–89.

Works Cited

Haar, Michel. "Nietzsche and Metaphysical Language." Trans. Cyril and Liliane Welch, in Allison, *The New Nietzsche*, 5–36.

Harari, Josué V. *Textual Strategies: Perspectives in Post-Structuralist Criticism.* Ithaca, N.Y.: Cornell Univ. Press, 1979.

Harpham, Geoffrey Galt. *On the Grotesque: Strategies of Contradiction in Art and Literature.* Princeton: Princeton Univ. Press, 1982.

Hartman, Geoffrey. "Beyond Formalism." In Richard Macksey, ed., *Velocities of Change*, 103–17. Baltimore and London: Johns Hopkins Univ. Press, 1974.

———. "Criticism, Indeterminacy, Irony." In *Criticism in the Wilderness*, 265–83.

———. *Criticism in the Wilderness.* New Haven: Yale Univ. Press, 1980.

Hayum, Andree. "Meaning and Function of the Isenheim Altarpiece: The Hospital Context." In *Grünewald en 1974*, 77–89.

Hegel, G. W. F. "The Doctrine of Essence," from *Encyclopedia of the Philosophical Sciences.* Trans. W. Wallace, in J. Loewenberg, ed., *Hegel Selections*, 129–217. New York: Charles Scribner's Sons, 1957.

———. *The Philosophy of History.* Trans. J. Sibree. New York: Dover Publications, 1956.

Heidegger, Martin. *Being and Time.* Trans. John Macquarrie and Edward Robinson. New York, Hagerstown, San Francisco, and London: Harper and Row, 1962.

———. "Language." Trans. Albert Hofstadter, in *Poetry, Language, Thought*, 187–210. New York, Hagerstown, San Francisco, London: Harper Colophon, 1971.

———. *Nietzsche*, 4 vols. Vol. 1, *The Will to Power as Art.* Trans. David Farrell Krell. London and Henley: Routledge and Kegan Paul, 1981.

———. "Nietzsche as Metaphysician." Trans. Joan Stambaugh, in Solomon, *Nietzsche*, 105–13. Orig. pub. in Heidegger, *Nietzsche*, vol. 1.

———. *On the Way to Language.* Trans. Peter D. Hertz, San Francisco: Harper and Row, 1971.

———. "The Origin of the Work of Art." In *Poetry, Language, Thought*, 15–88.

———. "The Resistance to Humanism" (1947). In David Ferrell Krell, ed., *Martin Heidegger: Basic Writings*, 193–242. New York: Harper and Row, 1977.

Hirsch, E. D. *The Aims of Interpretation.* Chicago: Univ. of Chicago Press; 1967.

Hollier, Denis. "Foucault: The Death of the Author." *Raritan* 5, no. 1 (1985): 22–30.

Huizinga, J. *The Waning of the Middle Ages: A Study of the Forms of Life, Thought and Art in France and the Netherlands in the Fourteenth and Fifteenth Centuries.* Garden City, N.Y.: Doubleday and Co., 1954.

Huysmans, J.-K. *Là-bas (Down There).* Trans. Keene Wallace. New York: Dover, 1972.

———. *Trois Primitifs: Les Grünewald du Musée de Colmar, Le Maître de Flémalle et la Florentine du Musée de Francfort-sur-le-Main.* Paris: Flammarion, 1905. Trans. Robert Baldick, in *Grünewald. With an essay by J-K Huysmans* (Weert, The Netherlands: Phaidon, 1976).

Ignatius of Antioch. "Epistle to the Romans." Trans. Maxwell Staniforth, in Betty Radice, ed., *Early Christian Writings: The Apostolic Fathers*, 101–7. Harmondsworth: Penguin, 1980.

Jakobson, Roman. "Closing Statements: Linguistics and Poetics." In T. A. Sebeok, ed., *Style in Language*, 350–77. Cambridge: MIT Press, 1960.

James, William. *Varieties of Religious Experience: A Study in Human Nature*. Ed. Martin E. Marty. Harmondsworth: Penguin, 1983.

Jameson, Fredric. *The Political Unconscious: Narrative as a Socially Symbolic Act*. Ithaca, N.Y.: Cornell Univ. Press, 1981.

Jansen, H. W. *History of Art: A Survey of the Major Visual Arts from the Dawn of History to the Present Day*. Englewood Cliffs, N.J.: Prentice-Hall; and New York: Harry N. Abrams, 1964.

Jaspers, Karl. *Psychologie der Weltanschauungen*. Berlin: Springer, 1960. Orig. pub. 1919.

Jauss, Hans Robert. "The Poetic Text within the Change of Horizons of Reading: The Example of Baudelaire's 'Spleen II.'" In *Toward an Aesthetic of Reception*, trans. Timothy Bahti. Theory and History of Literature, vol. 2, 139–85. Minneapolis: Univ. of Minnesota Press, 1982.

Jerome. "Letter 22." In *St. Jerome: Letters and Select Works*. Vol. 6 of Philip Schaff and Henry Wace, eds., *A Select Library of Nicene and Post-Nicene Fathers of the Christian Church*, second series, 22–41. New York: Christian Literature Company; Oxford and London: Parker and Co., 1893.

Johnson, Barbara. "Rigorous Unreliability." *Critical Inquiry* 11, no. 2 (1984): 278–85.

Kafka, Franz. "A Hunger Artist." In *Selected Short Stories of Franz Kafka*, trans. Willa and Edwin Muir. New York: Random House, 1952, 188–201.

———. *Briefe an Felice und andere Korrespondenz aus der Verlobungszeit*. Ed. Erich Heller and Jürgen Born. Frankfurt am Main: S. Fischer Lizenzausgabe, 1967.

Kandinsky, Wassily. *Concerning the Spiritual in Art*. Trans. M. T. H. Sadler. New York: Dover, 1970.

Kant, Immanuel. *Critique of Judgment*. Trans. J. H. Bernard. New York: Hafner, 1951.

Kenner, Hugh. "The Making of the Modernist Canon." *Chicago Review* 34, no. 2 (1984): 49–61.

Kierkegaard, Søren. *The Concept of Dread*. Trans. Walter Lowrie. Princeton: Princeton Univ. Press, 1973.

———. *Fear and Trembling*. Trans. Walter Lowrie. Princeton: Princeton Univ. Press, 1974.

———. *Repetition: An Essay in Experimental Psychology*. Trans. Walter Lowrie. New York: Harper and Row, 1964.

Kofman, Sarah. "Nietzsche et la métaphore." *Poétique* 2, no. 5 (1971): 77–98.

Krieger, Murray. "The Play and Place of Criticism." In *The Play and Place of Criticism*, 3–16. Baltimore: Johns Hopkins Univ. Press, 1967.

Works Cited

————. *Theory of Criticism*. Baltimore and London: Johns Hopkins Univ. Press, 1976.

Kristeva, Julia. "The Ethics of Linguistics." In *Desire in Language; A Semiotic Approach to Literature and Art*, ed. Leon S. Roudiez, trans. Thomas Gora, Alice Jardine, and Leon S. Roudiez, 23–35. New York: Columbia Univ. Press, 1980.

————. "Giotto's Joy." In *Desire in Language*. 210–36.

————. "How Does One Speak to Literature?" In *Desire in Language*, 92–123.

————. "Motherhood according to Bellini." In *Desire in Language*, 237–70.

————. "The Novel as Polylogue." In *Desire in Language*, 159–209.

————. *Powers of Horror: An Essay on Abjection*. Trans. Leon S. Roudiez. New York: Columbia Univ. Press, 1982.

————. "Stabat Mater." Trans. Arthur Goldhammer. *Poetics Today* 6, no. 1–2 (1985): 133–52. Orig. pub. as "Hérétique de l'amour," *Tel Quel* 74 (1977).

Lacan, Jacques. "Of Structure as an Inmixing of an Otherness Prerequisite to Any Subject Whatever." In Richard Macksey and Eugenio Donato, eds., *The Structuralist Controversy*, 186–94. Baltimore and London: Johns Hopkins Univ. Press, 1972.

Lacarrière, Jacques. *The God-Possessed*. Trans. Roy Monkcom. George Allen and Unwin, London, 1963.

Lacoue-Labarthe, Philippe. "Le Détour." *Poétique* 2, no. 5 (1971): 53–76.

Landolt, Hanspeter. *German Painting: The Late Middle Ages (1350–1500)*. Trans. Heinz Norden. Cleveland: World Publishing Company, n. d. Orig. pub. 1968.

Larson, M. S. *The Rise of Professionalism* (Berkeley and Los Angeles: Univ. of California Press, 1977).

Lentricchia, Frank. *After the New Criticism*. Chicago: Univ. Of Chicago Press, 1980.

Lévi-Strauss, Claude. *Tristes Tropiques*. Trans. John and Doreen Weightman. New York: Pocket Books, 1977.

Lingis, Alphonso. "The Will to Power." In Allison, *The New Nietzsche*, 37–63.

"Longinus." *On the Sublime*. Trans. W. Hamilton Fyfe, in vol. 23 of *Aristotle*, in G. P. Goold et al., eds., Loeb Classical Library. Cambridge: Harvard Univ. Press, 1973.

Luther, Martin. *Lectures on Genesis Chapters 1–5*. Vol. 1 in *Luther's Works*, ed. Jaroslav Pelikan. St. Louis: Concordia Publishing House, 1958.

Lyotard, Jean-François. *Derive à partir de Marx et Freud*. Paris: Union generale d'editions, 1973. Passage in text was translated by Stephen Watson in "Criticism and the Closure of 'Modernism,'" in *SubStance* 42 (1984): 15–31; p. 28.

————. *The Postmodern Condition: A Report on Knowledge*. Trans. Geoff Bennington and Brian Massumi. Theory and History of Literature 10. Minneapolis: Univ. of Minnesota Press, 1984.

MacIntyre, Alasdair. *After Virtue: A Study in Moral Theory*. Notre Dame, Indiana: Univ. of Notre Dame Press, 1981.

Malevich, Kasimir. *The Non-Objective World.* Trans. Howard Dearstyne. Chicago: Theobold, 1959.

Malone, E. E. "The Monk and the Martyr." *Studia Anselmiana* 38 (1956): 201–20.

Mann, I. C. *The Development of the Human Eye.* Cambridge: Cambridge Univ. Press, 1928.

Markus, R. A. "St. Augustine on Signs." In R. A. Markus, ed., *Augustine,* 74–92. Garden City, N.Y.: Doubleday and Co., 1972.

Marshall, Donald. "Plot as Trap, Plot as Mediation." In Paul Hernadi, ed., *The Horizon of Literature,* 71–96. Lincoln, Neb., and London: Univ. of Nebraska Press, 1982.

Marx, Michael J. "Incessant Prayer in the *Vita Antonii.*" *Studia Anselmiana* 38 (1956): 108–35.

St. Maximus the Confessor. *The Ascetic Life. The Four Centuries on Charity.* Trans. Polycarp Sherwood. Vol. 21 of Johannes Quasten and Joseph C. Plumpe, eds., *Ancient Christian Writers: The Works of the Fathers in Translation.* Westminster, Md.: Newman Press; London: Longmans, Green and Co., 1955.

Meier, Michael. "The Artist and His Works." Trans. Peter Gorge in Pevsner and Meier, 21–28.

Melancthon, *Elementa Rhetorices.* Wittenburg, 1531.

Merton, Thomas. *The Monastic Journey.* Ed. Brother Patrick Hart. Garden City, N.Y., Doubleday and Co., 1978.

Michaels, Walter Benn. "Fictitious Dealing: A Reply to Leo Bersani." *Critical Inquiry* 8, no. 1 (1981): 165–71.

———. "The Phenomonology of Contract." *Raritan* 4, no. 2 (1984): 47–66.

———. "*Sister Carrie*'s Popular Economy." Critical Inquiry 7, no. 2 (1980): 373–90.

Miller, D. A. "Balzac's Illusions Lost and Found." *Yale French Studies* 67 (1984): 164–81.

———. *Narrative and Its Discontents.* Princeton: Princeton Univ. Press, 1981.

Miller, J. Hillis. "The Critic as Host." In Harold Bloom, et al., *Deconstruction and Criticism,* 217–53. New York: Seabury Press, 1979.

Mink, Louis O. "Interpretation and Narrative Understanding." *Journal of Philosophy* 69, no. 9 (1972): 735–37.

Mitchell, W. J. T., ed. *On Narrative.* Chicago and London: Univ. of Chicago Press, 1981.

———. "Spatial Form in Literature: Toward a General Theory." *Critical Inquiry* 6, no. 3 (1980): 539–67.

Niebuhr, H. R. *The Meaning of Revelation.* New York: Macmillan, 1967.

Nietzsche aujourd'hui? 2 vols. Paris: Union Générale d'Editions, 1973.

Nietzsche, Friedrich. *Beyond Good and Evil: Prelude to a Philosophy of the Future.* Trans. R. J. Hollingdale. Harmondsworth: Penguin, 1973.

———. *On the Advantage and Disadvantage of History for Life.* Trans. Peter Preuss. Indianapolis and Cambridge: Hackett Publishing Company, 1980.

——. *On the Genealogy of Morals and Ecce Homo.* Trans. Walter Kaufmann. New York: Random House, 1969.

——. "On Truth and Lie in an Extra-Moral Sense," pt. 1. In *The Portable Nietzsche,* ed. Walter Kaufmann, 42–47. New York: Viking, 1954. For complete text in English see "On Truth and Lies in a Nonmoral Sense," in Daniel Breazeale, trans. and ed., *Philosophy and Truth: Selections from Nietzsche's Notebooks of the Early 1870's* (Atlantic Highlands: Humanities Press, 1979): 79–97.

——. *The Will to Power.* Ed. Walter Kaufman, trans. R. J. Hollingdale. New York: Random House, 1967.

Nock, Arthur Darby. *Conversion: The Old and the New in Religion from Alexander the Great to Augustine of Hippo.* London and New York: Oxford Univ. Press, 1933.

Nussbaum, Martha. "Affections of the Greeks." *The New York Times Book Review,* 10 November 1985: 13–14.

——. "Sophistry about Conventions." *New Literary History* 17, no. 1 (1985): 129–39.

O'Connell, R. J. "The Riddle of Augustine's 'Confessions': a Plotinian Key." *International Philosophical Quarterly* 4 (1964): 327–72.

Origen. *The Commentary on Matthew.* Trans. John Patrick; vol. 10 of Roberts and Donaldson, ed., *The Ante-Nicene Fathers.* Grand Rapids, Mich., Wm. B. Eerdmans Pub. Co., 1974.

——. *De principiis.* In *The Writings of Origen,* trans. Frederick Crombie; vol. 4 of A. Roberts and J. Donaldson, eds., *The Ante-Nicene Fathers. Translations of the Writings of the Fathers Down to A.D. 325.* Buffalo: Christian Literature Publishing Co., 1885.

——. *Prayer. Exhortation to Martyrdom.* Trans. John J. O'Meara, vol. 19 of Johannes Quasten and Joseph C. Plumpe, eds., *Ancient Christian Writers: The Works of the Fathers in Translation.* London: Longmans, Green and Co.; Westminster, Md.: Newman Press, 1954.

Panofsky, Erwin. *Albrecht Dürer.* Vol. 1 of 2. Princeton: Princeton Univ. Press, 1943.

Panofsky, E., and F. Saxl. *Dürer's Kupferstich "Melencolia I"; Eine quellen- und typengeschichtliche Untersuchung.* Leipzig-Berlin, 1923.

Pater, Walter. "The School of Giorgione." In *The Renaissance: Studies in Art and Poetry,* 92–106. New York and Toronto: New American Library, 1959.

Pevsner, Nikolaus. "An Introduction to Grünewald's Art." In Pevsner and Meier, 9–19.

Pevsner, Nikolaus, and Michael Meier. *Grünewald.* New York: Harry N. Abrams, 1958.

Plato. *Phaedrus and The Seventh Letter.* Trans. Walter Hamilton. Harmondsworth: Penguin, 1973.

——. *Republic.* Trans. D. Lee. Harmondsworth: Penguin, 1974.

——. *Symposium.* Ed. Kenneth Dover. Cambridge: Cambridge Univ. Press, 1980.

Pletsch, Carl. "The Self-Sufficient Text in Nietzsche and Kierkegaard." *Yale French Studies* 66 (1984): 160–88.

Plumb, J. H. *The Death of the Past*. Boston: Houghton Mifflin, 1970.

Polan, Dana B. "Fables of Transgression: the Reading of Politics and the Politics of Reading in Foucauldian Discourse." *Boundary 2* 10, no. 3 (1982): 361–81.

Poulet, Georges. "Criticism and the Experience of Interiority." In Richard Macksey and Eugenio Donato, eds., *The Structuralist Controversy: The Languages of Criticism and the Sciences of Man*, 56–72. Baltimore and London: Johns Hopkins Univ. Press, 1972.

Pseudo-Clement. "The First Epistle Concerning Virginity." Trans. M. B. Riddle, in *The Twelve Patriarchs*, vol. 8 of A. Roberts and J. Donaldson, eds., *The Ante-Nicene Fathers. Translations of the Writings of the Fathers Down to A.D. 325*, 55–60. Grand Rapids, Mich., The Christian Literature Publishing Company, 1951.

Quasten, Johannes. *The Golden Age of Greek Patristic Literature from the Council of Nicaea to the Council of Chalcedon*. Vol. 3 of 3 in *Patrology*. Westminster, Md.: Newman Press, 1944–60; 1960.

Ransom, John Crowe. *The World's Body*. Port Washington, N.Y.: Kennikat Press, 1964.

Réau, Louis. *Mathias Grünewald et le Retable de Colmar*. Nancy, Paris, Strasbourg: Berger-Levrault, 1920.

Recht, Roland. "Les sculptures du retable d'Issenheim." In *Grünewald en 1974*, 27–46.

Reik, Theodore. *The Compulsion to Confess*. New York: Farrar, Strauss and Cudahy, 1959.

Ricoeur, Paul. "Consciousness and the Unconscious." Trans. Willis Domingo in *The Conflict of Interpretations*, ed. Don Ihde, 99–120. Evanston, Ill., Northwestern Univ. Press, 1974.

———. *Interpretation Theory: Discourse and the Surplus of Meaning*. Fort Worth, Tex.: Texas Christian Univ. Press, 1976.

———. "Mimesis and Representation." *Annals of Scholarship* 2, no. 3 (1981): 15–32.

———. "Narrative Time." In Mitchell, *On Narrative*, 165–86.

———. "'Original Sin': A Study in Meaning." Trans. Peter M. McCormick in *The Conflict of Interpretations*, 269–86.

———. *The Symbolism of Evil*. Trans. Emerson Buchanan. Boston: Beacon Press, 1969.

———. *Time and Narrative*. Vol. 2 of 3. Trans. Kathleen McLaughlin and David Pellauer. Chicago and London: Univ. of Chicago Press, 1985. Orig. pub. as *Temps et Récit*, 1984.

Riegl, Alois. *Stilfragen. Grundlegun zu einer Geschichte der Ornamentik*. (2d. ed. Berlin: Richard Carl Schmidt, 1923.

Rousseau, Jean-Jacques. *A Discourse on Inequality*. Trans. Maurice Cranston. Harmondsworth: Penguin, 1984.

Rousseau, Philip. *Ascetics, Authority and the Church in the Age of Jerome and Cassian*. Oxford: Oxford Univ. Press, 1978.

Works Cited

Ryan, Michael. "The Act." *Glyph* 2 (1977): 64–87.

Said, Edward W. "Michel Foucault, 1927–84." *Raritan* 4, no. 2 (1984): 1–11.

———. "The Text, the World, the Critic." In Harari 161–88.

———. "Travelling Theory." *Raritan* 1, no. 3 (1982): 41–67.

Sartre, Jean-Paul. *Being and Nothingness: An Essay in Phenomenological Ontology.* Trans. Hazel E. Barnes. Seacaucus, N.J.: Citadel Press, 1977.

Scheja, Georg. *The Isenheim Altarpiece.* Trans. Robert Erich Wolf. New York: Harry N. Abrams, 1969.

Schmid, Heinrich Alfred. *Die Gemaelde und Zeichnungen von Matthias Grünewald.* Text, vol. 1; plates, vol. 2. Strassburg: E. I. Heinrich, 1908, 1911.

Schneidau, Herbert. *Sacred Discontent: The Bible and Western Tradition.* Berkeley, Los Angeles, London: Univ. of California Press, 1976.

Schoenberger, Guido. "Introduction" to *The Drawings of Mathis Gothart Nithart Called Grünewald,* ed. Guido Schoenberger, 9–24. New York: H. Bittner and Company, 1948.

Segre, Cesare. *Structures and Time: Narrative, Poetry, Models.* Chicago: Univ. of Chicago Press, 1979.

Sheridan, Alan. *Michel Foucault: The Will to Truth.* London and New York: Tavistock Publications, 1980.

Smith, Barbara Herrnstein. "Narrative Versions, Narrative Theories." In Mitchell, *On Narrative,* 209–32.

———. *On the Margins of Discourse.* Chicago: Univ. of Chicago Press, 1978.

Solomon, Robert C. *Nietzsche; A Collection of Critical Essays.* Garden City, N.Y.: Anchor Press, 1973.

Spengemann, William. *Forms of Autobiography.* New Haven: Yale Univ. Press, 1981.

Stewart, Susan. "The Pickpocket: A Study in Tradition and Allusion." *Modern Language Notes* 95 (1980): 1127–54.

———. "Shouts on the Street: Bakhtin's Anti-Linguistics." *Critical Inquiry* 10, no. 2 (1983): 265–81.

Stone, Lawrence. "An Exchange with Michel Foucault." *New York Review of Books* 29 no. 5 (December 16, 1982): 42–44.

Tate, Allen. *Essays of Four Decades.* Chicago: Swallow Press, 1968.

———. *The Forlorn Demon.* Chicago: Regnery Press, 1953.

Theresa of Avila. *The Way of Perfection.* Trans. E. Allison Peers. Garden City, N.Y.: Doubleday and Co., 1964.

Thomas Aquinas. *The Basic Writings of Saint Thomas Aquinas,* ed. Anton Pegis, 2 vols. New York: Random House, 1945.

———. *The Trinity and the Unicity of the Intellect (Exposition de Trinitate).* Trans. Sister Rose Emmanuelle Brennan. St. Louis and London: B. Herder, 1946.

Todorov, Tzvetan. *The Poetics of Prose.* Trans. Richard Howard. Ithaca, N.Y.: Cornell Univ. Press, 1971.

Valéry, Paul. *The Art of Poetry.* Vol. 7 of *Collected Works,* ed. Jackson Matthews, trans. Denise Folliot. New York: Pantheon, 1961.

Vance, Eugene. "Augustine's *Confessions* and the Grammar of Selfhood." *Genre* 6, no. 1 (1973): 1–26.

———. "Le moi comme langage: saint Augustin et l'autobiographie," *Poétique* 14 (1973): 163–77.

———. "Roland and the Poetics of Memory." In Josué V. Harari, ed., *Textual Strategies; Perspectives in Post-Structuralist Criticism*, 374–403. Ithaca, N.Y., Cornell Univ. Press, 1979.

Veblen, Thorstein. *The Theory of the Leisure Class*. New York: New American Library of World Literature, 1953; Orig. pub. 1899.

von Sandrart, Joachim. *Teutsche Academie der Edlen Bau-, Bild-, und Mahlerey-Künste von 1675*. Vol. 2. Ed. A. R. Peltzer. Munich: G. Hirth's Verlag, 1925.

von Simson, Otto. *The Gothic Cathedral: Origins of Gothic Architecture and the Medieval Concept of Order*. Bollingen Series 48. Princeton: Princeton Univ. Press, 1974.

Waddell, Helen. *Beasts and Saints: Stories of Mutual Charities between Saints and Beasts* [translations from *Apophthegmata Patrum*]. New York: Henry Holt and Co., 1934.

———. *The Desert Fathers* [*Vitae Patrum*]. Trans. Helen Waddell. Ann Arbor: Univ. of Michigan Press, 1957.

Weber, Max. *The Protestant Ethic and the Spirit of Capitalism*. Trans. Talcott Parsons. New York: Charles Scribner's Sons, 1976. Orig. Pub. 1904–5.

Wellard, James. *Desert Pilgrimage: Journeys to the Egyptian and Sinai Deserts*. London: Hutchinson, 1970.

Wellek, René. *The Attach on Literature and Other Essays*. Chapel Hill: Univ. of North Carolina Press, 1982.

White, Hayden. "Michel Foucault." In John Sturrock, ed., *Structuralism and Since: From Lévi-Strauss to Derrida*, 81–115. Oxford, New York, Toronto, Melbourne: Oxford Univ. Press, 1979.

Wimsatt, W. K., and Monroe C. Beardsley. "The Affective Fallacy." In *The Verbal Icon: Studies in the Meaning of Poetry*, 21–40. Lexington: Univ. of Kentucky Press, 1954.

———. "The Intentional Fallacy." In *The Verbal Icon*, 3–20.

Wittgenstein, Ludwig. *Philosophical Investigations*. Trans. G. E. M. Anscombe. New York: Macmillan, 1953.

———. *Tractatus Logico-Philosophicus*. Trans. D. F. B. Pears and B. F. McGuiness. London: Routledge and Kegan Paul, 1955. Orig. pub. 1921.

Zülch, W. K. *Der historische Grünewald: Mathis Gothardt-Nitchardt*. Munich: Bruckmann, 1938.

Index

Index

Index

Index

Remoboths, 274–75n.1
Repetition compulsion, 104–5
Repression, 52–55; ascesis as strong
form of, 54–55
Resistance: to analysis, 52–54; and
assent, 59–60, 63; and binary
oppositions, xv–xvii; as condi-
tion of creation, 31–32; and de-
sire, 61–62; failure of, 66; to
form, 57–59, 62–63; money as a
type of, 62–64; pleasure in, 62;
to temptation, 57–66. *See also*
Foucault; *The History of Sexu-
ality; On the Genealogy of Mor-
als*
Richards, I. A., 254
Ricoeur, Paul, 69, 279n.8; on evil,
64–65, 278–79n.5; on mimesis,
273–74n.14; on narrative, 82–
85, 87. *Works:* "Mimesis and
Representation," 273–74n.14;
"Narrative Time," 82–84;
"Original Sin," 64–65; *Time
and Narrative*, 85
Riegl, Alois, 25
Rousseau, J.-J., 8, 283n.10, 284–
85n.1
Rousseau, Philip, 14, 273n.13
Rufinus, 20–21
Ruskin, John, 243
Ryan, Michael, 292n.12

Said, Edward, 124, 243; on Nietz-
sche, 221, 222, 231. *Works:* "Mi-
chel Foucault, 1927–84," 222,
231; "The Text, the World,
the Critic," 124; "Travelling
Theory," 221, 243
Sartre, Jean-Paul, 55, 62–63
Scheja, Georg, 164–66, 170, 173, 175,
287–88n.5, 288n.10
Schleiermacher, F. D. E., 42
Schneidau, Herbert, 67
Segre, Cesare, 281n.7
Self: ascetic "image" of, 24–25; as-
cetic structure of, 28, 36–41;

and conversion, 42; doubling
of in temptation, 56–57; limit
to perfectability of, 43; pagan
concept of, 27
Semiotic mapping, 108–9
Sheridan, Alan, 225, 293n.1
Sin, 64–65
Smith, Adam, 29
Smith, Barbara Herrnstein, 76–77,
244–45
Socrates, 7, 9, 92, 282n.1. *See also*
Plato
Speech, 6–10, 22; and the body, 15–
16; and double mediation, 9–
10. *See also* Writing
Spengemann, William: *Forms of
Autobiography*, 92–93, 121,
284n.2
Stendhal (H. Beyle), 281n.9
Stewart, Susan, 272–73n.10, 283n.9
Stoics, 7
Stone, Lawrence, 293n.1
Stylites, Simon, 23
Sublime, the. *See* Isenheim Altar
"Suprematism," 275n.8

Tate, Allen, 244, 252, 254
Temptation, 26–27, 46, 56–66; of
Christ, 57–59; confession as
resistance to, 113–14; and de-
sire, 46–47, 50, 61–62; dou-
bling of self in, 56–57; and eco-
nomics, 63–64; in
hagiography, 69; to imitate,
50; compared to inertia, 66;
and interpretation, 48–49; and
language, 36–41, 69–70; and
profit, 55, 64; resistance to, 57–
66; as sign of repression, 54–
56; and transgression, 59–61.
See also Anthony; *Confessions*;
Demons; Desire; Figurality;
Isenheim Altar; Narrative;
Resistance
Textuality: and ascetic discipline,
14; and martyrdom, 14–15,